The Monumental Reliefs of the Elamite Highlands

Mesopotamian Civilizations

The Monumental Reliefs *of the* Elamite Highlands

A Complete Inventory and Analysis
(from the Seventeenth to the Sixth Century BC)

JAVIER ÁLVAREZ-MON

EISENBRAUNS | University Park, Pennsylvania

This research was supported under Australian Research Council's 2014–18 Future Fellowship (Project FT130101718) and by Macquarie University, Australia

Library of Congress Cataloging-in-Publication Data

Names: Alvarez-Mon, Javier, author.
Title: The monumental reliefs of the Elamite highlands : a complete inventory and analysis (from the 17th to 6th century BC) / Javier Alvarez-Mon.
Description: University Park, Pennsylvania : Eisenbrauns, [2018] | Includes bibliographical references and index.
Summary: "A comprehensive documentation and study of a corpus of eighteen monumental highland reliefs belonging to the Elamite civilization, ranging from the seventeenth to the sixth century BC"—Provided by publisher.
Identifiers: LCCN 2018048029 | ISBN 9781575067995 (cloth : alk. paper)
Subjects: LCSH: Relief (Sculpture), Ancient—Iran—Elam. | Art, Elamite. | Elam—Antiquities. | Iran—Antiquities.
Classification: LCC NB130.E43 A48 2018 | DDC 731/.540935764—dc23
LC record available at https://lccn.loc.gov/2018048029

CONTENTS

PREFACE AND ACKNOWLEDGMENTS

This book has been a long time in the making. It began in 2003 when I received a Fulbright-Hays scholarship to undertake research in Elamite archaeology and art at the Musée du Louvre in Paris and in Iranian museums. During my stay in Iran I had the opportunity to visit the Zagros highland valley of Izeh/Malamir, the Mamasani Fahliyan River Valley, and the plain of Marvdasht and digitally photograph a corpus of monumental relief sculptures carved into a number of cliff faces and boulders more than 2,500 years ago. In the ensuing years I was able to augment this photographic record, gradually generate a series of line drawings, and dedicate time to studying the reliefs. My most recent visit to the reliefs was in November 2017.

The principal aim of this work is to provide a comprehensive reference for the study of the reliefs. The methods I have used for analyzing and interpreting them are informed by both art history and archaeology, which I conceive as complementary disciplines. In other words, taking into account the archaeological context of an artifact is as important to me as using traditional methods of artistic analysis to determine the nature and significance of its form and theme. This complementarity affords multiple paths of enquiry for the investigation of the historical realities of an artifact. One of these realities that the reader will see prioritized here is cultic practice. Admittedly, it is due in part to personal bias that I stress ritual as a vital component of religion and an essential characteristic of what means to be human and that I perceive the reliefs as sacred art residing in a kind of awe-inspiring natural "Sistine Chapel." Another bias that, at heart, determines my understanding of the reliefs is their placement in a natural environment of remarkable beauty and phenomenological and aesthetic significance. My interest in both ritual-religious and aesthetic-ecological phenomena is the outcome of my own personal experience and a reaction to contemporary challenges: the dissociation of human existence from nature and the commodifying of the nonhuman environment on an unsustainable scale.

The survival of the Elamite reliefs presented here, undoubtedly secured by their remote location and anonymous existence, is a rare gift to current generations. Sadly, however, a significant increase in visitors in recent years and the development of the surrounding landscapes are already taking their toll on the reliefs. For anyone who cares about ensuring that future generations can continue to appreciate Iran's rich cultural heritage, the preservation of this remarkable corpus of monumental art should be a matter of urgency.

This study has enjoyed the support of numerous institutions, colleagues, friends and family members. For their pivotal participation during critical stages of this long journey, I owe a special debt of gratitude to my parents, Mercedes Sánchez Ortíz and Manuel Álvarez-Mon García y Güell, and to Lulu Álvarez-Mon Regalado, Dariush Akbarzadeh, Pierre Amiet, Gian Pietro Basello, Rémy Boucharlat, Mark B. Garrison, Margaret Harris, Yousef Hasanzadeh, Wouter F. M. Henkelman, Peter Hiscock, Mohammad Reza Kargar, Jaafar Mehrkian, Margaret Miller, Ali S. Mousavi, Shahrokh Razmjou, François Vallat, and Yasmina Wicks. Special thanks go to Mr. Asadi, the kind Bakhtiyari caretaker of the Kul-e Farah reliefs, who has labored for years to keep the reliefs out of harm's way. Many thanks to Jim Eisenbraun and Jerry Copper for their invitation to publish in the Eisenbrauns

Mesopotamian Civilization series, as well as the various readers who took the time to review and comment on my work. At the institutional level, I have had the privilege to receive the support of the U.S. Department of Education (2003 Fulbright-Hays), the University of Sydney (2007 Postdoctoral Fellowship), and the Australian Research Council (2014–18 Future Fellowship). I remain deeply indebted to the dynamism and vision of John Simons, former Deputy Vice-Chancellor at Macquarie University, and to my colleagues in the Department of Ancient History at Macquarie University. Finally, but not least, my academic career has been honored with the mentorship and friendship of the late Professor Ernie Haerinck, Emeritus Professor David Stronach, and Professor Daniel T. Potts, gentlemen and sources of inspiration for the striving for excellence in scholarship.

This book is dedicated to my father Manuel (1933–2017), *el viejo acampador*; unknowingly, his love for walking, the outdoors, and the mountains put me on a path that led me to this work.

Javier Álvarez-Mon Sánchez
Madrid, December 2017

PLATES

1. Map of southwest Iran with key sites mentioned in text (by the author); Landsat photograph of Iran. Courtesy of NASA Goddard Space Flight Center and U.S. Geological Survey.

2. (a) Landsat 3D rendering of the Izeh/Malamir Valley. Courtesy of Cameron Petrie, in Cameron Petrie, "Exploring Routes and Plains in Southwest Iran: Izeh," ArchAtlas (2005), version 4.1, http://www.archatlas.org/Petrie/Izeh.php, accessed 3 April 2018. (b) Map of the Izeh/Malamir valley with key sites (by the author).

3. Boulder of Xong-e Azdhar. Color photographs courtesy of Davide Salaris, 2016; line drawing by the author.

4. Relief of Shah Savar and view of the valley from the relief. Photographs by the author, 2003 and 2017.

5. Shekaft-e Salman, cave and waterfall. Photographs by the author, 2003.

6. Shefaft-e Salman, location of four reliefs. Photographs by the author, 2003 and 2017.

7. Kul-e Farah, location of six reliefs. Photographs by the author, 2003.

8. Relief of Qal-e Tul. (a) Line drawing by the author. (b) Fragmentary plaque from Susa, line drawing by the author.

9. Fahlīyān River plain and location of Kurangun. (a) Location of Kurangun. Northing: 30° 14.675' N; easting: 051° 27.638' E; elevation: 915 m above sea level. Photograph courtesy of NASA Goddard Space Flight Center and U.S. Geological Survey. (b) Kurangun. Photograph by the author.

10. Views of Kurangun. Top: photograph by the author, October 2017. Bottom: photograph by the author, March 2003.

11. View of Kurangun and superimposed line drawing by the author. Based on Vanden Berghe 1984, 28, fig. 2, with modifications by the author.

12. Details of Kurangun II. (c) Individuals in staircase. (d) Individual 13. (e) Individual 12. Photographs by the author 2003, line drawing by the author.

13. Views of Kurangun central panel. Photographs by the author, 2003, and by Gian Pietro Basello, 2014, courtesy of DARIOSH Project.

14. Photographs of seal impressions representing the Elamite god sitting on a coiled serpent. (a) Sealing of Tan Uli. Sealing on a fragmentary legal tablet from Susa. Late seventeenth–early sixteenth century BC. 6.9 cm high; 5.8 cm width. The inscription reads: "Tan-uli, *sukkalmah*, *sukkal* of Elam and Shimashki, sister's son of Shilhaha." (b) Sealing of the Scribe Sirahupitir. Sealing rolled over two small tablets. The inscription reads: "Sirahupitir scribe, son of Inzuzu,

servant of Attahushu." (c) Sealing of Tepti-mada. 2.4 cm high. The inscription reads: "Tepti-mada, shepherd of the people of Susa, sister's son of Shilhaha." Photographs by the author.

15. Kurangun, lateral southeast panel. (a) Line drawing by the author. (b) Photographs by the author, 2003 and 2017.

16. Naqsh-e Rustam, Elamite relief. Photographs by the author, 2003; drawing by Kaempfer (1712, 373).

17. Naqsh-e Rustam, Elamite relief. Color photographs and line drawings by the author, 2003 and 2017.

18. Relief of Shekaft-e Salman I. Photographs by the author, 2003 and 2017; aquarelle (bottom-right by J. de Morgan (1901, pl. 32b).

19. Glazed bricks from the Royal Tabernacle at Susa. Photographs by the author. Line drawings a1 and b1 after Amiet 1976, 20 and 28, figs. 3 and 22 (Creative Commons license; www .Persée.fr; courtesy of P. Amiet). Line drawing a2 by the author.

20. Elamite Princes. After P. Calmeyer 1980, pls. 27.1, 2, 3; 28.1. Courtesy of Deutsches Archäologisches Institut. Orient-Abteilung.

21. Kassite-Elamite Stele Sb 9. Photographs by the author; line drawing by the author.

22. Relief of Shekaft-e Salman II. Photographs by the author, 2003 and 2017; line drawing by the author; aquarelle by J. de Morgan (1901, pl. 32a).

23. (a1–4) Bronze bas-relief from Susa, Sb 133. (a) Photographs and line drawing by the author. (b) Line drawing after Scheil (1911, 88, fig. 18).

24. Reliefs of Shekaft-e Salman III(a) and IV(b). Photographs by the author, 2003 and 2017; line drawings by the author.

25. Views of Kul-e Farah IV. Photographs by the author, 2003.

26. View of Kul-e Farah IV. Photographs by the author.

27. View of Kul-e Farah IV. (a) Aquarelle by de Morgan (1900). (b) Photograph by the author, 2003.

28. Views of panel KFIV: AI. (a) Photograph by the author, 2003. (b) Mr. Asadi pointing at the king. Photograph courtesy of Kaisu Raasakka (https://www.flickr.com/people/ninara/). (c) Photograph by the author, 2017. (d) Detailed view of the pair of vessels in register AIII. Photograph by the author 2017. (e) Detailed view of vessels in a stand in register AI. Photograph by the author, 2003. (f) Elamite cultic goblets. Photographs by the author, 2003. (g1) Line drawings by the author of Elamite Goblets and amphorae vessels.

29. Relief of KFIV, panels -B and -C. Photographs by the author 2003.

30. Relief of KFIV, panels BI and BII. Photographs by the author, 2003.

31. Archer KFIV: CI4. (a–c) Photographs by the author, 2003. (d) Photograph by the author, 2017.

32. Latex cast of Archer KFIV: CI4, . Photographs by the author.

33. Latex cast of Archer KFIV: CI4. Photographs by the author.

34. Latex cast and details of archer KFIV: CI4. Line drawing and photographs by the author.

35. (a) Kul-e Farah IV photograph of panels BII, CI, and CII. Courtesy of Darafsh Kaviyani (Creative Commons license, Wikimedia). (b) Line drawing by the author. (c) Archers from panel AII. Photographs and line drawings by the author.

36. Kul-e Farah IV panel D. Photographs by the author, 2017.

37. KFIV, line drawing and structural composition, by the author.

38. KFIII. Photographs by the author, 2017.

39. KFIII, southern face. Photograph courtesy of Patrick C. Pentocello, 2008 (Creative Commons license); line drawing by the author).

40. KFIII, details of the southern face. Photographs by G. P. Basello, 2014, courtesy of DARIOSH Project.

41. KFIII, details of the southern face. Photographs by G. P. Basello, 2014, courtesy of DARIOSH Project.

42. KFIII, details of the platform bearers. Photograph and line drawing by the author.

43. KFIII, details of the southern face, naked individuals. Photographs by G. P. Basello, 2014, courtesy of DARIOSH Project.

44–46. KFIII, details of the southern face. Photographs by G. P. Basello, 2014, courtesy of DARIOSH Project.

47. KFIII, eastern face. Photographs by G. P. Basello, 2014, courtesy of DARIOSH Project; line drawing by the author.

48–52. KFIII, northern face. Photographs by G. P. Basello, 2014, courtesy of DARIOSH Project.

53. KFIII, western face. (a) Photographs by G. P. Basello, 2014, courtesy of DARIOSH Project. (b) Line drawing by the author. (c) Zebu from KFI. Photograph by the author. (d) Zebu from Persepolis, Apadana reliefs. Photograph by the author.

54. KFIII. Photographs by G. P. Basello, 2014, courtesy of DARIOSH Project; line drawing by the author.

55. Kul-e Farah VI. Photographs courtesy of Neda Dehnad, 2014.

56. KFVI. Photograph courtesy of A. Bakhtyar; line drawing by J. Álvarez-Mon.

57. KFVI, details. Photographs by the author, 2003 and 2017.

58. Platform bearers from Kul-e Farah VI. (a–b) Photograph and line drawing by the author. (c) Lower image courtesy of Neda Dehmad, 2014.

59. (a1–a2) Neo-Elamite limestone plaque Sb 43. Photograph and line drawing by the author. (b) Neo-Elamite limestone pedestal Sb 5. Photographs by the author. (c) Neo-Elamite limestone plaque Sb 43. Photograph by the author.

60. Kul-e Farah II with Mr. Asadi standing in front. Photograph by the author, 2003; line drawing by the author.

61. Kul-e Farah II. (a, b, d). Photographs by the author, 2003. (c) Head of an individual in a faiance plaque, Sb 3362. Line drawing by the author.

62. Kul-e Farah V. Photograph and line drawing by the author, 2003.

63. Kul-e Farah I. Bottom photograph with Mr. Asadi. Photographs by the author, 2003.

64. Kul-e Farah I. (a) Heliogravure by Dujardin published by Scheil (1901, pl. 23). (b) Photograph by the author, 2003.

65. Kul-e Farah I. Photographs by the author, 2017.

66. (a) Plaque of walking ibex from Susa. Photograph by the author, 2003. (b) Ibex from the inner frame of a window in the palace of Xerxes at Persepolis. Photograph by the author, 2003.

67. Kul-e Farah I, details of (a) a high official weapon bearer, (b) a high official, and (c) Hanni. Photographs by the author, 2003.

68. Kul-e Farah I and Mr. Asadi. Photograph by the author, 2003; line drawing by the author.

69. Weapon Bearers from (a) Bronze plaque from Susa Sb 133, (b) KFIV panel AII: 20, (c) KFVI: 11, (d) KFI: 2, and (e) Susa, limestone pedestal Sb 5. Photographs and line drawings by the author.

70. Musicians from (a) KFIV, (b) KFIII, (c) KFI, and (d) the Arjan bowl.

71. Elamite royal orchestra represented in the southwest palace of Sennacherib, room 33, marking the arrival to the royal city of Madaktu, ca. 653 BC. Line drawing after Rawlinson 1873, pl. 13. Photographs by the author).

72. Twelfth-century BC molded brick façade belonging to an "exterior sanctuary" (a *kumpum kidua*) probably located in the Apadana mound at Susa. It was composed of an alternating sequence of two divinities: a protective lama and a bull-man holding a palm tree. Housed at the Louvre Museum. Photographs by the author.

73. (a) Old Elamite-period bronze sculpture from the temple of Inshushinak at Susa depicting an Elamite divinity sitting in a coiled-serpent throne. Housed at the Louvre Museum. Photograph and line drawing reconstruction by the author. (b) Thirteenth-century BC monumental stone base of a divinity sitting on a three-coiled-serpent throne. Housed at the Louvre Museum. Photographs by the author.

74. Fourteenth-century BC Stele of Untash Napirisha. Housed at the Louvre Museum. Photographs by the author.

ABBREVIATIONS AND TEXT SIGLA

Abbreviations for Journals, Series, and Monographs

CAD	*The Assyrian Dictionary of the Oriental Institute of the University of Chicago*. Chicago: The Oriental Institute of the University of Chicago, 1956–2006
EKI	Texts published in König 1965
IrAnt	*Iranica Antiqua*
MDP	*Mémoires de la délégation en Perse*
RCS	Harper, P. O., J. Aruz, and F. Tallon, eds. *Royal City of Susa: Ancient Near Eastern Treasures in the Louvre*. New York: Metropolitan Museum of Art, 1992
YBYN	Miller, N. F., and K. Abdi, eds. *Yeki Bud, Yeki Nabud: Essays on the Archaeology of Iran in Honor of William M. Sumner*. Cotsen Institute of Archaeology Monograph 48. Los Angeles: Cotsen Institute of Archaeology, 2003

Additional Abbreviations and Sigla

AO	Antiquités Orientales. Museum siglum for objects in the collections of the Musée du Louvre, Paris
BM	British Museum. Museum siglum for objects and tablets in the collections of the British Museum, London
HC	Hands Clasped in front of the body (gesture)
IFP	Index Fingers Pointing (gesture)
KF	Kul-e Farah
RHHF	Right Hand Holding Food (gesture)
Sb	Objects and tablets from sites in the Susiana region in the collections of the Musée du Louvre, Paris.
SF	Snapping Fingers (gesture)
SS	Shekaft-e Salman

SITE NAMES WITH ALTERNATIVE SPELLINGS

Principal site names mentioned throughout the book

Names	Alternative Spellings
Izeh/Malamir	Īzeh/Mālamīr
	Iza/Māl-(e) Amir
Xong-e Azdhar	Hung-e Azdhar
	Hung-e Nauruzi
	Hong-e Nowruzi
	Hung-i Nauruzi
	Hung-i Azdhar
Shah Savar	Shahsavar,
	Šāh Savār
Kurangun	Kūrangūn
	Kūrāngūn
Naqsh-e Rustam	Naqš-e Rustam
	Naqsh-i Rustam
Shekaft-e Salman [SS]	Eshkaft-e Salman
	Eškaft-e Salman
	Šekāf-e Salmān
	Šekaft-e Salmān
	Shikaft-e Salman
	Eshkaft-i Salman
Qal-e Tul	Qaleh Tol,
	Qal'e-ye Toll,
	Qal'eh-ye Tol
Kul-e Farah [KF]	Kūl-e Farah
	Kul-i Farah

INTRODUCTION

This book seeks to provide the first comprehensive documentation and study of a corpus of eighteen monumental highland reliefs belonging to the Elamite civilization, ranging in date from the seventeenth to sixth century BC. The reliefs are dispersed across four different locations: the valley of Izeh/Malamir (Xong-e Azdhar, Shah Savar, Shekaft-e Salman and Kul-e Farah), the Ghale Tol plain (Qal-e Tul), the Mamasani Fahliyan river region (Kurangun), and the Marvdasht plain (Naqsh-e Rustam) (pl. 1).

The geographical settings and previous studies of the reliefs are described in this introductory chapter, followed by some notes on methodological aspects of the work. The bulk of the study is then presented in two main parts: Part I describes the reliefs systematically in chronological order and Part II is devoted to placing the reliefs in the historical and artistic contexts of the second and first millennia BC. Drawing the book to a close are some brief remarks on the legacy of Elamite monumental highland sculpture.

§i.1. The Setting of the Reliefs

Contrary to the Egyptian and Mesopotamian civilizations, which developed along rivers and water channels, the emergence of a political and cultural entity known as Elam is entrenched in the interaction between two distinct regions: the alluvial plain of southwest Iran (today in Khuzestan province) and the Zagros highlands. In geophysical terms, the alluvial plain is an extension of the Mesopotamian plain. It has large rivers fed by melting snow, rainfall, and aquifers, and it has marshes and desert to its west. Highland Elam lies in the Zagros Mountains, which are visible from the alluvial plain to the north and northeast, and which give birth to rivers that carve their way down into the plain. Numerous intermontane valleys are today home to agricultural villages and rich pasturages. In some areas the transition from the plain to the imposing mountain range is remarkably abrupt, while in others it is less distinct and quite amenable to communication between the lowlands and highlands. Of particular importance for the periods discussed here is the northwest-southeast corridor linking the Susiana plain (with Susa as its main urban center, lying ca. 83 m above sea

level), Ram Hormuz, Behbahan, Nurabad-Fahliyan, and the Marv-Dasht plain (with Anshan as its main urban center, lying ca. 1600 m above sea level) (pl. 1).

§i.1.1. Izeh/Malamir

The Zagros highland region of Izeh/Malamir is nestled in a mountain valley that averages an elevation of 750 m above sea level and a width of 8 km and extends northwest to southeast for about 21 km, acting as a natural passage linking the lowlands with the high plateau (pl. 2). It is 160 km to the southeast of Susa, the lowland alluvial capital of the Elamite Kingdom and the Persian Empire, and four walking days from the present-day town of Shushtar (Jéquier 1901, 133) (pls. 1 and 2).[1] During the early Islamic period, the caravan road from Susa to Isfahan made its way through the valley via the ancient city of Izeh, at the time one of the most important regional centers. It was also home to the winter headquarters of the powerful Chahar Lang Bakhtiyari tribe.

In sharp contrast to the arid landscape of the lowlands, Izeh/Malamir periodically receives heavy rainfall and snow runoff that wash down through the cliffs, waterfalls, creeks, and streams into seasonal lakes occupying the central part of the valley. Excellent grazing land and steep mountain slopes studded with oak trees add to the stunning scenery.[2] In the words of Austen H. Layard (1846, 75): "Mál Amír is perhaps the most remarkable place in the whole of the Bakhtiyárí Mountains. On all sides the most precipitous mountains rise almost perpendicularly from the plain."

Carved on the surface of cliffs and boulders in four different locations are a total of twelve Elamite reliefs: one at Xong-e Azdhar (pl. 3), one at Shah-Savar (pl. 4), four at Shekaft-e Salman (henceforth also SS) (pls. 5–6), and six at Kul-e Farah (henceforth also KF) (pl. 7). Another relief and a statue in fragmentary state have been found at Qal-e Tul, about 30 km south of Izeh/Malamir (pl. 8a).

Situated in the southwest side of the valley 2.5 km from the town center of Izeh is the majestic "romantic grotto" (Stein 1940, 129) of Shekaft-e Salman, where a waterfall cascades seasonally over a high cliff face, passing in front of the entrance to a natural cave below and merging with the spring water flowing from within its depths (pl. 5). Four reliefs were carved inside and to the right of the mouth of the cave (pl. 6). At the time of the visit of the French Delegation in 1898, a small chapel built over the flattened ground to the left of the cave still existed. Gustave Jéquier (1901, 139) wrote of the site: "Indeed, the aspect of this fantastic and grandiose site, lost in the monotonous landscape of Malamir and its surroundings, at once evokes the idea of these sacred places in all countries of the world, where the ancestors never failed to place the sanctuaries."

About 7 km from Izeh in the northeast of the valley is the gorge known as Kul-e Farah. It is surrounded on three sides by cliffs, while the fourth side opens to the valley, forming a natural "theater" (pl. 7). Kul-e Farah accommodates six reliefs, three carved on boulders and three along the cliffs. At its southern end lies the source of a seasonal creek that runs through the site and out onto the plain. The cliff relief of Shah-Savar (pl. 4) lies approximately 10 km to the southeast of Izeh, and the boulder relief of Xong-e Azdhar lies around 17 km to the northeast (pl. 3).

The history of the valley of Izeh/Malamir is poorly known. In the mid-nineteenth century, Layard (1846, 74–75) mentioned the existence of "ruins of a very ancient city" on its eastern side, and Jéquier (1901, 133, Fig. 1) noted some years later that there were "in Malamir numerous mounds covering ancient ruins." Aurel Stein (1940, 129) visited the valley in 1936 and commented on a large mound in the medieval town of "Idhej" bearing a ruined castle at its peak. A "tepe of Izeh (Malamir) once an Elamite stronghold" was apparently still visible when Walther Hinz (1972) visited in 1958. Hinz also reported that locals found an Elamite stele belonging to "the wall panelling of the palace of late Elamite princes of Ayapir/Malamir" (Hinz 1966, 44, pl. IX).[3] Major archaeological surveys of the Izeh plain were conducted in April–June 1976 under the direction of Henry T. Wright

1. The name Izeh goes back to the Abbasid caliphate, and the name Malamir goes back to the Mongol period. Izeh replaced Malamir in 1935 (Schippmann 1971, 218 n. 30).

2. According to Curzon (1892; reprinted 1966, 285), "there is more timber than in any part of Persia with the exception of the Caspian provinces."

3. To my knowledge, no further records of this find exist.

(1979). Together with M. Sajjidi, he made a small 2 × 1 m sounding at a location they referred to as the Izeh east face mound. They encountered Middle Elamite pottery comparable to forms excavated at Tall-e Ghazir and a related fragmentary inscription presumed to be of Middle Elamite date (Stolper 1978, 93; Sajjidi and Wright 1979, 107).[4] The reported ancient settlement mounds, together with the limited archaeological work and the reliefs presented in the ensuing pages, suggest that the area was part of an Elamite political and cultural koine during the second and first millennia BC.

§i.1.2. Qal-e Tul

The village of Qal-e Tul, popularized in Western literature through Layard's 1839–42 travel accounts (published in Layard 1842), is located ca. 30 km south of Izeh/Malamir (between Izeh and Ram Hormuz) (pl. 1). It was here at "Kalat Tul," in the castle of the Bakhtiyari Ilhani leader Mehemet Taki Khan, that Layard became a guest of honor after saving the life of one of the Khan's sons (Layard 1894, 147–52). Nothing is known about the Elamite past of this strategically positioned area other than an Elamite relief and a large fragmentary sculpture discovered by local farmers in 1935 (pl. 8a). To my knowledge, the present whereabouts of both are unknown.

A natural north-south corridor around 80 km long links Izeh/Malamir, Qal-e Tul, and the Ram Hormuz plain. The latter is home to the large, unexcavated Elamite urban centers of Tepe Bormi (18 ha.) and Tall-e Ghazir (7.5 ha), which no doubt played a pivotal role in fostering political and cultural networks of highland and lowland communities. Both were occupied during the second and first millennia (Miroschedji 1990, 57; Carter 1994; Wright and Carter 2003; Álvarez-Mon 2010a, 232–33; Alizadeh et al. 2014).[5] Further underscoring the significance of the Ram Hormuz region in the transmission of traditions during the Neo-Elamite II phase (725/700–520 BC)

and highlighting material cultural links between Susa, Ram Hormuz, and Arjan are the fortuitous discoveries of a richly equipped bronze "bathtub" coffin burial in a subterranean tomb in 1982 at Arjan, about 9 km northeast of the present-day city of Behbahan (Álvarez-Mon 2010a), and a second tomb housing two "bathtub" coffin burials and multitudes of precious grave goods in 2007 at Ram Hormuz/Jubaji (Shishegar 2015; Wicks 2015; 2017). The funerary goods from these tombs include a number of unique masterpieces of great artistic value and rare craftsmanship.

§i.1.3. Kurangun

The relief of Kurangun was carved on a rocky cliff face ca. 80 m high atop an outcrop of the Kuh-e Pataweh, which overlooks the Fahliyan River as it flows through the panoramic Mamasani region. The site is situated on the ancient artery linking Susa with Anshan (pls. 1 and 9). Architectural installations and ceramics have been observed along the slope of the mound where the Kurangun open-air sanctuary is located, but these have yet to be thoroughly investigated (pl. 9).[6] W. Kleiss (1993) believed that some of the pottery shards from the mound area could be dated to the second and first millennia BC, but Daniel T. Potts (personal communication) disputes the accuracy of these statements. Instead, the ceramic samples collected so far suggest Sassanian and Islamic periods (Zeidi, McCall and Khosrowzadeh 2009, 165; MS40).

The Mamasani region preserves substantial archaeological remains, some of which have received the attention of a joint Iranian-Australian archaeological team. The broader Mamasani project concentrated on the sites of Tol-e Spid (MS51), Jin-Jin (MS46), and the large site of Nurabad, as well as on a survey of the Mamasani settlements (Potts and Roustaei 2006; Potts et al. 2009). Based on preliminary results, a new pattern of second- and first-millennium BC occupation has emerged in the region, potentially providing new contexts for the interpretation of the sanctuary.[7] In addition, a stamped

4. These surveys and test excavations uncovered an Uruk-period settlement 2 km southeast of the town of Izeh: Tappeh Sabz'ali (Wright 1979, 64).

5. The ancient Elamite city of Huhnur/Hunar/Unar, already mentioned in third-millennium BC Mesopotamian texts, is probably to be identified with a mound located in this area (Mofidi-Nasrabadi 2005; Potts 2008a; but see Alizadeh 2013, 65).

6. Site listed as MS40 in Zeidi, McCall, and Khosrowzadeh 2009.

7. The occupation sequence of Nurabad, a large mound ca. 25 m high and covering ca. 5 ha, comprises the Mushki/Middle Susiana period (ca. 5500 BC) down to the Achaemenid period.

brick found at Tol-e Spid mentions a temple dedicated to Kilah-shupir by the twelfth-century BC king Shilhak-Inshushinak, indicating the presence of religious Elamite architecture in this region (König 1965, 94, 41A; Vanden Berghe 1966, 56; Potts 2004; Potts and Roustaei 2006). Finally, the Jin-Jin excavations have uncovered a monumental installation recalling Persian palatial architecture. This building has been associated with the Achaemenid (royal) way stations mentioned in the Persepolis tablets (Atarashi and Horiuchi 1963; Potts and Roustaei 2006; Potts 2008a; Potts et al. 2009).

§i.1.4. Naqsh-e Rustam

Two Elamite reliefs were carved at Naqsh-e Rustam at the westernmost extension of the Mountain of Husain (Kuh-e Husain) (pl. 16). This location marks the meeting of the Kuh-e Husain and the Pulvar River with the wide open plain of Marvdasht (pl. 1), and the presence of the reliefs could perhaps be linked to a neighboring natural spring (Schmidt 1970, 10) and an ancient road that weaved its way through the foothills of the Kuh-e Qaleh and Kuk-e Hasan (Kleiss 1981; Sumner 1986, 17, ill. 3). Very little is known about the archaeological history of this area before the Achaemenid Persian kings selected its mountainous ridge as their main burial ground.[8]

As we shall see, the wealth of visual and, to a lesser degree, textual information gleaned from a study of the reliefs at Izeh/Malamir, Qal-e Tul, Kurangun, and Naqsh-e Rustam compensate for the meagre archaeological evidence excavated to date. These carvings offer critical insights into the political, social, and religious history of Elam and demonstrate the existence of complex political entities enjoying extraordinary degrees of artistic and cultural sophistication.

§i.2. The Study of the Reliefs

Some of the most celebrated personalities in the history of ancient Near Eastern archaeological research

were involved in the discovery and study of the Elamite reliefs. The timeline below follows scholarly engagement with the reliefs over three centuries, with an emphasis on judgements by those who dedicated particular attention to their significance and place within ancient Iran.

The earliest-documented Elamite relief is the partly preserved panel at Naqsh-e-Rustam, a significant portion of which was cut away for the carving of a later relief of the Sassanian regent Bahran II (pl. 16). An early eighteenth-century line drawing produced by J. Chardin (1711, fig. 74) illustrated only the Sassanian portion, overlooking the Elamite traces entirely, while those of E. Kaempfer (1712, 373) (pl. 16) and, much later, R. K. Porter (1821, fig. 24) incorporated these sections, but assumed they had belonged to the Sassanian relief.[9] Persian scholar, artist, and poet Forṣat Shirazi (Atar-e Ajam 1896/1313; see Dabirsiaqi 2011) likewise drew the entire relief as a single work. It was not until the twentieth century that Ernst Herzfeld (1926, 244) would recognize two distinct reliefs and the Elamite presence.

The Malamir reliefs were first mentioned in Western literature by Major Henry C. Rawlinson. In 1836, he had been leading a heavily armed expedition of 3000 Guran Kurds through the Zagros Mountains into Bakhtiyari territory when he learned of the existence of Shekaft-e Salman, "one of the great curiosities of the place" and "a place of pilgrimage to local Lurs" (Rawlinson 1839, 84; Adkins 2004, 68). A few years later, in 1841, Austen H. Layard and Baron Clement A. de Bode visited the valley in separate parties to coincide with an assembly of Bakhtiyari Khans and both took the opportunity to visit and record some of the reliefs. Bode produced a description and accompanying drawing that would become the basis for a sketch by Pascal Coste (Bode 1843a, 1843b; Dieulafoy 1885, 224), while Layard (1846, 74–79) offered a preliminary account of the cuneiform inscriptions and a brief description of some of the carvings. Layard assigned the manufacture of reliefs to the "Kayanian" period, in reference to the legendary kings of the Avesta, and with respect to the overall artistic quality of Kul-e Farah I portraying Hanni of Ayapir (pl. 68), he declared: "The design is bold and the execution good" (Layard

8. For recent excavations revealing occupation of the area during the reigns of Cyrus or Cambyses, see Askari, Callieri, and Matin 2014.

9. Line drawings published by U. Seidl (1986, 14–16, figs. 3–7).

1846, 74).[10] The archaeological, epigraphic, and artistic significance of Izeh/Malamir were subsequently treated in brief commentaries by William S. W. Vaux (1884, 448) and Lord George N. Curzon (1892; reprinted 1966, 196).

Next followed members of the first French archaeological mission in Persia. In 1885, Charles Babin and Frédéric Houssay, two members of a small team headed by Marcel and Jane Dieulafoy, arrived in Malamir and took the first set of photographs of Kul-e Farah I and II (Dieulafoy 1885, 224–27, pl. 24). While acknowledging the importance of the site and its reliefs, Marcel Dieulafoy (1885, 224) judged that any further investigation at this stage would be premature and should be deferred until further progress was made in the excavations at Susa. Apparently less than impressed by the reliefs as they had been presented in the available documentation, the celebrated French historians Georges Perrot and Charles Chipiez (1890, 778) remarked, "All that can be said is that these sculptures do not reveal the art that flourished in Persia under the Achaemenids."

In October–November 1898, members of the second French archaeological mission directed by Jacques de Morgan journeyed from Isfahan to Susa via *le pays des Bakhtiaris*, crossing through Izeh/Malamir. According to a personal journal kept by Jéquier (1968, 107–8), they spent three exceedingly productive days (8–10 October) at Izeh/Malamir endeavoring to produce a topographic sketch, making an *estampage* of the inscribed relief of KFI and generating drawings of KFII, III, and IV and SSI, II, and III. The results of this enterprise were published in 1901 in the third volume of the *Mémoires de la Délégation en Perse*, combining a summary description of the reliefs by Jéquier (pp. 133–44), epigraphic work by Father Vincent Scheil (pp. 102–32), and sketches by Morgan (pl. 27).[11] Jéquier (1901, 142) attempted to place the reliefs in historical context, estimating that they dated to the "last time of the Elamite kingdom in the days of the struggle against the kings of Assyria." Despite noting the degraded state of the carvings, he described their general style as "reminiscent of the ancient art of

Babylonia, while the heaviness and lack of grace of the figures indicate a decadent art." Because the Shekaft-e Salman relief inscriptions translated by Scheil referred to Hanni of Ayapir, the same personage attested at Kul-e Farah (KFI), Jéquier took the carvings at the two sites as contemporary.

The results of the French missions attracted the interest of the wider academic community. German linguist Oskar Mann, for example, who was studying the Luri spoken dialects of the region, was inspired to produce copies of the reliefs and inscriptions (Mann 1910). Also interested in these remnants of Elamite artistic production were German archaeologists and Iranologists Friedrich Sarre and Ernst Herzfeld who in 1910 were first to observe that they could hold significant information regarding the genesis and characteristics of Persian sculptural arts.[12]

Kurangun and Qal-e Tul were the next two reliefs discovered. The first was encountered in April 1924 by Ernst Herzfeld who recorded it in a line drawing (Herzfeld 1926). Much later, two more sketches of the relief, differing slightly in certain details, would be published separately in the same year by Vanden Berghe (1986) and Ursula Seidl (1986). In 1935, just over a decade after the discovery of Kurangun, local farmers from the town of Qal-e Tul, south of Izeh, located a single relief panel. In its vicinity, they also detected part of a large sculpture (Stein 1940, 126; Hinz 1966, 45).

The Izeh/Malamir reliefs became a topic of conversation once again in 1943 in the volume *L'Iran antique, Elam et Perse, et la civilisation Iranienne* by Clément Huart and Louis-Joseph Delaporte (1943, 220–21). These authors perceived Assyrian art as the inspiration behind their production and, following Scheil and Jéquier (1901), attributed their manufacture to Hanni "prince of Ayapir" based on his KFI cuneiform inscription.

After more than half a century's hiatus, the next Western scholar to report a visit to the Izeh/Malamir valley appears to have been Walther Hinz in 1958 (Hinz 1966). He was followed by the Belgian archaeological mission

10. A complete bibliography of the occasional western visitors to the valley on their way from Shushtar to Isfahan is provided in L. Vanden Berghe 1963 and E. De Waele 1976a, 5–8.

11. Jéquier 1901; Scheil 1901; Morgan 1901, pls. 27–30, "Appendice, description du site de Malamir."

12. "Für den Entwicklungsgang der persischen Kunst, und nicht nur für die Kunstgeschichte, sondern für die Geschichte selbst ist das Verhältnis des Audienzreliefs zu einem Relief von Kul i Fara von großer Bedeutung" (Sarre and Herzfeld 1910, 144).

in 1962 under the direction of Louis Vanden Berghe, who also discovered the relief of Xong-e Azdhar (Vanden Berghe 1963, 38). The result of the Belgian mission's study was a seventeen-page report comprising twenty-eight plates and brief descriptions of the reliefs. In his evaluation of the reliefs, Vanden Berghe (1963, 39) followed Sarre and Herzfeld, stressing continuity with Persian art: "The art of Malamir announces already that of the Achaemenids or, conversely, the latter received numerous elements from Elamite art, such as the parade of individuals on several registers, the rows of processions that meet each other, the scene of the king sitting on the throne receiving his ministers, the absence of divinities, the employment of the Elamite garment and still many other elements."

Edith Porada's study of the pre-Islamic art of Iran, *Alt Iran*, published in 1962 (with French and English translations appearing in 1963 and 1965 respectively), omitted the Izeh/Malamir reliefs altogether but briefly commented on those of Kurangun and Naqsh-e Rustam (Porada 1965, 66–67). Walther Hinz's *Das Reich Elam*, published in 1964 and again in 1972 in English language as *The Lost World of Elam: Re-creation of a Vanished Civilization*, dedicated its final chapter to a survey of Elamite art but terminated prematurely in the "classical" period (ca. 1100 BC), since in the author's view "those finds and monuments which have come to light do not justify a detailed description of the [Neo-Elamite] period" (Hinz 1972, 162–79). While his text did not treat the later centuries of Elam, he nevertheless incorporated photographs of three of the Izeh/Malamir reliefs, having visited the valley on two occasions (in 1958 and 1963). Not unlike Jéquier's appraisal of the carvings as lacking in grace, Hinz (1966, 43) dismissed KFVI as "grossly executed," revealing "evidence of little artistic skill."[13]

In 1966 Louis Vanden Berghe published *Archéologie de L'Irān Ancient* in which he included three photographs of the reliefs and a summary of the "five" sculptures from Kul-e Farah and the four from Shekaft-e Salman,

which he dated to the eighth and seventh centuries BC.[14] He expressed similar sentiments to those of Jéquier and Hinz, emphasising the "poor artistic value" of the reliefs (Vanden Berghe 1966, 61–63, pls. 90–91). In the same year, Pierre Amiet's classic work on Elamite art was published. His chapter dedicated to "the end of Elam" included nine photographs of the Izeh/Malamir reliefs and sections of the carvings at Kurangun and Naqsh-e Rustam, which he dated to the end of the eighth and the seventh centuries BC, following Vanden Berghe (Amiet 1966, 549–69, figs. 421–28).

Some years later, Peter Calmeyer (1973, 152) would revive the notion of Sarre and Herzfeld, carried forth by Vanden Berghe, that the Kul-e Farah reliefs, particularly KFIV, could reveal evidence for a channel of artistic continuity linking Elam with Persia. In his view, they "presage conventions found in the art of the Achaemenid Empire" and reflect a "period of Elamite-Persian cohabitation." In his 1988 *Reallexikon der Assyriologie* entry on the Malamir reliefs, Calmeyer (1988, 283; 2009) again stressed the importance of Persia's Elamite heritage, contending that KFIII and KFVI should be regarded as "direct precursors of the Achaemenid tomb facades."

The most significant studies dedicated to the Izeh/Malamir Elamite reliefs were undertaken by Eric de Waele between 1970 and 1975. A total of nearly two months of in-situ study of the reliefs materialized in his Ph.D. dissertation (1976a) and a string of seven articles, featuring selected illustrations and line drawings, published between 1972 and 1989. A lack of supporting line drawings, quality photographs, and art-historical analysis somewhat limits the value of the Ph.D. manuscript, but it nonetheless reveals certain insights that were not incorporated in the published work. Because the dissertation was never made public, it had little or no impact on the field of ancient Near Eastern art, even despite De Waele's own words (1976a, preface): "The ten bas-reliefs from Sekaf-e Salman and Kul-e Farah near Izeh represent an iconographic source of exceptional wealth until now totally unexploited. Their contribution to Elam covers domains as diverse as history, religion, language,

13. Hinz failed to acquaint himself with the relief during his first visit on 3 March 1958, a happenstance that he amended during a second visit on 7 March 1963. The relative isolation of this boulder partially explains its marginalization and why, despite a reference to it by G. Jéquier (1901, 138–39), both Hinz (1966, 43) and Vanden Berghe (1963) initially overlooked its existence.

14. Vanden Berghe (1966, 61) misinterpreted the platform and platform bearers from KFIII, describing the latter as "four individuals with hands raised kneeling at the feet of a large personage."

sculpture and civilization in general (music, furniture, garments …). The work of my predecessors, however, are far from being satisfactory studies."

Vanden Berghe organized an exhibition dedicated to the rock reliefs of ancient Iran in Brussels between 26 October 1983 and 29 January 1984. The accompanying exhibition catalogue *Reliefs Rupestres de L'Iran Ancien* (Vanden Berghe 1984) offered a sample of the efforts made by Vanden Berghe, Ernie Haerinck, and Erik Smekens to comprehensively photograph the various rock reliefs in Iran. It was the first publication to address the Elamite reliefs as a single group.[15]

Between February and May 2003, the present author had the opportunity to visit Kurangun, Naqsh-e Rustam, and the valley of Izeh/Malamir to produce a digital photographic record of the reliefs. This led to the publication of a study of the platform bearers depicted in KFIII and detailed studies of KFIV and KFVI (Álvarez-Mon 2010a; 2010b; 2013). During a lecture at the National Museum of Iran (Tehran) in April 2012, I had the privilege of being presented with a latex cast of one of the best-preserved sections of KFIV (individual archer CI: 4).[16] This cast has unveiled significant, hitherto-unrecognized detail, facilitating further study and appreciation of Elamite sculptural relief (Álvarez-Mon 2015a).

In another publication (Álvarez-Mon 2014), I have discussed the relief carved in the open-air sanctuary at Kurangun within the context of art theory and the aesthetics of the natural environment. Archaeological work in the area by the University of Sydney, directed by D. T. Potts (The Mamasani Archaeological Project), has recognized the chronological relationship between this relief and the Elamite settlement of Tol-e Spid, which lies less than 3 km away (Potts et al. 2009).

My last visit to the reliefs in October–November 2017 confirmed their deteriorating state and the urgent need for restoration and safeguarding for future generations. The uniqueness and cultural significance of these monumental artworks demands a collaboration between the Iranian authorities and both local and international institutions to find ways to halt their degradation and, ultimately, to have them added to the UNESCO World Heritage List.

§1.3. Notes on Photographs, Line Drawings, and Measurements

Most of the photographs included in this work have been taken by me over the course of the past fourteen years.[17] The earliest images were captured in May 2003 with a Nikon Coolpix 990 (3.34 megapixels) and the most recent in October–November 2017 with a Nikon D5300 (24.2 megapixels) and various telephoto lenses. Despite the technological advantages of digital photography and almost limitless image storage space, I have been faced with much the same practical challenges as those who had previously attempted to photograph the reliefs. Some of the carvings, or parts thereof, are extremely difficult to photograph either because they are high above the ground or because they are seldom exposed to natural light. Sometimes they are instead flooded by a blanket of direct light, preventing an appreciation of the volume and nuanced details of the modeling. Each relief is different, but in general the best light comes from the side, creating sharp contrasts and highlighting details that are otherwise nearly impossible to discern. In order to address the challenges associated with poor natural light, I have sometimes digitally manipulated the exposure level of the images.

Because most of the photographs were taken from ground level, a degree of distortion of the reliefs increasing proportionally with height was unavoidable. I attempted to correct these distortions by digitally manipulating the angle of the photographs, but this solution is less than ideal and consequently the scale of the line drawings is not entirely accurate. The study of the best preserved reliefs would benefit from 3D digital scanning of the kind undertaken in 2008 by V. Messina and J. Mehrkian

15. Three photographs of the reliefs were included: SSII (Vanden Berghe 1984, 169), KFIII (Vanden Berghe 1984, 170), Kurangun (Vanden Berghe 1984, 170, 172, with detail of Kurangun II).

16. I received this cast from the Iranian authorities in an official public ceremony as a token of appreciation for my work on the study of Elamite art and culture.

17. The following friends and colleagues have kindly contributed with additional digital photographs: A. Bakhtyar, Gian Pietro Basello, Neda Dehnad, Patrick C. Pentocello, Kaisu Raasakka, and Davide Salaris.

(2010) on the Parthian relief of Hung-e Azhdar and from laboratory analysis of surface composition.[18]

The line drawings are my own interpretations and are based on both photographs and in-situ acquaintance with the reliefs. Their function is of essentially practical character: to offer a complete view of the compositions and to create a framework for a systematic discussion of all depicted elements. My earlier drawings were generated in four basic steps: (1) master photographs were selected (often out of hundreds taken) and manipulated digitally to improve light and contrast; (2) the photographs were printed and tracing paper was used to draw the figure outlines and, where present, details within;[19]

(3) the line drawings were scanned and, in many cases, digitally redrawn; and (4) the master photographs were reexamined and compared with older images in order to tidy up the final version. The time-consuming steps 2 and 3 were made obsolete when I became more comfortable with digital drawing software and could draw directly onto the screen.

Finally, as the reader will note, there is some unevenness in the provision of measurements throughout this work. Because it has not always been possible to record the measurements myself, their provision here is dependent upon availability in the published documentation.

18. Unlike the much younger Parthian relief from Xong-e Azdhar, most Elamite reliefs have been poorly preserved. Some, however, such as the better-preserved Shekaft-e Salman I and II, would benefit from 3D scanning.

19. On numerous occasions, I was unable to discern sufficient detail in the photographs to justify variance between similar subjects and therefore repeated the motif; see, for instance, the representation of rows of individuals KFIII: 18–34 (pl. 39).

The Reliefs

§1. Xong-e Azdhar (Seventeenth Century BC)

§1.1. Introduction

Xong-e Azdhar is a small gorge (*hong* in local Lorestani) located at the steep, rocky foot of the mountains about 17 km northeast of the town of Izeh (pl. 2). Its relief, first noted by Vanden Berghe (1963, 38), was carved on the upper part of the northwest surface of a 9 × 6 × 6.5 m boulder, facing toward the valley (pl. 3). It is composed of two registers, together measuring 1.35 m high × 1.95 m wide, divided horizontally by a partly broken-off narrow platform. The lower register clearly depicts eight individuals, but the one above has eroded to the point where it is difficult to determine whether or not it had incorporated a carving or an inscription. Also cut into the rock are two narrow channels that run down from the top of the boulder and along the right and left sides of the relief. The channel on the right makes a sharp left turn and terminates at the narrow central platform dividing the registers. It is not possible to determine whether these channels were part of the original design and, if so, what their intended purpose had been. On the opposite side of the boulder facing the cliff, another relief was added in the Parthian period, perhaps depicting a scene of homage or investiture (Messina and Mehrkian 2010).[1]

§1.2. Preservation

The upper register has completely disappeared and the lower register is badly eroded.

§1.3. Iconography

Eight individuals (1–8) are depicted in the lower register (pl. 3). The slightly larger-scale individual on the left (1) is seated facing right toward the others and wears a long garment. The waistline appears to be very narrow, but the image is too eroded

1. Past scholarship: Vanden Berghe 1963, 38; Börker-Klähn 1982, no. 117; Vanden Berghe 1984, 27; Carter 2014, 44, fig. 5.5b; Messina and Mehrkian 2015, 18.

to allow further description. The remaining seven (2–8) are all similar in scale and shown frontally. They stand in a line oriented left to face the seated figure. Each wears a long garment that flares sharply outward at the bottom. The last six (3–8) hold their hands up in front of their waists, possibly clasped in a worshiping gesture. The first (2) does not appear to make this gesture and may instead be interacting with the seated individual.

§1.4. Elements of Composition and Style

The composition is structured as a single line of individuals inside a register. A hierarchy level separates the slightly larger-scale, seated individual (a divinity or ruler?) from the seven individuals standing facing him/her, all depicted on the same smaller scale. The shared garment and gesture of the last six figures in line imply some degree of equality, while the one at the front is distinguished by possible direct interaction with the seated individual. The only perceptible stylistic note is the garment, which has a long, bell-shaped skirt flaring sharply outward at the bottom. Gender is not clearly defined.

§1.5. Chronology

Vanden Berghe (1963, 38) dated the relief to the Shimashki period (ca. 2050–1900 BC) and identified the imagery as seven worshipers paying homage to a monarch. Many years later, he instead envisaged a procession of worshipers before a divinity and shifted the date forward to the eighteenth century BC based on analogies with glyptic iconography (Vanden Berghe 1984). More recently, Messina and Mehrkian (2010, 31) dated the relief more broadly between the fifteenth and seventh century BC but then realigned their view with Vanden Berghe's, suggesting it was manufactured in "probably the Old Elamite period," specifically, "the beginning of the 2nd millennium BC" (Messina and Mehrkian 2015, 15, 18).

As Carter (2014, 44) has already observed, the relief is not easy to date because there are enormous gaps in our knowledge of the highland material record and no exact parallel for the depiction of a relatively large group of worshipers, apparently equal in status, facing a single ruler (or divinity). Yet two elements, one iconographic, the other stylistic, may still provide chronological clues: (a) the depiction of a group of standing individuals facing a seated deity or monarch and (b) the style of the long, elite robe.

In Mesopotamia and Elam, the iconography of the seated deity receiving a group of standing worshipers goes back to the Akkadian period, at which time the standing group was comprised also of deities (Amiet 1972, nos. 1562, 1566; Collon 1981, nos. 158, 160, 161). In Vanden Berghe's (1963, 38) view, the closest iconographic correspondences are found in Shimashki and Old Elamite glyptic, but he did not further elaborate on this point. I presume that he was referring not to the presentation scenes where an intermediary lama goddess is present but rather to those where a seated individual without obvious divine markers, perhaps a ruler, faces two individuals of equal size, both wearing long garments and making a worshiping gesture (Amiet 1972, nos. 1834, 1858, 1861, 1864). In one of these seals, the seated individual holds a cup (nos. 1834, 1834, 1861, 1864), and in the second (no. 1858), he raises one hand in the direction of the two worshipers. These seals are dated to the *sukkalmah* (Old Elamite) period and are considered typically Elamite, belonging to a "popular" bitumen series.[2] Their imagery may even be an abridged version of the scene on the Xong-e Azdhar relief.

A second clue for dating this relief is the style of the garments, which have very flared hemlines giving the skirt a bell-like appearance. On the long garments of seventeenth-century BC Elamite elites, this feature was often so exaggerated that the hem flared out into triangular tips. One of the most prominent examples of this garment style can be observed on the seal of Tan-Uli, *sukkalmah and sukkal of Elam and Shimashki* (pl. 14a), where it is worn by both ruler and divinity (Amiet 1972, no. 2330; Aruz 1992a, 117, no. 76). Based on the garment style and iconographic correspondences with the seals discussed above, it would be reasonable to place the manufacture of the relief sometime around the seventeenth century BC.

2. Except for seal no. 1858, all were manufactured in bitumen. Seal 1834 bears the inscription "Puzurriri, son of Ikupisha."

§2. Shah Savar (Seventeenth Century BC)

§2.1. Introduction

The Shah Savar relief was cut about 5 m high on the face of a prominent vertical cliff in the southeastern part of the Izeh/Malamir valley, about 10 km from Izeh.[1] It was carved inside a rectangular panel measuring ca. 0.61 m high × 3 m wide (pl. 4). No obvious natural features explain the choice of this site for the relief, but it does face a majestic view of the open valley and today looks down onto an old cemetery dotted with distinctive Bakhtiyari tombstones in the form of guardian lions and a ruined funerary chapel (Imanzadeh). In 1846, H. Layard relayed a local legend about this chapel (Layard 1846, 78): "An Imam on a black horse once visited this part of the plain, from which circumstance the Imam-Zadeh has received its name. They yearly sacrifice sheep here; and I suspect that the tradition is of a much remoter period than the time of the Imams."

§2.2. Preservation

The relief is badly weathered, but the outlines of a group of six individuals can still be perceived.

§2.3. Iconography

Layard (1846, 78) described the relief as representing an enthroned king facing five prisoners with their hands bound together. Jéquier (1901, 142; followed by Vanden Berghe 1963, 37–38) later provided the now-standard description, in which the seated individual extends one hand out toward the line of five individuals. The first in line holds out both arms, one raised slightly above the other, toward the seated figure,

1. Past scholarship: Layard 1846, 78; Jéquier 1901, 142–43; Vanden Berghe 1963, 37–38; De Waele 1973, 35; Börker-Klähn 1982, 170; Vanden Berghe 1984, 27.

and the four behind clasp their hands together in front, making a gesture of worship. Vanden Berghe (1984, 27) identified the seated individual as a deity (followed by Börker-Klähn 1982, 170, and Carter 2014, 44), but for Messina and Mehrkian (2015, 18), either a god or a king would be plausible.

(1) Large seated figure on the left wearing the long garment with triangle-tipped hemline, occupying the entire height of the relief and facing the line of five individuals. The upper legs are disproportionately long. The left elbow rests on the lap, but it is unclear whether the hand is placed on the knee or raised to hold up an object.

(2) Individual standing first in line, holding out at least one arm toward the seated figure. Depicted in a long garment on a slightly larger scale than the four behind. Remains of a large, unidentifiable object are visible above the ground level between individuals 1 and 2.

(3) Individual, slightly shorter than the one in front and taller than the three behind, wearing a long robe, possibly a square cap and braid, and making the hands-clasped worshiping gesture.

(4–5) Two shorter individuals of approximately equal height wearing a long garment and making the hands-clasped worshiping gesture.

(6) Last individual in the group, perhaps shorter than nos. 4 and 5, wearing a shorter, knee-length garment and making the hands-clasped worshiping gesture

§2.4. Elements of Composition and Style

The composition is structured as a group of individuals placed in a single line inside a register. Scale and type of garment are used to define status, and gestures are used to show relationship levels. At least four levels of status differentiation seem to be depicted. The largest individual (1) (a deity or ruler), of undistinguishable

gender, is seated on a chair without any obvious backrest and faces a line of standing individuals (2–6) arranged according to height and presumably social status. The first in line (2) is tallest and seems to interact with the seated individual (1). The next (3) is slightly shorter and possibly has a square cap, the following two (4 and 5) are slightly shorter again and share the same gestures, and the last in line (6) seems to be the smallest and is the only one wearing a short garment. The only notable stylistic element is the triangle-tipped hemline of the garment worn by individual no. 1.

§2.5. Chronology

Vanden Berghe (1963, 38) dated this relief to the Shimashki dynasty (ca. 2050–1900 BC) based on its similarity to that of Xong-e Azdhar and comparisons with cylinder seals depicting presentation scenes. De Waele (1973, 35; followed by Börker-Klähn 1982, 170) instead suggested the seventeenth century, and Vanden Berghe (1984, 27; followed by Messina and Mehrkian 2015, 18) later modified his proposal to incorporate the eighteenth century. Carter (2014, 44) proposed a broader date encompassing the first half of the second millennium.

The depiction of an enthroned high-status individual facing a group of worshipers, the pointed garment hemline, and the possible interaction between the two first individuals indeed suggest a date fairly contemporary with the Xong-e Azdhar relief, which I assigned above to the seventeenth century. The composition, however, differs in the depiction of status inasmuch as there are three slightly different scales used to distinguish between the individuals standing in line and the last individual is further differentiated from the rest of the group by a shorter garment.

§3. Kurangun I, II, and III (Seventeenth–Sixteenth and Ninth–Sixth Centuries BC)

§3.1. Introduction

The outdoor sanctuary of Kurangun is located on an outcrop of the Kuh-e Pataweh along the ancient highway linking the Elamite western lowland capital of Susa and the eastern highland capital of Anshan (Tal-e Malyan) (pls. 1 and 9). Its focal point is a rock-cut relief elevated ca. 80 m high on a cliff face overlooking the Fahliyan River as it flows through the panoramic Mamasani region (pl. 10).[1] The origin of the name Kurangun remains uncertain, but it possibly derives from the new Persian word *kurang(ah),* a place for reviewing troops, a race ground; derived from Mongol *küren,* camp, tent (cf. Bakhtiyari *k?rän,* "encampment").[2] The word Kurang(ah) may have received the typical Persian geographic suffix *–an* which changes into *–un* in much spoken local Persian. But also, west of Isfahan in the Bakhtiyari mountains, there is the Kūh-i-Rang (Kūh'rang) mountain, a source of the Karun river.[3]

§3.2. Preservation

Though easily accessible from the northern slope of the mountain, Kurangun is far away from urban centers and has, until recently, attracted only a very limited number of visitors. The survival of this relief, the oldest sections of which are now well over 3500 years old, in such an exposed location is quite miraculous, even if the surface has eroded considerably in some parts. The principal panel has lost much of its internal detail and for the most part only general outlines are visible. Other sections including

1. Latitude: 30° 14' 41.38" N; longitude: 51° 27' 38.21" E.
2. For a possible Mongol link to placenames formed from *kūrān,* see Eilers 1971, 453–54. I am grateful to Daniel T. Potts for alerting me to this reference.
3. The existence of Kurangun was revealed to the academic world in 1926 by E. Herzfeld (1926, 259), who had visited the site in April 1924. Herzfeld's recording was superseded by that of Vanden Berghe (1984, 1986), who worked on documenting the relief in May 1975 and December 1979. In 1986, a brief study by Ursula Seidl (1986) was published by the German Archaeological Institute in the series Iranische Denkmäler. More recently, Potts (2004) and the present author (Álvarez-Mon 2014) have further examined the character and significance of this relief, focusing on the identity of the divinities and its setting within the natural landscape, while Anne-Birte Binder (2013) has reexamined the date of the main relief.

a few steps of the lower staircase, the front section of the horizontal platform (see below) and the right panel have become entirely detached as result of major fractures in the rock. The eroded state of the carving has invited the opinion that some sections of the relief had been left unfinished (Seidl 1986, 7; Miroschedji 1989, 359). In some areas Vanden Berghe (1986) detected traces of clay or bitumen plaster, indicating that certain details such as the hair, beard, eye, ear and garments had been originally plastered and engraved with details that have now all but worn away. He encountered the same sculptural technique of plastering and engraving the modeled surface in Kul-e Farah reliefs III and IV and proposed that it may have been perpetuated in Achaemenid and Sassanid rock sculpture (see §16. Notes on Manufacture). The Kurangun relief was once linked to the river by a path on the side of the mountain (Seidl 1986, pl. 2).

§3.3. Iconography

A triangular section was cut out of the sloping upper section of the cliff to create a three-dimensional, northeast-southwest oriented, rectangular spatial unit for the main relief panel and adjoining horizontal platform,[4] which were linked by three flights of stairs (twenty-one steps in total) to the summit of the hill (pls. 10–15). The ca. 5 × 2 m platform is surrounded on three sides by a small, three-stepped frame, but the fourth side is broken away preventing a complete reconstruction of its original appearance. The floor preserves remnants of 26 relief-carved fish swimming in opposite directions (pls. 11, 13, 15). On the vertical surface of the rock about 60 cm above the platform are the remains of a rectangular, 1.60 × 3.64 m panel sculpted in low-relief with a worship scene centered on an enthroned divine couple oriented toward the staircase)(pls. 11, 13). The bearded male divinity sits on a coiled-serpent throne and in his right hand holds a ring and rod from which emerge two streams of flowing water. The streams arch backward and forward toward

two trios of worshipers framing the seated divinities. Three additional groups of worshipers line up to the left of the main panel, as if standing on the stairs, and in a lateral panel to the right is another group of worshipers divided into two registers. The upper register seems to include three individuals, the lower register four, and all appear to be ascending the stairs (pl. 15).

The structure of the composition can be divided into three sections carved during two separate time periods: a central panel (1–11) representing the oldest section of the relief and a left panel (12–47) and right panel (49–54), both added at a later date.

§3.3.1. Central Panel (Kurangun I)

(1) *Male Deity*. Male deity (0.83 m high) oriented in the direction of the staircase and, except for the chest and headdress, depicted in profile. He is seated on a throne made of the coiled body of a serpent, its head forming the backrest. The throne may have been set atop a double platform with triangular extensions at either end (see reconstruction by Seidl 1986, Abb. 2a; and, for analogies, Miroschedji 1981b, pl. I). The deity has a long rectangular beard, a pair of long sidelocks, long hair possibly collected into a braid at the back and a round headdress with a pair of horns and animal ears. He wears an ankle-length garment that exposes the feet; the right foot is set slightly forward, the toes of the left foot overlapping the heel. The left arm is flexed at 90 degrees and the hand holds a pair of serpents that seem to emerge from the throne; the right arm is extended forward to hold out objects, presumed to be a ring and rod, from which two streams of flowing water emerge.

(2) *Female Deity*. Female deity (0.81 m high) oriented toward the staircase, seated behind or perhaps beside the male but at a slightly lower level.[5] She is depicted in profile except for her chest, horns and animal ears. The throne is in the shape of an animal and does not appear to have a backrest. Seidl noted that since there is very little room for her feet, she may have sat cross-legged following an ancient Iranian tradition. Her hair bulges out in a large bun from behind a horned headdress with

4. The north-south orientation indicated in the line drawing presented by Herzfeld (1941, fig. 304) is oversimplified in comparison with Vanden Berghe's more precise drawing (Vanden Berghe 1986, fig. 2; [shown here in pl. 11]).

5. Vanden Berghe (1986, 159) understood the goddess as seated *next* to the god, not behind him.

pointy animal ears and a pendant (or possibly a braid) hangs from the back of her neck, following along the line of the left shoulder. She may also have sidelocks. According to Vanden Berghe (1986, 159) two serpents are held in the left hand, but Seidl (1986, 9) instead proposes that either the hands are both held outstretched or the right holds a vessel and the left rests on the lap.

(3) *Platform with Fish.* The horizontal platform (5 × 2 m) has preserved a low border composed of three step-like protrusions along two sides of what must have once represented a rectangular basin. Inside are the remains of 26 carved fish swimming in opposite directions. The fish are characterized by a long body, triangular head, two pairs of fins, and a tail (pls. 11, 15b). Seidl believed they were carved at the time of the original cutting of the relief, while Carter (1988, 146 n. 1; 1996, fig. 34.8) points out parallels with fish depicted on a late second-millennium sealing from Tal-e Malyan.

(4) *Central Object.* The nature of this object in front of the deity remains a mystery. Seidl (1986, 9) reconstructed a large fire stand based on correspondences with glyptic imagery from late third-millennium Susa and fourteenth-century Choga Zanbil, while Vanden Berghe (1986, 159) hesitantly identified either an offering table or a bush. Another alternative is highlighted by Early Dynastic Mesopotamian votive plaques and, more particularly, the stele of Ur-Nammu, which show a deity seated atop a platform holding out a ring and rod toward a standing individual (a ruler?) who libates water into a conical stand with sprouting vegetation (Moortgat 1969, nos. 114, 116, and 194).

(5) *Ring, Rod and Water Streams.* Two streams of water flow from the male divinity's outstretched hand holding the ring and rod. One arches forward to meet the hands of the first male individual (9) standing in front of him; the other arches backward over the goddess and into the hands of the male ruler (6) standing behind.

(6–8) *Elite Trio of Worshipers A* (to the right). Trio composed of a male (6), a female (7) and another male (8) standing behind the divine couple (pl. 13). Their outlines give a reasonable indication of their physical characteristics. All are depicted on a similar scale (ranging from 0.95 m to 1 m high) and the body is shown in profile, except for the shoulders, oriented toward the divine couple. The two men can be recognized by their

"visor" hairstyle,[6] but erosion prevents any assessment of whether they also have braids.[7]

Both wear an ankle-length garment, broad at the bottom and narrow at the waist. The first individual (6) receives the flowing water in both hands (probably with palms upward), which are raised in an Elamite gesture of devotion (pl. 11). The female in the middle (7) wears a hairstyle that bulges behind (a bun?) and a floor-length garment covering her feet. The right arm appears to be flexed at 45 degrees with the hand raised, palms facing outward. The outline of the left arm suggests it is in the same position (pl. 13). This gesture also seems to be performed by the last male (8), who is located around the corner.

(9–11) *Elite Trio of Worshipers B* (to the left). Another male-female-male trio facing the divine couple (pls. 11, 13). These individuals are shown at the same scale as trio A (ranging 0.95 to 1 m high) and reflect their actions, except for the third male (11) who appears to clasp his hands at waist level.

§3.3.2. *Left Panel (Kurangun II)*

(12) Worshiper (0.75 m high) oriented toward the right and placed nearest to the central panel (pls. 11, 12e). He is one of the best-preserved figures in the relief, having conserved a smooth surface over the face, chest, garment and legs, and internal details such as the mouth, nose and eye. He wears a long garment with a broad belt, and seems to have a short beard (or no beard?) and no braid. His hands are clasped at waist level in a worshiping gesture.

(13–14) Pair of worshipers (0.96 m and 1.07 m high). This pair exemplify the standard depiction of all worshipers in the left panel. They are shown in profile oriented toward the divine couple with hands clasped in worshiping gesture. Both have a short beard and long

6. The "visor" hairstyle was also described by Amiet as a bowl hairstyle, "coiffure en écuelle" (Amiet 1966, 410, fig. 310). Here the former term "visor" will be used.

7. The reconstruction by Vanden Berghe (1984, 28, fig. 2) depicts individual 9 with a long back braid (pl. 11), while in some photographs, individual 11 appears to have a long back braid (see upper photograph in pl. 13).

hair collected into a braid ending in a knob and wear a knee-length garment with a wide belt.

(15–16) Pair of worshipers.

(17–18) Pair of worshipers.

(19–47) Worshipers carved along three implied (or unpreserved) staircases continuing down from the flight of stone-carved stairs above. All are oriented in the direction of the divine couple and clasp their hands in worshiping gesture.

(19–30) Bottom row comprising 12worshipers (ranging from 0.68 m to 0.90 m high).

(31–39) Middle row comprising 9 worshipers (ranging from 0.85 m to 0.88 m high).

(40–47) Upper row comprising 8 worshipers (ranging from 0.85 m to 0.88 m high).

§3.3.3. *Right Panel (Kurangun III)*

This side panel has been separated from the main part of the relief by a large fracture in the rock that continues out into the horizontal platform. Its two badly preserved registers show seven individuals (possibly eight?) positioned behind the large-scale elite worshiper (8). In the lower register there are outlines of four individuals (48–51) (0.8 m high) climbing a staircase which reaches the ground level of the large-scale worshiper belonging to trio A (8). All seem to clasp their hands together at waist level. Carved in the top register are at least three additional individuals who also seem to ascend shallow steps (52–54). Henkelman and Khaksar (2014, 214 n. 6) suggest the badly eroded individual at the front may be holding a staff or spear.

§3.4. Elements of Composition and Style

The original relief is structured along two rectangular panels. One is carved on the vertical cliff face and incorporates the divinities and elite worshipers and the other is the horizontal "basin" with fish. The vertical panel centers on the seated divine couple who are framed harmoniously by two trios of worshipers and linked to them by two streams of water. At a later date, large groups of worshipers (36 to the left and 7 to the right) arranged along staircases and oriented toward the deities were

introduced into the scene. Excluding the deities and the two large-scale elite trios, the physique of most worshipers is characterized by a short beard, flat chest, narrow waist and knee-length garment. The arms are flexed at a 90-degree angle with hands held together in the front of the waist. All except for individual no. 12 appear to have a characteristic long braid ending in a knob just above elbow level.

§3.5. Chronology

Based on Herzfeld's description (1926, 259) and accompanying line drawings, N. Debevoise (1942, 79) was the first to recognize that the carvings had been manufactured in two separate time periods, reasoning that the worshipers exhibited along the staircases predated the "*Gutian*" central panel because: "*it is almost impossible to believe that anyone would have carved such a large group of people simply coming down to look at an earlier relief.*" It is generally agreed that the three flights of stairs, the "fish basin," and the central panel were carved sometime during the *sukkalmah* period.[8] This timeframe is substantiated by close iconographic parallels between the central panel and Elamite royal cylinder seals, in particular those of kings Kuk-Nashur II (ca. 1620 BC) and Tan-Uli (ca. late seventeenth early sixteenth century BC), the latter providing the closest analogies (pl. 14a).[9]

8. As noted, Carter has pointed out parallels with fish depicted on a single sealing from Anshan (Tal-e Malyan) dated to the late second millennium BC (Carter 1988, 146 n. 1; 1996, fig. 34.8; see also Amiet 1992, 81). Yet fish designs, while not plentiful, are common and range from different time periods (Negahban 1991, 96–97).

9. Chronology follows Potts 2016, 152–53, 177. For the seals of Kuk-Nashur, see Amiet 1972, no. 2327. For Tan Uli, see Amiet 1972, no. 2330; see also Miroschedji 1981b, pl. I (see pl. 14a). Binder (2013) has recently suggested a later date based on aspects of continuity with sixteenth-century and fifteenth-century glyptic from Haft Tappeh. This repertoire requires careful reexamination judging by the existing multiple, and sometimes contradictory, line drawings. For example, the seal of the great governor Athibu, mentioned by Binder as a critical piece of evidence for the new redating (2013, 66, fig. 28), has been rendered differently in four separate line drawings: one by Negahban (1991, ill. 18), two by Amiet (1996, fig. 4; Amiet 1998, 110, fig. 1, seal 8), and one by Mofidi-Nasrabadi (2011, pl. 8, seal 13). For comparisons with a photograph of the seal, see Negahban (1991, pl. 37, fig. 281). Recent excavations reveal that Haft Tappeh was also occupied during the *sukkalmah* period, the seventeenth and sixteenth centuries

The relief was later expanded by the incorporation of numerous smaller-scale worshipers on both sides of the central panel and along the staircases. Vanden Berghe (1963, 32; 1986, individual nos. 13–49) took the figures on the left as eighth-century additions, while Carter (1984, 172; followed by Seidl 1986, 11, 12; Miroschedji 1989, 359; and Amiet 1992b, 81) believed they were carved together with the rest of the platform at the end of the second millennium based on parallels with Kul-e Farah IV. Obvious compositional and stylistic analogies between the rows of worshipers depicted at Kurangun and in KFIV and KFIII indeed suggest they belong to a similar artistic tradition and hence their manufacture dates must have been reasonably close. Yet, according to my own study of these reliefs, KFIV belongs to the ninth–eighth century (Álvarez-Mon 2013) and KFIII to the eight–seventh century (redated herein). The only preserved feature of the Kurangun worshipers that distinguishes them from the KFIV and KFIII worshipers and could vouch for a slightly different date is the knobbed curl at the end of the long hair braid.

The seven individuals carved to the right of the central panel are thought to have been further additions made at the end of the Neo-Elamite period (Vanden Berghe 1986, nos. 9–12; Seidl 1986, 12–13).[10] Seidl (1986, 12 n. 43) noted parallels between four of these individuals and those depicted in KFII, which she dated to the late Neo-Elamite period (following Vanden Berghe 1963; De Waele 1973; Calmeyer 1973). In my opinion, Kurangun III ought to be considered a unified work added to the relief sometime after 800 BC and before 550 BC. Given the level of erosion of the relief it would be unfeasible to offer a more precise date, but it is nevertheless worth noting that groups of similarly portrayed individuals with hands clasped at waist level appear in KFII and KFV, both datable to the seventh and sixth centuries BC.

To summarize, the available evidence suggests that the sanctuary was cut out of the cliff and the central panel (Kurangun I) carved in the late seventeenth / early sixteenth centuries BC. It was possibly expanded twice: once around the ninth–eighth century BC (Kurangun II) the other around the seventh–sixth century BC (Kurangun III). The presumed abandonment of the sanctuary at the end of the Neo-Elamite period would suggest a break in the continuity of cult in the Mamasani region, which belies the overall pattern presently revealed by archaeological, textual and artistic evidence (see above, §i.1).[11]

§3.6. Discussion

Since textual sources remain silent on Kurangun, its native Elamite name remains unknown and any associated religious beliefs, ritual activities, and intended audiences must be adduced from its main "architectural" and sculptural characteristics. The reliefs are not visible from the bottom of the valley, suggesting that interaction with the sanctuary and its sacred imagery was achieved by walking to the top of the cliff and descending via three flights of stairs to the intimate setting of the narrow platform. Indeed, the presence of real stone staircases next to "virtual" flights of stairs and relief-carved devotees corroborate the notion that Kurangun, with its dramatic natural setting, had served as a location for periodic pilgrimage and worship of Elamite deities.[12]

Over the course of the second millennium an abridged version of the imagery in Kurangun's central panel became an iconic visual formula for Elamite royalty: a male divinity seated on a coiled-serpent throne presenting the ring and rod—and, on at least one occasion, streams of flowing water—to a high status Elamite individual or ruler (pl. 14a).[13] The identification of the

BC (Mofidi-Nasrabadi 2014b, 90–98, figs. 11–13), thus, as noted by Potts (2016, 171), reinforcing correspondences between Kurangun and the Haft-Tappeh glyptic repertoire. One of these correspondences is provided by the seal of the judge Ishmekarab-Ilu, whose imprints were found at both Susa (Amiet 1973, 37, pl. IX.48) and Haft Tappeh (Negabhan 1991, 90, nos. 387–89).

10. Miroschedji (1989, 359) takes them as twelfth-century BC additions.

11. The Elamite open-air sanctuary of Naqsh-e Rustam presents a direct example of continuity between Elamite and Achaemenid-Persian sanctuaries. For continuity in the textual and artistic records, see Henkelman (2008, 2018) and Álvarez-Mon (2010b, 2018).

12. The only means to obtain an overall view of the relief is by standing on the edge of the cliff directly opposite it; the photographs in pls. 10 and 12 are taken from this vantage point.

13. The iconography has been thoroughly discussed by Miroschedji (1981b) and Potts (1999, 182, with refs.).

divine couple is hotly debated.[14] For Amiet (1972, 294; 1973, 17; following Hinz 1971, 673) the male divinity is the Elamite Great God ([d]GAL), initially recognized as an epithet of Humban and (soon afterward) the highland god Napirisha (Amiet 1972, 52). Miroschedji (1981b; followed by Wiggerman 1997, 45) instead nominated the lowland Elamite god Inshushinak, but this was rejected by Françoise Grillot and François Vallat (1984; followed by Vanden Berghe 1986, 159 and Seidl 1986), who reasserted an identification with the highland divine couple, the Great God Napirisha and the Great Goddess Kiririsha. Carter (1988, 148; based on Grillot 1986) stressed the geographic location of the valley at the intersection of roads linking Anshan and the city-port Liyan, which resided under the divine aegis of Napirisha and Kiririsha respectively.

In a more recent contemplation of the site's significance, Potts (2004) questioned the assumed highland/lowland dichotomy between Napirisha and Inshushinak and instead stressed the documented association of both deities with water imagery and with their Mesopotamian counterpart Enki/Ea.[15] It appears that Miroschedji (1981b, 25) reached a similar conclusion on this topic: "Certainly, we can turn around the difficulty and assume that the relief [this time in reference to the upper register of the stele of Untash-Napirisha] represents Inshushinak under the traits of Napirisha, which implies that the iconography of the two divinities was interchangeable."[16] It is tempting to envisage a syncretism in which the key attributes of two representatives of the lowland and highland Elamite pantheons were merged into a single encompassing reality: an enthroned Great God ([d]GAL) holding a ring and rod issuing streams of water, compellingly manifested through equivalence with the primeval, life-giving aspects of flowing sweet water.[17]

A study by G. Gropp (1992, 113) proposed the conceptualization of the sanctuary as a three-dimensional unity defined by the presence of an enclosed rectangular ritual basin. Even if it cannot be supported with solid archaeological evidence, there is no reason to strictly reject this attractive hypothesis. Not unlike the worshipers carved along virtual staircases, the horizontal platform with a low stepped border and relief-carved fish does at least imply a *symbolic* basin. It is even possible that this border had continued along the now-missing outer edge to form, as Gropp proposed, a real basin that could hold a shallow pool of water. Carter (1988, 147 n. 6) further speculates that "*water probably flowed out of the rocks at Kurangun in antiquity.*" These hypotheses highlight the embedded symbolic interplay of visual features: the holy waters that emerge from the hands of the Great God are received by the worshipers and implicitly "stream down" into a rectangular Abzû basin teeming with fish (Miroschedji 1981b, 9).

Potts (2004, 143) extends the previous interpretative boundaries of Kurangun to encompass the natural environment, emphasizing the *numinous* and *immanent* properties of the sanctuary engendered by the spectacular surrounding natural scenery dominated by the Rudkhaneh-e Fahliyan River. Indeed, from the vantage point of the sanctuary the scenery is breathtaking: the river flows majestically through the wide, open valley and turns sharply southwest as it strikes the outcrop of the Kuh-e Pataweh, directly below Kurangun (pls. 9, 10).[18]

Kurangun does not lend itself easily to classification, but from a structural viewpoint, its basic elements—a set of three staircases leading down onto a single rectangular platform and into the presence of deities—conform to characteristic principles of religious architecture. Certain ideological similarities reinforce this comparison,

14. See the central panel in Vanden Berghe 1986, 159 n. 6; Trokay 1991; Potts 2004.

15. The counterpart of Napirisha in Mesopotamia was Enki/Ea, the god of the underground sweet, flowing water (Abzû) representing fertility and abundance, but there is also evidence suggesting that Inshushinak had Enki/Ea and Enzag as epithets (Vallat 1997). This insight may be further supported by two versions of coiled serpents forming the throne of the divinity: one is androcephalic, the other has a dragon head (Seidl 1986, 20–21; Miroschedji 1981b, 47). For further discussion, see §18 below.

16. See also Garrison 2009.

17. In this sense, the Old Elamite sanctuary of Kurangun may offer a precedent to the often-discussed religious "revolution" of Untash-Napirisha at Choga Zanbil.

18. Potts (2004, 149) has reviewed the importance of water resources in the Nurabad-Fahliyan region, stressing the unique properties of this agricultural area, which enjoys the highest rainfall in Fars, allowing for double cropping.

namely that Kurangun: (i) may have been conceived as a shrine "housing" the divine couple; (ii) provided visual legitimation of social order (exhibited by the deities' dispensation of holy water and the ring and rod); and (iii) was a sacred space, the center of communal pilgrimage and worship.

At the same time, Kurangun is by no means a building. As an open stage perching on the side of the cliff overlooking the river valley, with no de facto separation between that which lies within from that which lies without, it contrasts with standard notions of religious architecture where walls and gateways ensure the privacy of the ritual action, demarcate sacred from profane space, and frame aesthetic experience. Kurangun transcends rigid notions of sacred-profane dualism and opens aesthetic experience to a broader level of evaluation. It also invites closer inspection of formal structural elements to the extent that they showcase key aspects of the Elamite belief system.

While keeping in mind that significant additions were made to the original sanctuary (Kurangun I, ca. 1600) twice during the Neo-Elamite period (Kurangun II and III, ca. ninth–sixth century), from the perspective of its final composition it can be said to exhibit the following references to concrete aspects of Elamite sociopolitical and religious realities:

1. The representation of worshipers along staircases most likely references a communal ritual at the final stage of a pilgrimage when real worshipers descended the actual staircases to the platform (pl. 12). The attendance of large groups of worshipers points to a shared experience of communing with the divine, although the specific religious and sociocultural characteristics of this event remain unknown.

2. An implied visual interplay between the holy water emanating from the hands of the divinity and the basin enclosing the swimming fish (pls. 11, 13). While the existence of an actual basin cannot be confirmed because the outer edge of the platform is missing, the conceptual reference is at least difficult to dismiss. Stone Abzû basins symbolizing the fertility and primeval aspect of groundwater were essential cultic accoutrements of Mesopotamian, Assyrian, and Elamite temple ritual. Every temple in Mesopotamia seems have had its own version of this basin, whether a small pool or simply a polished vessel filled with water.[19]

3. The open-air sanctuary atop an outcrop of the Kuh-e Pataweh may have been ideologically linked to the religious shrine/s topping Elamite ziggurats (the *kukunnum*), which according to archaeological and textual evidence were constructed in urban centers from the Susiana plain to the Persian Gulf port of Liyan (Bushire) (pl. 1). Although it is uncertain whether the act of receiving the ring, rod and holy waters from a divinity was part of an actual Elamite royal investiture ceremony that took place in the *kukunnum* atop the ziggurat, it is tempting to envisage comparisons with the event depicted high up on the cliff at Kurangun, especially as the central panel incorporates iconic visual formula of second-millennium BC Elamite royalty, elites, and court officials.

4. The symbolic role of water assumes a further dimension at Kurangun when the natural environment and, specifically, the waters of the Fahliyan River are added into the equation. The sanctuary materializes as an axis mundi capturing a moment of sacred revelation (a hierophany) in which water becomes the active medium intersecting sociopolitical and religious dimensions of Elamite culture. Water emanates from the deity and emerges as an all-encompassing immanent "life-force" directing the mind and senses to associate the experiences of divine revelation and ritual practice with the experience of the natural environment.

This breakdown of key artistic components suggests that the sanctuary site was deliberately chosen with a view to creating a highly theatrical setting for sacred revelation. The powerful emotional experience triggered by the natural environment here was channeled into a religious paradigm. One of the paradoxes of this experience is that the borderline between the "in-here"

19. Álvarez-Mon 2014, 759, fig. 7a–e.

(the sanctuary) and the "out-there" (the environment)—or between culture (and human agency) and nature (and natural and/or divine agency)—becomes permeable and so indistinct that the individual is placed in an altered state of being: a *ganz andere* (wholly other) type of numinous event of unconstrained space, rising above temporal limits. Hence, it could be said that at Kurangun the intrinsic, awe-inspiring, numinous agency of the natural environment truly embodied and informed the emotional character and transcendence of the sacred event.[20]

20. For more on the role of the numinous in ritual contexts and in connection with the natural environment and aesthetics, see Rappaport 1999, 379; on a similar topic extending into theoretical discussion of aesthetics within the context of Western philosophical traditions, see Álvarez-Mon 2014, 762.

§4. Naqsh-e Rustam I and II (Seventeenth–Sixteenth and Eight–Seventh Centuries BC)

§4.1. Introduction

Naqsh-e Rustam (Pictures of Rustam) lies 6 km north of Persepolis in an area where the westernmost part of the Kuh-e Husain (Mountain of Husain) foothill meets the wide-open plain of Marvdasht and the Pulvar River enters the plain. Naqsh-e Rustam is generally known as the main burial location of four Achaemenid Persian kings and the monumental Ka'ba-e Zardusht tower (pl. 1). Less widely known is that "long before Darius, this spur of the Husain Kuh had been regarded with reverence" (Schmidt 1939, 98), a reverence associated with an Elamite open-air sanctuary marked by a monumental rock relief (pls. 16, 17). The topographic setting appears to have had both religious and practical significance, linking the relief to a natural spring (Schmidt 1970, 10) and to a main branch of the Achaemenid royal road system that connected Persepolis with Naqsh-e Rustam and weaved its way through the foothills of the Kuh-e Qaleh and Kuk-e Hasan (Kleiss 1981; Sumner 1986, 17, ill. 3).[1]

§4.2. Preservation

The Elamite relief was almost completely obliterated by the cutting of a new relief during the time of the Sassanian King Bahram II (276–93 AD).[2] Of the central panel, only the faint lines of two coiled-serpent thrones belonging to a pair of divinities are visible. The heavily eroded head of a queen can be discerned to the left and the outline of a better-preserved male figure around the corner to the right.

1. Past scholarship: Herzfeld (1926, 244) was first to identify the remains of the Elamite relief, which were mostly destroyed by the later Sassanian addition. Later descriptions and studies of the relief by Schmidt (1970, 121; with earlier references) and Seidl (1986, 14–19; 1999) provide the standard references for the historical background, description, and dating of this relief.

2. We can only speculate on the reasons for the mutilation of the Elamite reliefs. They may perhaps be related to the religious fervor of the magus Kartir, the Zoroastrian high priest who raised Bahran II to the Sassanian throne and was known as a zealous persecutor of competing religious beliefs (Lukonin 1967, 118).

§4.3. Iconography

The estimated dimensions of the ancient panel are 2.5 m high × 7 m long. Like the central panel of Kurangun (I), the central panel of this relief (Naqsh-e Rustam I), ca. seventeenth–sixteenth century BC, preserves vestiges of two divine coiled-serpent thrones (pls. 16, 17).[3] The seated deity at the rear wears an ankle-length fleeced garment. The crowned head on the far left side of the central panel is usually presumed to be a queen, and the male individual standing around the corner on the right side is sometimes referred to as a king.[4] Both of these figures flanking the central panel can be recognized as additions made to the relief during the Neo-Elamite period (Naqsh-e Rustam II). In the lower middle zone of the central panel, the foot of a worshiper oriented toward the divinities can be observed, but the date of its carving is unclear.

Lady with Crown. The general profile of the head to the left of the central panel reveals the distinctive outline of three towers forming a tall mural crown (pl. 17). Also visible are the remains of a large eye and nose and a distinctive hairstyle that seems to cover the ears, curving at the cheeks and extending into a bulbous shape at the back. Together with an absence of facial hair, correspondences with Assyrian queens depicted wearing crowns suggest that the head belongs to a female. Noting the relatively low level of her head in comparison to that of the standing male, Schmidt (1970, 121) reasoned that the woman must have been seated. He did not raise the possibility that the two figures had belonged to different time periods and, therefore, different compositions.

The Standing Male Worshiper. An individual stands behind the seated divine couple, to the right of the central panel and around the corner (pl. 17). The main outlines of this male figure are mostly discernible, but internal details of the garment, headdress, and, possibly, a small animal held in his arms cannot be confidently asserted.[5] He is bearded and probably has a pair of long sidelocks. His head and feet are oriented left toward the central panel, while the rest of his body is shown frontally to emphasize the broad shoulders and narrow waist. The headdress has a pointed visor at the front and ties (?) with bulbous terminals at the back. The long ceremonial garment preserves remnants of diagonal lines forming a broad V-shaped band over the shoulders and chest. Bands of this style are often interpreted as incorporating fringes (the *vêtement croisé à franges*), even when the rows of tassels are not readily recognizable. Thus, both here and more broadly throughout this study, I qualify the band as "fringed" even if the internal tassel details are not necessarily obvious in the image (for further discussion, see Álvarez-Mon 2010b). The skirt has the distinctive bell shape with flared hemline.

§4.4. Chronology

The estimated date of the two deities sitting on coiled-serpent thrones has been made on the basis of analogies with the central panel of Kurangun (I), ca. seventeenth–sixteenth century BC. Although from the outset most commentators considered the manufacture of the crowned female head and the male worshiper to be fairly contemporary, a precise date has not been agreed upon. Porada (1965, 66) dated both to between the ninth and seventh centuries. Amiet (1966, 560–62) and Vanden Berghe (1984, 103) dated them to between the eight and seventh centuries. Seidl (1986, 19) proposed the ninth century for the female head and the twelfth century for the male. Miroschedji (1985, 280 n. 64; 1990, 74 n. 27) dated both to the seventh century, more specifically around the time of Ashurbanipal, but not without hesitating and in one publication instead assigning the male to the twelfth century (Miroschedji 1989, 360). Critical to the seventh-century dating is the distinctive headdress of the male figure, comparable with the long-visored headdress of

3. For a review of the evidence regarding the serpent throne, see Miroschedji 1981b and Garrison 2009. The serpent is generally represented with a single horn and a mouth wide open with the tongue out, perhaps spitting fire.

4. For the identification as queen and king, see Porada 1965, 66, Amiet 1966, 560–62, Vanden Berghe 1984, 103, and Miroschedji 1985, 279; 1990, 74.

5. I have suggested the possible presence of a small animal in the arms of the worshiper (Álvarez-Mon 2010, pl. 25). It should, however, be noted that the earliest line drawings do not confirm their presence (Seidl 1986, 15–16, figs. 4–7) and that the image of the king as offering bearer is uncommon in the Neo-Elamite period.

Atta-hamiti-Inshushinak, and the crenellated mural crown on the female head, reminiscent of those adorning seventh-century Assyrian queens.

§4.4.1. Mural Crowns

The appearance of a mural crown (*corona muralis*) in an Elamite context is novel. This tall crown, which is intended to resemble a row of connected fortification towers, conceals the top of the head and ought to be distinguished from the short turreted or castellated mural crown, which slides down over the head to reveal the hair.[6] While these two crown styles both find parallels in first millennium Assyrian and Elamite sculptural art and are clearly related in terms of ornamentation and symbolism (a defensive city wall), they are patently different in conception.

Short Mural Crown. A fragmentary early seventh-century bronze relief, reportedly fixed to the base of a throne or altar in the *Ekarzagina* chapel of Ea in Babylon's Marduk temple (*Esagil*) (Parrot and Nougaryrol 1956, 197), depicts the Assyrian king Esarhaddon (705–681 BC) in an adoration scene with his mother Zakutu/Naqi'a, wife of Sennacherib and grandmother of Ashurbanipal, who wears a short mural crown (AO 20.185, purchased by the museum around 1956).[7] Naqi'a holds a mirror in her left hand and raises a cone-shaped object up to her nose in her right hand.[8]

A second crown of this type is exhibited in a celebrated bas-relief (BM 124920) from the north palace at Nineveh. Here Ashurbanipal is shown reclining on a couch, and facing him is an enthroned lady wearing a small crown in the form of a defensive city wall

connected by fortification towers (six on its visible side) (see Álvarez-Mon 2010a, pl. 23c).

Tall Mural Crowns. A composite line drawing of polychrome brick fragments from the Ishtar temple at Nineveh by Thompson and Hutchinson (1931, fig. 2B, pl. XXXI) shows the upper part of an enthroned figure wearing a garment embellished with rosettes and a tall mural crown with three distinctive towers separated by two gateways (Álvarez-Mon 2010a, pl. 23b). The face is missing, but the line drawing incorporates an additional fragment preserving the lower section of a beard and an arm and hand raising a beaker (?), implying that the figure is male. J. Reade (1987, 139) has questioned the accuracy of this reconstruction, suggesting that these pieces may not belong together and that the gender of the crowned figure therefore cannot be clarified. Its dating to the time of Ashurnasirpal II (883–859 BC), however, seems to be uncontested.

Another tall mural crown with three towers, but no obvious gates, can be seen on Libbali-sharrat (formerly Ashur-sharrat, wife of Ashurbanipal) on a stele from Assur (Berlin Vorderasiatisches Museum VA. 8847; Álvarez-Mon 2010a, pl. 23b). Of the series of stone stelae excavated from the Assur *Stelenreihen*, this is the only example that visually represents one of the royal wives commemorated in the text (Börker-Klähn 1982, 217, no. 227).

Two small modeled heads from Elam must also be included in this discussion. One is a small faience head from Susa (Sb 3582) with a distinctive hairstyle that protrudes above the ears and around the sides of the head and is flattened on the top (Amiet 1966, 488, fig. 366; Martinez-Sève 2002, 46, fig. 10; Álvarez-Mon 2010a, pl. 23g). It belongs to a series of faience heads dated to the seventh and sixth centuries BC (Amiet 1966, 498, fig. 375; see also Martinez-Sève 2002, 41, fig. 1).[9] The second is a damaged terracotta head (Sb 3081; 5.4 cm high; 5.6 cm long), also from Susa, with a very high hairstyle, perhaps once covered by a diadem band or a crown (Amiet 1967, 43; Álvarez-Mon 2010a, pl. 23d). The date of this head has

6. One ought to differentiate between the mural or turreted crown discussed here and the merlon (crenellated) crown commonly exhibited in Persian-Achaemenid art. See also comments by Unger (1938).

7. Álvarez-Mon 2010a, pl. 22. Nougayrol credits Naqi'a with having influenced her son Esarhaddon's policy toward Babylon, his reconstruction of the holy city being perhaps the result of her authority (Parrot and Nougayrol 1956, 158 n. 1). The identity and political role of Naqi'a and the dating of the bronze relief to the time of Esarhaddon are discussed by Melville (1999, 25–26, 47–48).

8. For commentary and possible identification of this strange ice-cream-cone-shaped object, see Reade 1977, 34.

9. Amiet (1966, 498) reflects on the stylistic similarities between this head and the one exhibited on a faience container that he dates to the eight–seventh century BC (but dated ca. ninth–eighth century BC by Heim [1992, 207, fig. 145]).

been placed "just before the Achaemenids" (Amiet 1967, 43), in direct connection with the "queen" at Naqsh-e Rustam, or in a period of transition between the Neo-Elamite and the Achaemenid periods (Martinez-Sève 2002, 79, fig. 76).

Finally, I should mention a crowned royal Persian head of lapis lazuli found at Persepolis and dated to the fifth or fourth century BC (housed at the National Museum of Iran).[10] It has been identified as an Achaemenid "prince" (Porada 1965, 161), perhaps Xerxes (Sami 1971, 96), or a "queen" (Amiet 1967, 43). While this head wears a mural rather than crenellated crown, its profile reveals a comparable hairstyle: short at the forehead, extending diagonally down toward the neck and forming a bulbous, curly mass at the nape of the neck (Álvarez-Mon 2010a, pl. 23f).

Addressing the symbolism of heraldic city representations in coinage, Calmeyer (1992) traced the iconography and ideology of the walled city (and city gates) back to Assyrian, Babylonian, and Persian roots, adding that real cities may have been depicted. The symbolic significance of the mural crown in a late Neo-Elamite context at Naqsh-e Rustam may have been similarly related to a city.

§4.4.2. *The Male's Headdress*

The iconography of the male worshiper (perhaps carrying a small animal) and the long, fringed garment with bell-shaped skirt has a rather broad chronological span commencing in the Old Elamite period.[11] The best clue as to the elite male worshiper's date is his exceptional composite headdress, which finds analogies in both the extended "visor" of the twelfth-century Elamite kings at Shekaft-e Salman and the headdress of Atta-hamiti-Inshushinak. The back of the headdress includes a number of appurtenances that perhaps had a practical function, such as

securing the hair or headdress in place, and a pair of ties or braids (?) with bulbous ends emerging from the bottom. These unusual elements may be the only indications of a later, Neo-Elamite date—perhaps in the seventh century BC, as maintained by Miroschedji (1990, 74 n. 27).

§4.5. Discussion

The interpretation of the female figure as a queen is reasonably assured, inasmuch as she wears a crown that is used to designate royal status in Assyria. The male (worshiper or offering bearer?) is also high in status if we are to judge by his traditional Elamite elite headdress and long, fringed, bell-shaped garment known from Susa and Izeh/Malamir. While the queen may have been seated as Schmidt suggested (1970, 121), it is plausible that the different elevation of her head with respect to the male reflects a noncontemporaneous production rather than a compositional element.

Nothing is known about who was behind the production of Naqsh-e Rustam II, but the novel depiction of a crowned Elamite queen with direct Assyrian prototypes forces us to contemplate a period of close interaction between Assyrian and Elamite highland elites, corresponding with a period in the lowlands (ca. 674–626 BC) characterized by Assyrian and Elamite artistic cross-fertilization.[12] If the carving took place during the second half of the seventh century or—accounting for the similarities between the queen and the Elamite glazed terracotta head and Persian lapis lazuli head—as late as the sixth century BC, we may be looking at an Anshan-based royalty that espoused Elamite religious beliefs and employed combined Elamite and Assyrian artistic accoutrements.[13] The addition of the royal female and elite (royal?) male figures reveals both a continuity of cultic practice at the site and an attempt to stake a political claim over this territory of Fars in the late Neo-Elamite period.

10. The head, was found in 1946 in the 32 Column Hall (the eastern hall opening to the open area located in front of the Throne Hall of Xerxes, the 100 Column Hall; Schmidt 1953, 125, fig. 59; Sami 1971, 96).

11. For the male worshipers, see the gold figurine from Susa bearing a lamb (dated to the late *sukkalmah* period by Pittman [2003]; see also Tallon 1992a, 146–48, figs. 89–90; 150, figs. 92–95). For the garment with extended corners, see the seal of "sukkalmah, sukkal of Elam and Shimashki" Tan-Uli (pl. 14a) (Aruz 1992a, 117, fig. 76).

12. For the crowns of first-millennium BC Assyrian and Elamite queens, see Álvarez-Mon 2009; for the Elamo-Assyrian period in the lowlands, see Álvarez-Mon 2010a.

13. Only a small portion of the large site of Tal-e Malyan has undergone archaeological fieldwork, and it is very likely that remains of Neo-Elamite and Persian settlements are actually present at the site.

§5. Shekaft-e Salman I (Twelfth and Eleventh–Seventh Centuries BC)

§5.1. Introduction

Shekaft-e Salman (Salomon's Cave) is the name given to a spectacular natural formation composed of a cave with a seasonal creek and waterfall (pls. 5–6). Two reliefs (SSI and SSII) were sculpted to the right of the cave, on the vertical face of the cliff (pls. 5–6, 18, 22), and two more (SSIII and SSIV) were sculpted inside the mouth of the cave (pls. 6, 24). Relief SSI is carved within a rectangular panel elevated about 8.5 m above ground level; it measures 3.3 m (lower side) / 2.60 m (upper side) in length and 1.93 m high (pl. 18). It depicts a fire stand, three adults (two males and one female), and a child, all oriented toward the cave and performing gestures of worship. Parts of the carving bear inscriptions in the Elamite language. Projecting from below the relief is a narrow horizontal ledge measuring 2.40 m long and 1.20 m wide.[1]

§5.2. Preservation

The relief is quite eroded, but its position in a niche and elevation beyond direct public reach have contributed to the preservation of important manufacturing details.

§5.3. Iconography

The relief image is composed of five elements: a fire stand and four individuals standing, oriented left toward the cave (pl. 18). A distinct change in surface depth splits the niche in two, separating the deeper-set fire stand and first adult male from the trio behind (adult male, child, and adult female). This surface variation appears to continue below the horizontal ledge.

1. Measurements after De Waele 1976a, 33–34. Past scholarship: Layard 1846, 78–79; Jéquier 1901, 139–40, with drawing by Morgan pl. 32b; Stein 1940, 129–30, fig. 45; Debevoise 1942, 84; Vanden Berghe 1963, 34–35, pls. 22–23; Hinz 1964, 120; Seidl 1965, 182; Vanden Berghe 1966, 62, 162, 213, pl. 91b, right; Vanden Berghe 1968, 16, 23; De Waele 1973, pl. 31; Calmeyer 1973, 141–52; De Waele 1976a, 30–34.

(1) *Fire stand* (total: 78 cm high; flame: 24 cm high; width of the bowl: 30 cm). The stand is composed of three parts: a truncated conical foot, a large bowl on top, and fire schematically represented by a conical outline. De Waele (1976a, 31) identified this object as a "fire altar."

(2) *Male A* (1.85 m high). Male standing on a small pedestal (75 cm long × 3–4 cm high) before the fire stand. He is oriented toward the cave and is represented in profile with the left shoulder projected forward in an unusual, exaggerated manner. Both arms are held in front, flexed at a 45-degree angle at the elbow, and the hands are closed into a fist with the index fingers extended. He has a long beard, a pair of long sidelocks ending in a curl, a "visor" hairstyle, and a long braid that extends down the back and ends in a curl at waist level. The ear is partly covered by the hair, the almond-shaped eye is frontally represented, and the long eyebrow extends from the bridge of the nose. The mouth and most of the beard have eroded away. The left shoulder is round and wide, the back is rounded, the waist is narrow, and the arms and legs are muscular (especially the calves). Traces of a long line on the left arm may delineate musculature. The garment is short-sleeved, is belted at the waist, and has a bell-shaped, knee-length skirt. The feet are bare. An inscription was added over the garment and legs.

(3) *Male B* (1.87 m high; 78 cm wide at arm level). Male standing behind Male A (2) is oriented toward the cave with hands clasped together at waist level in a worshiping gesture. His chest is depicted frontally, displaying broad shoulders. The garment skirt and details of the face, hairstyle, and physique are analogous with Male A. The inscription continues from Male A over the surface of the relief and onto the garment of Male B.

(4) *Male Child* (80 cm high). Male child standing oriented toward the cave behind Male B (3). He adopts the same clasped-hands gesture and wears a comparable garment with short sleeves, fringes crossing the chest in a V, and a bell-shaped skirt. The feet are bare. The face is beardless, and the hair is collected into a long braid ending in a curl.

(5) *Female* (1.80 m high; robe 88 cm wide at the bottom). Female adult standing oriented toward the cave behind the male child (4). The chest is depicted frontally

and the right arm is flexed at the elbow, with the hand raised and index finger extended in an upward-pointing gesture. The left hand is held in front of the waist and may be clasping a folded towel. The short-sleeved top of the garment molds over the small breasts, and the long, bell-shaped skirt flares into two triangular tips at the hemline covering the feet. A small band at the forehead follows the line of the hair, which extends upward in a large mass and bulges at the back. The face is rather round, with pronounced cheeks, small mouth, and a double chin. The thick eyebrow extends out from the bridge of the nose. Part of the ear is hidden under the hair. The neck is adorned by a necklace, and either an extension of the necklace or a braid runs down along the arm (se the female represented similarly in Shekaft-e Salman II).

§5.4. Elements of Composition and Style

Structure of the Composition. The fire stand, three adults, and child together occupy the entire register. All four individuals stand oriented toward the fire stand and the cave in hieratic worshiping positions and none of them interact. The male members of the group are all positioned in front of the female. The three adults are shown on much the same scale, ranging from 1.80 to 1.87 m in height.

Elements of Style. The royal figure is depicted in profile except for the frontal chest of the trio at the back (male B, child, and female) and the forward-projecting shoulder of male A. The proportions emphasize broad shoulders, strong muscular arms and legs, a narrow waist, and large buttocks. Both adult males wear long beards and "visor" hairstyles with a pair of long, braided sidelocks ending in a curl and a long back braid. Male B (3) and the child (4) wear a garment elaborately decorated with large fringes crossing in a V at the chest; Male A (2) may have worn the same garment, but its details cannot be discerned. The child's long braid and gesture also mimic those of the adult males. A reconstruction of the adult female's sophisticated hairstyle is facilitated by supplementary information from the better-preserved SSII (see below).

§5.5. Inscription

The poorly preserved Elamite inscription (pl. 18)—extending over the skirt and legs of Male A, the space between Males A and B, the skirt of Male B, and the space between Male B and the female (above the child's head)—was added to the relief sometime during the seventh or sixth century BC by Hanni, *kutur* (caretaker, protector, ruler) of Ayapir (see KFI below for further discussion of Hanni). Attempts to translate the fragmentary and difficult text have ascertained references to Hanni, son of Tahhihi and *kutur* of Ayapir; the god Humban; and the goddess Mashti/Parti.[2]

§5.6. Chronology

Debevoise (1942, 83) dated the relief to the eighth century BC based on stylistic analogies with Assyrian art and the stele of Atta-hamiti-Inshushinak. Vanden Berghe (1963, 39) and Amiet (1966, 552) arrived at the same conclusion via the inscription of Hanni of Ayapir, who, at the time, was placed in eighth century.[3] Initially, De Waele (1973, 35) also dated the relief after 1000 BC, but following Amiet's (1976) seminal study of glazed bricks from the Acropole at Susa, he brought the date back to the twelfth century (De Waele 1976a, 337). Vanden Berghe (1984, 27) did not acknowledge this higher dating in his later work, instead maintaining his eighth- to seventh-century date.

Here I present an alternative proposal: that the original composition of SSI was essentially the same as SSII (below), depicting *only* the royal family (composed of king, queen, and prince), and was carved around the same time, that is, approximately the twelfth century BC. A comparison with the corpus of molded glazed bricks from Susa is crucial to this dating, as De Waele noted. In my opinion the relief was later expanded in the direction of the cave with the addition of the fire stand (1) and the male ruler (2). That these elements did not belong to the original manufacture is suggested by the distinct vertical edge behind the male ruler (2), resulting from a deeper cutting of the front section of the panel into the rock. It is difficult to clarify when this addition occurred. Relying on the gesture and type of fire stand, which are examined respectively in §§5.6.3 and 5.6.4, I can presently offer only a very broad chronological range extending from the eleventh to the seventh century BC.

§5.6.1. *The Royal Tabernacle on the Susa Acropole*

In 1976 Amiet conducted an analysis of twenty-five fragmentary, polychrome-glazed, molded faience bricks housed at the Louvre Museum and established that they had once belonged to relief panels adorning the façade of a monumental building on Susa's Acropole. According to his reconstruction (pl. 19), the façade portrays royal Elamite couples molded in high relief with a depth of between 20 cm and 25 cm (Amiet 1976; 2000, 4–5). From the color of the glazes, he was able to recognize two kings: one in a light green, almost whitish color, and another in a golden yellow color (Amiet 1976, 19, figs. 1 and 2). Further study of the bricks by Heim unveiled three representations of a woman's hand holding a towel, suggesting that at least three queens had been present (Heim 1989, 233, nos. 159–61). The only brick that had survived in a complete state belonged to the shoulder of a queen and was glazed in a sharp green color. Amiet (1976, 18) noted with "astonishment" that the imagery had close parallels with Neo-Elamite art, but a study published shortly afterward by Lambert (1978) would reveal that a brick belonging to the left side of one king's chest had been inscribed with the name of the ruler Kutir-Nahhunte (ca. 1155–1150) of the twelfth-century BC Shutrukid House (founded by Shutruk-Nahhunte, ca. 1190–1155). The secure chronological markers provided by these glazed relief panels deserve closer scrutiny.

The King. Of the king's head, only the rectangular beard with individually delineated locks and a pair of braided sidelocks are visible. He has a broad chest and narrow waist, and he wears a short-sleeved garment with broad fringes along its borders; the left fringe crosses over the top of the right (see pl. 19b1). The fragmentary

2. Translation after König 1965, SSIA=EKI 76C, SSIB=EKI 76D; and De Waele 1976a, 136.

3. For the *imbroglio* between the Shutur-Nahhunte mentioned in the Hanni inscription from Kul-e Farah I and Shutruk-Nahhunte II, see Vallat 1995.

preservation of the bricks prevents a reconstruction of the skirt. The king's right hand is clasped over the left in a gesture of worship. Fingernails are defined and a brace-let is worn on the right wrist. Associated glazed bricks depict a large shoe oriented to the left and, above it, the curved hem of a long garment.

The Queen. The surviving portion of the queen's face reveals a small mouth, a nose, a frontally represented left eye, and part of the eyebrow in relief. The preserved upper left arm and small breast are covered with a sharp green glaze. The presence of a three-leaf palmette clasp below the diagonal hem of the short sleeve may indi-cate that a light, close-fitting cloak is worn.[4] Two frag-mentary bricks reveal sections of the right hand, whose extended fingers overlap the left wrist. The left hand is closed into a fist and holds a drooping object, possibly a small towel. Two additional bricks have been associated with this queen: one shows the lower back section of a floor-length garment; the other shows a foot, perhaps shoeless, oriented left (shown here in pl. 19a1).

Lambert (1978) restored another inscription on the garment of a different figure that mentions Shilhak-Inshushinak, the brother and successor of Kutir-Nahhunte (ca. 1155–1150). It declares that he restored a temple with baked bricks in the *alumelu* (high rising)— a high part of town identified as the Acropole—left unfinished by (his father) king Shutruk-Nahhunte and (his brother) Kutir-Nahhunte. He dedicated this temple to the Lord of the *alumelu* (Inshushinak). Lambert interpreted this building as a sort of dynastic tabernacle composed of a courtyard and a chapel. The chapel pre-sumably housed sculptures of the monarchs, and the courtyard walls exhibited colorful, molded faience bricks representing various royal couples. He added that this chapel may have been a *kumpum-kidua* adjacent to the temple of Inshushinak in the Acropole (Lambert 1978, 9).[5] The surviving fragments of molded faience bricks

have showed that at least three royal couples must have been represented on the façade of the royal tabernacle in the Acropole. It is possible that more couples belonging to the Elamite ruling classes were exhibited, including additional members of the Shutrukid dynasty and, based on the noted similarities with queen Napir-Asu, perhaps also members of Untash-Napirisha's (Igi-halki) dynasty.

Though fragmentary, the royal couples from Susa are strikingly similar in various ways to those of Shekaft-e Salman I and II. Parallels are palpable in such details as the rulers' distinguishing pair of long, braided sidelocks with a curl at the end, the short-sleeved garment style with bands crossing over the chest in a V, the wide shoul-ders, and the clasped-hands gesture. Parallels are also visible in the queens' small, defined breasts, the short-sleeved garments, and perhaps the towel held in the left hand. At the same time, they are not exactly identical; in the Susa version, there is no suggestion that a child was represented, and the king wears a long robe and shoes (versus short robe and probably bare feet). The queen differs on several counts: she wears a palmette clasp on her upper arm, she seems to lack the long neck-lace extension or braid (?) running along the left shoul-der, the palm of her right hand is open, and her skirt is not covering her feet. Despite these differences in detail, the overall similarities strongly suggest that the Elamite ruling couples on SSI and SSII were carved around the twelfth century BC, most likely in connection with cultic activities pursued in the highlands by members of the Shutrukid house.

§5.6.2. *The Elamite Prince*

A pair of iron linchpins from Uruk, each topped by a bronze torso and the head of a young Elamite "prince"

4. The fourteenth-century BC bronze statue of queen Napir-Asu also shows a clasp worn over the right shoulder in the shape of a palmette with seven leaves and a fibula on the upper arm. These hold together a close-fitting light cloak decorated in the same way as the short-sleeved shirt (Tallon 1992b, 132, no. 83).

5. Various interpretations have been given for the term *kumpum kiduia*. Vallat (1999, 38) sees a chapel associated with the royal palace (*hiyan*), perhaps a tabernacle (*suhter*) containing the royal symbols

of power and the representations of royal and divine personalities. He speculates that the royal palace was located in the Apadana mound (Vallat 2004, 179). Further, Heim (1992, 126; 1989, 237–49) suggests that this building was *exterior to* the main sanctuary of Inshushinak in the Acropole mound. We know of a building described as a *kumpum-kiduia* and consecrated to Inshushinak by Shilhak-Inshushinak. It had a façade made of molded bricks depicting a symbolic sacred grove composed of rows of human-headed bulls holding palm trees and lama protective deities (see pl. 72 and discussion in Part II; König 1965, EKI 43, n. 4; Lambert 1978, 7; Malbran-Labat 1995, 94, no. 41; originally published by Scheil 1901, no. 30).

clasping his hands together in a worshiping gesture (pl. 20), offers close analogies with the male child represented in the relief of SSI (and in SSII, discussed below). They were unearthed during excavations outside the sacred precinct of the temple of the Parthian god Gareus, though out of context in the surface debris. These objects were published by J. Schmidt (1978), studied by P. Calmeyer (1980, pls. 27.1, 2, 3; 28.1), and discussed by M. Van Ess and F. Pedde (1992, 70). Each figure has a broad neck, pointed chin, visible ears, a heavy monobrow, and a rounded, bowl-like hairstyle with a peculiar front-roll that looks like a knob in profile and another upward roll at the back. The waist is narrow, shoulders are broad, bracelets adorn the wrists, and a short-sleeved, V-neck garment is worn. Running across the chest are two horizontal lines covered with a pseudoinscription.

Although he tentatively classified these objects as "Babylonian?" and noted royal chariots with linchpins topped by worshipers in the slightly later Apadana reliefs at Persepolis, Calmeyer (1980, 105) recognized their similarities with Elamite art and dated them to the Neo-Elamite period based on stylistic analogies with the Atta-hamiti-Inshushinak stele, ca. seventh century, and the children in SSI and SSII, who were also dated to the seventh century at that time. His late Neo-Elamite date is supported by the unusual front-roll hairstyle, which is clearly still at home in the seventh and sixth centuries on KFII and KFV (see below §13 and §14). This evidence points to a remarkable continuity in the depiction of the Elamite prince from the twelfth century when SSI and SSII were carved.

§5.6.3. Gestures

Three different gestures are represented in SSI: hands clasped in front, *one* hand with the index finger pointing, and *both* hands with index fingers pointing. The latter is particularly significant because of its possible dating implications for Male A. Henceforth, the *index-finger-pointing* gesture will also be referred to as IFP.

The Clasped-Hands Gesture adopted by Male B (3) and the male child (4) is defined by hands hel together in front of the waist or chest and is a standard expression of devotion. Via the sculptural arts, the performance of this pious gesture par excellence by the devoted could be

fixed in perpetuity. Its appearance in statues of human worshipers is traceable back to at least the beginning of the Early Dynastic period in both Mesopotamia and Elam (Moortgat 1969, figs. 57–58; Amiet 1966, 92, no. 48). It is well represented throughout much of Elamite history, and in the highland reliefs it is performed by large numbers of individuals simultaneously (Amiet 1966; Choksy 2002). Apparently not reserved for humans, this gesture can also be seen enacted by deities (Ornan 2005, 77, 94).

The Index-Finger-Pointing Gesture with One Hand made by the adult female (5) in SSI is known in textual sources of the Neo-Assyrian and Neo-Babylonian periods as the *ubāna tarāṣu*, "pointing (or stretching) a finger" (for the divinity). It is characterized by the raising of a *single* hand with the fist clenched and one slightly bent forefinger pointing forward (crooked forefinger pointing). Generally, the other hand either extends toward the deity with palm open or holds a status symbol (Magen 1986, 94–104, pls. 7–9; Goldman 1999, 46, gesture #17; Ornan 2005, 37). This gesture may fall within the category of the *shuilla* "lifting the hand" gestures (SHU.IL₂.LA[2], *qātu nashû*) which in Mesopotamian ritual contexts express notions of greeting, prayer/supplication/ petition, and blessing (Frechette 2008).[6] The *shuilla* gesture is a sign of subservience made in response to or in anticipation of divine favor,[7] and the prayers associated with it are found in Neo-Babylonian and Neo-Assyrian ritual texts (Shibata 2010, 70). These prayers were addressed to the deity at the moment the divine image was returned to its position on the dais in the cella following its removal for a cultic procession. It is possible that the king stood on a baked brick dais to greet the deity (Shibata 2010, 73). In Assyria this gesture of

6. But see Shibata 2010, 81 n. 44: "However, we must be aware that it would not be appropriate if we would project modern concepts such as 'praying,' 'greeting' and 'blessing' in ancient Mesopotamia naïvely. Such concepts were rather not distinct clearly [*sic*] from each other in Mesopotamian native category, as pointed out by Landsberger in 1928. I prefer to designate the gesture of hand-lifting as a gesture of greeting only because it is a better analytical concept, which offers us more accurate understanding."

7. In Frechette's (2008) recent contribution to this subject, the range of meanings assigned to the gesture of "lifting the hand" is expanded to incorporate "not just the behavior of the client but also that of the patron."

supplication was also made before divine symbols. One of its earliest appearances is on the cult pedestal of the god Nusku from Ashur, where the thirteenth century king Tukulti-Ninurta is portrayed twice in the act of worshiping with the index finger slightly bent in the direction of a divine symbol (Magen 1986, pl. 7, figs. 1–2). It was a standard gesture in Assyrian reliefs until the time of Sennacherib (705–681 BC), when it was replaced by the Babylonian *appa labānu* "nose rubbing" gesture (Magen 1986, 104–8, pls. 10–11; Ornan 2005, 86). The depiction of a ca. twelfth-century Elamite queen on SSI making an IFP gesture *with one hand* is intriguing and invites us to consider links with Assyria (and with an Assyrian form of worshiping). It should be noted, however, that in the Elamite version, the index finger is always straight rather than bent and that the queen may also be holding a towel in the left hand.

The Index-Finger-Pointing Gesture with Both Hands performed by Male A (2) in SSI is defined by the flexion of both arms at a 45-degree angle in front of the body, with one arm overlapping the chest, and separately depicted hands closed in fists with index fingers extended into a pointing position. This IFP gesture is also attested on SIII, KFII, KFV, and KFVI, where it is always reserved for the highest-status individual represented in the relief (a ruler or, less likely, a deity). To the best of my knowledge, this gesture is unattested outside Elam. Generally speaking, the pointed forefinger is a "gesture of indication" and implies that the individual making it is directing his or her attention (and ours) toward someone or something.[8]

The three Kul-e Farah reliefs (KFII, KFV, and KFVI) depicting rulers performing this gesture are all dated to the seventh and sixth centuries. The hairstyles of these rulers all lack braids, which superficially suggests that Male A on SSI (and the male on SSIII) belonged to an earlier period. It is more likely, however, that he was added at a later date, but through his hairstyle and other aspects of his representation, the artist sought to underline continuity with the earlier standard depiction of the Elamite king at Shekaft-e Salman. Thus, rather frustratingly, for the time being, a broad eleventh- to eighth-century BC

date remains the most appropriate proposal for the earliest use of this gesture.

§5.6.4. Fire Stand (or Altar)

Braziers, censers, and fire altars are all incorporated here under the rubric of "fire stand." Fire stands were used for the ritual burning of offerings, which may have included incense (*thymiaterion*). Ideally the term fire altar should be applied only where there is no doubt that the fire (or a fire divinity) was a sacred element of cultic worship (Garrison 2012). Such is the case, for example, with Nusku, a deity attested in the Elamite pantheon since at least the Middle Elamite period. Nusku is both the god of fire and fire itself and, like the fire god Gibil (Girru, Gerra), may take the place of the sun god in nocturnal incantation rites (Michalowski 1993, 156–57). The *Maqlû* incantation series reveals that he was responsible for ensuring that the gods can smell incense.[9] Thus when connected to a fire deity, a fire stand used as a censer or lamp may have an ideological dimension that cannot appreciated if a purely functional approach is taken. The depiction of a fire stand in religious ceremonies at Susa goes back to Akkadian glyptic, where a male deity with a serpent lower body faces a stand with burning flames.[10] The worship of Nusku during the Middle Elamite period is attested at Choga Zanbil by the presence of his temple and cylinder seals representing a fire altar.[11] In addition to this more obvious link between the fire god and fire implements, it is worth noting that in Elam a storm-god was also associated with a worshiper kneeling before a flaming fire stand.[12]

To help establish a date for the Elamite fire stands, I will now examine the most reliable iconographic comparisons available, the twelfth century Kassite land grants (boundary-stones) and the ninth- to seventh-century

8. For the continuity and historical adaptation of this gesture in Western art, see "Pointing/Indicating" in Roberts 1998, 741–43.

9. "Without you (the fire god Nusku), the great gods smell no incense" (see incantation series in tablets II, line 10, and VI, line 114; mentioned in *CAD*, s.v. *eṣēnu*).

10. Mecquenem 1943, 57, fig. 49.3; Amiet 1972, no. 1591; Roach 2008, no. 2178.

11. See Porada 1970, 33, Group III, nos. 28, 30, and possibly 31.

12. For the representation of the storm god in western Elam, see Álvarez-Mon 2015c.

Assyrian reliefs (Wigand 1912, 18–19), together with the archaeological evidence from Choga Zanbil.

§5.6.4.1. Kudurru of Melik-shipak I (1186–1172 BC)

The first relevant fire stand is exhibited on a *narû* (stone) stele found at Susa, where it is supposed to have arrived as war booty (Sb 22). The stele bears a land-grant inscription (also known as a *kudurru*) and a carved relief scene depicting the Kassite king Melik-shipak I (1186–1172 BC) introducing his daughter, the priestess Hunnubat-Nanaya (who holds a harp), to the goddess Nanaya. This princess could have been the eldest daughter of Melik-shipak, who married an Elamite king, either Kidin-Hutran II or Shutruk-Nahhunte (Potts 2016, 224). Placed in front of the deity is an object that has been identified as a perfume burner (Scheil 1908, 87) or a censer on a stand (*nignakku*, NÍG.NA; see *CAD*, N2, p. 216; slanski 2003, 46, 142; Ornan 2005, 21). The fire stand reaches to above the waist of Melik-shipak. It has a long body that narrows toward a neck marked by a horizontal band framed by rings. On top is a shallow bowl from which emerges a conical form, presumably a stylized representation of flames (see Assyrian fire stands below). The inscription commemorates a gift of land to Hunnubat-Nanaya (Scheil 1908, 87–94, pl. 13.I.). The text makes reference to the stand under its Sumerian logogram (NÍG.NA) and K. E. Slanski (2003, 47) argues that it was supposed to represent a gift from Meli-shipak to Nanaya, "another example of the integrated text and imagery."

§5.6.4.2. Kassite-Elamite Stele (Twelfth and Eighth Centuries BC)

A smaller version of the fire stand on the *kudurru* of Melik-shipak I appears on a Babylonian-Elamite stele, also found at Susa (Sb 9) (pl. 21).[13] The stele was manufactured in Mesopotamia, also during the Kassite period, and depicts an enthroned divinity offering the ring and rod to a ruler (Amiet 1966, 410–11, fig. 310). This iconography replicates a tradition recognizable in the celebrated code of Hammurabi and reproduces iconic visual formula of Elamite royalty attested since the late

seventeenth century BC in glyptic and on the Kurangun relief. The king stands with hands clasped together at his waist beside the (reconstructed) fire stand, which is similar or even identical to the stand in Melik-shipak's *kudurru*. Its body is cylindrical with a horizontal band and ring at the neck. Damage to the upper section impairs recognition of the shape of the bowl, but the triangular tip of the flame is still visible in front of the Elamite king, just above the level of his knee.

The significance of the stele for the present discussion lies in the carefully detailed image of the king, which provides an excellent example of the refined hairstyle, pair of braided sidelocks, mustache, and garment worn by generations of Elamite rulers. The carefully arranged parallel lines of hair are shaped into the "visor" hairstyle, a term coined by Amiet in reference to its outline.[14] The clear detail reveals that the "visor" is a carefully cut, angular hairstyle with a shorter front section ending in a sharp tip and a slightly longer back section covering the ear. Also intricately detailed are a delicate mustache curling at the tip, rows of tight curls of facial hair, two sections of long wavy locks forming a neat beard, and a pair of braided sidelocks narrowing toward the bottom, where they are completed by two curls. The characteristic long back braid is missing from the image and replaced by a short braid with a pair of bands.

The Elamite king was added in a later recarving of the stele, the date of which remains unresolved. On historical and iconographic grounds, Amiet (1976, 410, fig. 310), followed by Carter (1992, 122) and Calmeyer (1995, 39), argued that he is a twelfth-century Shutrukid ruler. Following Seidl (1965, 181), Harper (1992, 181–82, no. 117) supported a twelfth-century date for the Kassite original (deity and fire stand) but proposed the eighth century for the Elamite addition.[15] A proper dating of this individual is of further interest to the present study because of the close stylistic analogies with some of the rulers depicted in the Izeh/Malamir reliefs. Based

13. For a description, see Seidl 1965, 175–77.

14. Amiet (1966, 410, fig. 310) also referred to this hairstyle as a "coiffure en écuelle" (bowl hairstyle).

15. It should be recalled that Seidl (1965, 182) proposed this Neo-Elamite date based on close analogies with the reliefs from Shekaft-e Salman at a time when (a) they were believed to have been commissioned by Hanni of Ayapir and (b) Hanni's KFI relief was dated to the eighth century BC.

on physical attributes and style of representation, this addition could have been made during or slightly after the twelfth century. However, the Elamite ruler wears a garment that crosses in a V shape at chest level (Amiet's *vêtement croisé à franges*) and has fringed ladder-band borders ornamented with round bracteates, a distinguishing feature of first-millennium BC Mesopotamian and Elamite elite garments (Álvarez-Mon 2011, 3). Everything taken into account, I am inclined to conclude that the addition was made around the eighth century BC by a Neo-Elamite king following standard royal iconography defined by the Shutrukid rulers.

§5.6.4.3. Assyrian Fire Stands (Ninth–Seventh Century BC)

A cultic scene on a bronze strip from the Balawat gates of Shalmaneser III (ca. 846 BC) offers a clear depiction of a tall (approximately shoulder-height), slender, truncated conical stand with a round bowl and flames emerging from the top (Börker-Klähn 1982, 187, fig. 146). It is placed between an offering table and two standards. The scene is set next to a river in mountainous environs, and the ritual takes place before a stele bearing an image of an Assyrian ruler who is making a single-handed IFP gesture. At the time of Sennacherib's Lachish campaign (701 BC) a similar tall, slender fire stand is represented inside a fortified Assyrian camp. In another depiction dated to the same ruler (known only from a drawing that was possibly made by A. H. Layard), a man slaughters a sheep next to another individual who faces the fire stand.[16] The bowls atop these two stands have an out-turned rim. The final example is exhibited in the celebrated libation scene from Ashurbanipal's (668–ca. 627 BC) lion hunt series. Holding a vessel in his right hand, the king stands in front of a table laden with offerings and a tall, slender conical stand with a ringed neck and a flat-based bowl from which the flames emerge (Ataç 2006, 74). The Assyrian fire stands reviewed here are tall cultic instruments reaching about shoulder level, so that the flame is positioned directly in front of the

face. They were a significant part of the paraphernalia used for rituals involving the sacrifice of animals, offerings, and the burning of incense—"food of the gods" (Back and Green 1992, 109).[17]

The tall, slender Kassite and Assyrian fire/incense stands differ from the much smaller fire stands observed in the Elamite reliefs.[18] In addition to SSI, two other Izeh/Malamir reliefs, KFV and KFI, show a large-scale ruler oriented toward a fire stand.[19] De Waele (1973, 107) labeled the fire stand from KFV a *thymiaterion*. Though he did not elaborate further on its function, the use of this Greek term implies that he took it as a censer stand for burning aromatic substances. He also interpreted the stands of SSI and KFI as "fire-altars" (De Waele 1973, 31, 49). These Elamite stands are composed of three parts: an elongated conical body, a bowl atop the body, and flames represented by a triangular outline (the detail of the flames is clear in KFI; see pl. 65e). The priest (identified as such in the accompanying epigraph) who faces the stand in KFI with both arms extended above the fire is presumably in the act of making a ritual offering, suggesting its function as a fire stand (pl. 68). In all three cases, the fire stand is rather small in relation to the person standing next to it, reaching to just above the knee, and lacks the ringed neck seen in the Mesopotamian examples.

§5.6.4.4. Elamite Fire Stands (Thirteenth–Seventh Century BC)

Roman Ghirshman encountered two different types of fire stand during his excavations at Choga Zanbil. The first is characterized by a small, cylindrical, terracotta body that widens into a bowl on top (Ghirshman 1968, pls. XLIV.5, XCI; G.T.Z. 982–84). Three stands of this

16. Barnett et al. 1998, 100, pl. 321, 422 right, room XXIV (MM); and pls. 346 and 348, room XXXVI (OO).

17. See *CAD*, s.v. *kinunu*; Neo-Assyrian *kanunu*: kiln, stove, brazier.

18. Note also that the Kassite-Elamite stela Sb 9 (discussed above) incorporates a fragmentary (reconstructed) fire incense stand between the deity and the recut image of the Elamite king. This stand is also a small, slightly above-knee-height version.

19. De Waele (1976a, 178) also mentions a boulder situated near KFIV (next to the five individuals with long garments and hair gathered in a bun) with two carved circular depressions on its top surface, which he identifies as a fire altar.

type were found inside the monumental tomb IV of the so-called *palais-hypogée*, placed at the foot of the funerary bed and possibly containing charcoal remnants (this was suggested by the excavator with a question mark; see Ghirshman 1968, pl. XCI; G.T.Z. 982–84). They measure: 18 cm high, bowl 8 cm diameter (G.T.Z. 982); 18 cm high, bowl 12 cm diameter (G.T.Z. 984); and 22 cm high, bowl 14 cm diameter (G.T.Z. 983). These diminutive fire stands appear to be represented in fourteenth-century BC seals found in Chapel III at Choga Zanbil. Shown next to a deity, possibly a storm god, holding a branch, the flaming stands fall slightly short of knee height (Porada 1970, 33–34, nos. 28–31; Álvarez-Mon 2017b).

The second style of fire stand, also made of terracotta, was found in the courtyard of the temple of Ishnikarab, a god of justice who was also known to escort the dead to the netherworld (Ghirshman 1966, 91, pls. LXIV.1, XCVI.21, XCVI.21). There is a taller version of this style that measures 38.8 cm high and has an elongated, conical body narrowing toward the top where the bowl sits. It flares a little at the base (14.6 cm diameter). Its bowl is ca. 14 cm in diameter and has a series of four ridges, the lowest one being slightly thicker. The smaller version is 23.3 cm high, has a 9.2 cm diameter base, and is topped by a 15 cm diameter bowl with a flaring rim. The courtyard yielding these two stands had three distinct stratigraphic layers containing materials dated from the thirteenth to the seventh century BC. The fire stands were found in the third layer, which equates to the surface level of the courtyard and has been dated to the seventh century BC, the end phase of the city's settlement according to Behzad Mofidi-Nasrabadi (2014a, 385).

To summarize, the peculiar *IFP gesture with both hands* made by the rulers in the SSI relief appears to be unique to Elam. As we shall see below, it is also represented in SSII, KFII, KFV, and KFVI, the last three of which I place in the seventh–sixth century BC. But since Male A (2) in SSI (and the ruler on SSIII) follows the traditional twelfth-century approach to the depiction of the king (e.g., hairstyle and physique), he must surely predate the Kul-e Farah rulers who do not. At the same time, the fire stand or altar depicted in SSI and in the seventh- to sixth-century KFV and KFI reliefs appears to follow the tradition of small fire stands seen in the Choga Zanbil archaeological record and glyptic, the taller examples (ca. 40 cm high) with ridges offering the best comparisons. Thus while the addition of Male A (2) to the original SSI panel depicting the royal family was positioned broadly between the eleventh and eighth centuries BC, the fire stand may bring the date as low as the seventh century BC.

§6. Shekaft-e Salman II (Twelfth Century BC)

§6.1. Introduction

Shekaft-e Salman II is located to the left of Shekaft-e Salman I, at a similar elevation of around 8.5 m and also to the right of the cave, seasonal creek, and waterfall (pls. 5–6). It was carved inside a square panel measuring 1.92 m high × 2.23 m wide and depicts a group of three individuals oriented toward the cave in the following order: an adult male, a male child, and an adult female (pl. 22).[1]

§6.2. Preservation

This is the best-preserved Izeh/Malamir relief. Like SSI, it resides out of direct reach of the public and was carved in a rectangular niche below a rock ledge, which somewhat protected it against weathering. It preserves significant details for reconstructing the characteristics of Elamite royal representation and the manufacture of the reliefs. Some areas have retained patches of plaster and signs of polychrome painting (see chapter 16), while those more exposed to inclement weather, such as the child (Male child [2]), show signs of severe erosion.

§6.3. Iconography

(1) *Male* (1.80 m high; 0.71 m wide at elbow level). Individual standing on a low pedestal, oriented left toward the cave and holding his hands clasped at waist level. He wears a short-sleeved garment with long fringes that cross the chest in a V shape and short fringes bordering the sleeves. A curved line at the neck may indicate an undergarment or a necklace. The narrow waist is marked by a wide band, presumably a belt, and the

1. Measurements after De Waele 1976a, 38–39. Past scholarship: Layard 1846, 78–79; Jéquier 1901, 140–41, aquarelle Morgan pl. 32a; Stein 1940, 129–30, fig. 45; Debevoise 1942, 42; Vanden Berghe 1963, 35–36, pls. 23–24; Hinz 1964, 44, 120, pl. 18; Seidl 1965, 182; Vanden Berghe 1966, 62, 162, 213, pls. 91b–g; Amiet 1966, 552–53, no. 421; Vanden Berghe 1968, 16, 23; Calmeyer 1973, 141–52; pls. 40–41; De Waele 1976a, 35–38.

bell-shaped skirt flares out above the knee in a fringed hemline. The thighs and calves are muscular with a pair of curves marking the lower calf muscle. The visible arch of the foot could suggest either well-molded shoes or, most likely, bare feet. Strong arms are emphasized by a curve outlining the biceps. The hands are clasped, the right hand over the left, and most of the fingers are long and thin. A band just above the left wrist extends along the length of the forearm to the elbow. If functional in purpose, it may be an accoutrement related to archery (see the bronze plaque in pl. 23). The hair is worn in a "visor" hairstyle that covers the top of the ear, and a narrow band runs along the forehead. A pair of chest-length, braided sidelocks thin gradually toward their ends, where they curl upward in opposite directions. Another long braid runs along the left shoulder and ends in a curl above the elbow. The face is carefully detailed with a long, thick eyebrow reaching the bridge of the nose (clearly a monobrow), a frontally depicted eye, well-defined cheek and lips, a mustache that curls upward at the end, and a long beard, neatly squared at the bottom.

(2) *Male Child* (0.76 m high; 0.30 m wide at elbow level). Male child standing behind the adult male (1), oriented in the same direction and performing the same hands-clasped gesture. He too wears a garment with short sleeves and fringed borders crossing the chest in a V shape. Another V shape, which may represent an undergarment, is visible at the neck, and a necklace composed of round beads hangs just above it. The garment skirt is knee length and has a fringed hemline like that of the adult male (1). The waist is narrow, and the legs are muscular. The bowl-like "visor" hairstyle is demarcated from the face by a band running along the top of the forehead. A long braid follows the outline of the shoulder and ends in a large curl just above the elbow. Facial hair does not seem to be depicted.[2]

(3) *Female* (1.72 m high; 0.68 m wide at elbow level). Female standing behind the male child (2), oriented in the same direction. The right hand grips the left wrist, and the left hand may hold a folded towel.[3] A garment

with short sleeves and curved neckline is worn, and the clear definition of the small breasts and nipples suggests that a top made of fine fabric is depicted. The arms are strong, and the waist is narrow. The long, bell-shaped skirt reaches to the ground and covers the feet. It is divided into a sequence of three long fringes: an upper row of long fringing, a middle row of wavy fringing increasing in length to form a triangular gap in the center, and a bottom row composed of fifteen long tassels. Facial details and hairstyle are very well preserved. The face is round, with a double chin, a small, slightly smiling mouth, a thick monobrow, and a frontally depicted eye. Around the neck is a choker, perhaps fixed by a clasp from which pends a long braid (?) ending in a curl.[4] The hair sweeps upward at the front, covers the ear at the side, and is collected up into a bulging bun-like mass at the back, leaving the neck exposed. A narrow band runs along the forehead at the hairline. Near the ear is a double-circular shape, interpreted by De Waele (1976a, 38) as part of a clasp system to fix a veil in place over the head, but perhaps it is better recognized as an earring or the ear.

§6.4. Elements of Composition and Style

Structure of the Composition. This relief is very similar to the original panel of SSI. The three human figures stand in hieratic worshiping positions occupying the entire register. All are oriented toward the cave, and there is no interaction between them. The male adult male is tallest (1.80 m) and positioned first, the adult female stands slightly shorter (1.72 m) and is positioned last, and the small male child (0.76 m) is placed in between them.

Elements of Style. Stylistically, this relief is very similar to SSI, but additional details can be discerned due to its better preservation. Particularly notable are the complex sequence of bands on the left arm of the adult male and the female's remarkable hairstyle and sumptuous

2. The eye appears to have been carved twice, one above the other, perhaps the outcome of a correction of the face.

3. The presence of a towel was not mentioned by De Waele (1976a, 38), although he notes that the fingers of the left hand are visible to the left of the right hand. The line drawing of SSII here in

pl. 22 seeks to convey in the form of dots the possibility that the queen is indeed holding a towel.

4. It is difficult to determine whether the braid is artificial and linked to the clasp and thus belongs to the choker.

garment, with a short-sleeved top of fine fabric and a wide, bell-shaped skirt with layers of long fringes.

§6.5. Inscription

Three captions were added to the relief by Hanni in the seventh–sixth century BC (pl. 22). One of them (IIA), now unreadable, was inscribed over the fringe of the adult male's skirt. Another (IIB) runs along the skirt of the male child and according to Hinz (1962, 116) reads, *Zashehshi(?), daughter(?) of Hanni.* The third (IIC) was added above the fringed hemline of the female's long dress and has been read, *Amatema, wife or daughter (?) of Hanni.*[5] There are inconsistencies in these translations. Where Hinz (1963, 116) read *ru-tú-ri* (from *rutu*,

wife), König (1965, 168; EKI 76I) read *pa-ak-ri* (from *pak*, daughter). The identification of Amatema with Hanni's wife could potentially conflict with the inscription from Shekaft-e Salman IIIB line 4 (also added by Hanni), where Huhin is named his "sister-wife" or his "legitimate wife" (according to translations by Hinz and König respectively). Likewise, it is hard to reconcile the image of a male child with the female name label, Zashehshi(?), Hanni's presumed daughter.

§6.6. Chronology

This relief should be dated to the twelfth century BC in accordance with its close semblance to the trio represented in Shekaft-e Salman I.

5. Translation after Hinz 1962 and De Waele 1976a, 136–37, corresponding to König 1965, EKI 76G, H, J. An excerpt of De Waele's dissertation addressing the inscriptions was published in *Le Muséon* 89: De Waele 1976b.

§7. Qal-e Tul (Twelfth Century BC)

§7.1. Introduction

The village of Qal-e Tul is located about 30 km south of Izeh/Malamir (between Izeh and Ram Hormuz) and is strategically situated at a gateway to the highlands (pls. 1 and 8a). In 1935, a fragmentary relief measuring 0.74 × 1.03 m was brought to light by local farmers at the western edge of the village (Stein 1940, 126; Hinz 1966, 45).[6] As described by Stein, it seemed that the relief had been detached from some kind of structure. If the composition was symmetrical, the preservation of the left borderline would suggest that the register depicting two groups of three individuals facing each other across a center line is complete. Stein also mentioned the find of "a large block of stone" near the relief. This "stone" was published years later by Hinz (1966, pl. XII.2) and turned out to be the lower part of a large seated statue in the round wearing a long garment that widens at the bottom and covers the feet. Together these two finds suggest that a substantial artistic program involving both round and relief sculpture had been carried out in this town.[7]

§7.2. Preservation

There is no information on the whereabouts of the relief (or sculpture fragment), and therefore an assessment of its condition must rely on older photographs published by Stein and Hinz. Judging by these images, the relief was carved inside a single horizontal register. Its edges are rough and irregular, perhaps due to removal from its original location as Stein proposed.

6. Stein visited the site in January 1936. The relief was found near the gendarmerie post during the digging of an irrigation channel to the southwest of the village.

7. Past scholarship: Stein 1940, 124–26, fig. 43; Debevoise 1942, 83; Vanden Berghe 1959, 60, pl. 90a; Ghirshman 1966, 60, pl. 90b; Hinz 1972, 129–30, pl. 17; Börker-Klähn 1982, 233, no. 272; Carter 2014, 44, fig. 5.5b.

§7.3. Iconography

The relief exhibits the meeting of two groups (A and B) of three individuals each. One group is headed by a female and the other by a male (pl. 8a).

§7.3.1. Group A

(A1) Large-scale female occupying the entire height of the relief. She is oriented left, facing group B, and holds the right arm out in front, flexed at 45 degrees at the elbow, with the hand open and extended in the direction of the male figure (B1) at the head of group B. Facial details have almost completely disappeared. The hairstyle is round and bulges at the back. The most prominent feature is the elaborate cape distinguished by long, voluminous sleeves and a long, bell-shaped skirt with a fringed hemline covering the feet.

(A2) Individual oriented left and smaller in scale than A1. An ankle-length garment is worn and the arms are folded in front, perhaps holding an animal.

(A3) Individual similar to A2 but smaller in scale. An ankle-length garment is worn.

§7.3.2. Group B

(B1) Large-scale male occupying the entire height of the relief. He is oriented toward the right in the direction of group A. The left arm is held out in front, flexed at 45 degrees at the elbow, with the hand open and extended in the direction of the female figure (A1). Facial features have almost completely disappeared. A garment with an ankle-length, bell-shaped skirt is worn.

(B2) Individual oriented right and smaller in scale than B1. The arms are folded in front, perhaps holding an animal (like A2). An above-knee-length garment is worn. There seems to be a small braid at the back, which would identify this as a male.

(B3) Individual similar to B2 but smaller in scale. Again there appears to be a short back braid suggestive of male gender.

§7.4. Elements of Composition and Style

The structure of the composition is a horizontal register containing a row of six individuals divided by a central axial line into two groups of three. The two groups stand facing one another across this line and reflect each other in terms of their internal scale and gesture variations. The scale of the figures decreases with distance from the center; the large-scale, high-status male and female at the front of each line are followed by a smaller figure, and then another figure who is smaller still. On the female side, all individuals wear a long garment, while on the male side, they wear a short garment and may have a short braid. The (probable) braided hair of the males and the style of the high-status female's robe offer stylistic cues as to the likely manufacture date of the relief.

§7.5. Chronology

Debevoise (1942, 83) dated the relief from the thirteenth to the eighth century BC. Carter (2014, 45 n. 39) likens the high-status female's garment to one worn by the twelfth century princess Bar-Uli on an inscribed pale blue chalcedony stone of Shilhak-Inshushinak (1150–1120) and consequently restricts the date to the earlier centuries of Debevoise's proposed range (Amiet 1966, 445, no. 340).[8] This elite female garment is distinguished by what Spycket (1981, 315) calls "pans en pointe" (pointed folds) covering both shoulders, which in fact probably represent wide sleeves like those seen on Bar-Uli, as Carter suggests. This garment style is also found on an incised

8. Without explanation, Hinz (1972, 129–30) had earlier suggested that the relief could hardly originate from the time of Shilhak-Inshushinak. The Bar-Uli bead was purchased in 1919 from the French-Armenian antiquities dealer Isaas Élias Géjou (d. 1939), known for his involvement as a seller of (looted) cuneiform tablets from Mesopotamia. Up until 1914 Géjou seems to have dealt exclusively in antiquities from Mesopotamia. http://www.britishmuseum.org/research/search_the_collection_database/term_details.aspx?bioId=93482, accessed 21 December 2016.

fragmentary plaque from Susa depicting a worshiping (?) male and female (pl. 8b). The male has a bare chest, a typical "visor" hairstyle (or cap?) without a braid and a long, bell-shaped skirt with a diagonal fringe and fringed hemline (feet are not represented). Following behind him is a much shorter woman (or girl?) with a round face, a round earring, and hair that bulges out at the back. Her long garment ends in upturned tips and seems to be open at the front, suggesting that it is an open gown, perhaps with wide sleeves. The archaeological context of the plaque is unknown, but it has been dated by Amiet (1966, 444, no. 339) to the Middle Elamite period on analogy with the Bar-Uli bead and by Spycket (1981, 315, fig. 206a–b; 1995, 28, pl. 11; followed by Carter 2014, 48, 59, fig. 5.9b) based on her dating of a garment on a 6 cm high headless limestone female statuette found in 1932 in the Ville Royale (see Mecquenem 1934, 208; Sb 5889). Considering these garment analogies, the Qal-e Tul relief could reasonably be assigned to the twelfth century BC.

§7.6. Discussion

Over the years since its publication, the scene on this relief has been subject to various interpretations. Stein (1940, 126) described it in simple terms as "two standing figures in bell-shaped robes, facing each other. Two smaller figures on either side seem to be carrying gifts." Debevoise (1942, 83) regarded the larger figures as a male and a female, each followed by two male attendants. Hinz (1966, 45; 1972, 129–30) envisaged a scene of greeting between a king and queen followed respectively by two princes and two princesses, adding that "in the whole of the ancient Near East, there is no comparable 'family portrait'" (Hinz 1972, 129). Börker-Klähn (1982, 72, 233, no. 272; followed by Henkelman 2008, 12, 47 n. 18, 47 n. 121) counters that the relief hardly depicts a dynastic tableau, and he instead sees two rulers followed by their retinue concluding a treaty, a scene analogous to one on the throne base of the ninth-century Assyrian king Shalmaneser III, in which the monarch shakes hands with his Babylonian counterpart (Yamada 2000, 166 n. 314). According to Carter (2014, 44, fig. 5.5b), the relief shows a male and a female followed by attendants, and the females (Group A) may carry sheep "and perhaps present them to the male party facing them."

There is little doubt that the imagery depicted in the Qal-e Tul relief is unique in that it shows the meeting of two groups headed by a man and a woman whose garments and large scale point to their elite status. Those following behind (family members? ministers? attendants?) are smaller in scale and wear different garments and hairstyles, although all in group B appear to have a short braid.[9] Regardless of whether a family, a royal marriage, or the conclusion of a treaty is portrayed, the large-scale female is testimony to the singular role allocated to females in Elamite culture (Carter 2014).

9. In light of the present research, this might be a novelty. At Kurangun ca. 1600 BC, long hair braids seem to be reserved for deities, while at Shekaft-e Salman around the twelfth century BC they become a conspicuous mark of royalty. Nonroyal elite individuals wearing their hair in a short braid appear conspicuously in the KFIV relief, dated to around the ninth–eighth century.

§8. Shekaft-e Salman IV (Twelfth–Eleventh Century BC)

§8.1. Introduction

This relief is located inside the large mouth of the cave about 1.95 m above the floor, to the left of SSIII and the seasonal waterfall (pl. 6). A single individual is carved inside a 2.30 × 1.25 m rectangular frame located to the right of a large, 3.10 × 2.25 m panel (pl. 24b). At the foot of the relief is a ca. 1.30 m long platform (14 cm wide on the left expanding to 55 cm wide on the right). The relief is carved to a depth of 3–6 cm.[1]

§8.2. Preservation

A combination of water seeping from the wall and vandalization by hacking, graffiti, and painting have caused considerable damage to the surface of this relief. Most of the overall outline and the volume of the body have been preserved, and certain internal details are still visible, but the face, hands, and garment decoration have all but vanished.

§8.3. Iconography

A single male individual (2.18 m high; 0.99 m wide at shoulder level) stands on a small pedestal (1.08 m long; 4–5 cm high; ca. 10 cm wide), oriented right toward the interior of the cave. The body is depicted in profile except for the chest, which is shown frontally, and the hands are clasped together at the waist in a worshiping gesture. A garment with short sleeves, fringes crossing the chest in a V shape, and a long skirt with fringed hemline is worn. The narrow waist is belted and the feet appear to be bare. Also visible are a long, square beard, a pair of sidelocks, and a "visor" hairstyle with a back braid ending in a curl.

1. Measurements after De Waele 1976a, 43. Past scholarship: Layard 1846, 78–79; Jéquier 1901, 141, pl. 33; Vanden Berghe 1963, 36–37; Seidl 1965, 182; Vanden Berghe 1966, 62, 162, 213; 1968, 16, 23; Calmeyer 1973, 141–52; pls. 38.1, 39.1; De Waele 1976a, 42–43.

§8.4. Elements of Composition and Style

The depiction of the body and hairstyle follows the standard representation of the Elamite ruler attested in the glazed brick panels at Susa (pl. 19b) and in the Shekaft-e Salman I and II reliefs (pls. 18, 22), all of which are dated here to around the twelfth century BC.

§8.5. Inscription

A poorly preserved Elamite inscription was added over the long skirt by Hanni in the seventh–sixth century BC. According to the translation proposed by König (1965, EKI 76F) and De Waele (1976a, 140) it contains references to the goddess Mashti/Parti and to the gods of Ayapir.

§8.6. Chronology

De Waele (1976a, 337) dated this relief to the twelfth century BC based on stylistic analogies with Shekaft-e Salman I and II. Vanden Berghe (1984, 27) instead dated it to the eighth–seventh century based on Hanni's inscription. Based on my own analysis of its stylistic characteristics, a twelfth- to eleventh-century BC date seems most appropriate.

§9. Shekaft-e Salman III (Eleventh–Seventh Century BC)

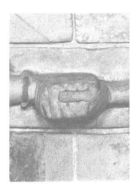

§9.1. Introduction

This relief was carved in a large (2.35 m high × 4.45 m wide), rectangular panel in the mouth of the cave, to the right of SSIV and behind the waterfall (pls. 6, 24a). It is elevated approximately 4 m above the floor and at its foot lies a platform measuring 3.9 m long × 0.5 m wide. The panel is divided into three sections. Its left section is a large (2.10 m high × 2.05 m wide at the bottom; 2.45 m wide in the middle), smooth, rectangular panel with a long inscription to the right. The central rectangular section (2.25 m high × 1.15 m wide), which depicts a male figure, is carved deeper into the rock (depth of carving 0.6–3.5 cm). The panel to the right (70 cm wide) is empty (pl. 24a).[1]

§9.2. Preservation

Like SSIV, this relief has been eroded by water seepage and further damaged by vandalism (graffiti and black paint). The broad outlines of the body can generally be reconstructed, but certain parts, such as the head, beard, and hands, are much more difficult to discern. The inscription is in a relatively good state of preservation.

§9.3. Iconography

The single male individual (2.22 m high; 1 m wide at the shoulders) is depicted in profile and oriented to the right in the direction of the cave. Both arms are flexed at 45 degrees at the elbow, with the hands held in front of the face and the index fingers extended in a pointing gesture. The garment is short-sleeved, is belted at the narrow waist, and has a short, bell-shaped skirt revealing muscular legs. The hair is arranged

1. Measurements after De Waele 1976a, 40–41. Past scholarship: Layard 1846, 78–79; Jéquier 1901, 141–42, pl. 25.1; Vanden Berghe 1963, 36; Vanden Berghe 1966, 62, 162, 213; Vanden Berghe 1968, 16, 23; Calmeyer 1973, 141–52; pls. 38.2, 39.1; De Waele 1976a, 39–41.

in the "visor" hairstyle with a pair of braided sidelocks ending in opposing curls and a long braid at the back ending in a curl. The face is eroded.

§9.4. Elements of Composition and Style

As in SSIV, the depiction of the body, hairstyle, and braids follows a standard twelfth-century representation of the Elamite ruler, but the IFP gesture with both hands corresponds with Male A in SSI, who has been dated here to the eleventh–seventh century.

§9.5. Inscription

The left panel bearing the Elamite language inscription measures 2.10 m high, ranges in width from 2.05 m (bottom) to 2.45 m (middle), and its depth is distinctively different from the central panel, receding further into the rock. It was manufactured and inscribed under the rulership of Hanni in the seventh–sixth centuries BC. Attempts to translate this long text have been hindered by the substantial number of words that are otherwise unattested (*hapax legomena* or "singletons"), a problem that may be gradually resolved if more Neo-Elamite texts surface. Hinz (1962), König (1965, 167, EKI 76 and 76A), and De Waele (1976a, 137–39) have presented translations of this inscription, but all should be regarded as "optimistic" in their interpretative scope (for further discussion, see comments on Hanni's KFI inscription below, §15.5).

The inscription first introduces Hanni, son of Tah-hihi and protector of Ayapir.[2] Hanni mentions the carving at Tarrisha of images of himself, his wife (?) Huhin, and his child and places the sculpture under the magical protection of the goddess Mashti, mistress of Tarrisha.[3] Next is a reference to Shutruru, *ragipal* of Hanni (master of the palace, weapon bearer of Hanni, and military

commander).[4] Offerings, sacrifices, and prayers are made to Mashti for the protection of the images followed by a curse against anyone who would disfigure the sculptures, remove the inscriptions, enter the building, and carve his own name. The curse ends: "May the terror of Napiriša, Kiririša (and) Tepti, who have (always?) protected/let thrive Water and Earth, . . . be placed upon him!" (tentative translation by Henkelman 2008, 328).

§9.6. Chronology

Vanden Berghe (1984, 27) dated this relief to the Neo-Elamite period (eight–seventh century BC) based on the inscription of Hanni, while De Waele (1976a, 337) attributed it to the twelfth century BC on the basis of comparison with the male rulers in SSI and SSII. It is challenging to date stylistically because most of the detail has been lost and only part of the body outline is visible. Judging by the preserved parts of the outline, this ruler clearly adopted standard features of royal representation defined during the twelfth century BC. Yet the gesture should alert us to the possibility of a later date. As noted above in relation to Male A from SSI, this gesture could be dated as early as the eleventh century and as late as the seventh century.

§9.7. Discussion

The cutting of an inscription by Hanni next to this relief (SSIII) provides a further stimulating layer of meaning for the perception of the Elamite past of Izeh/Malamir. Its presence highlights a continuity with the past and the persistent sacredness of the site, while its contents may reveal an intriguing ancient example of political and religious appropriation. Much about the inscription remains uncertain, but it is assured that Hanni, the protector of Ayapir, sought to secure the magical protection of the goddess Mashti, mistress of Tarrisha, for a relief representing his family: himself, Huhin (his wife?), and his child. We have seen that he placed inscriptions over the three other reliefs in the cave and added captions on

2. See the inscription of Hanni on KFI for discussion of key words shared by both inscriptions.

3. Hinz (1962, 112) translates *rutú shutú* as *Gattin-schwester*, "sister-wife"; König (1965, EKI 76:3) translates *ru[t]ú sh[u-t]ú* as *erwälten (geliebten) rechtmässigen Gattin*, "chosen (beloved) legitimate wife."

4. See discussion of Shutruru above.

SSII to associate the images with his family members. There is no indication that he was aware of the identity or antiquity of the depictions of the illustrious Elamite royal families he co-opted (assuming, of course, that the inscription next to SSIII was intended to refer to the individuals depicted in SSII). The curse at the end of the inscription against those who would mutilate or co-opt the imagery illuminates an intriguing contradiction in the attitude toward imagery appropriation in ancient Elam. Neither authorship nor antiquity seems to have prevented Hanni, a local ruler, from adding inscriptions and labels to identify the images as his own family members and then soliciting protection for them. The goddess Mashti, worshiped in Elam since at least the Middle Elamite period, seems to be critical in the religious pantheon of Ayapir.[5]

5. Untash-Napirisha dedicated a temple at Tepe Deylam (KS47) to Inshushinak, Mashti, and Tepti (Potts 2010b, no. 48).

§10. Kul-e Farah IV (Ninth–Eighth Century BC)

§10.1. Introduction

Kul-e Farah IV is a sizeable sculptural enterprise covering a vertical rock-cliff surface of about 100 sq m (ca. 17.7 m wide × 6 m high) on the left bank of a seasonal creek (pls. 7, 25–37). This relief was conceived as a single unit depicting a communal banquet centered on an enthroned high-ranking individual, presumed to be an Elamite king, accompanied by several attendants, a group of individuals wearing long garments, a weapon bearer/chief archer, several archers, and more than a hundred additional individuals dressed in short garments (pl. 37). An orchestra composed of six harp players and a "conductor" provides a musical background to the ceremony. No less than 141 individuals partake in a ritual featuring the consumption of a morsel of food, most likely a piece of meat. Social hierarchy is determined by position within registers, activities, and type of garment. Presiding over the ceremony is a king seated on a high-backed throne and framed by two tables bearing food and vessels. The arrangement and structure of the composition hint at complex planning and an artistic enterprise of genuine originality without parallel in the arts of the ancient Near East. The disjointed and weathered masses of the rock sculpture encountered today still offer some clue as to what must have been its rather impressive appearance in antiquity.[1]

§10.2. Preservation

The entire surface of the relief has been subject to erosion. In the most eroded parts, only unintelligible signs of the original raised images survive (see, for example,

1. Past scholarship: major studies of KFIV have been offered by Layard (1846), Jéquier (1901), De Waele (1976a, 78–103; 1981; 1989), and Álvarez-Mon (2013, 2015b). The earliest extant drawings were sketched by Jacques de Morgan after a heliogravure of panel A (Jécquier 1901, pl. 30. To my knowledge, no other drawings or sketches of KFIV were produced until those of De Waele in 1981 (figs. 7, 8). Photographic records of KFIV have been published by Vanden Berghe (1963), De Waele (1973, 1976a, 1989), and Álvarez-Mon (2013, 2015b), but none of these authors have been able to generate a record of the relief in its entirety. A complete photographic documentation has remained unattainable because many sections are either difficult to reach or seldom exposed to natural light.

TABLE 10.1. Estimated dimensions of Kul-e Farah IV panels (in meters)[a]

	DIII	DII	DI	CII	CI	BII	BI	A	-B	-C
Length	1.20	0.40	1.90	3.50	1.00	0.90	0.85	2.30	1.20	1.80
Height	ca. 1.00	0.55	0.90	ca. 2.60	1.20	1.35	0.92	2.80	2.65	0.65
Height of	0.48	0.50	0.47	note[b]	0.40	0.42	0.44	note[c]	0.48	0.51
Human figures	0.53		0.52		0.51	0.45	0.46		0.55	0.55
									0.42	

[a]All dimensions adapted after De Waele 1976a, 101–3. The correspondences between De Waele's divisions and the panel divisions adopted here are as follows: DIII (De Waele 1), DII (De Waele 2), DI (De Waele 3), CII (De Waele 6), CI (De Waele 4), BII (De Waele 5), BI (De Waele 7), A (De Waele 8), -B (De Waele 9), -C (De Waele 10).

[b]CIIa: 1–8 (0.53/0.62); CIIa: 9–11 (0.50); CIIb: 12–14 (0.54/0.57); CIIc: 15–21, orchestra, vertical harp players (0.57/0.61); "conductor" and horizontal harp players (0.48/0.53); CIId: 22–28 (0.44/0.49).

[c]Panel A register I: 0.80 m high; seated king: 0.46 m high; standing individuals: 0.38/0.43 m high; kneeling individual (14): 0.26 m high; table in front of the king: 0.20 m high; table behind the king: 0.22 m high; individuals (1, 2, and 3): 0.32/0.38 m high; individuals in panels AII, AIII, AIV, and AV: 0.42/0.47 m high; two vessels in register AIII: 0.32/0.38 m high.

panel -C), but otherwise most of the figures can still be recognized by their outline. An area of the relief situated below a protruding section of the rock has preserved exceptional details of the original carving and painted plaster (see archer CI: 4 and chapter 16).

§10.3. Iconography

For the practical purposes of its study, the relief is divided into six main panels (panels A, B, -B, C, -C, and D) that are structurally organized to show their orientation toward panel A, which bears the central scene of the king (pl. 26).

§10.3.1. Panel A (Main Scene)

Panel A is composed of five registers carved along a large protruding area of the cliff (pls. 27–28). The top register (AI) is trapezoidal in shape, while the four registers below (AII–V) are arranged horizontally. All five registers continue around the right corner of the boulder into panel -B.

Register AI (nos. 1–14). Banquet ceremony depicting a high-status individual seated on a chair (hereafter *king* on a *throne*) accompanied by servants and an elite entourage arranged in rows.

(AI: 10a) King sitting on a throne. The beard is short and the hair appears to be gathered into a braid. A long garment with short sleeves and a horizontal band at the hemline suggestive of a fringe is worn; the waist is narrow and belted. The left arm is extended to rest the hand on the knee, and the right arm is bent upward with the hand positioned at mouth level holding a small piece of food between the fingers (for details of this motif, see CI: 4 below).[2] Henceforth, this *right-hand-holding-food* gesture will also be referred to as RHHF.

(AI: 10b) Armless, straight-legged throne with a high backrest that curves outward at the top. Underneath the throne is an object with a large head, a narrow, segmented body, and a pedestal with two short legs. This feature could be identified as ornamentation of the throne or, more likely, an incense stand.[3]

(AI: 9) Low, square table stand behind the king that holds three elongated pear-shaped vessels positioned upright next to each other (see also vessels AIII: 29 below).

2. De Waele (1976a, 95) instead suggests that the right hand is holding a vessel.

3. For a similar feature under the throne of the Elamite king, see the twelfth-century BC king Shilhak-Inshushinak and princess Bar-Uli (Álvarez-Mon 2013, 247, fig. 15b).

(AI: 8) Individual standing next to the table stand. A knee-length garment is worn and the remains of a short beard are visible. One hand seems to be held at chest level, the other extends downward.

(AI: 1) A small individual in a short garment standing a few inches above a horizontal line connecting the shoulders of individuals AI: 7 and AI: 8. Both hands are raised, one closer to the mouth in the RHHF gesture. The interpretation of this individual is open to speculation.[4]

(AI: 7) Individual with a narrow waist wearing an ankle-length garment. The right hand is raised to the level of the mouth, probably making the RHHF gesture.

(AI: 6) Individual similar to AI: 7.

(AI: 5) Badly eroded individual, possibly wearing a short garment.

(AI: 11) Square table in front of the king. The legs end in broad terminals and are connected by a rail with a convex underside. Unidentifiable articles rest on top.

(AI: 12) Individual oriented to the left wearing a knee-length garment. The figure leans in slightly over the table with arms and hands reaching forward.

(AI: 13) Individual oriented to the left wearing a knee-length garment. An unidentifiable object is held in both hands.

(AI: 14) Kneeling individual oriented to the left. Both hands are extended forward to handle some kind of bulky mass (an animal carcass?).

(AI: 2, 3) Pair of individuals standing oriented to the left above the table on either a platform or a line demarcating another register. Both wear short garments and make the RHHF gesture. The left arm of the first individual is flexed at 90 degrees at the elbow, with the hand held out in front. The second individual (AI: 3) appears to be holding a staff in the left hand,

perhaps as a sign of mature age and authority (for detail, see especially pl. 28a).

(AI: 4) Individual belonging to the row depicted in panel -B register I (see below). The figure wears an ankle-length garment.

Register AII (nos. 15–24). Located below AI and occupied by two rows of individuals who face each other across a vacant center space (pl. 27). The register continues around the boulder to include two more individuals (-BII: 6, 7).

(AII: 20) Individual with broad shoulders and narrow waist wearing a knee-length garment. The figure carries a large quiver with arrowheads and holds a bow in the left hand. The right hand is extended down near the grip of a weapon, perhaps to be identified as a short sword or dagger, which hangs down behind the short skirt. I will refer to this individual as a weapon bearer and chief archer.

(AII: 15, 19) Two individuals wearing knee-length garments. Each holds a small bow with bent terminals in the left hand and raises the right hand to mouth level, probably making the RHHF gesture.

(AII: 16–18) Three individuals standing between the two bow bearers. All three make the RHHF gesture and flex the left arm at 90 degrees at the elbow.[5]

(AII: 21–24) Five individuals oriented to the left wearing knee-length garments. All make the RHHF gesture and flex the left arm at about 90 degrees at the elbow.

Register AIII (nos. 25–34). This is located below AII and occupied by two rows of individuals standing to the left and right of a central space where two tall vessels (AIII: 29) are set down. The register continues around the boulder (-BIII: 8–13).

(AIII: 28, 30) Two individuals, one oriented right (28), the other left (30), both facing in toward the open central space where the two tall vessels stand. They wear long garments with a fringed hemline. The right hand makes the RHHF gesture; the left arm is bent at about

4. In reliefs KFIII and KFVI, we encounter a large-scale king carried atop a platform, but I do not think a similar interpretation can be applied here. This figure's small size and the RHHF gesture (versus hands clasped at the waist in KFIII and fingers pointing in KFVI) suggest he is probably another participant in the communal meal. Hence, the horizontal lines in KFIV appear to be used to mark the separation between registers and spatial plans (see also figures AI: 2, 3 and figure panel -B: 13).

5. Layard (1846, 77) thought the hands of these individuals were bound.

90 degrees at the elbow, and the hand is open with thumb upward.

(AIII: 25–27) Three individuals oriented right wearing short garments. All make the RHHF gesture and have the left arm bent at about 90 degrees at the elbow, with hand open, palm upward. The front leg of no. 25 and the garment of no. 26 preserve some evidence of plaster (see chapter 16).

(AIII: 31–34) Row of four individuals in short garments oriented to the left. All make the RHHF gesture and have the left arm bent at about 90 degrees at the elbow, with the hand open, palm upward.

(AIII: 29) Pair of tall vessels with an elongated pear-shaped body; the mouth is flat and wide; the neck is narrow and broadens at shoulder level; the foot is narrow and flat, widening at the base (pls. 28, 28d, f, g1). Similar vessels may be held in the table stand behind the king (AI: 9). For further discussion of this vessel type, see the Elamite goblet below in §10.5.1.

Register AIV (nos. 35–43). Horizontal register with four individuals oriented right (35–38) and five individuals oriented left (39–43) toward an empty center space. The register continues onto the other side of the boulder (-BIV: 14–16). All wear knee-length garments and make the RHHF gesture. Those in the group on the left hold their left arms flexed at 90 degrees at the elbows; those in the group on the right hold their left arms at a slightly greater angle with the hands lower.

Register AV (nos. 44–49). Horizontal register with a row of six individuals oriented to the right. All wear knee-length garments and make the RHHF gesture. The left arm is flexed at 90 degrees at the elbow, the hand held open, palm upward. The right corner has broken off and as many as three more individuals may be missing.[6] The register continues around the boulder (-B: 17).

§10.3.2. Panel B (-B)

This panel faces the creek bed, situated to the right of panel A (pl. 29). The surface is significantly eroded, and

judging by the sketch made by Morgan at the beginning of the twentieth century, a section atop the panel (-B: 2) is now missing. The five registers of this panel continue on from those of panel A. All sixteen individuals (or seventeen if AI: 4 is counted) stand in rows oriented toward the left. There are some variations in their garments, but otherwise they have the same short, braided hairstyle, and their gestures are identical: the RHHF gesture and the left arm flexed at 90 degrees at the elbow, hand held open, palm upward.

(-BI: 1–5) Six individuals (including AI: 4) wearing ankle-length garments.

(-BII: 6–7) Two individuals cut off below waist and thigh level by a break in the rock preventing an assessment of garment length.

(-BIII: 8–13) Six individuals wearing knee-length garments.[7]

(-BIV: 14–16) Three individuals wearing knee-length garments.

(-BI: 17) Remains of a single individual wearing a knee-length garment.

§10.3.3. Panel C (-C)

This panel is poorly preserved, with three registers continuing from panels A and -B (pl. 29). One register preserves the remains of a row of seven individuals (IV: 1–7), but of the other two registers (III and V), only scattered traces of plaster survive.

(-CIV: 1–7) A row of individuals identical to AIV: 35–43 and -BIV: 14–16. A break in the stone separates nos. 1–3 from 4–7.

§10.3.4. Panel B (Composed of BI and BII)

These two panels to the left of panel A are separated from each other by a large crevice in the rock (pl. 30). Inside the gap are two registers, each containing a row of three individuals standing facing panel A (BI: 16–21). De Waele (1976a, 92 n. 1, 103) believed that a ca. 90 cm wide section

6. Note that Morgan's sketch fails to accurately represent the long diagonal break on the surface of the rock (for instance, the break goes through individual IV: 40 and not IV: 39).

7. The smaller scale of individual 13 can be explained by the lack of space left to represent him.

of this panel, containing a third register and at least five individuals, had been forcefully removed. Panel BI also appears to have been defaced with a sharp tool. All individuals are oriented to the left, make the RHHF gesture, and extend their left hand downward.

(BI: 16–18) Row of three individuals with a short, braided hairstyle, each wearing a short-sleeved, knee-length garment. The waist is narrow and belted, and the legs are muscular. No. 18 has preserved evidence of facial hair, a diagonal fringed border on the upper part of the garment (probably originally present also on nos. 16 and 17), and the thumb of the right hand.

(BI: 19–21) Row of three individuals similar to BI: 16–18. No. 20 has preserved a narrow belt, the short sleeves and diagonal (probably fringed) border of the upper part of the garment, the left arm, the contour of the strong muscular legs, and some facial features, such as the ear and the tip of the beard.

(BII: 1–15) Three horizontal registers, each depicting a row of five individuals with identical gestures, garment, and short, braided hairstyle, all oriented to the right. They make the RHHF gesture, and the left arm is flexed at about 90 degrees at the elbow, with the hand held open, palm upward. Individual BII: 5 has retained detail of the braided hairstyle, eye, ear, narrow belt, and hem of the garment's right short sleeve.

§10.3.5. Panel C (CI, CII)

The surface to the left of panel BII can be divided into two areas: one carved below a protruding section of rock and incorporating a group of seven individuals (panel CI) (pl. 31a), the other carved above the protruding rock and exhibiting large groups of individuals organized in rows (panel CII) (pl. 35b). To the left of panel CI and below panel CII there is a section of the rock that has been broken and removed (pl. 35a). Judging by the location of archers in CI (1–6) and CII (22–28), it is very likely that it originally included additional archers (see pl. 35a).

§10.3.6. Panel CI (1–7)

This is the section with the best-preserved carvings of KFIV, located below the rock projection, to the left of the

main banquet scene in panel A (see pl. 35a). Seven individuals (CI: 1–7) are depicted oriented to the right (pl. 31a) in an arrangement that contrasts sharply with the martial sequences observed in the previous registers.[8] Two groups may be defined: a trio above (CI: 1–3) and a quartet below (CI: 4–7). The latter includes the exceptionally well preserved individual CI: 4. nos. CI: 1–6 are represented in profile except for a small section of the upper chest and the shoulder, which is shown projected forward. All have broad shoulders, a narrow waist, and a knee-length garment and hold a short bow in the left hand with the curved terminals directed toward the ground. Individual CI: 7 differs in that he is represented without a bow, and his left arm is flexed at 90 degrees at the elbow, with the hand outstretched, palm upward, making the RHHF gesture.

(Panel CI: 1–3, 5–6) Individual bow bearers similar to CI: 4 (described in detail below). The left hand appears to be closed into a fist, clasping a small bow with the curved terminals directed down toward the ground like in AII: 15, 19.

(Panel CI: 7) Individual similar to the previous in panel CI except for the position of the left arm and absence of a bow.

§10.3.7. Individual Archer CI: 4

The production of a latex cast of archer CI: 4 has shed light on previously undetected artistic detail, providing a rare opportunity to further explore the various nuances in its manufacture. The cast allowed me to reproduce both frontal ("positive") and rear ("negative") perspectives of the relief, and to experiment with the photographic possibilities offered by a controlled environment. For the frontal perspectives, artificial light was projected onto the cast from the front and sides to reveal modeling and surface details; for the rear perspectives, the light was projected from behind the cast to reveal the carving depths (for selected samples, see pl. 32).

General description (pls. 31–34). The figure measures 50 cm in height and is oriented toward the right. He is

8. There is no apparent justification for this arrangement other than a possible relation to the archers' identity.

represented in profile except for a small section of the upper chest and forward-projecting shoulder. Parts of his hair, neck, back, and right shoulder have preserved evidence of the plaster, engraving, and possibly color pigmentation that originally covered the surface of the relief (pl. 31c). His physique is characterized by a broad neck and shoulders, narrow waist, and prominent buttocks. One leg is in front of the other with both feet fully visible.

Head (pls. 31c, 32e, g, h). The head is illustrated in profile. While some parts of the face, including the forehead, have been damaged, others have survived quite well. Especially notable is the preservation of a white plaster-like material, skillfully incised with parallel lines that curve back upward in a U shape to depict a short, neatly trimmed beard divided into three sections. Despite the eroded surface, one can still perceive remains of the outlines and volume of an almond-shaped eye and iris as well as a thick eyebrow arching from the temple to the bridge of the nose. The nose is prominent and straight, with a slightly rounded tip, and the nostril is clearly modeled. The lips appear slightly parted, the bottom one curved. The shape of the ear is defined by modeling forming a continuous band. The hair is carefully collected into a below-shoulder-length braid with segments defined by parallel diagonal striations beginning around the crown and a terminal section marked by long vertical lines.[9]

Right arm and hand (pl. 33). The right arm, damaged in sections, is flexed at 45 degrees at the elbow and shown in profile across the chest. The hand is positioned in front of the mouth. All five fingers are carefully modeled and fingernails are clearly visible, especially on the thumb and index fingers. A set of lines crossing the fingers initially appeared to me as detail of the knuckles, but seen more clearly in the cast they could instead represent rings on all four fingers (but not, as far as I can tell, on the thumb). The thumb and index fingers hold a small, triangular shaped object that I interpret as a morsel of meat.

Left arm, hand, and bow (pl. 33). The left shoulder and arm are positioned in a peculiar manner. While the right arm is represented in profile, the forward projection of the left shoulder exposes a small section of the upper left side of the chest and the entire left arm in an unusual manner. The left arm extends down toward the ground, the elbow beside the right elbow. Part of a small bow is visible between the closed left hand and the garment skirt. The bow's orientation is difficult to discern, but the depiction of archers AII: 15 and AII: 19 and those next to them (CI: 1–3, 5–6) and above them (CII: 22–28) supports the hypothesis that it was a composite bow held with curved terminals and bowstring facing downward.

Garments (pls. 31–34). The archer wears a garment with short sleeves, a broad belt, and a knee-length, possibly wrap-around, garment. Damage to the chest and the front of the garment below the belt makes the details difficult to reconstruct. The back is in comparatively good condition, preserving remains of the original plaster and possibly pigmentation. The sleeve appears to terminate in a double band: the narrower outer band preserves traces of discs; the wider inner band possibly preserves a row of rosettes. A line emerges from under the right arm and extends down diagonally across the garment to the left. I struggled to make sense of this feature until I revisited the Elamite "divine warriors" represented in a fragmentary bronze bas-relief plaque (Sb 133) found during the early excavations of the Acropole mound at Susa (pl. 23) (comprehensively examined in Álvarez-Mon 2015c; see also Morgan 1900, 163–64, pl. 13; Scheil 1911, 86–88, fig. 18; Börker-Klähn 1982, 173). Based on other parallels with these warriors, I suspect that what I originally interpreted as a garment fold could instead be a dagger tucked under the girdle (the hilt obscured by the right arm).

Modeling, plastering, engraving and color. Following observations made by Vanden Berghe (1986, 161–62), I have suggested that, technically speaking, KFIV should be considered more than mere "rock-sculpture" (Álvarez-Mon 2013). Its rather complex manufacture combined up to five steps: (1) a flat panel was cut out of the rock, (2) imagery was sculpted in low-relief, (3) the surface was plastered, (4) sections of the plastered surface were engraved with details, and (5) the relief was possibly painted. The sculptural craft of the Elamite

9. Vanden Berghe 1963, 31 n. 3: "On distingue nettement chez ces personnages, dont nous donnons ici une photo de détail (pl. XIX), les caractéristiques du type élamite: une tête plutôt arrondie, un œil très grande, presque en forme de huit, un nez busqué aux narines larges et développées, des lèvres for marquées, des cheveux réunis en longues nattes tressées à boucle terminale, retombant sur le dos, et une barbe très courte."

highlands was therefore evidently a multifaceted enterprise (detailed further in chapter 16). The cast and photographs of CI: 4 provide new possibilities for scrutinizing the artist's treatment of volume, depth, and surface detail using modeling, engraving, and color.

Modeling (pl. 33). While much of the original volume of the sculpture has been lost through surface erosion, we can still appreciate some of the ways that the shallow depth of carving and the plastering of the surfaces were used to achieve a "natural" plastic treatment of body parts. In its present form, the diverse array of carefully modeled relief volumes ranges from a depth as low as 0.1 cm (in the modeling and engraving of the ear) to as high as 1.8 cm (for the modeling of the buttocks). This can be best observed in the right hand holding the piece of meat. Here the fingers were modeled in decreasing depth from the first to the fifth, giving a three-dimensional appearance. A more intensive use of modeling is seen in the braid, back, and buttocks and their background. No outlines mark the boundaries between these distinct parts; instead, they emerge from their background through the smooth, rounded modeling of the surface (perhaps once enhanced by plaster). In the similarly modeled shoulder and neck, it is again through careful depth of carving and surface modeling that volume is produced and body parts are differentiated (pl. 31c). This treatment of the body is not restricted to archer CI: 4 but can be observed on other well-preserved parts of KFIV.[10]

Further evidence for exploitation of the artistic possibilities offered by carving-depth variation is found on the adjacent monumental boulder relief of Kul-e Farah III, which exhibits a ceremony involving the raising of a divine or royal sculpture atop a platform. The depth of carving and surface modeling of this relief ranges between 2 cm and 10 cm, producing a three-dimensional work of plastic art (see chapter 11).

Plastering, engraving, and outlines (pls. 31c, 33). After the relief was carved, its surface seems to have been plastered with a compound whose nature has yet to be determined.[11] Detail was added by incising the plaster with a sharp object. The hairstyle (long hair pulled back into a braid), hands (e.g., fingernails and, possibly, rings), and face (a large eyebrow, a substantial nose, a beard with well-defined locks) were all targeted for this treatment.

Color (pl. 31c). Except for some spotted remains of what appears to be a white-colored pigmentation over segments of the hair, the nose, and especially the upper back, most evidence for color has been lost. Therefore, the extent to which polychromy might have dominated the visual experience of the carving cannot be established. Substantiation for the application of color is, however, provided by painted plaster remnants on other Izeh/Malamir reliefs. The best indications of color known to me are preserved on Shekaft-e Salman II (see chapter 16).[12]

§10.3.8. Panel CII (1–28)

This panel is located high above ground; hence the photographic record available to me, and presented here, is sharply distorted (pl. 35a, b). Four main groups can be distinguished according to garment style, position, and type of activity. Except for the "music conductor" CIIc: 21 the general orientation is toward the right.

(CIIa: 1–8) Eight individuals wearing long garments (1–8) stand in a line along a slightly sloping register. All make the RHHF gesture and extend their left hand down in front.

(CIIa: 9–11) Individuals similar to nos. 1–8, located out in front above a broken section of rock above panel BII. Individual no. 11 stands alone, separated from nos. 9–10 behind.

(CIIb: 12–14) Isolated trio wearing short garments.[13] They make the RHHF gesture and appear to hold the left arm at almost the same angle as the right.

(CIIc: 15–21) Musical ensemble composed of two trios of harp players; the trio at the back is arranged in

10. Such as in panel BI: 16–21. For instance, this layer is observed over the surface of figure BI: 18, some of the individuals along BII: 1–5, and DI: 5, and, most particularly, over the body and head of individual CI: 4.

11. This statement requires confirmation through scientific analysis of the plastered surface and pigmentation.

12. On KF IV, evidence of paint is perhaps also preserved on the surface of BI: 18.

13. According to De Waele (1976a, 89) these three individuals may wear their hair in a bun.

a horizontal line, the trio at the front in a diagonal descending line. An individual labeled here the "music conductor" faces the harpists with both arms held slightly above the waist, the right hand visibly open.[14] Two types of harps are represented. The two musicians at the front each hold a small horizontal harp with a frame composed of a horizontal resonance box and a vertical rod. The two behind instead each hold an angular harp with vertical strings and a frame composed of a vertical resonance box and a horizontal rod. The resonance box is positioned at the left side of the face (note the vertical line between the jaw and the chest marking the resonance box). Some of the strings as well as the index and little fingers of the right hand are visible. The musicians all wear short garments, and their hair is collected in a bun at the back. All are rather slender, and the curvature of the back, waist, and leg muscles are well marked.

(CIId: 22–28) Seven individuals standing oriented to the right in three rows: a pair (22–23), a trio (24–26), and another pair (27–28). All wear knee-length garments. The right hand makes the RHHF gesture, and the left arm is stretched downward holding a small bow horizontally with its curved terminals oriented downward. These individuals form a group of archers together with CI (1–6).

§10.3.9. *Panel D (D)*

An area at the lower left periphery of the main relief is composed of three panels: DI (1–9), DII (10–11), and DIII (12–16). All individuals are oriented toward the right (pl. 36).

(DI: 1–9) Panel with a single register running horizontally at one end and sloping at the other. The register accommodates nine individuals: the five at the back (1–5) stand on the horizontal line, and the four (6–9) in front stand on the downward slope. All nine make the RHHF gesture and most appear to hold the left arm at a similar angle to the right arm.

(DII: 10–11) Small panel with a pair of poorly preserved individuals wearing knee-length garments. The gestures are the same as those represented in panel DI.

(DIII: 12–16) L-shaped rectangular panel positioned furthest from the main composition. It depicts a pair (12–13) and a trio (14–16) of individuals. All five wear long garments, make the RHHF gesture, and hold the left arm at a similar angle to the right. They appear to have a short hairstyle without the characteristic long braid. Gender is undetermined.[15]

§10.4. Elements of Composition and Style

Taken as a single unit, the relief exhibits a minimum of 141 individuals, a high-backed throne, a low table stand holding three vessels, a square table, and two long-necked vessels (pl. 37).[16] Social hierarchy is depicted through the use of registers, placement of the individuals in relation to others, garment types, gestures, and activities performed. We can distinguish both specific individuals and groups: a king on a throne (AI: 10), high-status individuals in long garments (AI: 6, AI: 5?; AI: 4; AIII: 25, AIII: 30; -BI 1–5; CIIa: 1–11; DIII: 12–16), a weapon bearer / chief archer (AII: 20), two archers (AII: 15, 19), harp players and a "musical conductor" (CIIc: 15–21), two groups of six (CI: 1–6) and seven (CII: 22–28) archers, attendants to the king (AI: 8?, 12, 13, 14), and more than a hundred other participants wearing short garments. This last group is by far the largest, and the individuals belonging to it are characterized by, in addition to their short garment, their braided hair and RHHF gesture (CI: 4). Visible stylistic variations are minimal and limited to the position of the arms and hands. All participants except for the "musical conductor" stand oriented in the direction of the vertical focal line in panel A.

The above analysis illuminates an impressive artistic program characterized by a distinctive stylistic grammar

14. This individual is the only one in the entire relief represented with his back turned against the central scene in panel A. He is also not participating in the consumption of food.

15. De Waele (1989, 32) suggested that this group of five individuals was composed of priests, distinguished by their hair-buns and long garments. He linked their presence in this particular location to the "fire altar" rock with two circular cavities on top (De Waele 1976a, 178).

16. As mentioned, additional participants in the communal ritual may have been depicted in registers AIII, -BIII, AV, -BI, possibly also in panel -C, and in missing sections of panel BII.

and iconography. At the individual level, the partially preserved motifs together with the remarkable details of CI: 4 enable a more precise articulation of elements of style. At the general level, the breadth of the composition (17.7 × 6 m) and its distribution, arrangement, and structure hint at an artistic enterprise of remarkable inventiveness requiring careful planning.

§10.4.1. *Individual Style*

In KFIV, the key criteria of corporeal representation are the depiction of the lower body and the head in profile and the display of the forward-projecting shoulder. This arrangement is less challenging when no parts of the body cross over each other, but it tests the ability of the artist when the arms must interact with chest and shoulders. As we have seen, the iconography of KFIV stipulated that the largest majority of individuals partaking in the ritual meal were depicted with the right hand directly in front of the mouth holding a piece of food, while the free left arm extended forward at various angles. Inventive solutions had to be developed for two major representational challenges: (a) where the body is oriented to the right, the right arm has to be depicted in front of the chest; in this case, the left shoulder and arm are shown projected forward in an unusual manner, as if appended to the right arm (see for instance CI: 4 in pl. 34); (b) when the body is oriented to the left, the left arm crosses over the chest, and the right arm and shoulder performing the RHHF gesture are made fully visible out in front of the body (see for instance AIII: 30–34; pl. 27).

These depictions were executed with extraordinary precision at the service of specific corporeal features that, while sometimes realistic, also reveal an ideal canon of representation. The endeavor to depict realistic individual features has been illustrated best by individual CI: 4, with his elaborate braided hairstyle, hands marked with detail of nails and knuckle lines (or rings), heavy eyebrows, substantial nose, proportionate ear, full lips, beard with well-defined locks, thick neck, arched lower back creating a narrow waistline, and muscular arms and legs. These various elements of style, conceived as part of an ambitious artistic program encompassing at least 141 individuals, imply the existence of a master plan and a canon of artistic proportions expressed through the

hand of expert artisans. The carefully detailed face and hair of CI: 4 raise the possibility that specific individuals were portrayed; if this were the case, KFIV might be accurately defined as a communal portrait.

§10.4.2. *Structure of the Composition*

Despite its overall complexity, Kul-e Farah IV exhibits a well-thought-out compositional structure combining a series of horizontal registers occupied by rows of communal banquet participants and a large open area (panels CI and CII) with additional participants placed outside of registers (pl. 37). The focus of attention is patently established by register AI where the enthroned king is surrounded by attendants, and perhaps community leaders. Framing this scene on the same hierarchic level are panels -BI and CII, which depict two groups of individuals in long garments, perhaps to be identified as religious leaders. The majority of the other partakers in the banquet, including a weapon bearer / chief archer (AII: 20) and two archers (AII: 15, AII: 19),[17] are inside the registers, martially organized in rows on both sides of an imaginary focal axial point and oriented toward it. Located in panel A, this axial point serves as the composition's backbone, running down vertically from the upper register (I) and dividing registers II, III, and IV approximately in half. The freely dispersed archers (CI: 1–6) in panel CI and the harpists (CII: 15–20), the row of long-robed, high-status individuals (CII: 1–11), and the pairs and trios of participants and additional archers (CII: 12–14; CII: 22–28) in panel CII are all outside the boundaries imposed by registers but are nonetheless directed toward the axial focal point. The freer distribution of the "archers" in CI together with the fact that the rock was not conditioned into a flat panel may suggest an attempt to represent a mountainous background.

§10.5. Chronology

I have recently stipulated on art-historical grounds that KFIV was manufactured in the ninth–eighth century BC

17. Besides the attendants to the king, the musicians, and their "conductor," AII: 20 seems to be the only participant who is not holding a piece of food with two fingers.

(Álvarez-Mon 2013). A Neo-Elamite date had already been proposed by several earlier scholars (Jéquier 1901, 142; Vanden Berghe 1963, 39; 1984, 102–3; Calmeyer 1973, 151; De Waele 1981, 52) based on the engraving of the late Neo-Elamite inscription of Hanni on the nearby KFI relief and based on compositional parallels with other reliefs at Kul-e Farah and the Achaemenid Persian reliefs from the Persepolis Apadana. Later, however, when the inscriptions of Hanni at Shekaft-e Salman were found to be secondary additions, scholars started to favor an earlier date for KFIV. Art-historical comparisons thereafter stressed analogies between the Shekaft-e Salman reliefs and imagery developed at the time of the Shutrukid Dynasty (twelfth century BC), leading to the view that the House of Shutruk-Nahhunte had also been responsible for some of the Kul-e Farah reliefs (Amiet 1992b, 86–87). Two art-historical arguments have been used to support dates for KFIV ranging from the fourteenth to the ninth century BC: (a) stylistic similarities of the vessels depicted in the relief with the tall Elamite ritual goblet found in the archaeological records of Susiana and Tell-e Malyan and (b) iconographic similarities with banquet scenes exhibited in seals from Choga Zanbil.

§10.5.1. The Elamite Goblet

Panel A exhibits three vessels supported by a table stand (AI: 9). Since their shape is somewhat indistinct (pl. 28c, e), I make the following observations with some reservation. Contrary to the interpretation in Morgan's sketch (pl. 27, left), the vessels do not seem to rest on their foot but instead hang from the perforated table stand. The neck is elongated and narrow and the body is ovoid in shape. While the shape of the foot remains elusive, the neck and body are comparable with the vessel pair in AIII: 29, which are clearly tall, narrow goblets (correctly drawn by Morgan in pl. 27, left, [as is clear from the photograph in pl. 28d]).

Carter fittingly suggested (1996, fig. 21) that the vessels in AIII: 29 recall the distinctive ceremonial Elamite goblets, whose presence in the archaeological record is concentrated in the Middle Elamite period and declines significantly beyond ca. 900 BC. This goblet is characterized by a long, cylindrical neck broadening toward the mouth; an elongated, ovoid body narrowing toward

the base; and a broad, round foot (see actual examples in pl. 28f, g1). The close match of these stylistic features with the KFIV vessels necessitates a consideration of the following two points: (1) little is known of the archaeological record and ceramic sequences of Izeh/Malamir or, by the same token, the urban and political entities of Huhnur and Ayapir; and (2) though it may have reduced in popularity, the Elamite goblet did not disappear from the archaeological record after 900 BC, being still well represented for some time in the Neo-Elamite I period (ca. 1000–750/700 BC).[18]

§10.5.2. Elamite "Banquet" Seals

Carter pointed out possible parallels between the KFIV banquet and the banquet scenes on fourteenth-century BC seals from Choga Zanbil. The corpus of Choga Zanbil "banquet seals" (classified as Group VII in Porada 1970) forms an iconographic and stylistic unity characterized by an individual (identified as a king), who usually sits on a square tabouret without a backing and holds (and probably drinks from) a small vessel. On many of the seals, a small table with vessels, a fish, or a small caprid stands in front of the king (Porada 1970, 57–62). Four of these elements—the king, the tabouret, the table, and the vessels—will now be evaluated against their KFIV counterparts.

1. The king is generally depicted in the seals on a similar scale as the other participants. He holds a vessel up to his face in his right hand, sometimes drinking from it, but the position of left hand is difficult to determine. He wears a fringed garment and possibly a headband or circular cap, and his hair reaches shoulder level. The KFIV king has braided hair and is shown on a larger scale than the other participants. His right hand makes the RHHF gesture, and his left forearm rests on his lap.

2. The tabouret depicted in the seals is generally square, has an internal, X-shaped frame, and lacks

18. This is the tall Elamite ritual "beaker" represented in Neo-Elamite I burials excavated by Mecquenem and Miroschedji (Wicks 2017, 109; qualified as a low-capacity pouring vessel). Narrow Elamite goblets were associated by Ghirshman with the end of Elam (which he placed in the seventh century BC; Ghirshman 1966, 87; 1968, 51).

a backing. The KFIV throne has an internal frame with a low horizontal rail and perhaps an ornamented rail (or an incense stand or lamp) and has a high backrest with an ornamental protuberance at the top.

3. The tables depicted in the seals are rather diverse, but the most common is a simple square with an internal X-shaped frame, sometimes raised on straight legs, or a U shape with a triangular base. On KFIV, two tables are represented. The one behind the king (AI: 9) was probably provided with perforations in which the vessels could rest, and the square one in front (AI: 11) has a broad horizontal lower rail with an arched surface underneath and broad feet (perhaps originally ornamented with animal paws/hooves or pinecones?).[19]

4. The vessels represented in the seals are generally small globular goblets with narrow necks. Those from KFIV are instead tall and relatively slim.

In sum, the "king," table, tabouret, vessels, and general iconography (drinking from a vessel) of the fourteenth-century Choga Zanbil banquet seals do not correspond with imagery exhibited on KFIV. More noticeable similarities reside at the ideological and ritual level with the performance of a sacred banquet ceremony before the king, perhaps at the royal court (Porada 1970, 59) or in the main religious installations of the ziggurat.

Porada (1970, 61–62, 130–31) perceptively noted that the theme of the Elamite banquet had great longevity, lasting until the eight–seventh century BC and influencing a series of Neo-Assyrian/Babylonian banquet scenes of linear style. The Neo-Assyrian banquet seals in the British Museum collections have been classified into three main groups according to the presence of a pot stand, a table with offerings, and an incense burner. Most seals in the pot-stand group are dated to the ninth century BC, but the theme may have continued throughout the eighth century. One of the main features differentiating the fourteenth-century Elamite banquet seals from their late ninth- to eighth-century Mesopotamian cousins is the high-backed throne, which, according to

D. Collon (2001, 64), appears during the second half of the eighth century. The backrests of these thrones have curved terminals and one clearer example seems to depict an animal head, perhaps a duck or ostrich (see Álvarez-Mon 2013, 245, fig.13).

More pertinent to this discussion is a royal banquet scene on an ivory strip from Fort Shalmaneser at Nimrud, presumably dated to the ninth-century BC reign of Ashurnasirpal or his son Shalmaneser III. At the scene's core is the king sitting on a high-backed throne, holding a vessel in his right hand and resting his left forearm on his lap. Behind him is a table stand with terminals in the shape of lion paws that perhaps rest on pine cones. It holds three small spherical goblets with narrow necks and pointed feet. The two tables in front of the king are of a standard Assyrian type: they have an almost square frame, two horizontal middle rails, a vertical rail below the convex underside, and lion paw terminals supported by pine cones (see Álvarez-Mon 2013, 245, fig.13).

§10.5.3. Bronze Plaque Sb 133 (Ninth–Eighth Century BC)

Also relevant to a study of the KFIV iconography is the abovementioned bronze relief plaque Sb 133 (pl. 23). The relief had at least two registers separated by a horizontal line. Engraved on the lower register is a garden setting with trees and two large birds. The upper register bears two scenes in raised relief: one a partly preserved animal beside the lower body of an individual in a long garment oriented to the left and the other, situated below, a row of seven uniformly represented divine male warriors oriented to the right. Each carries a large quiver over the right shoulder and holds a sickle-like weapon in the right hand and a small bow with bent extremities in the left. The left arm (and perhaps the hand?) is marked by a series of bands that are attached to the elbow and circle around, crossing at wrist level. As suggested by Amiet, the relief may postdate the Shutrukid period.[20]

19. For possible comparative examples, see Álvarez-Mon 2013, 245, fig. 13.

20. The fragmentary text describes offerings of rams by an unknown ruler to various Elamite divinities: Manzat (inscription behind the second individual); Nahhunte and Laqamar (behind the fourth individual); Lagamar, Pinigir, and Kiririsha (behind the fifth individual); and Nahhunte and Kiririsha (behind the sixth individual).

In a recent study, I proposed lowering its date to the ninth–eighth century BC (Álvarez-Mon 2015).

§10.6. Discussion

With its enthroned king, table stand with vessels, square table (with possible animal paw/hoof terminals), and throne with an object below (perhaps an incense burner, lamp, or candelabrum), KFIV exhibits greater complexity of style and composition than the abridged banquet scenes on the seals from Choga Zanbil. Closer parallels are instead shared with Neo-Assyrian glyptic imagery, and particularly with the ivory strip representing an Assyrian royal banquet, all dated to the ninth and eighth centuries BC.

In a single relief, KFIV freezes in time a communal banquet in which participants partake in the ritual consumption of a morsel of food, probably meat (judging by the animal sacrifice depiction in AI: 14) against a background of harp music. Structurally, it is a well-thought-out representation of a social order whose hierarchical zenith is a king surrounded by community leaders. The creative genius of this artistic production is the expression of the gravity of the ritual through a highly organized scheme of formulaic simplicity but profound ideological significance.

Looking to the Greco-Roman symposia (as studied by Smith 2012, 23–33), it is possible to underline six attributes of this social institution that can be applied to the KFIV imagery: (1) The meal represents an idealized model of the community, that is, an image of the community defining their view of themselves. (2) Social boundaries of the meal are defined along age and gender lines. Most individuals represented in KFIV are males

of a similar "ideal" body type and height. It is unclear whether female members of the community are represented, but a group of individuals who wear their hair in a bun (DIII: 14–16) could be women. Likewise, community elders cannot be easily recognized, though individual AI: 3 is a possible candidate (pls. 27, 28a). (3) sharing a meal is a customary form of bonding and implies some level of equality among participants. (4) Ranking is established through proximity to the ruler, and thus the noble and priestly class form the royal entourage. (5) The presence of musicians marks a celebratory occasion, the culmination perhaps of a set of rituals leading to consumption of the "first portion" of the meal. (6) The idealization of a community represented by a group of selected individuals sharing a meal, organized according to a sophisticated social structure, demonstrates an emphasis on the participatory nature of the performance (the sharing of the sacrificed animal). This does not necessarily reject the exaltation of the royal figure but, I think, reflects an equalizing aspect of a society. It is a collective ritual experience in which the individual establishes a meaningful connection with society and history.

The study of KFIV has revealed a distinctive artistic enterprise of extraordinary originality without precedent in the arts of the ancient Near East. It is apparent to me that this accomplished and ambitious production materialized out of a mature and well-established artistic tradition. This tradition was intimately attached to notions of place (Kul-e Farah and Izeh/Malamir), of "ethnic" identity (a social group characterized by distinctive physical features, particularly long, braided hair), and of custom and ritual (defined by a communal shared meal). All together, place, community, and tradition provide a nexus of identity markers defining a population with a specific sociopolitical and ritual ideology.[21]

21. The participation of bowmen in communal feasting with a pastoralist element of the society recalls the shepherds from Uruk who performed "bow obligation" and served as bowmen for the late Neo-Babylonian and Achaemenid kings ca. 525–520 BC (Kozuh 2006).

§11. Kul-e Farah III (Eight–Seventh Century BC)

§11.1. Introduction

The Kul-e Farah III relief extends along the vertical surface of a large boulder situated between the southern face of the cliff and the left bank of a seasonal creek, in the vicinity of KFII and KFIV (pls. 7, 38–54).[22] The perimeter of the boulder expands from 12.25 m at the top to 15.95 m at the base. The maximum relief height varies from 1.92 m (north face) to 4 m (south face).[23] Most of its vertical faces were flattened to receive the images of about two hundred individuals, three zebus and eighteen round-horn sheep.

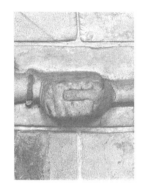

22. Between Kul-e Farah II and III lies a boulder with a blank rectangular panel cut out, suggesting it was meant to receive a relief. The date of this unfinished work, however, remains unknown.

23. Past scholarship (in order of appearance): *Descriptions of the relief*: Layard 1846, 74–77; Jéquier 1901, 133–44; Debevoise 1942, 78–80; Conteneau 1947; Vanden Berghe 1959, 1963; Hinz 1964; Amiet 1966; De Waele 1972a, 17–32; 1972b, 31–46; Calmeyer 1973, 135–52, pls. 30–40; De Waele 1976; 1981, 45–61; Vanden Berghe 1984; De Waele 1989, 29–38; Álvarez-Mon 2010a, 27–41; Álvarez-Mon 2010b; 2013, 207–48. *Published reproductions, line drawings and photographs*: two sketches of KFIII depicting the southern (2a) and southwestern (2b) sides by Morgan (Scheil 1901; Jéquier 1901, 134–39; pls. 28 [2a] and 29 [2b]); photograph by Mann (1910, 446); drawing of the southern face after Morgan (Hüsing 1908, 51, fig. 32); 1936 photograph by Stein (1940, pl. 45); two photographs by Vanden Berghe (1963, pl. XIV) depicting the southern (2e, on top) and southwestern (2e, below) sides; photograph of upper right section of southern face by Vanden Berghe (1966, pl. 91); Amiet's (1966, 55, no. 422) reprints of a photograph by Vanden Berghe (1963, 29, pl. XIV); four selected photographs by De Waele (1972b, figs. 2, 4, 5, 7); photographs of the southern and northern faces by Grunewald published in Calmeyer 1973 (pl. 34.1–2); and selected photographs by De Waele (1973, 31–46) of the southeast corner (p. 37), detail of platform bearers (p. 38), detail of individual on south face (p. 41), and the row of individuals on the south face (p. 45); the photographs of KFIII in De Waele's doctoral dissertation (1976a, pls. 38–68), which are some of the best, but it was never published, and the original photographs remain unavailable to me; four selected photographs depicting the southern face (fig. 1) and details of the southern face by De Waele (1976a, 93–101, figs. 2, 3, 9); two photographs showing the platform bearers after removal of debris and the lower section of the southeast corner by De Waele (1981, pls. I and II); photograph of the southern face by Vanden Berghe (1984, 170, pl. 2); and a line drawing of the harp orchestra represented in the northern face by De Waele (1989, 31, fig. 2).

§11.2. Preservation

The effects of both natural and human agency have left their marks on various parts of the boulder. The exposed northerly surface has eroded dramatically, probably as a consequence of the dominant northern incline of the top surface of the boulder (pl. 48), and numerous other parts have been vandalized (e.g., S:56–58) to the extent that it is often difficult to offer any kind of informed reconstruction (e.g., N: 196–91). The most unspoiled sections are along the lower northern and southern faces, where substantial detail of the lower bodies of the four platform bearers (S: 2–5) and the legs and feet of two other individuals (N: 195–96) are preserved thanks to the accumulated earthen debris that long kept them hidden below ground level. Several other zones scattered around the relief have been preserved quite well, providing further proof of individual physical distinctions and the likely presence of a layer of plaster with engraving and pigmentation.[24]

§11.3. Iconography

The preliminary study of KFIII by the French mission of 1898 summarily identified the imagery as a procession carved along the four faces of the boulder, which were allocated the labels a, b, c, and d (Lampre 1900, fig. 2.2). When Vanden Berghe briefly described the relief in 1963 following an in situ inspection the year prior, he referred to the cardinal orientations of its faces rather than adopting the labels a–d. He interpreted the imagery as a double procession, the coming together of a queen and her retinue (on the north face) and a king and his retinue (on the south face) to participate in a sacrifice of animals. Vanden Berghe (1963, 30) did not recognize the role of the platform bearers, describing them simply as "four kneeling individuals" placed at the feet of the large-scale individual. No further study of KFIII was made until De Waele's 1976 dissertation. Like Vanden Berghe,

De Waele divided the boulder into five faces according to their main orientation toward cardinal points, and it is this same division that I have adopted here. Beginning with the southern face I have numbered a total of two hundred individuals and twenty-one animals.

Panel S (south face). Includes eighty-one individuals (S: 1–81)

Panel SW (southwest face). Includes forty-eight individuals (SW: 82–129)

Panel W (west face). Includes four individuals (W: 130–33)

Panel N (north face). Includes sixty-three individuals (N: 134–96)

Panel E (east face). Includes four individuals (E: 197–200) and twenty-one animals (zebus E: z1–z3; round-horned sheep E: s1–s18)

§11.3.1. *Panel S: 1–81 (South Face)*

Rectangular panel (4.9 m wide at base; 4 m high) (pl. 39).[25] The central focus is a large-scale human figure (S: 1) carried atop a platform by four kneeling individuals (S: 2–5). Standing behind this central group are sixty-seven individuals (S: 15–81), most of whom are placed inside four parallel registers. Nine more individuals are arranged in four groups in front (S: 6–14). The individuals S: 15–81 and S: 6–14 are similar in terms of their scale, braided hairstyle, and gestures. The main discernible difference is the type of garment worn; some are short, and others are long with a long fringe at the hemline.

(S: 1) Male figure (pls. 39–40) (2 m high; 2–10 cm carving depth). The male is carved in deep relief, depicted in profile standing atop a platform oriented toward the right. He wears an ankle-length garment with short sleeves and a broad belt. The back of the garment has a large, ornate, horizontal band filled with undulating vertical lines, and a long fringe ornaments its hemline. Much of the head and face have been obliterated, but based on the outlines, this individual may have had a frontally protruding ("visor"?) hairstyle held by a

24. Already Jéquier (1901, 137–38) noticed the exceptional level of detail exhibited: "Une seule tête nous donne quelques traits de la physionomie de ces hommes: une tête très arrondie, avec l'oeil très grand, posé de face, et un nez légèrement busqué; on n'aperçoit plus la forme des lèvres, mais la barbe est taillée très courte."

25. The measurements provided by Vanden Berghe (1984, 112–13) for the "offering scene" (southern face) are height: 2.45–3.22 m; total length: 6.5 m.

band or, less likely, a helmet with a visor. The lower back section of the hair ends in a sharp angle with two curved sides. Protruding from the back of the head are a knot and a long, slightly wavy extension, which may be a hairband or a short braid.

The outline of the chin seems to indicate the presence of a short beard (contra Jéquier [1901, 137] and De Waele [1976a, 5, 8], who suggest the face is beardless). The neck is thick and the shoulders broad; the back is curved and ends in a narrow waist; the chest is straight. The visible right arm is flexed at about 75 degrees at the elbow, and the forearm is extended in front (pl. 40). The left forearm is partly visible in parallel with the right. Since this section of the relief has been heavily damaged, the exact gesture and placement of the hands are open to speculation. Based on the position of the arms, the preserved portions of the hands, the parallels with other individuals represented in this relief (see N: 180), and the known range of hand gestures made by Elamite elites, I believe the hands could be restored in the CH gesture, thus matching most of the individuals represented in the relief.

(Platform). Individual S: 1 stands on a composite, rectangular pedestal (73 cm long × 6 cm high) positioned in the middle of a larger platform (162 cm long × 20 cm high). The depth of the carving (ca. 10 cm) gives this section of the relief a three-dimensional aspect (pl. 41 bottom).

(S: 2–5) Platform bearers (pls. 39, 41–42) (62–65 cm high; 2–2.5 cm carving depth). Four keeling individuals are positioned antithetically, the inner two facing in toward one another, the outer two facing outward. In combination, the placement, orientation, modeling, and depth of carving imply three-dimensionality, as if each bearer were positioned at a different corner of the platform. All four are characterized by their broad shoulders and strong arms, contrasting with narrow waists. The platform rests on their shoulders and is held in their open, V-shaped hands. The best-preserved individual (S: 4) has a tight dome-shaped cap, hair bulging in a mass over the shoulder, and a short beard with a well-marked, angular chin. A band just below the collar suggests the presence of either a necklace or, most likely, the neckline of an undershirt. The long garment is girdled by a wide belt and ornamented with fringes that cross the chest in a wide V shape and another long fringe at the hemline. The feet are bare, and the toes are bent. A bracelet is worn on the right wrist. The outlines of the hand and thumb are clearly visible on all four individuals. The slight curvature of the thumb and the five toes indicates a carefully detailed manufacture.

(S: 6) Individual (pls. 39, 45c–d) (2–2.5 cm carving depth). This individual stands to the right of the platform and oriented to the left. A long garment with a broad fringe at the hemline is worn. The face is long, and the chin is square. The back is slightly hunched, and the arms are flexed at about 90 degrees at the elbow, with the forearms extended in front. The hands, which are particularly well preserved, are joined together. The braided hair at the back of the head appears to have completely eroded.

(S: 7–9) Trio (pl. 41) (2.5–5 cm carving depth). Three individuals stand oriented to the left on a straight, almost horizontal baseline "on top" of the right side of the platform. All wear short garments and hold their arms flexed at about 75 degrees at the elbow, with the forearms extended in front. Contrary to most of the other participants, the outline of their hands suggests they are cupped together as if holding something in between.

(S: 10–12) Naked individuals (pls. 39; 43a, e–h) (2.5–5 cm carving depth). Three naked individuals (ca. 56 cm high) stand oriented to the right on a horizontal baseline behind individual S: 13 and a zebu (E: z2). The chest is represented frontally, and the arms are extend straight downward, either both in parallel with the body (S: 10–11) or the left arm positioned slightly forward (S: 12). The face is clean shaven, and the head is bald (or the hair is very short). Possible traces of the depiction of genitalia are visible.

(S: 13) "Cattle driver" (pls. 39, 43a–d) (68 cm high). This individual stands oriented to the right on a horizontal baseline that extends to the right and continues underneath the rear leg of zebu E: z2. This individual wears a short garment and is markedly taller than the naked figures behind. The head is tilted slightly back, or perhaps, as De Waele (1976a, 59) suggests, a tall, conical hat is worn. The positioning of the arms is exceptional but difficult to clearly define: the right

arm appears to be flexed at 90 degrees at the elbow, with the hand outstretched, palm upward, while the left arm reaches upward, the hand perhaps touching the rump of the zebu (panel E: z3) or holding a stick. Two of the fingers appear to make a *snapping-fingers* (SF) gesture. De Waele (1976a, 59) perceives a dagger at the right side of the body and assumes this individual is a male.

(S: 14) Individual (pls. 39, 44) (56 cm high; 2.5–5 cm carving depth). This single individual is positioned above the naked figures S: 11–12 and directly in front of the large-scale human figure on the platform (S: 1). Location, body orientation, and gestures assign this individual a key role in the visual narrative. The direction of the feet indicates that the lower half of the body is oriented to the right, facing forward, while the upper body is turned to the left, facing backward. Both arms are raised in the direction of the large-scale figure, but the badly preserved forearms and hands make the gesture difficult to discern. The thumb and index finger could be making an SF gesture, or perhaps the index finger is extended to make the IFP gesture. In either case, the gesture is clearly directed at the large-scale figure (S: 1). A long garment is worn, and the hairstyle is unclear.

The area behind S: 1 and the platform bearers is divided into four horizontal registers (I–IV) incorporating sixty-three individuals (S: 18–81). Three more individuals are located outside these registers, two (S: 15–16) standing out in front of register I and one (S: 17) out in front of, and slightly above, register IV, on the platform.

(S: 15–16) Duo (pls. 39, 45a–b) (78 cm high; 2.5–5 cm carving depth). These two individuals stand oriented to the right in front of register I and behind the head of the large-scale figure (S: 1). Their taller height distinguishes them from most other individuals in the relief (except for S: 1, N: 177, and the platform bearers). Each wears a long garment with short sleeves, broad fringe at the hemline, and a broad belt and is characterized by a flat chest, hunched back, narrow waistline, protruding buttocks, frontally represented eye, and square chin. The first individual (S: 16) wears a braid. The braid of the second individual (S: 15) seems

to have completely eroded. The clasped hands of this figure (S: 15) are relatively well preserved, revealing details of the fingers (compare with the better-preserved individual N: 180).

(S: 17) Individual (pls. 39, 41) (0.5–2.5 cm carving depth). This individual is alone outside any visible register, standing oriented to the right atop the platform. The figure wears an above-knee-length garment with short sleeves. The gesture is unclear.

(S: 18–81) Large Group (pls. 38–39) (50–55 cm high; 0.5–2.5 cm carving depth). Four horizontal registers depicting sixty-three individuals in profile standing oriented to the right. The two registers in the middle are separated from the upper and lower register by two thick horizontal bands. Except for their garment style, all individuals are similarly represented. Each has a distinctive "visor" hairstyle with braid, short beard, frontally depicted eye, narrow waist, and rounded back.[26] The hands are clasped together; the fingers of the left hand are shown over the right hand, and the right thumb points upward.

Register I (S: 18–34) (2.81 m wide). Individuals wearing a short-sleeved, above-knee-length garment.

Horizontal band (13–30 cm high; ca. 2.5 cm deep).

Register II (S: 35–50) (3.10 m wide). Individuals wearing a long garment with short sleeves and a broad fringe at the hemline.

Register III (S: 51–66) (3.22 m wide). Individuals wearing a long garment with short sleeves and a broad fringe at the hemline. Nos. S: 55–58 have been hammered out and are almost completely destroyed. The drawings made by Morgan in 1898 suggest this section was already missing when the French Mission visited the site. Nos. S: 51–53 have preserved engraved detail of the beard, eye, and garment fringes and decoration. Especially notable on S: 51 are the remains of the striated beard and braid and checkered lines over the right shoulder, which seem to have been made by engraving a plaster material added to the surface of the rock.

Horizontal band (10–14 cm high; ca. 2.5 cm deep).

26. De Waele (1976a, 57) suggested the buttock muscles appear to suffer from "hypertrophy."

Register IV (S: 67–81) (3 m wide). Individuals wearing an above-knee-length garment with short sleeves. Nos. S: 67–70 retain some of the best-preserved detail in the entire relief, providing significant additional information for the reconstruction of the manufacture and characteristics of this relief. The volumes delineating the body outline are visible, as are details of the eyes, eyebrow, ear, a section of the mouth, and some striations marking the "visor" hairstyle, braid, and short beard. These features are well represented on nos. S: 68 and S: 69 and especially on S: 70 (pl. 46), which preserves the frontally depicted almond-shaped eye with marked iris, large lips, and a short beard divided into three sections: two across the face marked by a series of diagonal striations in a herringbone pattern and one below the chin marked by vertical lines (pl. 46d). The hair preserves similar detail, with long parallel striations for the locks and diagonal striations for the braid. A checkered pattern decorates the garment at the right shoulder, and the hem of the short sleeve is marked by a band. These striations do not seem to have been engraved directly into the rock surface but rather over a plaster that in some places preserves evidence of a white pigmentation.

§11.3.2. Panel SW: 82–129 (Southwest Face)

This is an almost square panel (lower side ca. 2.40 m wide; upper side 2.20 m wide; height ranges from 2.15 m on the left side to 1.62 m on the right side; depth of carving 0.5–2.5 cm). It is divided into four horizontal registers containing forty-eight individuals who are similarly, but not identically, represented (pl. 47). They are depicted in profile standing oriented toward the right in rows. In the top three registers, the individual at the head of each row wears a long garment. All others are characterized by their above-knee-length garments with short sleeves, the characteristic "visor" hairstyle collected into a mid-length back braid, flat chests, narrow waistlines, and hands-clasped gestures. The position of the head in relation to the line of the chest and the length of the neck exhibits some variation. The state of preservation differs between individuals.

From top to bottom:

Register I (SW: 82–94) (2.20 m wide). The first individual in the line (SW: 82) is differentiated from those behind by a slightly greater height and an ankle-length garment with fringed hemline.

Register II (SW: 95–108) (2.45 m wide). The first individual in the line (SW: 95) is differentiated from those behind by a slightly shorter height and an ankle-length garment with fringed hemline.

Register III (SW: 109–20) (2.28 m wide). The relatively well-preserved first individual in the line (SW: 109) is differentiated from those behind by an ankle-length garment with fringed hemline.

Register IV (SW: 121–29) (1.77 m wide). There is an empty, unsculpted space at the front of the register. All individuals in the line wear an above-knee-length garment.

§11.3.3. Panel W: 130–33 (Western Face)

Panel in the shape of a small triangle (70 cm wide at the bottom) created by flattening out the converging northern and southwestern panels. Inside it are a row of three individuals (1.35 cm high; 0.50–2.50 cm carving depth) who stand on a line continuing from SW panel register III (W: 130–32) and, above them, a single individual stands along the line of SW panel register II (W: 133). All four individuals are represented in profile oriented toward the right; they are characterized by above-knee-length garments with short sleeves, "visor" hairstyles with mid-length back braids, flat chests, narrow waists, and hands-clasped gestures.

§11.3.4. Panel N: 134–96 (Northern Face)

A trapezoidal panel (6.90 m wide at the bottom; 5.50 m wide at the top; left side 2.27 m high; right side 1.92 m high) (pls. 48–52). Represents a total of sixty-two individuals and is structurally divided into two main sections (right and left) oriented toward a large-scale figure (N: 177). The right section is divided into three horizontal registers containing a total of 43 individuals (N: 134–76) standing oriented to the left in rows. The left section incorporates two groups of 19 individuals (N:178–96)

oriented toward the right and a rough area that was either damaged or remained unfinished (see below for discussion).

(N: 177) Large-scale individual (pls. 48–50) (2.06 m high; ca. 6.5 cm carving depth). This male human figure stands atop a pedestal and occupying the entire height of the relief. He is oriented to the left with the lower body and head shown in profile and the upper body shown frontally. The shoulders are broad, and the chest is framed by two robust arms flexed at the elbow, the hands clasped in front of the waist. There are some remains of a short-sleeved garment with long fringes that cross over the chest in a V shape and descend down to the narrow waist, which appears to be encircled by a wide belt. A horizontal line about midway down the ankle-length skirt suggests it is composed of two layers. A "visor" hairstyle is worn and an irregular extension, perhaps a small braid or loose ends of a hairband, hangs down the back. The back of the head and beard are defined by an angular outline,[27] but heavy damage to the face, right shoulder and right side of the chest make their outlines too difficult to determine. The feet, well-defined in volume, are positioned on a small, rectangular, three-dimensional platform. The left foot is in the foreground, set slightly behind the right with the toes covering the right heel. The large size of the feet and lack of toe definition suggest he may be wearing shoes.

(Pedestal) (pl. 50a, c) (top 30 cm long).

(N:134–76) Group of individuals (0.5–2.5 cm carving depth). This group is composed of forty-three individuals arranged in three registers, all depicted in profile standing oriented to the left. All but three (N: 134, N: 145 and N: 146) wear above-knee-length garments with short sleeves (pl. 48). Each has a "visor" hairstyle and a long braid. Where the lower body has survived, the feet can be observed on two different planes, with the heel of the forward foot overlapping the front of the rear foot. The hands are held clasped together above the waist. A thick horizontal

band measuring 32–35 cm in height and protruding like "a sort of bench" separates registers II and III (De Waele 1976a, 69).

(N: 134–44) Register I (2.45 m long). Eleven individuals stand in a row. The end of the register is empty. Individual N: 134 seems to be slightly larger, is dressed in an ankle-length garment with short sleeves and stands well out in front of the rest of the group, separated from them by a large empty space. The remaining ten individuals wear knee-length garments.

(N: 145–58) Register II (3.10 m long). Fourteen individuals, mostly similar to those in the register above, stand in a row. The first two, N: 145 and N: 146, are treated differently. Like N: 134 in register I above, they both wear ankle-length robes and are positioned ahead of, and slightly detached from, the rest of the group. Each of the remaining twelve individuals wears a knee-length garment revealing a calf muscle well-defined by a curve. Some of the better-preserved outlines suggest a degree of individualization of the participants; for instance, N: 149 seems to have a flat face with a long, pointy nose and a small, narrow chin, while N: 157 has a protruding "visor" hairstyle. Other features to note are the gestures: while most individuals clasp their hands together, others seem to cup them as if holding an object (N: 149, 153, 154, 155).

(N: 159–76) Register III (3.30 m long). Eighteen individuals in knee-length garments stand in a row. The first three appear to stand on a slightly higher horizontal plane.

(N: 178–96) Nineteen individuals are arranged in four groups (perhaps originally forming four registers), represented in profile and oriented to the right. All wear above-knee-length garments with short sleeves. The middle and lower-right sections of this side of the boulder have preserved parts of figures that appear to have been either damaged or left unfinished (De Waele [1976a, 299] maintained that the work was unfinished, following Jéquier [1901, 137–38]).[28]

27. De Waele (1976a, 66) describes the beard as "more or less long," but the photographs available to me reveal an angular line suggestive of the outline of a short beard.

28. I am unable to grasp the logic of this assumption. The lowest section of this part of the relief reveals the remains of a sequence of (six?) lower bodies (pl. 50b, d, N: 191–96). The proposal that they were unfinished implies that they were carved simultaneously, starting at the bottom. It is most likely, to my mind, that the relief was finished and that this section suffered mutilation afterward.

(N: 178–83) Six individuals stand in a row on a two-level (stepped) horizontal baseline (1.37 m long) (pls. 48, 51). This group provides a good example of the diverse treatment and individualization of participants. The first four (N: 178–81) occupy the taller front portion of the register where the baseline is lower, and hence they are larger in scale than the two behind (N: 182–83). The first three are relatively well preserved. They all share a "visor" hairstyle with short back braid, but their faces are diverse. The last individual (N: 183) is represented in smaller scale than the others and leans slightly forward. N: 180 is the best-preserved of the group. His hands preserve outlines allowing a reconstruction of the "hands-clasped" gesture (pl. 51): the right hand is positioned on top, holding the left hand, and two of its fingers (most likely the index and middle fingers) protrude, revealing outlines of nails. Outlines of the fingers of the left hand are also visible.

(N: 184–89) Register with six individuals (1.80 m long). The remains of the head and extended arms of N: 184 are visible below N: 178. It is possible that there are remains of another individual (N: 185?) directly behind, just above the rough rock surface.[29]

(N: 186) Vessel bearer (pls. 48; 52a, c; 70b) (0.55 m high). This individual is wearing an above-knee-length garment. The head is tilted slightly backward. The characteristic gap between the braid and the back of the neck does not seem to be present; instead, the hair appears to have been left loose over the shoulders, raising a question over gender. A small vessel with spherical body is held up above the head in the left hand. The right hand is at waist level and appears to hold another vessel that is larger but also seemingly spherical in shape. De Waele (1976a, 67) applies the term *aryballos* to both vessels.

§11.3.5. Trio of Harp Players

Musical ensemble composed of a trio of musicians (N: 187–89) who each play a similar angular harp on the left side of the body (pls. 48, 52a–b, 70b). All three

harpists wear short-sleeved, above-knee-length garments and have their hair gathered into buns at the back of the neck. The index and little finger of the visible right hand are extended, and the middle fingers seem to be bent to pluck the vertical strings. The left arm and hand are not visible. The harp has a broad vertical soundbox ending in a curved tip. A large number of evenly spread strings extend down to a horizontal rod at waist level. The loose ends hanging from the rod are knotted together and then flare back out into a triangular shape. The harp of N: 189 is slightly smaller and held in a higher position. Like the musicians in KFIV, the bodies of these harpists are rather slender and sinuous, with narrow waists and well-marked curvatures of the back, waist, and leg muscles.

(N: 187) Harp player 1. Individual wearing an above-knee-length garment with short sleeves and hair collected into a bun at the back.

(N: 188) Harp player 2. Similar to N:187.

(N: 189) Harp player 3 (72 cm high from feet to top of harp). Similar to N: 187 and N: 188 except the harp is slightly smaller and is held slightly higher.

(N: 190) Individual represented behind and below N: 189, wearing an above-knee-length garment and braided hair.

(N: 191–96) Six incompletely preserved individuals standing oriented to the right on a baseline (ca. 1.40 m long) at approximately the same level as that of the large-scale figure N: 177. Of the first four individuals (N: 191–94), only parts of the head, legs, and feet are visible. The two behind (N: 195–96) have almost completely disappeared, but their feet are in a relatively good state of preservation because they were below ground level.

§11.3.6. Panel E: 197–200 (Eastern Face)

This panel occupyies the narrow, eastern surface of the boulder, sloping increasingly inward as it gains in height (2.55 m high; ca. 0.95 m wide at bottom; 0.58 m wide at top; 0.5–2.5 cm carving depth) (pl. 53). The panel is structurally divided into three parts: the bottom is occupied by a row of four individuals (E: 197–200) represented in profile and oriented to the left; above them is a group of three zebus (E: z1–z3), and above the zebus are eighteen

29. The presence of individual N: 185 is in need of corroboration. In the photographs I inspected, a pair of legs and bare feet are visible in front of and just below individual N: 186.

round-horned sheep organized in six rows of three (E: s1–s18).[30] All animals are oriented to the right.

(E: 197–200) Four individuals standing in a row (ca. 80 cm long) at the bottom of the panel oriented to the left. All wear above-knee-length garments with short sleeves and the "visor" hairstyle with a braid at the back. The legs of the first three individuals are well-preserved; the ankles are narrow, the calf muscles are well-defined, and the toes of the back foot overlap the heel of the front foot.

(E: z1–z3) Zebus (z1: 62 × 36 cm; z2: 67 × 36 cm; z3: 72 × 40 cm). Three large zebus represented one below the other. Each is characterized by a curved back; humped shoulders; a pair of frontally represented, small, straight horns; a single ear just below the right horn; a pointy muzzle; a bulging chest; four individually depicted legs; male genitalia; and a long tail hanging between the rear legs almost to the ground. The mouth is slightly open. The front left leg is forward, and the right is directly below the hump. The rear left leg is under the genitalia, and the right is behind the tail. The rear right leg of the middle zebu (E: z2) stands on the same baseline as the individual behind it (S:13). On z1 the left ear is visible between the horn and the hump, and on z2 the eye is visible.

(E: s1–s18) Round-horned sheep (sheep length 23–25 cm; sheep height 14–15 cm). Eighteen round-horned, long-tailed sheep organized in six rows of three. They have pointed muzzles, round horns depicted frontally, and thin legs. The long tails of the first two sheep in each row hang down between the legs to about the level of the hock, while on the last sheep the tail is instead shown behind the legs.

§11.4. Elements of Composition and Style

At its most basic compositional and thematic levels, the KFIII iconography revolves around a procession characterized by the "meeting" of two large groups of

participants represented in static positions (pl. 54). The central figure in each group is a large-scale male standing on a platform. Both groups seem to converge on an area occupied by rows of animals, musicians, and additional individuals (three of them naked) whose gestures and orientations suggest that they perform a range of activities. The sophisticated configuration of the relief and the specific stylistic approaches to the depiction of animals and humans demand further consideration and are examined respectively below in §§11.4.1 and 11.4.2.

§11.4.1. Structure of the Composition

The general structure of this relief, measuring up to 4 × 15.95 m, is demarcated clearly through the scale, orientation, and organization of its participants. Like the neighboring KFIV relief, it hints at a highly original artistic enterprise without parallel in the ancient Near East. According to the three elements—scale, orientation, and organization of participants—three main groups can be discerned within the structure (pl. 54).

Group A (comprises individuals S: 1, S: 15–81 and panels SW and W). This area is occupied by an assembly of 117 individuals distributed across four parallel registers; all stand oriented toward the right in rows behind the large-scale figure S: 1. There is clear correspondence between scale and organization. At the head of the assembly is the tallest figure, S: 1. Out in front of the upper register (Register I), directly behind the head of S: 1, stand two figures, S: 15 and S: 16, who at 78 cm high are distinctively larger than the remaining figures S: 17–81, who measure just 50–55 cm high.[31] Two thick horizontal bands separate the two middle registers (II and III) from those above (I) and below (IV) (pl. 39): the one on top measures 13–30 cm high, the one below measures 10–14 cm high.

Group B (comprises panel N: 134–77). This area is occupied by an assembly of forty-three individuals distributed across three parallel registers; all stand

30. Vanden Berghe (1963, 30) incorrectly noted six registers with thirty-six gazelles.

31. No exact heights for these individuals are provided in De Waele's 1976 work, but based on the dimensions of the SW face and comparative scale provided by the line drawings and photographs, they seem to be of a size equal to or smaller than those represented in the southern panel.

oriented toward the left in rows behind the large-scale figure N: 177. A thick horizontal band separates registers II and III.

Group C (comprises panels N: 178–96; S: 2–14; and panel E). This area is framed by the two large-scale figures from groups A (S: 1) and B (N: 177). Because group C is not organized into well-defined continuous rows formed by parallel registers, its composition is structurally more complex than groups A and B. Nevertheless, the orientation and style of particular individuals together with the horizontal baselines linking various individuals and animals allow its organization into seven subgroups.

C1 (N: 186–89) A vessel bearer followed by a group of three harp players; all stand oriented to the right in the direction of N: 177.

C2 (N: 178–85; 191–96) Rows of individuals standing oriented to the right.

C3 (E: Z1–3; S: 1–18) Herd of domestic animals composed of three zebus and eighteen round-horned sheep oriented to the right.

C4 (S: 10–13) Three naked individuals headed by a taller, clothed individual; all stand oriented to the right. They are linked to the zebu (E: z1) in front of them by a well-marked horizontal baseline that extends out underneath the animal's rear legs.

C5 (E: 197–200; S: 6–9). Two rows of individuals oriented to the left.

C6 (S: 14) Single individual with feet oriented to the right and torso, head and hands turned back toward the left.

C7 (S: 2–5) Four platform bearers.

Emphasis on orientation reveals a permeable zone of interaction between those participants oriented right and those oriented left, while assigning a strategic role in the visual narrative to the platform bearers (C7) and to individual C6 (S: 14) (pls. 44, 54). The platform bearers do not have a single dominant orientation; underneath the platform, one pair is oriented right and the other left, presumably stressing their placement at each of its corners. The orientation of the isolated individual C6 is ambiguous: the lower half of the body is oriented right, while the upper half is twisted backward at torso level in order to face the large-scale figure S: 1 to the left.

§11.4.2. *Individual Stylistic Characteristics*

§11.4.2.1. Scale

Large scale. Standing out from the rest of the participants are the 2 m tall (2–10 cm carving depth) individual S: 1, who stands on a pedestal carried atop a platform, and the 2.06 m tall (ca. 6.5 cm carving depth) individual N: 177, who stands atop a pedestal. Their comparative size suggests they are the leading participants in the event depicted.

Regular scale. The rubric "regular" scale applies to the largest majority of the participants, who are all approximately 55–56 cm in height (0.5–2.5 cm carving depth).

Irregular scale. The rubric "irregular" scale applies to a small number of participants in the southern panel whose height clearly extends above the norm.[32]

(S: 13) "Cattle herder" measuring 68 cm high; standing in front of three "regular" scale (ca. 56 cm high) naked individuals (S: 10–12).

(S: 15–16) Two individuals in long garments measuring 78 cm high.

(S: 2–5) Four platform bearers. Considering they are kneeling, these figures are by far the largest in scale after S: 1 and N: 177. From knee to head, the two in the center (S: 3 and S: 4) measure 65 cm in height, and the outer two (S: 1 and S: 4) measure 62 cm.

§11.4.2.2. *Body Representation and Gestures*

In KFIII there is a marked contrast between the individuals placed collectively in rows clasping their hands together in front (*general-normative*) and the single individuals whose gestures are unique (*particular-extraordinary*). In addition to repetition, scale, and orientation, this integration of the general-normative and particular-extraordinary suggests a keen awareness to

32. That said, two individuals represented in ankle-length garments in the SW panel (SW: 82 and 109), each leading a group of people, are slightly taller. Note that the first individual leading the group in register II (SW: 95) is also wearing an ankle-length garment but is represented at a slightly smaller scale.

the power and centrality of formalized gestures in the negotiation of relationships.

General-normative. At a communal level, the emphasis on the gravity and the orchestration of the act increases with the number of individuals performing the same gestures and movements. The vast majority of the participants in KFIII are shown in the general-normative static position, not interacting, standing upright, and clasping their hands together in front of their body at waist level. Stylistically, three groups can be distinguished by the orientation of the upper body.

Body depicted in full profile oriented to the right. This applies to all individuals exhibited in the west and southwest panels; all participants in the southern panel except the platform bearers (S: 2–5); groups S: 6–9, S: 10–13, and individual S: 14; group N: 178–83 in the northern panel and, hypothetically, the badly preserved remains of N: 184–85, 190, 191–96.

Body depicted in full profile oriented to the left. This applies to all individuals standing behind the large-scale figure N: 177 in the northern panel, individuals E: 197–200, and individuals S: 6–9.

Shoulders depicted frontally and the rest of the body and head oriented to the left. This applies exclusively to individual N: 177. This position suggests that the frontal display of the upper part of the garment and broad shoulders contrasting with a narrow waist were meaningful.

Particular-extraordinary. A distinction can be made between the representation of groups and individuals. In the former category are the four platform bearers (S: 2–5), the three harp players (N: 187–89), and the three naked individuals (S: 10–12); in the latter are the three individuals (S: 13, S: 14 and N: 186) whose unique gestures and locations suggest they are key active players in the events depicted.

(S: 2–5) Kneeling platform bearers positioned antithetically; the two in the center face inward and the outer two face outward. Like N: 177 the chest is depicted frontally to emphasize the upper part of the garment and broad shoulders contrasting with the narrow waist.

(S: 10–12) Three naked individuals shown in profile oriented to the right with the left shoulder projected slightly forward, giving it an awkward, dislocated appearance. Both arms extend straight down in line with the body. The left arm of S: 12 at the front of the group is slightly out in front of the body. The extended position of the arms and hands is most unusual and contrasts with the gestures of all other participants depicted in the relief.

(N: 187–89) Three musicians playing vertical harps on the left side of the body with the right hand positioned over the strings.

(S: 14) Single individual with the lower half of the body oriented right and the upper half (torso and head) twisted around to face the left. The arms and hands are raised toward the large figure S: 1. This unusual pivoting, or double orientation, of an individual standing directly before a large-scale figure is seen also in KFII (individual KFII: 6).

(S: 13) "Cattle herder" oriented to the right with the head tilted backward. The right arm is flexed at 90 degrees, with the hand extended, palm upward; the left hand appears to be reaching out to touch the rump of the zebu in front (panel E: z3).

(N: 186) Individual in front of the harp players raising a small vessel in the left hand above the head. The right hand is at waist level and seems to hold a larger vessel.

§11.4.2.3. *Clothing*

Two main garment types are clearly distinguishable: a short garment reaching to about the knee and a long garment reaching to the ankle (both types appear to have short sleeves). This enables classification of the participants into two categories, with a third group being unclothed (S1: 10–12). The assumption is that these categories should reflect social status.

Special clothing features.

(S: 1) Large-scale figure dressed in an ankle-length garment with short sleeves, a broad belt encircling the narrow waist, and a broad fringe at the hemline. A large ornate band with undulating parallel lines at the back of the garment possibly also represents a fringe.

TABLE 11.1 Garment types exhibited at Kul-e Farah III

Panels	Short Garment	Long Garment
South face	S: 7–9	S: 1 (Large-scale human figure)
	S: 13	S: 2–5 (Platform bearers)
	S: 17	S: 6
	S: 18–34 (register I)	S: 14
	S: 67–81 (register IV)	S: 15–S16
		S: 35–50 (register II)
		S: 51–66 (register III)
Southwest face	SW: 83–94 (register I)	SW: 82 (register I)
	SW: 96–108 (register II)	SW: 95 (register II)
	SW: 110–20 (register III)	SW: 109 (register III)
	SW: 121–29 (register IV)	
West face	W: 130–33	
North face	N: 135–44 (register I)	N: 177
	N: 147–58 (register II)	N: 134 (register I)
	N: 159–76 (register III)	N: 145 (register II)
	N: 178–83	N: 146 (register II)
	N: 184–89	
	N: 190	
	N: 191–96	
East face	E: 197–200	

(N: 177) Large-scale figure wearing an ankle-length garment with short sleeves. The fringed borders of the upper part of the garment cross over the chest and continue down to the narrow waist. The hemline was most likely also fringed, but the lower section of the garment is too damaged to confirm this. Foot arches are visible, but toe details are not obviously present.

(S: 2–5) Platform bearers wearing long garments with diagonal lines forming a wide V shape on the chest, indicating the crossing of fringed borders. Another fringe runs along the hemline. The best preserved is S: 4, who preserves the remains of either a necklace or, more likely, the neckline of an undershirt. A bracelet is worn on the right wrist, a wide belt at the waist, and the delineation of toes conveys the absence of shoes.

(S: 15–16) Two individuals (standing behind the head of S: 1) characterized by flat chests, hunched backs, narrow waists, and long garments with fringed hemlines.

(S: 35–50 and S: 51–66) Two rows of individuals wearing long garments with fringed hemlines.

From these observations it can be inferred that the long garments represented in KFIII are characterized by fringed borders. The fringes are arranged in a V shape across the chest and most likely overlap at waist level. The garment worn by individual S: 1 seems to be unique in that it has also preserved a broad band with an undulating pattern above the waist. Fringes have not been noted on the shorter garments.

§11.4.2.4. Hair, Headdresses, and Beards

Hair.
A distinctive trait of cultural identity exhibited on most Kul-e Farah III participants is the mid-length hair braid, which links them directly with the worshipers represented in the nearby reliefs KFIV, KFVI, and KFI, as well as in Kurangun II and III, where the braid ends in a curl. In addition to the braid, most participants have the characteristic frontal Elamite "visor" hairstyle protrusion. The exceptions are:

(S: 2–5) Platform bearers with hair bulging in a mass over the shoulder.
(N: 187–89) Harp players with hair bulging in a bun over the shoulder.
(S: 10–12) Naked individuals with bald head.

(N: 186) Vessel bearer with long hair that seems to have been left loose over the shoulders, raising a question over gender.

Headdresses

(S: 2–5) Platform bearers with tight dome-shaped cap.

(S: 1) Large-scale individual wearing a "visor" hairstyle with an extension, perhaps a braid or headband tie, that emerges from the back of the head and seems to end at shoulder level.

(S: 13) "Cattle herder" represented with the head tilted backward, creating an unusual rounded shape, or perhaps, as De Waele (1976a, 59) suggests, a tall, conical hat is worn.

(N: 177) Large-scale individual wearing a "visor" hairstyle with an extension, perhaps a braid or hairband tie, at the back.

Beards

(S: 1) Large-scale individual who is described by De Waele (1976a, 58) as beardless, but who in my view seems to have a short beard.

(S: 2–5) Individuals with short beards.

(S: 10–12) Naked individuals, probably beardless.

(N: 177) This large-scale individual has a beard, but heavy damage to the face and right shoulder makes its length difficult to determine. De Waele (1976a, 66) suggests it is "more or less long."[33]

§11.4.2.5. Herd of Animals

Panel E incorporates three zebus (E: z1–z3) and eighteen round-horned sheep (E: s1–s18) that all appear to be moving in a herd. This ratio of one zebu to six sheep seems to be significant (for further discussion, see section §18.3).

§11.4.2.6. Objects

Platform S: 1. Individual S: 1 stands on a small, double-stepped, rectangular pedestal (73 cm wide × 6 cm high) positioned centrally atop a long platform

33. Vanden Berghe (1963, 30) identified this figure as a queen.

(162 cm wide × 20 cm high) supported by four individuals. The considerable depth at the back of the platform (10 cm) gives a sense of three-dimensionality.

Pedestal N: 177. Individual N: 177 stands on a small, three-dimensional, rectangular pedestal measuring 30 cm long. The feet are positioned atop the pedestal in perspective, with the left toes overlapping the right heel.

Vessels. The only two vessels represented in the relief are both held by individual N: 186. One is a small spherical vessel raised in the left hand above the head, the other is larger and also seemingly spherical. De Waele (1976a, 67) describes both vessels as *aryballoi*.

Harps. Three angular harps of a similar type are held at waist level by N: 187–189. All have a broad vertical soundbox ending in a curved tip, and a large number of strings connected to a horizontal rod. The loose ends of the strings (or a set of tassels?) hang down and are knotted together below (for further discussion, see §17.2).

§11.5. Chronology

The manufacture date of KFIII has previously been stipulated based on parallels with the other Kul-e Farah reliefs. Jéquier (1901, 142) was first to take the reliefs as a single corpus manufactured at about the same time. Though he stressed the difficulty of dating them with precision, he proposed their placement in the last period of the Elamite Kingdom ("époque Elamite récente"), at the time of the notorious wars against Assyria documented in the Assyrian royal annals and monumental palace reliefs. He justified this date primarily on art-historical grounds. To him, the general style of the sculptures prompted analogies with the art of Babylon, but their style was "graceless" and "heavy" and suggested an art "in full decadence." Jéquier (1901, 139) believed they could have been made by the same hand and possibly even represented the same individual, named as Hanni of Ayapir in the inscription of Kul-e Farah I. He therefore adopted the seventh century BC date proposed for the KFI inscription, translated by Scheil (1901, 102–12) in the first volume dedicated to the *élamites-anzanites* texts.

Jéquier's "époque Elamite récente" date was embraced by most specialists. Vanden Berghe (1963, 39; 1984, 102–3;

followed by De Waele 1976a, 337) specified the eight–seventh century BC, and Amiet (1966, 544) initially supported an eighth-century date for the group of reliefs KFI–IV. Calmeyer (1973, 152) attributed the same four reliefs to a "period of Elamite-Persian cohabitation." In 1984, however, Carter (1984, 172) proposed shifting KFIV to a somewhat earlier, pre-1000 BC, date. Amiet (1992b, 86–87) adopted this new date and extended it also to KFII, KFIII, and KFVI, adding that these reliefs manifested the expression of a local monarchy that developed in eastern Elam after the invasion of the Babylonian king Nebuchadnezzar I (ca. 1104) or perhaps slightly later, at the beginning of the tenth century BC.[34] Taken as a whole, these dates place the manufacture of Kul-e Farah III within a wide chronological frame of about four hundred years (ca. 1000 to 600 BC).

A more precise date for KFIII is best established by means of stylistic and iconographic comparisons with the better-dated reliefs of KFIV (ninth–eighth century), KFVI, and KFI (seventh–sixth century). All four reliefs share close stylistic analogies in terms of the structural organization of the composition along registers and, above all, the canon of proportions, representation of the human body (hairstyle, mid-length braid, profile, garments), and the style of the harps. The KFIII platform bearers are an especially important iconographic element shared with KFVI.

§11.5.1. Plaque Locus 143

The chronology of KFIII may be further clarified by an 11 × 8 cm limestone plaque from the Acropole at Susa (locus 143), perhaps representing the upper-right section of a larger, decorative square panel of a monumental construction, possibly of religious character (pl. 59a). It was carved with the image of a double-winged figure or genius in a half-kneeling atlas pose, followed by a human-headed, winged scorpion with lion paws. The arms of the genius are spread in a W position, with each hand supporting an elongated, peg-like object.[35]

A helmet topped by a rounded knob and, conceivably, an extended visor are worn,[36] and the long hair is divided into five segments with a pair of wavy sidelocks extending over the ear. The upper body is represented frontally. A horizontal line extending from one shoulder to the other could mark the neckline of an undergarment, or perhaps a necklace (?). The outer garment is bordered by thick fringes and parallel bands that continue from the shoulders down to the waist, where they meet but do not overlap. A wide belt composed of narrow bands separates the garment shirt from the long skirt, which is ornamented with three narrow, parallel bands and a broad fringe at the hemline. Even if the garment differs slightly, the half-kneeling atlas pose and bare feet with well-defined toes present palpable iconographic and stylistic similarities with the Kul-e Farah III and VI platform bearers. In my own recent analysis of this plaque, I suggested that it ought to be linked to a period of political and cultural renewal at Susa after 625 BC (Álvarez-Mon 2010a, 92–94, pl. 47).

In conclusion, I am inclined to retain the Neo-Elamite date for KFIII originally stipulated by Jéquier, Vanden Berghe, Amiet, Calmeyer, and De Waele. As it presently stands, a date in the eighth or seventh century BC remains most plausible on the basis of a combination of factors: stylistic analogies with a plaque from Susa (locus 143); the platform bearers' fitted dome-shaped cap and braidless hairstyle, reminiscent of Elamite king Te'umman in Assyrian reliefs; the close similarities among Elamite orchestras from Kul-e Farah (KFI and KFIV) and Assyria (the royal orchestra from Madaktu); and close artistic and ritual analogies with Persian relief sculptures.

34. This reclassification does not include KFV, which is dated together with KFI to the seventh–sixth century BC.

35. The kneeling genius shares close iconographic analogies with three winged genii represented in a series of late Neo-Elamite mythological seals from the Acropole at Susa; these half-kneeling winged genii hold a peg-like object in each hand. For the Susa seals, see Amiet 1973, pl. II, figs. 8, 9, 10. For a Mannean tile representing a similar kneeling genius, see Hassanzadeh and Mollasalehi 2011. For possible interpretations of the objects held by these genii, see Álvarez-Mon 2010a, 102 n. 200.

36. The tip of the visor has been damaged, and only the outline remains. The rounded protuberance on the top of the helmet was at home in Elam since the *sukkalmah* period (Amiet 1966, 309, 397, 308; 1992, 257–65, fig. 24). Versions of this helmet (with a short visor) are worn by the bronze Arjan candelabrum atlas figures and the royal bodyguard of the king depicted in the Arjan bowl (Álvarez-Mon 2004, 211).

§11.6. Discussion

The problem of identifying the large-scale individuals depicted in the highland reliefs has persisted since their discovery. Perrot and Chipiez (1890, 774), for example, interpreted the large-scale figures in Kul-e Farah I (Hanni) and Kul-e Farah II as deities. Later, the large-scale individual carried on a platform in KFIII was taken by De Waele (1973, 31–45), followed by Root (1979, 158 n. 82), as a divine statue. Conversely, it appeared as a king to Jéquier (1901, 130), followed by Debevoise (1942, 85), Hinz (1966, 43), Amiet (1966, 554; 1992b, 86), Calmeyer (1973, 140–41), Vanden Berghe (1984, 112–13), and Miroschedji (2003, 34). A review of the basic arguments reveals that although both interpretations have merits, it is very likely that we are dealing with the representation of a ruler, perhaps one explicitly co-opting divine imagery.

Divine statue. According to De Waele (1976a, 198), a free-standing divine sculpture must be represented atop the platform in the southern panel of KFIII because the king was already shown in the northern panel (N:177).[37] In support of this interpretation, he pointed out depictions of deities carried away on platforms by Assyrian soldiers following the defeat of a city (De Waele 1976a, 196). He further highlighted the Mesopotamian practice of transporting divine sculptures in sacred processions and envisaged possible parallel Elamite religious festivals linked to processional ways at Susa and Choga Zanbil (De Waele 1976a, 194).[38] These baked-brick-paved

processional ways and the references to a *bît akitu* as the final destination of the procession inspired his suggestion that the open-air sanctuaries of Kul-e Farah (and Shekaft-e Salman) had functioned as some type of *bît akitu*.[39] He proposed that the KFIII imagery could depict a sacred procession that had commenced in a city (presumably situated in the Izeh/Malamir plain) arriving at its final destination.[40] Even more specifically, it appears to be the actual moment in the ceremony when the divine statue was "about to be brought down from the dais, since those carrying it have knelt down" (De Waele 1976a, 185–205; 1989, 32).

An example of an impressive display of the meeting of two divine processions in an open-air sanctuary that would offer a comparison for De Waele's interpretation of KFIII is found at the Hittite site of Yazilikaya. Here a relief depicts Teshub carried aloft by two individuals dressed in long garments. Teshub and the other deities participating in this event are identified, as was usual, by specific divine symbols, headdresses, or acolytes.[41] At Kul-e Farah, the apparent absence of such divine accoutrements from the representations resists the identification of the large-scale figures as deities.

Royal imagery. Jéquier (1901, 130) suggested that the large human figure atop the KFIII platform was a "grand personnage" performing a gesture of adoration, and Hinz (1966, 43) likewise saw it as an individual, perhaps a high priest, "in the act of adoration." Neither, however, clarified whether they regarded the figure as a real human being or a human sculpture, or to whom (or what) the gesture of adoration was addressed. Vanden Berghe

37. Note that at KFVI, individual 10 is represented with the chest depicted frontally, an indication of elite status. Whether or not this individual can be considered a ruler is uncertain.

38. Ample textual and artistic evidence from Mesopotamia and Assyria indeed indicates that divine anthropomorphic statues were carried on platforms out and away from their temples and hometowns in contexts associated with religious festivals and warfare (Álvarez-Mon 2015, 42, 43, pls. 6, 7). For examples of religious processions and the carrying of sculptures, see Pongratz-Leisten 2006, 98–103. For examples of the carrying away of divine sculptures upon defeat by the Assyrian army, see Ornan 2005, figs. 117–20. See, for instance, slab reliefs from the southwest palace of Sennacherib (705–681 BC) depicting the looting of a town that, judging by the location of the reliefs within the palace walls, must have been located in southern Mesopotamia (Court LXIV, EEE; slabs 606–8; Barnett et al. 1998, 127–29; pls. 450–55). Except for two small fragments, the original slabs were lost, and we must rely on pencil drawings signed T. S. Bell. These sculptures have been said to represent divine anthropomorphic statues (Ornan 2005, 77, 94). Ten out of eleven sculptures appear to

be beardless, and, more importantly, all but one hold symbols in their hand. This latter exception is shown beardless and without distinctive emblems, the hands clasped in front of the waist. The hairstyle appears to be long, sitting over the shoulder. Sennacherib campaigned four times in southern Mesopotamia from 704/3 to 700 BC.

39. For the *bît akitu* from Choga Zanbil, see Mousavi 1990. For the Akitu and its variations in Assyrian cities, see Pongratz-Leisten 1997.

40. Kul-e Farah and Shekaft-e Salman are about 7 km and 2.5 km respectively from the Izeh town center.

41. In the Sumerian urban context, lower status deities were taken on journeys to visit higher status ones in order to ensure their own good fortune and the abundance and fertility of their city (Pongratz-Leisten 2006, 100). Embedded within the theology of this act was the definition of the religious and political hierarchies of the city-states.

(1984, 112–13) and Miroschedji (2003, 34) preferred to see a human figure standing atop the platform.[42] Both authors proposed that KFIII gives visual expression to the political system insinuated by Hanni's KFI inscription, where he emphasizes his vassalage to the Elamite king Shutur-Nahhunte; in their eyes, the procession of male rulers represents an "alliance between a king and a lower-ranked tribal chief."[43] This interpretation echoes the reflections of classical-period authors on encounters between the Great King (or his representative) and the Uxian inhabitants of the Zagros (Briant 2002, 731).[44] Finally, Calmeyer (1973, 146) and Henkelman (2011b, 132; 2008, 59) envisaged the platform bearers from Kul-e Farah (III and VI) enacting an actual ceremony involving pastoralist and sedentary members of Elamite society.[45]

Whether a divine cultic procession, a "secular" alliance of rulers, or a periodic reunification of the mobile pastoralist and sedentary elements of the society, these interpretations assume the representation of an actual event. This event implies a sequence of rituals involving a journey, an organized body of people (and animals) advancing in a ceremonial manner (a procession), and the possible ascent of a ruler atop a platform. The presence of a raised platform on which a ruler may have stood encapsulates the rationale of the reliefs. By no longer existing as an instrument of transportation and acquiring a transcendent value of its own, it brings an additional symbolic dimension to the ritual. As such it was transformed into a platform of exaltation, enabling the ruler to oversee ritual activities in an open space with fitting solemnity.[46]

42. Note that these interpretations were made in reference to KFIII, but given their close analogy, I apply them also to KFVI.

43. Vanden Berghe (1963, 30) initially identified the large figure in the northern panel of KFIII as a queen. He saw a scene of sacrifice framed by a king (to the left) and a queen (to the right).

44. For further discussion, see section §18.3.

45. From a purely practical stance, one may have difficulty conceiving of a real person maintaining any semblance of noble poise while being transported free-standing atop a moving platform. Yet at least one fairly recent example of precisely this activity is documented: a picture taken on 7 June 1980 shows Robert G. Mugabe, president of Zimbabwe, being carried standing on a platform. According to one of the platform bearers, "We carried him for about 20 m in a regal march while the entire school body clapped slowly. It was an electrifying moment" (in *Chronicle*, http://www.chronicle.co.zw/president-mugabe-a-unique-brand-of-statesmanship/, accessed 5 June 2017; for the photograph, see Smith, Simpson and Davies 1981).

46. I am paraphrasing M. Boyce (1982, 53) in reference to the interpretation of two white limestone plinths from Pasargadae: "made to enable the Great King to perform religious rites in the open with fitting solemnity."

§12. Kul-e Farah VI (Seventh–Sixth Century BC)

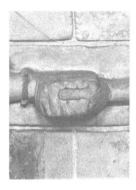

§12.1. Introduction

The relief of Kul-e Farah VI was carved on the northwest face of a boulder 3.75 m high × 2.80 m wide (northwest face) located about 300 meters outside the ravine housing the other reliefs (pls. 7, 55–58). The relative isolation of this boulder explains its marginalization and why, despite being mentioned by Jéquier (1901, 138–39), its existence was initially overlooked by both Hinz (1966, 43) and Vanden Berghe (1963).[1] Jéquier (1901, 138–39) reported the poor preservation of this relief, which he considered to be far more deteriorated than the others. When Hinz made a point of viewing it during his second visit on 7 March 1963 he dismissed the carving as *grossly executed*," revealing "*evidence of little artistic skill*" (Hinz 1966, 43). It was not until 1976 that the first description of this relief in its entirety was provided De Waele (1976a, 109–14).[2]

§12.2. Preservation

A combination of heavy weathering and vandalization have left only general outlines and some internal details that are often difficult to interpret. When examined in conjunction with comparative information from the other Kul-e Farah reliefs and related Elamite artistic traditions, however, KFVI comes into focus as another exceptional Elamite relief.

§12.3. Iconography

KFVI was carved over the northwest face of a rock boulder (pls. 55–56). It measures 3 × 2 m and has a carving depth of 5–11 cm. The central focus of its imagery is a

1. Hinz failed to make acquaintance with the relief on his first visit (3 March 1958), a happenstance which he amended on a second visit (7 March 1963).

2. Past scholarship: Jéquier 1901, 138–39; Hinz 1966, 43–44, pls. IX, X; De Waele 1972, 19–20, 24, fig. 1; De Waele 1973, 38–39, fig. p. 39 right, line drawing fig. p. 38 top; Calmeyer 1973, 41–152; pls. 35–36; De Waele 1976a, 109–14, 290; pls. CVII–CXIII A–B, CXIV, CXV A–B; De Waele 1979, 95, figs. 4–5; Calmeyer 1988, 283–85; Álvarez-Mon 2010b, 27–41; 2015a, 1–50.

large-scale individual (1) standing on a pedestal (2a) atop a platform (2b) carried by four platform bearers (3–6). Behind the large-scale individual stand nine worshipers arranged in groups of three along three horizontal registers (7–15). Another single worshiper is located below, to the right of the platform bearers (16). All individuals are oriented toward the left except for two of the platform bearers.

(1) *Large-scale Individual.* (pls. 56–57) Large-scale human figure (2.05 m high) standing on a pedestal atop a platform carried by four kneeling individuals. The body is represented in profile and oriented to the left with an exaggerated, unnatural forward projection of the right shoulder. The depiction of a section of this shoulder between the raised hands accentuates this unusual arrangement. This stylistic choice seems to prioritize the display of hand gestures and most closely recalls the depiction of the KFIV communal banquet participants. The strong arms are flexed at a 45 degrees angle at the elbow, the hands raised to shoulder level; the line of the right forearm crosses the upper arm. The hands are closed into a fist with forefinger extended to make the IFP gesture. The short-sleeved garment preserves some striations of fringing on the upper chest and has a wide belt that accentuates the narrow waist. Its ankle-length skirt ends in a long, wavy fringe. The left foot is shown behind the right, its toes overlapping the right heel. Hinz (1966, 43) noted that the head was unadorned and that the characteristic long Elamite braid was missing. He recognized a "visor" hairstyle and an extension composed of five parallel undulating lines emerging at the back of the head and touching the back just below the shoulder. The face has lost much of its detail; the eyes and nose appear to have been mutilated, though the mouth is still visible. The chin is broad and protruding. Following Hinz (1966, 43), De Waele (1976a, 110) regarded the unusually large face as beardless. In my opinion, the outline of a wide chin and jaw are instead indicative of a short beard.

(2a–b) *Pedestal and platform.* The large-scale human figure stands atop a 0.84 m wide × 0.10 m high pedestal (2a) that protrudes out from the face of the relief, directly above the heads of the two central platform bearers. The pedestal rests on top of a larger, 1.95 m wide × 0.25 m high, rectangular platform (2b).

(3–6) *Platform bearers* (pl. 58) Four platform bearers (85 cm high) kneeling on one knee and supporting the

weight of the platform on their shoulders. They hold the edge of the platform in their hands with fingers extended underneath and thumb raised vertically against the side. The two central platform bearers face in toward each other, while the outer two face outward. All four are similarly dressed in a short-sleeved garment with fringes extending diagonally from the shoulder to the narrow waist. The kneeling leg is delineated by a vertical line that runs down the long skirt with a fringed hemline. All appear to be sitting on the heel of their rear foot, which is raised on bent toes. Their heads are shown in front of the platform and all wear a tight, round cap, a neat hair-bun at the back, and a short beard. The eyes and eyebrow are visible in individual no. 4, and no. 6 has preserved evidence of a bracelet on the right wrist.

(7–15) *Worshipers* (pl. 56). Behind the large-scale figure are nine individuals divided into rows of three along three registers. They stand oriented to the right and all except nos. 10 and 11 are portrayed similarly in profile with hands clasped together at waist level. All wear the distinctive mid-length braid and most have a frontal protrusion above the forehead consistent with the "visor" hairstyle. The only exception, no. 8, has a high top that protrudes slightly at the back instead of the front. All have a short beard, but the chin size and angle and the position of the head seem to vary from individual to individual (no. 12, for instance, has a small chin and the head is slightly forward). The waist is narrow, and on the better-preserved figures a broad belt is visible. Where their outlines can be discerned, the legs appear muscular. The right foot is positioned out in front of the left, its heel obscured by the left toes. There is no obvious indication of shoes.

(7–9) *Upper row.* Group of three individuals (60 cm high) depicted in profile with hands clasped together at waist level. No. 7 at the front wears a long garment with a fringed hemline and the eye is clearly visible. Nos. 8 and 9 wear short garments. There are noticeable differences in hairstyle: no. 9 has a tuft at the front; no. 8 has a high top that protrudes backward.

(10–12) *Middle row* (63 cm high). No. 12 at the back of the group wears a long garment and the head is positioned slightly forward. Nos. 10–11 in front are highly individualized and ought to be treated separately (pls. 56–57).

(10) *Elite individual* (63 cm high) Male with broad, frontally depicted shoulders and chest. The chest is framed by strong upper arms and a sharp angle is created at the elbow by the raising of the hands above the waist, perhaps clasped together or holding one or more unidentifiable objects.[3] The garment is short-sleeved and its upper section is ornamented with fringes forming a V shape. The narrow waist is encircled by a broad belt and the long garment skirt has a fringed hemline. The beard is short and defined by sharp angles (especially at the chin) and the hairstyle may have incorporated a long back braid.

(11) *Weapon bearer* (63 cm high). Male represented frontally like no. 10, displaying wide shoulders, chest and the decorated upper portion of the garment. He has a short beard and hair with a short tip at the back, possibly remnants of a braid, and wears a short-sleeved garment with fringes crossing over the chest, a belt encircling the narrow waist, and a skirt reaching to just below the knees. The legs are muscular and there is no evidence of shoes. The right arm extends along the side of the body and the hand seems to hold a U-shaped object that reminded De Waele (1976a, 113) of an Egyptian *ankh* or "cross of life." In my opinion, it seems to have open terminals recalling the characteristic shape of the Elamite "rings"; but this interpretation may be biased by my own familiarity with these enigmatic objects (e.g., Álvarez-Mon 2010a, pls. 34–38). The left arm is bent and the forearm and hand overlap the left side of the chest. The hand appears to be holding a bow, and a dagger is tucked under the belt on the right side of the body (the dagger hilt visibly overlaps the fringe). A quiver decorated by hatching is carried over the right shoulder (the diagonal shoulder band is visible) and the feathered ends of the arrows inside are designated by vertical and horizontal stripes. Hanging at the waist, toward the back and almost touching the ground,

is a long sword (most likely inside a scabbard) with a lunate-shaped pommel (pl. 57).

The quiver, lunate-pommeled long sword and (probable) bow and dagger offer additional evidence to broaden the discussion of weapons and the identity and social roles of weapon bearers in the Kul-e Farah reliefs. The lunate-pommeled blade weapon is of particular interest. Ashurbanipal's Assyrian reliefs at Nineveh display snapshots of the Ulai River battle at Tell Tuba in 653 BC including a scene where "*Ituni, the sut resi of Teumman, king of Elam*" is about to cut his composite duck-headed bow with a small, lunate-pommeled dagger. Calmeyer (1988, 33) has suggested that Ituni's dagger and bow were specifically Elamite weapons. On an eighth century basalt stone from Arslan Tash, east of Karkemish,[4] a bearded weapon bearer carries a braced composite bow in his left hand, which crosses in front of the body, a long spear in his right hand, and has a lunate-pommeled sword hanging from the back of his waist like the KFVI weapon bearer.

Key features of the KFVI sword are its narrow grip with a pommel in the shape of a crescent (often described as lunate-shaped or oval) and a broad blade extending to the ground. Taking the scale of the sword in relation to its bearer at face value, we are looking at a rather long weapon, most likely represented in its scabbard. Differentiating a dagger from a sword is not always easy, especially when traditions of short "swords" also exist. The extensive corpus of daggers and swords excavated from burials in Luristan provide an important reference for the study of blade weapons. They reveal notable developments in the Iron Age III (ca. 800/750–650 BC), when the bronze-bladed swords of the Iron Age I and II (ca. 1300/1250–800/750 BC) were replaced by those of iron and the maximum total length increased from 44 cm to reach up to 68.5 cm (Overlaet 2003, 151). Iron Age Iranian archaeological contexts have produced numerous crescent-shaped or lunate-pommeled daggers and swords

3. The photographs I have examined do not allow me to explain the presence of three narrow parallel rectangles on the left side of the upper chest; it also seems as if the left hand could be opened upward, holding these "objects."

4. See http://www.pbase.com/dosseman/image/92394827, accessed 20 July 2014.

(Overlaet 2003, 166) and they are particularly well represented in Iron Age III burials in the Pusht-e Kuh region (Overlaet 2005, 32, pl. 13). Proceeding from this evidence, it would be reasonable to identify the blade weapon represented at KFVI with the lunate-pommeled, iron-bladed Iron Age III long sword (ca. 800/750–650 BC).

(13–15) *Lower Row* (63 cm high). Group of three individuals depicted in profile with hands held clasped together at waist level. All wear short garments. There are noticeable differences in their head proportions with the head of no. 14 unusually large compared to the others.

(16) *Recluse worshiper* (50 cm high). A worshiper is represented alone to the right of the four platform bearers. The orientation, gesture, hairstyle, and short garment are comparable with the individuals in the lower row, and the head seems to be slightly forward in relation to the rest of the body. The legs are no longer visible. De Waele (1976a, 179) ascribes the role of guiding the platform bearers to this individual.

§12.4. Elements of Composition and Style

Scale, orientation and arrangement play critical roles in defining the status of the participants. The most important individual is elevated on a platform and depicted on a much larger scale than the three rows of individuals lined up behind him. The center row is occupied by two individuals with chest depicted frontally: one weapon bearer (no. 11) and another individual who must also be of significant status (no. 10). To whom, or to what, this ritual scene is addressed is unknown (see discussion in §17.2).

§12.5. Chronology

Thematically and stylistically it is obvious that KFVI is most closely related to the KFIII boulder relief. Correspondences with this and other monumental Elamite reliefs are demonstrable in five respects:

1. A male ruler or deity is carried atop a platform by four kneeling individuals (compare KFIII) who find

parallels in Plaque locus 143 from Susa, suggesting a seventh- to sixth-century BC date.

2. The composition structurally prioritizes a ruler carried atop a platform, followed by three parallel registers occupied by individuals (compare especially KFIII).

3. The depiction of the physiques, hairstyles, garments and gestures (compare variously KFIII, KFV, KFIV, and Kurangun II and III).

4. The *IFP* gesture made with both hands by the large-scale figure (compare SSI, SSIII, KFII and KFV). At the same time, KFVI differs from the other reliefs in its depiction of two elite individuals with frontal chest, one (no. 10) perhaps of priestly function, the other (no. 11) a weapon bearer, and in certain details of the platform bearers (differing from those of KFIII).

5. The long sword with crescent-shaped pommel carried by the weapon bearer, which can be quite confidently placed in the Iron Age III period (ca. 800/650 BC).

§12.5.1. *Stone Pedestal Sb 5*

Another object that may help to further clarify the date of KFVI is a rarely discussed stone pedestal found at Susa (pl. 59b). The imagery carved on its surface can be considered one of the last expressions of a long ancient Near Eastern tradition of representing the aftermath of the conquest of a city.[5] This object was produced just prior to the emergence of the Achaemenid Persian Empire, which brought about a radical new vision for the representation of imperialism and the "other," moving away from such displays of punitive warfare.

Pedestal Sb 5 is a damaged square basalt block (59 × 59 cm) housed at the Louvre Museum and summarily studied by Jéquier (1905, 23–24) and Amiet (1966, 535–37, nos. 410A–C). Based on the condition of its upper surface, the pedestal appears to have supported a sculpture that was removed by force. On three of its faces (faces A–C)

5. See Álvarez-Mon forthcoming b. Incidentally, some of its motifs can be linked to iconography on earlier sculptural works kept in the same sacred area of the Acropole (e.g., the famed victory stele of Naram-Sin and the base of the standing fragmentary statue of Puzur-Inshushinak).

it has preserved a continuing representation of a mound from which emerges a city wall with crenellated towers. This mound serves as a background to three events apparently linked with the conquest of the (unidentified) city above. Two distinct groups of men can be discerned: a victorious group with short garments, short hair, seemingly clean-shaven faces, and carrying weapons; and a defeated group who are shown naked and have distinctive long beards. Face A depicts one individual falling, about to crash against the rocks, and vultures pecking at another two who have already hit the ground and are either wounded or dead. Face B depicts a beardless individual with a bow and quiver and in front of him stands a naked, bearded man with hands tied behind his back. Another beardless individual raises an axe in his right hand to execute a second naked, bearded, kneeling man whose hair he grasps in his left hand. Face C may depict a family: a child holding the hand of a woman behind, who is touched on the shoulder by a naked man behind her. A smirking conqueror shepherds them from the rear, grasping the naked man's hair.

Of particular interest to us is the naked, bearded man on Face B who awaits execution on his knees, with both hands raised in front of his chest making the Elamite IFP gesture, which we have seen also on the Izeh/Malamir reliefs (see detail in pl. 59b). This representation is atypical and raises important questions about the identity of the defeated individuals (and their town), as well as the meaning of the gesture: does it signify subordination and supplication, a plea for victor's benevolence? Or is it a plea for *divine* protection and intervention? (See IFP gesture in §5.6.3.)

Based on comparative artistic evidence, Jéquier (1905, 23) dated the pedestal to the time "des patésis" (in reference to the Neo-Sumerian renaissance of Gudea of Lagash and his family, ca. 2150–2100 BC). Amiet (1966, 535) later noted its parallels with two other eighth- and seventh-century statue pedestals found at Susa, also

depicting a fortified town; one still preserving the feet of a statue (Amiet 1966, 538, fig. 411, and 539, fig. 412). He also compared the garment skirt of the bow and quiver bearer on Face B, which curves around the legs and descends into a triangular tip at the center, with the skirt of a divine being depicted on plaque Sb 43 from Susa (Amiet 1966, 531, fig. 407) (pl. 59c). Muscarella (1992, 201, fig. 142) regards this plaque as emerging from a distinctly Elamite background based on the "style, the hair form of the figure on the left, and the off-center hilt of the sword," but as matching in iconography and all details of style a scene commonly witnessed in Neo-Assyrian art of the late eighth and seventh century BC. More recently, I have suggested that the plaque's imagery is indicative of an artistic development that took place in Susiana and in the area east of Khūzestān as a consequence of the Assyrian intervention sometime between ca. 653 and 626 BC (the "Elamo-Assyrian period"; see Álvarez-Mon 2010a, 98, 278). Furthermore, the representation of the fortress above the hill in pedestal Sb 5, although fragmentary (and most likely missing the side depicting the main gateway) finds significant parallels in the late Neo-Elamite fortresses shown in Assyrian reliefs and, more importantly, in the two other "fortress-pedestals" from Susa and the fortress depicted in the Arjan bowl. Since, according to Stronach (2004, 718), these "Zagros forts" are a type of generic fortified structure that may well have been common to the central and southern Zagros highlands in the seventh and sixth centuries BC, the pedestal may have represented a victory over a town located in the highlands and possibly once supported a sculpture of an Elamite ruler active at Susa sometime between 650 and 550 BC.

In brief, considered all together, the evidence outlined above suggests a broad timeframe of two hundred years (ca. 800–600 BC) for the manufacture of KFVI, but a narrower post-653 BC date is probably most appropriate.

§13 Kul-e Farah II (Seventh–Sixth Century BC)

§13.1. Introduction

The relief of Kul-e Farah II was carved on the surface of a ca. 8.50 × 5.20 m rock boulder situated on the southern side of the gorge, to the left of a seasonal creek and in the vicinity of reliefs KFIII and KFIV (pls. 7, 60–61). The relief represents four worshipers standing behind a large-scale human figure who faces a scene of animal sacrifice.

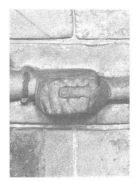

§13.2. Preservation

More than a century ago, Jéquier (1901, 137) observed, "This monument was, like all the others, very damaged by the rains which eat away this slightly tender stone. The two small scenes to the right and left are extremely vague and unclear, but you can still see quite easily the silhouette of the central character." As it stands, the four worshipers inside the register to the left have been heavily eroded and only general outlines can be provided. The remaining sections are in better condition, allowing for the reconstruction of internal details. Of the large-scale ruler, the outlines are relatively well preserved, but the pointed fingers have almost completely disappeared, and much of the internal detail has been lost. In the slaughter scene, the oulines of two naked individuals and the animals have mostly been preserved. No evidence of plaster or paint is visible to the naked eye.[1]

§13.3. Iconography

A rock boulder supports an almost rectangular 3.55 × 2.40 m relief on its southwestern face (pl. 60). The relief depicts (from left to right): four individuals inside a small,

1. Past scholarship: Layard 1846, 74–77; Perrot and Chipiez 1890, 776, fig. 464; Jéquier 1901, 137, pls. 27, 66b; Hüsing 1908, fig. 31, pl. 44b; Debevoise 1942, 85, 105; Conteneau 1947, 2142; Vanden Berghe 1959, 61, 162, 213; Vanden Berghe 1963, 28–29, pls. XII, XIII; Seidl 1965, 184; Amiet 1966, 554–56, nos. 422–23; Vanden Berghe 1968, 16, 23; De Waele 1972, 19–20, 24; line drawing, fig. 1, pl. 66c; De Waele 1973, 40; Calmeyer 1973, 141–52; De Waele 1976a, 51–54; pls. 34–36, 37A–B.

well-defined rectangular panel (1–4); one large-scale individual (5); and an animal sacrifice scene composed of a standing naked individual (6), a naked individual (7) bending over a zebu (z1), and six smaller round-horn sheep (s1–s6).

(1–4) *Four worshipers* (pls. 60, 61a). Four individuals standing inside a rectangular panel (48 × 34 cm; 1 cm carving depth) behind the large-scale individual. All four are depicted in profile oriented to the right, except for the chest, which is shown frontally. Each wears a long hair braid ending in a knob and a short-sleeved, ankle-length garment. The waist is very narrow and the hands are clasped in a worshiping gesture. The individual at the front of the group (4) is slightly taller (34 cm) than the three behind him (32 cm) and has preserved details of a short beard. His braid also appears to be longer than that of the others. According to De Waele (1976a, 53), he is probably wearing a round cap.

(5) *Large-scale individual* (pls. 60–61b). Individual depicted in profile oriented to the right (1.90 m high; depth of relief: 0.2–6 cm).[1] The arms are held out in front, flexed at a 45-degree angle at the elbow; the right hand is raised to about mouth level, and the left hand is slightly lower. De Waele (1976a, 52) suggested that the right index finger and thumb make the SF gesture, while the left hand is closed into a fist with the thumb extended. I am uncertain about this interpretation, as there seem to be two lines suggestive of extended index fingers, and it was precisely this gesture that Layard (1846, 77) originally described. While the SF gesture appears to be attested in KFIII (individual S: 14), correspondences with the large-scale rulers in KFVI, SSI, and SSIII make an IFP gesture most likely. The garment has short sleeves and a bell-shaped, knee-length skirt. The hemline is adorned by a long fringe, and another possible fringe marked by slanted lines runs down the damaged back of the skirt. This short garment contrasts with the long garment worn by the four small worshipers behind. The waist is narrow and the legs are thick and muscular. De Waele (1973, 52) describes a headdress characterized by a round cap,

but instead I see a large, round bulge at the front, extending into a back braid that reaches below shoulder level. Visible facial features are an ear, a long eyebrow extending to the bridge of the nose, an almond-shaped eye, and a long beard that reaches at least the level of the elbows. The feet are large with no indication of individual toes, and the tips seem to be slightly upturned (indicative of shoes?).

(6) *Doubly oriented individual* (pl. 60). Individual (40 cm high) positioned at the top left corner of the rectangular panel depicting the animal sacrifice scene, between the hands of the large-scale figure to the left and the zebu to the right. This individual appears to be bald, beardless, and naked. The lower half of the body is oriented to the right, while the upper half turns backward (to the left) in the direction of the large-scale figure. Either both arms are raised with a 90 degrees bend at the elbow to gesture toward the large-scale figure or, as De Waele suggested (1973, 53), the left extends in the opposite direction toward the sacrificial scene. This individual presents striking similarities with KFIII S: 14: both are placed directly in front of a large-scale figure; both twist their upper body to look backward, resulting in a double pivoting orientation; and both raise one or both arms in a similar manner to gesture toward a large-scale figure behind. We might even recognize a direct association between their gesture(s) and those of the large-scale figure. Though small in scale, these two doubly oriented individuals seem to play a crucial role in the ritual depicted.

§13.3.1. Scene of Animal Sacrifice (pl. 61d) (80 × 80 cm; 1–5 cm carving depth)

(7) *Butcher* (25 cm high). Individual oriented to the right leaning in, so that the torso is almost horizontal over the carcass of a zebu (z1). The head is slightly raised and the forearms are on the zebu's chest, the hands between its forelegs. The legs are partly obscured by the animal, implying that they are on the opposite side to the viewer. This individual appears to be naked and may have a short beard.

(z1) *Butchered zebu* (57 cm long). Zebu carcass lying on its back with stiff legs extended upward, the forelegs and rear legs angled slightly away from one another. The

1. De Waele (1973, 174–75) interprets this individual as a king in the function of a great priest. He is presumed to be the king because no such individual is present in the register to the left and to function as a great priest because he makes a religious gesture combining the snapping of the fingers and the raising of the hands.

rear hooves are well demarcated from the legs, and the tail ends in a tuft of hair. The hump and horns are visible, as are the eye and, possibly, the open mouth and protruding tongue.

(s1–s6) *Six round-horned sheep* (30 cm high; 22–27 cm long). Six smaller quadruped carcasses arranged closely in two rows of three. All are lying on their backs with stiff legs extending upward, the forelegs separated in a V shape and the rear legs positioned side by side. The tail is visible slightly behind the rear legs, and the head is pulled slightly backward, with a rounded protrusion marking the round horns.

Perrot and Chipiez (1890, 777) suggested that the group of seven animals in this scene could be understood as a lioness with six cubs,[2] while G. Jéquier (1901, 137) instead decided that they were "without doubt, gazelles laying on their back." De Waele (1976a, 53–54) much later reidentified them as oxen with humps (bœufs à bose): "Their representation is dense and offers a very intertwined view. The fatty hump is near the head and horns are not represented." Since, like the animals butchered in KFV (see chapter 14), the smaller animals lack the characteristic zebu hump, tail, and horns (when visible), I would instead suggest that their head protrusion

represent horns and that they ought to be identified as round-horned sheep.

§13.4. Elements of Composition and Style

As for the previous reliefs, scale and orientation play a critical role in defining the arrangement and status of the participants. The most important individual is depicted in large scale and is followed by a group of four much smaller individuals. Together they face a sacrificial scene in which one individual gestures back toward them as another butchers the zebu. The gestures and positioning of the bodies reveal an attempt to depict movement and action, an animated body language that contrasts sharply with the formal hieratic worshiping gestures performed by the elite individuals.

§13.5. Chronology

This relief has to be dated in connection with KFV to the seventh–sixth century. For discussion, see section §14.5 below.

2. "Devant le dieu sont étendus les corps de sept animaux, où l'on croit reconnaître une lionne avec ses lionceaux. Sur la lionne est penchée une figure qui, d'après la forme des pieds, ne peut guère être que celle d'un homme; a-t-on voulu représenter le chasseur dépouillant le gibier?" (Perrot and Chipiez 1890, 777).

§14. Kul-e Farah V (Seventh–Sixth Century BC)

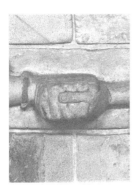

§14.1. Introduction

The relief of Kul-e Farah V was carved not far to the right of KFIV, on the rocky cliff face to the left of the seasonal creek (pls. 7, 62). The iconography and compositional structure of this heavily eroded, 2.40 × 1.85 m relief are remarkably similar to KFII: four worshipers are arranged in a vertical register behind a large-scale human figure who stands facing an animal sacrifice scene. The addition of a fire stand to the scene brings this relief close also to SSI and KFI.[1]

§14.2. Preservation

Erosion and surface cracking have taken their toll on this relief. Today it is difficult to discern the vertical column of four small individuals, the front of the large-scale figure's head is damaged, the fire stand is heavily eroded, and the sacrificial scene has retained only its general outlines.

§14.3. Iconography

The composition of this relief (pl. 62) is remarkably similar to that of KFII (for which, see pl. 60). It comprises four main parts: to the left is a group of four individuals (1–4) arranged vertically behind a large-scale individual; in the center is the large-scale individual (5); to the right is a sacrificial scene incorporating one individual (6), one zebu (z1), and six round-horned sheep (s1–s6); and below this scene is a fire stand (7).

(1–4) *Vertical register with four individuals.* Four individuals of slightly different heights (from top to bottom measuring 28 cm, 26 cm, 20 cm, and 25 cm high) standing behind the large-scale individual. They are arranged vertically, separated from each

1. Past scholarship: Layard 1846, 74–77; Jéquier 1901, 138; Vanden Berghe 1963, 33, pl. XX; De Waele 1973, 3, fig. 3; De Waele 1973, reliefs on pp. 40–41; Calmeyer 1973, 141–52; De Waele 1976a, 104–8, pls. CIII.A–B, CIV–CV, CVI.A–B.

other by four horizontal baselines, and are oriented to the right with a frontally depicted chest and arms. They wear ankle-length garments, have long hair possibly collected into a braid, and hold their hands clasped in front of their narrow waists.

(5) *Large-scale individual.* Individual (1.90 m high) represented in profile oriented to the right. Both arms are flexed at a 45-degree angle at the elbow, with the hands raised in front of the chest making the IFP gesture.[2] The garment has short sleeves and an ankle-length skirt with a long fringe at the hemline and a vertical fringe delineated by curved lines running down the back. The waist is narrow and girdled. The right foot is set behind the left, and, as on the large-scale individual in KFII (5), the toes look like they could be a little upturned. Above the forehead there seems to be a bulge of hair, now disfigured by a hole, and at the back the hair is long and possibly braided. An ear, eye, eyebrow, nose, and long beard extending down behind the right arm are still visible.

§14.3.1. Scene of Animal Sacrifice

This is a small (40 × 90 cm) rectangular panel directly in front of the arms of the large-scale individual.

(6) *Butcher* (19 cm high). At the bottom left of the panel, an individual leans over a zebu carcass. The torso is horizontal above the animal, the head is in the same line, and the hands reach down between its forelegs. The slightly bent legs are represented on the viewer's side of the zebu. There is no indication of clothing, but genitals are not visibly delineated.

(z1) *Butchered zebu* (42 cm long). A zebu carcass lying on its back with stiff legs extended, the rear legs together, the forelegs possibly separated in a V position. The horns, hump, and tail ending in a tuft of hair are still visible.

(s1–s6) *Six round-horned sheep.* Six carcasses of smaller quadrupeds arranged closely in three groups of two (the top two measure 45 cm long, the middle two 40 cm long, and the bottom two 38 cm long). They are poorly preserved but are clearly lying on their back with stiff legs extended, the rear legs together, the forelegs

separated in a V position. The head is pulled backward. The horns, and in general the tails, are too eroded to be perceived. De Waele (1976a, 107) identified these six animals as oxen with humps (*boeufs à bose*), but since they are significantly smaller in size than the zebu, and since I cannot discern any humps, I instead propose their identification as round-horned sheep.

(7) *Fire stand* (60 cm high; 30 cm foot and 30 cm upper conical section; depth of carving 0.2–6 cm). Below the sacrificial scene stands an object comprising two elongated triangles, one underlying (as a base) the other, which has noticeably rounded corners. This fire stand, labeled a *thymiaterion* by De Waele (1973, 107), is also examined here in connection with the fire stands of SSI (ca. eleventh–seventh century BC; see §5.6.4) and KFI (ca. seventh–sixth century BC; see §15.3 below).

§14.4. Elements of Composition and Style

The structure of the composition is very similar to that of KFII except for the vertical (rather than horizontal) arrangement of the four worshipers behind the ruler and the absence of the doubly oriented gesturing individual (KF2: 6).

§14.5. Chronology

De Waele (1973, 337) regarded KFII and KFV as the last Elamite reliefs sculpted in the Izeh/Malamir valley and assigned them respectively to ca. 700–650 BC and ca. 550 BC. His apparent grounds for this were that the "rudimentary" manufacture reflects a later date—KFV is considered the later of the two due to its especially poor craftmanship (De Waele 1973, 264). Supporting this chronological arrangement is the perceived "logic" of their placement, with the KFII boulder being more centrally located than KFV (De Waele 1973, 333). De Waele (1973, 327) further estimates that the image of the ruler represented entirely in profile, the lack of modeling, and the sacrificial scenes "full of life" exhibit a new artistic tradition.

Although these comments cannot be adequately supported, the depictions of four worshipers following

2. In disagreement with De Waele 1973, 105. As per his interpretation of the large-scale individual of KFII, De Waele believes that the right hand makes the SF gesture and that the left is closed in a fist.

a large-scale human figure facing an animal sacrifice in KFII and KFV do indeed appear to belong to the same (or a closely related) tradition and should be considered fairly contemporary. Advocating for an especially close association is the comparability of the animal sacrifice scenes, which both show an apparently naked individual butchering a zebu next to six slaughtered sheep. Furthermore, in both reliefs the large-scale elite figure seems to be directing an IFP gesture toward the scene.[3]

The garments of the large-scale figures in KFII (knee-length) and KFV (ankle-length) differ, but both appear to wear their hair in a distinctive style characterized by a large bulge above the forehead. This hairstyle, which offers an important dating clue, is worn by a bearded male head depicted on a fragmentary Elamite faience plaque (Sb 3362; 6.5 × 7.5 cm) (pl. 61c). A thick roll of hair made up of separate, wavy sections bulges out above his forehead and is fixed in place by a narrow (decorated?) hairband. The plaque was excavated at Susa in 1923–24 by Mecquenem, who did not clarify its exact location but discussed it in connection with a corpus of seals of "basse époque" found in the same season at the same "level" (Mecquenem 1925, 9; drawing 46).[4] Amiet (1966, 517, fig. 394) places the plaque in the eight–seventh century BC, and a similar date could be considered for the manufacture of KFII and KFV. A later dating is strengthened by similarities with the much better preserved sixth-century KFI relief, where two high-status individuals are arranged vertically—one standing above the other—behind a large-scale individual (Hanni).

3. Note that De Waele interpreted the hands as making the SF gesture. I have discussed this gesture in connection with individual S: 14 in KFIII (dated to the eight–seventh century BC) where the individual stands in front of the large-scale ruler with the upper body oriented in his direction and the lower body oriented in the opposite direction (pl. 44).

4. It is difficult to determine what Mecquenem meant by "at the same level," since his excavation methods did not incorporate stratigraphic principles. One of the faience cylinder seals associated with the plaque (Álvarez-Mon 2013, 245, fig.13 a) was classified by Mecquenem as "basse époque" (a label embracing the Neo-Elamite period before the Achaemenids) (Mecquenem 1925, 10). This seal has been dated from the eight–seventh century to the fourteenth century (Aruz 1992b, 211, no. 149).

§15. Kul-e Farah I (Seventh–Sixth Century BC)

§15.1. Introduction

The relief of Kul-e Farah I was sculpted within a rectangular 1.68 × 1.35 m panel in a vertical niche about 5.50 m above ground level (pls. 7, 63–68) (0.2–3.5 cm carvng depth).[1] KFI is by far the most widely represented and discussed relief in the Izeh/ Malamir valley.[2] It represents the last link in a long tradition of Elamite highland relief carving and incorporates multiple elements of elite representation from earlier reliefs in the valley. Its importance is magnified by a long, generally well-preserved, but still poorly understood, inscription of a local ruler named Hanni, son of Tahhi, "caretaker, protector, ruler" (*kutur*) of Ayapir and vassal of the Elamite king Shutur-Nahhunte son of Indada (König 1965; EKI 75–76).[3] The relief depicts two high officials standing behind the large-scale figure of Hanni, who presides over an animal sacrifice and a fire offering made by a priestly figure. The event takes place against a background of music. All individuals depicted in the reliefs are identified by accompanying epigraphs.

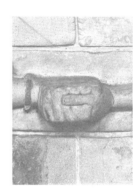

1. After De Waele 1976a, 49.

2. KFI was described for the first time by Layard (1846, 74–77), followed by Jécquier (1901, 133–43). The earliest photographs (or heliogravures, an early form of photography) of Kul-e Farah I, and apparently of Kul-e Farah II, were taken in 1885 by naturalist and anthropologist Frédéric Houssay and engineer Charles Babin, the collaborators of Marcel and Jane Dieulafoy at Susa (pl. 64a) (Dieulafoy 1885, pl. 24). Drawings of Hanni "king of Anzan" and the "Anzanite musicians" produced after these photographs were published by Dieulafoy (1890, fig. 30). The same year, Perrot and Chipiez published drawings of the two "Susiana" reliefs now known as KFI and KFII (Perrot and Chipiez 1890, 775–76, figs. 463 and 464 respectively). A heliogravure made by Dujardin was included in Scheil (1901, pl. 23). Vanden Berghe (1963, 23 n. 1) labeled the reproductions of the reliefs from Kul-e Farah published by Jécquier (1901, pls. 27–33) as "heliogravure," but they are in fact sketches produced by J. de Morgan in situ. For additional bibliography, see Vanden Berghe 1963, 25–27; 1984, 122, 155; De Waele 1972, 22; Calmeyer 1988, 285; and Álvarez-Mon 2010a, 47.

3. For *kutur*, see Henkelman 2008, 20.

§15.2. Preservation

Due to its position inside a niche under a large rock ledge, the relief has survived the natural elements and the passing of time relatively well. It has, however, suffered targeted mutilation by vandals who have hammered away most of the heads, faces (mouth, ears, nose), hands, and sections of the garments. Judging by the documentation of the French Mission, these scars were already present in 1885. The inscription is still in reasonable condition and does not seem to have been subject to deliberate damage.

§15.3. Iconography

The large-scale figure of Hanni (1) is shown standing in front of two high officials (2 and 3), presiding over a sacrifice of animals and a fire offering made by a priestly figure (12). As in KFIV and KFIII, the event is accompanied by music (4a–c).

(1) Hanni *of Ayapir* (pls. 64, 67c, 68). Large-scale figure (1.18 m high) occupying almost the entire height of the relief panel. The head and feet are shown in profile oriented to the right, while the chest, arms, hands-clasped gesture, and possibly the long ceremonial garment are depicted frontally.

Headdress (pl. 67c). Judging from both a line drawing by Dieulafoy (1890, fig. 30) and the present state of the relief, Hanni wears a slightly bulbous cap, somewhat reminiscent of the bulbous headdress worn by the Elamite king Humban-haltash III/Ummanaldasi (646–645 BC) in the Assyrian reliefs (Álvarez-Mon 2011, figs. 29, 44).[4]

Hair and face. A long braid extends down over the right shoulder and along the arm, ending in a knob just below the elbow. A hatched surface directly behind the neck could possibly represent part of a second braid. Most of the face has been mutilated, but there are still remains of the high-quality engraving of a fine mustache with a downward-curved tip and an elegant beard composed of small, fishhook-shaped curls over the cheeks and long, wavy sections of hair flowing from the chin down to the chest.[5]

Clothing. Opinions on the style and number of garments worn by Hanni are divergent (see Álvarez-Mon 2011).[6] In my own estimation, there are three separate pieces of clothing. A pair of curved lines at the neck and a single line crossing each upper arm may together indicate a short-sleeved, round-necked undershirt. Over the top is a heavy, thigh-length mantle embellished with fringes and borders with large rosettes enclosed within ladder bands. The right side of the garment crosses over the left, so that the fringed, decorated borders form a V shape at the chest. A wide belt composed of four narrow bands encircles the waist. From underneath the mantel emerges a heavy, bell-shaped (*à volants*), skirt also combining long fringes with rosette-filled ladder bands. Together, all these garment features may represent a ceremonial "Ayapir"-style highland dress.[7] Without examining the relief in situ himself, and presumably relying on the accounts of his associates Babin and Houssay, Dieulafoy (1885, 226) suggested that the color of the coat was green with blue, white, and gold fringes; he further estimated

4. A conclusion reached by Jécquier (1901, 135: "une sorte de bonnet bas et arrondi") and Vanden Berghe (1963, 25: "on distingue cependant un bonnet rond enveloppant les cheveux"). Of further interest regarding the longevity of this headdress are the close similarities with the dome-shaped headdress of the "Median" nobles depicted throughout the Persepolis reliefs (Root 1979, pl. XVII). Ethnographically, it is a reminder of the slightly bulbous traditional black felt headdress of the Bakhtiyari peoples who claim Izeh/Malamir as part of their ancestral territory (pl. 68, top). Shahbazi (1992, 726), following Walser (1966, 69), takes this "plain rounded cap," probably made of felt and sometimes adorned with a ring at the back to which

an appendage could have been attached, as Elamite in origin. See also Álvarez-Mon 2010a, 5.

5. Hanni lacks the pair of side braids characterizing Elamite royalty and displayed by both Humban-haltash III and the Elamite kings at Shekaft-e Salman. This absence may reflect his nonroyal, subservient status. The photograph published by Scheil in 1901 already reveals defacement of the head.

6. Jéquier (1901, 136) identified a shirt, a cape, and a long garment wrapped in a shorter one. Debevoise (1941, 83–84) suggested three pieces of clothing: a garment, a knee-length coat, and a long garment flaring out at the bottom in a bell shape. Vanden Berghe (1963, 25–26) proposed just two pieces: a cape or shawl and a long garment *à volants*.

7. The Susa Acropole texts refer to textiles made in the "Ayapir" style (and also in the Shala and Zazayadani styles); see Potts 2010a, 114. For the garment, see Álvarez-Mon 2011.

that the skirt was white with fringes of the same blue, white, and gold combination.[8] He also suggested that golden shoes are worn, rather than the bare feet recognized by other scholars (see Jécquier 1901, 136; Vanden Berghe 1963, 25; De Waele 1976a, 46).

(2) *Shutruru, weapon bearer, ragipal of Hanni, and gilirra* (pls. 67a, 68, 69d) Shutruru (47 cm high) stands behind Hanni, his feet approximately at Hanni's waist level, oriented to the right in a striding stance (one leg in front of the other). In the main inscription and accompanying epigraph, two different titles are used to refer to Shutruru of Ayapir: *ragipal* of Hanni (Hinz 1962:111; EKI 75B) and *gilirra* (Hinz 1962, 113; EKI 76:12). These titles indicate the high status of Shutruru: he was the "master of the palace," the bow bearer of Hanni, and military commander. Henkelman has noted certain individuals who held similar official positions within the Elamite and Persian palaces and administration, such as the Elamites *Zinêni* and *Umbakidinnu* at Hidalu and *Ashbazana* and *Parnakka* at Persepolis (Henkelman 2008, 22 n. 42).[9]

Shutruru has been damaged by what appear to be intentional blows to the face, right side of the chest, left arm, feet, and various other parts of the body, but generally the outlines of the body, and much of the bow and quiver, can be clearly discerned. The best-preserved section is the left side of the chest where sections of the garment fringes and bands with the remains of rosettes are still visible. The skirt, legs, and feet are covered by four registers of cuneiform characters.

Headdress, hair, and face. The head is adorned by a slightly bulbous headdress, probably similar to the one worn by Hanni. The hair is collected together into a bun at the back of the neck (De Waele 1976a, 46). Some lower curls of a chest-length beard have

been preserved, but the face (ear, eye, nose, and lips) is almost completely obliterated.

Clothing. The garment is short-sleeved and ends above the knee. The chest is depicted frontally to show a border band with rosettes and broad fringes embellishing the upper part of the garment. The fringes cross the chest in the characteristic V shape, the right side overlapping the left, and a wide belt composed of three narrow bands marks the waistline.

Legs and feet. The muscular legs are depicted in profile in a striding position. According to De Waele (1976a, 47), the feet are bare.

Arms and hands. The right hand has lost most of its detail, and it is difficult to interpret its relationship to the long sword (?) on the right side of the body (see below). The left arm is flexed at around 45 degrees at the elbow, and the hand grips the curve of a braced bow, raising it in front of the body. The thumb seems to be extended.

Weapons: bow and quiver. The braced bow in the left hand measures about half of Shutruru's height and has terminals in the shape of duck (?) heads with long beaks.[10] Protruding from behind the shoulder is the upper section of a quiver with some arrows still visible inside.

Weapon: sheathed sword? On the right side of the body, extending from about waist level to the ground, is a long object that can possibly be interpreted as a long sword inside a decorated sheath. If so, the right hand may be holding its hilt (De Waele 1976a, 47). Weapon bearers carrying similar long, sheathed swords alongside the body are depicted in KFIV AII: 20 and KFVI: 11.

(3) *Shutruru (no. 2?), nisikkir of Hanni* (pls. 67b, 68).[11] High official (47 cm high) standing behind Hanni's legs and directly below the weapon bearer (2), with whom he oddly enough shares his name (EKI 75C). In terms of physical appearance, he shares elements of Hanni's

8. In Dieulafoy's own words (1885, 226): "Une sorte de tunique faite d'étoffe gros vert, serrée la taille par une ceinture, couvre le torse; un large ornement composé de fleurons brodés et d'une passementerie part de chaque épaule pour venir se croiser sur la poitrine et court tout le long du vêtement. Cette passementerie a tons bleu, blanc et or.... Au dessous de la tunique apparaît une jupe traînante bordée, ainsi que la tunique, d'un galon et d'une frange. Cette robe serais blanche et les broderies bleu, blanc et or."

9. See also Potts 2010a on the function of the "master of the palace" at the Neo-Elamite courts.

10. I take this as a composite bow; for the role of the composite bow in Elamite history, see Álvarez-Mon forthcoming a.

11. De Waele suggests the reading Shutrurura(?) (1976a, 141, IB3). A third individual, also named Shutruru, is attested as a high priest during the reign of Shutruk-Nahhunte II, ca. 717–699 BC (Henkelman 2008, 27; stele EKI 74 I.43).

hairstyle and dress, as well as his hands-clasped gesture, raising interesting questions about what exactly his functions could have been. His court title *nisikkir (of) Hanni* may literally mean "he who preserves, protects" Hanni, and according to Henkelman (2008, 23 n. 43), he could be identified as (captain of the) body guard.

Clothing. A line crossing the neck suggests that an undergarment like Hanni's is worn. The upper body is represented frontally, so that the decorated border of the short-sleeved outer garment can be seen running diagonally down the chest. The long skirt is composed of three rows of fringing.

Headdress, hair, and face. The head is adorned by a bulbous cap and long back braid ending in a knob at elbow level. A long, elegant beard is carefully detailed with small, fishhook-shaped curls over the cheeks and long, wavy sections of hair flowing down from the chin to the chest. The elbow-length braid, also adopted by Hanni, recalls the long braids (also ending in a circular knob) of the Shutrukid rulers in the reliefs of Shekaft-e Salman.

(4a–c) *Musicians* (pls. 65a, 68, 70c). Occupying the top right corner of the relief is a trio of similarly coiffed and dressed musicians standing in a line, all oriented to the right (vertical harp player: 37 cm high, 40.5 cm with harp; horizontal harp player: 35 cm high; drum player: 36 cm high). Although they have been defaced, some remarkable workmanship can still be observed in the treatment of the instruments and volume of the figures. In particular, the face of the first musician has preserved the outlines of the chin, cheek, eye, and mouth (4c). The gender of the musicians, who are beardless and appear to wear their hair gathered into buns at the back, is open to interpretation, although the epigraphs over their long garments indicate they are male. All wear long ceremonial robes and double-banded belts.

(4c) *Sunkir-su* (...). First musician at the head of the trio holding a large fourteen-stringed vertical harp with a frame composed of a vertical resonance box and a horizontal neck. The loose ends of the strings are knotted together into a decorative triangular shape with a hanging fringe.

(4b) *Sumunu* (...). Second musician in line holding a small, nine-stringed, horizontal harp with a frame composed of a horizontal resonance box and a vertical neck (there is no fore pillar). The fingers of the right hand are still partly visible.

(4a) *Sunkir* (...). Third musician in line is a percussionist playing a square drum.

(5) *Sheep carcasses and heads* (pls. 65d, 68) (each carcass 18 cm long). Below the three musicians lie the headless, stiff-legged carcasses of three sheep in a vertical arrangement next to their three horizontally arranged round-horned heads.

(6) *Tempti-Humban, animal handler A* (pls. 65b, 68) (20.5 cm high). Individual identified by an epigraph as Tempti-Humban, standing oriented to the right behind a quadruped. He seems to be depicted off-balance, leaning forward with one foot slightly off the ground. The right hand is on top of the animal's rump, and the left hand is extended toward the head, possibly holding a horn. The upper chest is depicted frontally, and the garment is short, revealing strong, muscular legs. There may be a vertical line along the front of the skirt marking a garment border.

(7) *Horned goat* (pls. 65b, 68) (23 cm high). Quadruped depicted in profile with a long, scimitar-shaped horn, a small beard, and muscular legs and body. The scale and shape of the horns is reminiscent of the "goats at the window" represented in the inner frames of two windows in the main hall of the palace of Xerxes at Persepolis (pl. 66b).[12]

(8) *Animal handler B* (pls. 65c, 68) (24 cm high). Individual standing oriented right behind a quadruped, most likely a zebu, perhaps pushing or holding the animal's rump or tail with one (or both?) arms. The head and most of the body of this individual have been defaced. He wears a short garment and a round headdress.

12. They are facing south from rooms 5 and 6 of the eastern and western apartment. It is worth noting that a sculpture representing an ibex was discovered by Herzfeld in the Apadana at Persepolis (Schmidt 1953, 73). Like the guardian mastiff dogs, it is possible that a pair of ibexes had guarded one of the Apadana gateways. The complete relief depicts two servants, one carrying two open vessels, the other guiding an adult male ibex (Schmidt 1953, 243, pl. 187).

(9) *Zebu* (pls. 65c, 68) (17.5 cm high). A large quadruped with strong rear legs, a well-defined chest, and a kidney-shaped right shoulder outline that rises into a sharp hump above the back. The left hindleg and foreleg are depicted in front of the right.

The stylistic treatment of the "kidney-shape" muscle recalls the depiction of a similar feature on a 15 × 13 cm limestone plaque found by Mecquenem at Susa in 1932 (pl. 66a). The plaque depicts a male ibex in profile with extended legs, the left hindleg and foreleg both stepping forward.[13] The male animal has a highly detailed face and anatomy, including the same "kidney-shape" right shoulder muscle, with muscles depicted through volume and incision. The careful and accomplished manufacture evidenced by this naturalistic anatomical treatment is exceptional,[14] a quality that led Mecquenem to attribute this work to the Achaemenid period.[15]

(10) *Animal handler C* (pls. 65c, 68) (24 cm high). Individual identified by an epigraph as *Teduhunti*, oriented right with arms extended, most likely holding the zebu (9) by its horns. He has strong, muscular legs and wears a short garment with a possible diagonal borderline on the skirt and a round headdress.

(11) *Fire stand* (pls. 65e, 68) (13 cm high). An altar described by De Waele (1973, 31) as being composed of three parts: a conical-shaped base supporting a round bowl topped by a conical-shaped fire (detail of the flames is clear). Similar fire stands are represented in KFV and in SSI (see discussion above in §5.6.4 and §14.3).

(12) *Kutur, offering priest* (pls. 65e, 68) (26.5 cm high). An individual identified by an epigraph as a priest (*kutur*) standing oriented to the left before the fire altar with both arms extended, possibly holding an object directly atop the flames. Most of the upper half of the body has been defaced. The lower half reveals muscular legs and

a short skirt with a possible diagonal line down the front marking a garment border.

§15.4. Elements of Composition and Style

KFI is the most recent of the monumental Elamite reliefs carved in the Izeh/Malamir valley and consequently emerges as a multifaceted artwork assimilating aspects of the two corpora of reliefs at Shekaft-e Salman and Kul-e Farah. Hanni clearly integrated elements of the Shutrukid royal iconography displayed at Shekaft-e Salman, including in particular the long braid with knobbed end, the frontal display of the upper body, the hieratic worshiping gesture, and the emphasis on the royal family (voiced in his inscription). Salient references to the earlier Kul-e Farah reliefs are the body orientation and worshiping gesture of the large-scale figure on the north side of KFIII (ultimately referencing Shekaft-e Salman); analogies between the musical trio and the KFIII and KFIV ensembles (even if the musicians and instruments are treated differently); the use of scale and position to define status, thus the presence behind him of the religious and military leaders (referencing KFIII, KFV, and KFVI); the presence of a weapon bearer (referencing KFIV and KFVI); and the sacrifice of animals associated with a fire altar (referencing KFV and SSI). From the perspective of manufacture, the preserved sections point to a finely executed and acutely detailed carving with a highly polished surface (see chapter 16). These references suggest that the artisans who produced KFI sought to integrate its visual characteristics into artistic, sociopolitical, and religious traditions that were already well established.

§15.5. Inscription

An extensive Elamite inscription carved inside twenty-four horizontal registers occupies the upper half of the relief, surrounding and animating the background of the sculptures.[16] There are also nine epigraphs, mostly

13. Precisely where the plaque was found is unknown, but Mecquenem (1947, 89–90, fig. 57) reported that it had emerged from "around the Donjon" mound.

14. Compare the position of the legs with the abovementioned "goats at the window" from the palace of Xerxes at Persepolis.

15. This plaque (Sb 3782) is currently exhibited in the Persian Achaemenid section of the Louvre Museum and is dated to the seventh–sixth century BC (http://www.louvre.fr/en/oeuvre-notices /gazelle-relief, accessed 20 August 2014). Analogies with animal styles observed in Neo-Elamite glyptic support this date.

16. Excluding a small section of the upper-left area of Hanni's skirt where the inscription seems to continue.

inscribed over the skirts of the individuals (pl. 64). This inscription has played an important role in the history of Elamite and Near Eastern languages and despite problems of translation is a valuable source of information on royal ideology and cultic practices for the late Neo-Elamite period. After Austen Henry Layard visited the site in 1841 and copied the inscription and five of the epigraphs (Layard 1851, 36–37), it became a center of attention for numerous specialists. The standard translations in German and French have relied on the work of Layard (Sayce 1874; Oppert 1879; Weissbach 1894), Scheil (König 1965, 155–60, pl. 14, EKI 75), and Hinz (1962, 106–16; relying on Weissbach and Scheil as well as observations made during his own visits to the site). De Waele (1976a, 131–43) addressed some of the confusion among the various translations after a personal inspection of the inscriptions and proposed a concordance of Hinz's and König's work.[17] Writing in English, Matthew Stolper (1988, 276–79) provided a summary of the inscription's contents with additional commentary, and, more recently, Henkelman (2008, 23) examined key words and passages in order to shed light on theological concepts at the time of Darius I. As highlighted earlier, the reader should be aware of the persistent problems in defining the late Neo-Elamite lexicon.

The contents of the KFI inscription can be divided into four main parts:[18]

Part I (§1–§5). Opens with an invocation to Tirutir, a divinity unattested elsewhere in Elamite sources (Vallat 1983, 15), and to the Elamite deities Napir, Shimut, and Humban. Hanni, son of Tahhihi and *kutur* (caretaker, protector, ruler) of Ayapir,[19] dedicates the Kul-e Farah complex to Tirutir, the Lord who bestows *kiten* or *kitin* (divine magical protection) "in the height (of) Heaven and divine protection in the depth (of) Earth" (Henkelman 2008, 328).[20]

Part II (§6–§9). Hanni talks about his piety, religious ceremonies, and the *kiten* of the gods Tirutir, Napir, Shimut, and Humban. He comments on having his image (*zalmu*) sculpted together with an inscription.[21]

Part III (§9–§20). Next, there is mention of an armed campaign, Hanni's loyalty toward king Shutruk Nahunte, son of Indada, and his suppression of two revolts. One was in Shilhite, where he captured (twenty?) key rebel leaders. He subsequently dedicated booty and prisoners to the gods, constructed a temple for Narsina (?) at Ayapir, held a festival, and sacrificed 120 (?) mountain goats/sheep in Ayapir for the god.[22] The other revolt took place at the River Pirrin, where Hanni captured eighty mountain goats/sheep and poured their blood in Ayapir for the divinity.

Part IV (§21–§24). The last part concludes with a prayer to the gods Napir, Shimut, and Humban for divine protection of the relief and curses against anyone who dares to damage it. According to Henkelman (2008, 365): "May the kitin of Tepti, the founder?-of-kitin, of sipak Napir, protector of the gods, of Shimut, herald of the gods, of Humban, under (whose) kitin a king (stands), be placed upon my relief!"

Epigraphs (numbers after the line drawing in pl. 68)[23]

1 (§A). Placed over the lower part of Hanni's skirt. It identifies *Hanni*, the son of Tahhihi and caretaker of Ayapir, and mentions having his image and inscription magically protected by Tirutir.

2 (§B). Placed over the short skirt of the weapon bearer: *Shutruru, ragipal of Hanni.*

3 (§C). Placed along the upper half of the long skirt: *Shutruru* (...).

4a (§D). Placed over the skirt. Identifies the tambourine player to the left as *Sunkir* (...).

17. This study was included in his 1976 doctoral dissertation (De Waele 1976a) and published in De Waele 1976b.

18. Line numbers follow those of De Waele 1976a, 136–37.

19. *Ayapir* refers to the valley of Izeh/Malamir itself or to a region in the vicinity (Scheil 1901, 105; Stolper 1988).

20. *Kiten* (or *kitin*) is one of the most frequent, and key, terms of the inscription. It stands for "divine protection, god-given royal power," and seems to be a concept crucial to Elamite theology and

royal ideology. The term is discussed in depth by Henkelman (2008, 9, 364 n. 851).

21. *Zalmu* (image, figure, or relief) is an Elamite loan word from Akkadian *salmu*. According to Stolper (1988), it refers here not merely to the reliefs that bear the inscriptions but also to the ensemble of inscribed figures with their texts.

22. Stolper (1988) points out similarities between this narrative and victory inscriptions from Mesopotamia.

23. Letters after König 1965, 160, pl. 14 (translations of 75F–D and H–J after König).

4b (§E). Placed over the skirt. Identifies the harp player in the center as *Shumumu* (…).

4c (§F). Placed over the skirt. Identifies the harp player to the right as *Sunkir-su* (…).

6 (§G). Placed over the skirt of the ibex herder, animal handler A: *Tempti-Humban* (…).

8 (§H). Unclear.

10 (§I). Placed over the skirt and the legs of the zebu holder, animal handler B (at the back): *Teduhunti* (…).

12 (§K). Placed on the sides and upper skirt of zebu holder, animal handler C (at the front): "Kutur, the Priest."

§15.6. Chronology

Kul-e Farah I was commissioned by Hanni of Ayapir, a vassal of the Neo-Elamite king Shutur-Nahhunte, son of Indada, and is the only relief with an undisputed late Neo-Elamite date. Based on epigraphic similarities with other late Neo-Elamite inscriptions, Stolper (1988, 279) suggests a date anywhere between the end of the eighth century BC and the early sixth century BC. Vallat (1996, 2006) has favored a roughly sixth-century BC date, recognizing two Neo-Elamite kings bearing the name Shutur-Nahhunte: one the son of Huban-immena III,

reigning after 647 BC, the other the son of Indada, reigning sometime between 585 and 539 BC. More recently, J. Tavernier (2004, 19, 21) has proposed that the inscription belongs to the last quarter of the seventh century BC.[24]

From an artistic viewpoint, the long fringes and ladder bands filled with rosettes (probably metal appliqués) adorning Hanni's garment find a close counterpart on a fragmentary polychrome faience slab from Susa generally dated to the Neo-Elamite period (Bouquillon et al. 2007, 110, fig. 46), while his headdress recalls the bulbous royal headdress of the Elamite king Humban-haltash III (646–645 BC) in the Assyrian reliefs. Equally important are the correspondences of the KFI musicians with Elamite and Assyrian orchestras depicted in the Arjan bowl (ca. 600 BC) and in Assyrian reliefs of the seventh century BC.[25] Comparable harps are played by musicians in reliefs depicting the royal Elamite (court-based) orchestra from Madaktu after the defeat of Te'umman by Ashurbanipal (ca. 653 BC) (pl. 71).[26] These correspondences further support a date in the last quarter of the seventh century BC for KFI, although a slighter later date (ca. 625–585 BC) cannot be rejected.[27] In short, textual and artistic evidence together indicate that KFI was manufactured between ca. 650 and 550 BC.

24. See also Henkelman 2008, 7.

25. These correspondences add further support to the date advocated by J. Tavernier for KFI, that is, the last quarter of the seventh century BC or possibly shortly thereafter.

26. The royal Elamite orchestra depicted in the southwest palace of Sennacherib, room 33, marks the arrival of the newly appointed (by Ashurbanipal) Elamite king Ummannigash/Huban-nikash II to the royal city of Madaktu just after the battle of Ûla(-)ya/Ulai river (Tell Tuba) and the death of Te'umman in 653 BC (Barnett, Bleibtreu, and Turner 1998, room 33, pl. 313). For the Elamite musicians in the Arjan bowl, see Álvarez-Mon 2004. For the Elamite royal orchestra from Madaktu, see Álvarez-Mon 2017.

27. Henkelman and Khaksar 2014, 223: "KFI may therefore be dated to the late seventh or early sixth century BC."

§16. Notes on Manufacture

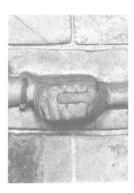

Vanden Berghe (1986, 161–62) was the first to notice certain unusual features in the manufacture of the Kul-e Farah and Kurangun reliefs. Over the surface of KFIII and KFIV he detected traces of what he took as a layer of bitumen plaster, and occasionally details of the hair, embroidered garments, and beard curls engraved into the plaster were still visible. He wondered whether the reliefs had also originally been painted (Vanden Berghe 1984, 17). A study of the more recent Sassanian reliefs from Bishapur by G. Herrmann (1981, 21–22) similarly noted the remains of a 1–2 mm to 6–8 mm thick plaster over the entire surface of relief no. VI depicting an enthroned king. An analysis of a sample of the plaster by the British Museum determined that it was made chiefly of gypsum. Herrmann believed the plastered surface had also originally been painted but found it difficult to comprehend the use of plaster in such an open environment exposed to weathering.[28]

Based on these and my own in situ observations, at least five different stages in the manufacture of many, if not all, Elamite highland reliefs can probably be recognized:[29]

1. A flat panel was cut in the rock. Evidence of this stage can be seen along the edges of the reliefs. At Kul-e Farah, two of these cut-out panels were never carved, one located on a boulder next to KFIII, another in the vicinity of KFV. No attempt appears to have been made to form geometrically perfect panels or a completely even surface, and in some cases the rock face even seems to have been deliberately left unprepared (see for example KFIV, panel CI, archers).
2. The imagery was carved in relief at a depth varying from 2 cm to 10 cm (see, for example, KFIII, S: 1).
3. The surface appears to have been plastered and modeled with a solid mastic-like compound perhaps combining bitumen and limestone (this opinion is based only on personal observation). This material is observed over the surface of

28. Herrmann (1981, 22) believed this layer of plaster did not belong to the original surface "deliberately chosen by the patron and designer" and speculates that the use of plaster was meant to be short-term and only for specific occasions, not made to last.

29. I should note that De Waele did not comment on the presence of plaster or pigmentation. Instead, he interpreted these remains as the result of an exceptional "marble-like" polishing of the rock surface (De Waele 1976a, 276, 286, 292).

figure KFIV, BI: 18 (pl. 30); some of the individuals along KFIV, BII: 1–5 (pl. 30); KFIV, DI: 5 (pl. 36); KFIII, S: 70 (pl. 46); and most particularly over the body and head of KFIV, CI: 4 (pl. 31c). At Shekaft-e Salman, the better-preserved relief of SSII may offer substantial evidence of this plaster over the long garment worn by the queen (pl. 22). It can also be observed at Kurangun on the eye, the belt, and the bottom of the long garment of individual 13 (Vanden Berghe 1986, 162) (pl. 12d).

4. Detail appears to have been added to the plaster (and directly to the rock surface?) by incision with a sharp object. Evidence for this "drawing" approach is observed in the archer from KFIV (CI: 4) where, for instance, the hair, beard, eyes, ear, and segment of the back are incised. It is also observable in KFIII, S: 70, where the eye, beard, hair, and garment of the individual worshiper are incised.

5. The reliefs were possibly painted, but this last stage is no longer apparent since most of the plaster has not survived.[30] There is evidence of some white colored (?) paint left on the surface of KFIV, CI: 4, and perhaps KFIV, BI: 18. Additional evidence can be found in SSII where the headdress and garment of the queen appear to have preserved remains of a white layer of plaster and red (?) paint.[31] At Kurangun, individual 13 may also have preserved traces of pigmentation (pl. 12d) (Vanden Berghe 1986, 162).[32]

The likelihood that the manufacture of the reliefs involved sculpting, plastering, modeling, engraving, and possibly painting presents a multifaceted and original understanding of the field of Elamite sculptural crafts, whose characteristics will add a significant chapter to the history of sculptural relief in the ancient world. Another unexpected and significant outcome emerging from the study of the reliefs has been the close correspondence between the mudbrick relief panels from monumental building facades at Susa and some of the carvings from Izeh/Malamir (see below, §18.2). The shared proportions and representational style suggest the existence of coordinated artistic strategies (master plans) supported by specific craft traditions and manufacturing techniques and employed across highland and lowland artistic production.[33]

30. As noted above, M. Dieulafoy (1885, 226) suggested that Hanni's garments were white, green, blue, and gold. No further comments were made as to the nature of these pigments.

31. I am uncertain, however, whether the paint is original or a later addition.

32. This research could be enhanced by technological improvements in pigmentation analysis.

33. These correspondences are further examined in Álvarez-Mon 2018.

PART II

The Reliefs in Context

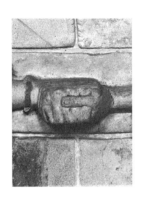

§17. Highland Sanctuaries

To explain the dynamic political system, cultural personality, and remarkable longevity of Elam, we must take into account its dimorphic, highland-lowland, territorial composition, embodied in the use of the royal titles "king of Anshan and Susa" or, conversely, "king of Susa and Anshan." While recognizing this heritage, critical aspects of the Elamite civilization such as religion and ritual, society, and art are overwhelmingly represented by, and understood through, evidence from the urban and religious centers of the lowland alluvial plain that engaged in varying levels of interaction with their Mesopotamian neighbors. Consequently, Elam tends to be perceived as a centralized, Mesopotamia-like cultural and political entity, and not infrequently as a mere extension and emulation of lower Mesopotamia. To the contrary, however, the case could be made that the "true" Elam is actually to be found in the highlands among the amorphous confederacies of highland peoples of diverse linguistic and cultural backgrounds who periodically extended their authority westward to incorporate the agriculturally rich lowlands.

It is against the background of these two notions of Elam, and taking into consideration the imbalance of the available evidence, that I will now discuss the reliefs described in the previous pages. As we have seen, these carvings offer an extraordinary corpus of narratives of self-representation revealing a shared sense of identity spanning more than a millennium from around the seventeenth to the sixth century BC. Since they are not directly associated with any major excavated settlement and, with the exception of KFI, the textual record remains silent about the participants' identities and the role of the reliefs and open-air sanctuaries,[1] I will focus here on two other core aspects defining their significance: one pertaining to the notion of place, or why the reliefs were carved where they are (in the natural environment), and the other to the notion of theme, or why the overarching subject of the reliefs is ritual performance defined by pilgrimage, animal sacrifice, and feasting.

1. As noted in the introduction to the relief of Kurangun, archaeological work and surveys conducted in the Mamasani plain have revealed a network of settlements contemporary with the Old Elamite carving of Kurangun and with its expansion in the first millennium BC. Similarly, archaeological work conducted in the Izeh plain suggests the existence of a Middle Elamite settlement.

§17.1. Natural Environment

In the field of ancient Near Eastern studies, a recognition of interactions between art and the natural environment is a relatively recent development, and the theoretical and methodological foundations of this subfield are just beginning to be articulated.[2] The philosophical underpinning of these studies is the tension between human and natural agencies that arose at the very moment people began to impregnate nature with concepts derived from beliefs. Thus, in a way, beliefs conditioned the intention, expectation, and qualification of the experience(s) of nature and at the same time they created the very possibility of these experience(s). In this sense, we think of the world of nature, made, interpreted, and experienced by humans, as a one-sided, socially constructed event.

In a recent publication, I drew upon the work of the theologian St. Thomas Aquinas and the classical art historian Vincent Scully to argue that artistic manufacture and the natural environment form close-knit associations that feed upon one another to generate beliefs of a very particular kind (Álvarez-Mon 2014). Within a religious context, Aquinas contrasted the sensible and imperfect realm of creation (the bound and limited) against the supersensible, transcendental, and perfect realm of the Creator (the unbound and unlimited). To Aquinas, the natural world could be beautiful and sublime, inasmuch as it was an expression of divine agency (the ultimate instigator and source of all that is good and true) (Eco 1988; McInerny and O'Callaghan 2010). Scully (1962, 3) directly addressed the biases of the academic world and chastised critics for ignoring or denying "any intended relationship between temples and landscape." He also outlined two major impediments to a better understanding of Greek monumental sacred architecture and its relationship to the larger natural environment: first, scholars' lack of primary involvement with the place where the sanctuaries were located and, second, the secularization of the natural landscape that began with modernity.[3]

These remarks resonate for regions with physical environments comparable to those of Greece, such as the Hittite and Elamite highlands, where natural landmarks such as mountains, rivers, caves, waterfalls, gorges and springs provided the stage for sanctuaries and carved reliefs (Beckman 2004, 263; Ullmann 2010; Harmanşah 2015).[4] Here, the natural landscape was not conceived as a neutral setting or "background"; rather, it was an active participant in defining and determining human activity, experience, spirituality, discourse, and art.[5]

The Elamite reliefs offer conspicuous examples of natural agency determining art production. It is impossible to fully grasp their significance—and hence the cultural conventions, beliefs, and sensibilities of their makers and audiences—without taking into consideration their specific placement and surrounding natural contexts. As we have seen, this interplay between nature and art is dramatically revealed at Kurangun, where the formal ceremonial presentation and worshiping gestures of the individuals meeting with the Elamite divinities suggest an idealized, emotional sacred realm informed by the natural environment. A similar assessment can be made of the cave and waterfall at Shekaft-e Salman and their mesmerizing power to capture the attention of the royal families and worshipers represented in the reliefs. One could also argue that, even if they are less obvious, significant phenomenological spiritual implications underlie the choice of location for the six Kul-e Farah reliefs.

The apparent absence of deities at Shekaft-e Salman and Kul-e Farah, in contrast to the earlier iconography of Kurangun and Naqsh-e Rustam, may reflect a cultural change and could perhaps be interpreted as a phenomenon of animism; that is, divinities were not represented because they already existed, resided, and were manifest within and through nature (in this case, cave, waterfall,

2. See Milano et al. 2000; Steadman 2005; Álvarez-Mon 2014; Harmanşah 2007, 2015.

3. See Edlund 1987; Alcock and Osborne 1994. For comparable reflections on landscape and religion in Roman Gaul, see Derks 1997.

4. Harmanşah (2015) examines Anatolian rock reliefs and their interactions with natural landscapes and local communities in the context of a *longue durée* and as generators of cultural identity and memory.

5. A body of scholarship has now developed centering on the evaluation of landscapes and natural landmarks as "places which exist regardless of human agency but have acquired significance out of their association with powerful religious, aesthetic, or other cultural meanings" (Knapp and Ashmore 1999, 11).

creeks). This interpretation, however, has to be moderated by the account in Hanni's two long inscriptions on SSIII and KFI, which indicate that these open-air sanctuaries also included temples to the goddess Mashti (at Shekaft-e Salman) and possibly to the god Tirutir (at Kul-e Farah). It is therefore possible that while in Kurangun and Naqsh-e Rustam the divine was embodied in imagery carved in the reliefs, at Shekaft-e Salman and Kul-e Farah it was instead embodied in sculptures kept inside sanctuaries (bearing in mind, however, that we do not know if any temples had accompanied the reliefs *before* the time of Hanni). In any case, a dimension manifesting a dialectic between the natural world and art is clearly embedded in all of the reliefs. As I will argue below, we can discern in the highlands an embodiment of the sacred in nature that is mirrored in urban religious settings by an embodiment of nature in the sacred, as, for example, in monumental temple facades that both depict divinities and echo the natural world.

§17.2. Ritual Performance: Pilgrimage, Animal Sacrifice, and Communal Feasting

If the location of the sanctuaries and their resident deities were a vital component of Elamite religion, visiting and interacting with them were fundamental elements of what it meant to be a member of Elamite society. Going to the places where the gods resided, whether open-air sanctuaries or temples, certainly involved journeys of religious significance—pilgrimages of various proportions—necessitating both physical and mental preparedness. The scarcity of excavated material and textual evidence again preconditions our understanding of these acts, but it is nevertheless apparent that the process of reaching the reliefs and interacting with the sacred entailed the performance of ritual acts. In fact, conceived all together, the reliefs seem to outline a likely sequence of events: KFIII and KFVI exhibit the festive arrival of a procession, defined by large groups of people accompanied by a selection of animals (zebus and round-horn sheep), musicians, and a ruler atop a platform; next KFI, KFII, and KFV reflect on the sacrifice of animals, while KFIV exhibits a communal meal entailing the ritualized consumption of food.

It is essential to stress the codified precision with which these acts (arrival-procession, animal sacrifice, and feasting) were depicted, as they display textbook attributes of "ritual" as defined by the anthropologist Roy A. Rappaport (1999, 32–50). Namely, ritual requires the active participation of performers and has a high degree of formality, so that "behaviour in ritual tends to be punctilious and repetitive"; ritual is defined by (more or less) invariance, and therefore "invention is limited and the sanction of previous performance is maintained"; and, finally, ritual is ceremonial and lacks material usefulness. Rappaport (1999, 346) spoke of these characteristics as "meta-orders" that bind together into coherent wholes "the natural, the cultural and the social, the individual and the group, the discursive and the non-discursive."

In the Elamite reliefs, the precision and coherence of this visual order is supported through highly structured internal social organization pivoting around a large-scale ruler surrounded by community leaders (e.g., pls. 37, 54). These identifications are justified by a combination of scale, placement within the composition, hair and garment styles, and the types of gestures performed (see table 17.1). In fact, the large-scale individuals are comparable in size and seem to comply with a specific cannon of proportions: at Shekaft-e Salman, the height of the male rulers ranges 1.85 to 2.22 m, the two female rulers are 1.72 m and 1.80 m, and the two male children are 0.72 m and 0.80 m. At Kul-e Farah, the height of the various ruling individuals ranges between 1.90 and 2.06 m.[6] At Kurangun the elite trios measure between 0.95 m and 1 m high (the seated male deity: 0.83 m; the female deity: 0.81 m).

The clear demarcation of social hierarchy and the formalized physical representation of participants, including dignified gestures of worship and ritual food consumption, convey a structurally and stylistically idealized portrait of group identity. As I shall discuss below, a clear distinction can be made between the representation of the ruling classes in the reliefs at Xong-e Azdhar, Shah Savar, Shekaft-e Salman, Naqsh-e Rustam, and Kurangun and those at Izeh/Malamir. In the former, the

6. Exceptions are the depiction of the seated ruler in KFIV and Hanni in KFI, who measures ca. 1.18 m high.

TABLE 17.1. Representation of the ruling class

Relief	Theme	Height
Xong-e Azdhar (seventeenth century)	Seated large-scale individual (deity or ruler?) (no. 1) faced by seven standing individuals (nos. 3–8); no obvious status difference among the latter	
Shah Savar (seventeenth century)	Seated large-scale individual (deity or ruler?) faced by five standing individuals (nos. 2–6); no obvious status difference among the latter	
Kurangun I (seventeenth–sixteenth century)	Divine couple (nos. 1–2) worshiped by two male-female-male trios of elite human individuals (nos. 6–8, 9–11)	
Naqsh-e Rustam I (seventeenth–sixteenth century)	Two deities sitting on coiled-serpent thrones	
Qal-e Tul (twelfth century)	Meeting of two groups; large-scale female (no. A1) followed by two smaller individuals (nos. A2–A3) and large-scale male (no. B1) followed by two smaller individuals (nos. B2–B3)	
SSI (twelfth century)	Royal family composed of a king (male A), queen, and prince as worshipers	1.87 m 1.80 m 0.80 m
SS II (twelfth century)	Royal family (king, queen, and prince) as worshipers	1.80 m 1.72 m 0.76 m
SS IV (twelfth–eleventh century)	Ruler worshiping	2.18 m
SS III (eleventh–seventh century)	Ruler worshiping	2.22 m
SSI (eleventh–seventh century)	King (male B) in front of the royal family next to a fire stand	1.85 m
KFIV (ninth–eighth century)	Banquet ceremony with seated ruler (AI: 10a)	46 cm seated (largest scale in scene)
Naqsh-e Rustam II (eight–seventh century)	Worshiping male ruler and crowned female	
KFIII (eight–seventh century)	Procession with ruler (S1) held aloft on a platform	2 m
KFIII (eight–seventh century)	Second ruler (N177) standing on a pedestal	2.06 m
KFVI (seventh–sixth century)	Procession with ruler (no. 1) held aloft on a platform	2.05 m
KFII (seventh–sixth century)	Ruler (no. 5) and animal sacrifice	1.90 m
KFV (seventh–sixth century)	Ruler (no. 5) and animal sacrifice	1.90 m
KFI (seventh–sixth century)	Ruler (Hanni, no. 1) and animal sacrifice	1.18 m

[a]Gestures are only stated where visible. Abbreviations for gestures: (HC) Hands Clasped, (IFP) Index Fingers Pointing, (RHHF) Right Hand holding Food, (SF) Snapping Fingers.

Headdress/hair/ braids/beards	Garments	Hand gestures
	Long	HC (nos. 3–8)
	Long (nos. 2–5); short (no. 6)	HC (nos. 2–6)
Horned tiara, long beard, side braids and back braid (male deity no. 1); horned tiara, side and back braid (female deity no. 2); "visor" hairstyle (male nos. 6, 8, 9, 11?); rounded, bulging hair (female nos. 7, 10)	Ankle-length (males); floor-length (females)	Holding serpents and objects (nos. 1–2); HC (no. 11); arms flexed 45 degrees at the elbow, varied hand positions (nos. 6–10)
	Long flounced (deity to the right)	
	Floor-length, fringed hemline, long voluminous sleeves (no. A1); ankle-length (nos. B1, A2, A3); above-knee-length (B2, B3)	Salutation gesture (A1, B1); HC (A2, A3, B2, B3)
"Visor" hairstyle, side braids, long back braid with terminal knob, long beard (king); round-shaped hair with a band and back braid (prince); rounded, bulging hair, back braid or necklace extension? (queen)	Short-sleeved, knee-length (king and prince); short-sleeved, floor-length (queen)	HC (king and prince); one hand raised with IFP (female)
All as per SSI	Short-sleeved, knee-length, fringed borders (king and prince); short-sleeved with flounced skirt (queen)	HC (king, queen, and prince)
As per king (Male A) in SSI	Short-sleeved, ankle-length	HC
Back braid (head damaged)	Short-sleeved, knee-length	IFP
As per king (Male A) in SSI	Short-sleeved, knee-length	IFP
"Visor" hairstyle, back braid (?), short beard	Short-sleeved, long garment with (fringed?) hemline band	RHHF, left forearm rests on leg, hand on knee
"Visor" hairstyle with band, side braids (?), long beard (male); bulbous hairstyle with crown (female)	Short-sleeved, long garment with fringed hemline (male)	HC (male only)
Frontally protruding ("visor"?) hairstyle with rear extension (braid?), short round beard	Short-sleeved, long garment with fringed hemline (and upper border?)	HC
"Visor" hairstyle" with rear extension (braid?), a long beard (?)	Short-sleeved, long garment with fringed upper border	HC
"Visor" hairstyle with rear extension (braid?), short beard	Short-sleeved, long garment with fringed hemline and upper border	IFP
Hairstyle with bulge at the front, back braid, long beard	Short-sleeved, knee-length garment with fringed hemline	IFP?
Hairstyle with frontal bulge, back braid (?), long beard	Short-sleeved, long garment with fringed borders	IFP
Bulbous cap, long braid ending in a circular knob, mustache, long, highly detailed beard	Short-sleeved, long garment with ladder-band borders enclosing large rosettes and fringes.	HC

TABLE 17.2. Elamite orchestras/musical ensembles

Musical ensemble	KFIII	KFIV	Madaktu	KFI	Arjan
Vertical angular harp	3	4	7	1	2
Horizontal harp	—	2	1	1	—
Lyre	—	—	—	—	1
Drum	—	—	1	1	1?
Lute	—	—	—	—	1
Double pipes	—	—	2	—	1
Singers and clappers	—	—	15	—	—
Clothing	Short garments	Short garments	Ankle-length garments for adults; knee-length garments for children	Ankle-length garment	Ankle-length garments for the lyre player and drum player
Hairstyle	Bun at the back	Bun at the back	Mainly short hair	Bun at the back	Short with possible bun at the back
Gender	inconclusive	inconclusive	Four bearded males; three female singers(?) characterized by long hair and others of inconclusive gender	inconclusive	All male (bearded) except perhaps for the double-pipes player
Date		ca. 875–700	ca. 650	ca. 650–550	ca. 620–600

ᵃThe vertical harp is plucked with the hand, whereas the horizontal harp is played with a stick-shaped plectrum held in the right hand.

ᵇThe exceptions are the double-pipe player, the three singers at the back, and possibly the third harp player from the rear.

participants are engaged in acts of worship, whereas in the latter, the acts also include the sharing of a communal meal, the sacrifice of animals, and the performance of music. Before discussing the implications of these differences within historical context, the less perceptible ceremonial role of music, and perhaps recitation, ought to be emphasized.

The existence of Elamite musical ensembles or orchestras has been known since 1853, when A. H. Layard published drawings of reliefs from the southwest palace of Sennacherib at Nimrud representing the royal orchestra and choir from Madaktu (pl. 71) (Layard 1853, pls. 48–49).[7] The topic of Elamite orchestras was first specifically addressed in De Waele's 1989 publication treating the three represented at Kul-e Farah (pl. 70a–c). To this corpus we may add the illustration of an orchestra playing

in a banquet scene on the large, engraved, bronze bowl deposited in the Neo-Elamite tomb near the ancient city of Arjan (pl. 70d). These depictions offer some of the earliest and most detailed evidence of musical ensembles in the historical record. In addition to assisting a chronological reckoning of the Neo-Elamite reliefs, this imagery broadcasts sociocultural sophistication through the types of instruments, the gender and age of the musicians, and the key role assigned to formalized sound in ceremonies involving processions, animal sacrifices, and feasting.[8]

These musical ensembles depicted in the first half of the first millennium BC do not emerge out of a cultural vacuum. By the time they were carved, Elam had already tallied a millenary musical tradition boasting some of the earliest representations of musical assemblages.[9]

7. Note that the terms "musical ensemble" and "orchestra" are used here interchangeably in the sense of a group of people performing music together, without any implications of the actual "orchestration" of their music. The term "choir" is defined here as a musical ensemble of singers. The installation of Humban-nikash II in Madaktu (version 1) is shown in the southwest palace of Sennacherib at Nimrud, room XXXIII (Barnett et al. 1998, pls. 300, 304, 308).

8. For background information, see De Waele 1976a, 1989; Rashid 1984; Lawergren and Gurney 1987; Barnett et al. 1998; Cheng 2001; Lawergren 2003, 2009, 2018; Dumbrill 2005; Álvarez-Mon 2013, 2017a; Henkelman and Khaksar 2014.

9. A sealing found in the village of Chogha-Mish dated to the late fourth millennium BC depicts a group of four individuals sitting on the ground. One holds a string instrument (possibly a harp), another

The Elamite orchestras of Kul-e Farah, Madaktu, and Arjan involve from three to twenty-six individuals and are characterized by the primacy of string instruments, especially harps, supplemented by drums, pipes, and, in the case of the royal Elamite orchestra from Madaktu, singing and clapping (see table 17.2) (Álvarez-Mon 2017a). Based on later Islamic musical compositions (ca. AD 1300), Lawergren (2009; 2018) suggests that heterophony (a single melodic line) was the likely mode of performance and that harps would have played the tune along with the singer, a flute, a lute, a tambourine, and a drum.[10] The special relationship between sound and place is conveyed by the reliefs. As discussed by Henkelman and Khaksar (2014), it is difficult to dismiss the likelihood that the extraordinary, theater-like, natural acoustic qualities of Kul-e Farah provided a perfect stage for the recitation of cultic songs.

holds a wind instrument (a horn?), and a third seems to be playing a round bodied object (a drum?); these three are accompanied by an individual without visible instruments, possibly a singer (Delougaz and Kantor 1996, pls. 45N and 155A).

10. On the quest to unveil the sonority of these orchestras, see Rashid 1984, 138. For terminology and philology, as well as discussion of individual instruments, see Dumbrill 2005.

§18. Historical Context

No less than 465 individuals are depicted in the reliefs studied in the previous pages.[1] To go beyond the description and study of the significance of each individual relief in isolation, the imagery will now be integrated into its historical context, in particular targeting specific aspects of the Elamite social identity, religious practices, and beliefs from about the seventeenth to the sixth century BC. Again, it is important to bear in mind that our understanding of these subjects relies primarily on material evidence unearthed in lowland urban centers and that artistic, religious, and political discourses were largely defined by elite groups.

§18.1. The Seventeenth–Sixteenth Century BC: Xong-e Azdhar, Shah Savar, Kurangun, Naqsh-e Rustam, and the *Sukkalmahs*

Beginning around the late nineteenth century BC, Elam underwent a political and possibly territorial reorganization under the leadership of the *sukkalmahs*, "grand regents," and an expansion that took Elamite political and economic interests beyond traditional boundaries. In tandem with Assyria and Babylonia, Elam rose to become a political and military powerbroker of unprecedented prestige and influence. The kingdom was distinguished by unique systems of government, succession, and titulature, aspects of which, I will argue, may have been publicized in the reliefs. The organization of power followed a tripartite structure along the lines of a "triumvirate" composed of a chief ruler ("*sukkalmah*"), a senior coregent ("*sukkal* of Elam," often a brother of the *sukkalmah*), and a junior coregent ("*sukkal* of Susa," often a son or nephew of the *sukkalmah*). This system may have protected Elam against disastrous dynastic struggles. Another singularity of Elamite kingship is the use of the epithet *ruhu-shak*, "son of the sister of," in most cases a title with the function of providing legitimacy to its bearer.[2] Together with a rich terminology of family affiliation, this

1. Xong-e Azdhar (8), Shah-Savar (6), Qal-e Tul (7), Kurangun (54), Naqsh-e Rustam (5), SSI (5), SSII (3), SSIII (1), SSVI (1), KFI (10), KFII (7), KFIII (200), KFIV (141), KFV (6), KFVI (11).

2. For Elam, see in general Malbran-Labat 1995, 173; Potts 2016, 153. For an evaluation of incestuous marriage in the general context of the ancient Near East (with a focus on Egypt and Persia), see Frandsen 2009. A recent review of the epithet *ruhushak* by Potts (forthcoming) based on the examination of

expression underlines the singular role played by family and, in particular, by women in Elamite history and politics.[3]

The ca. seventeenth-century BC reliefs carved on a boulder at Xong-e Azdhar (pl. 3) and along the cliffside at Shah Savar (pl. 4), both in the valley of Izeh/Malamir (pl. 2), inaugurate a highland sculptural tradition defining the iconography of the ruling classes and perhaps of deities. They provide the first evidence of groups of individuals worshiping a seated ruler or deity of a larger size. In Xong-e Azdhar, there is no observable variation in the scale of the individual worshipers depicted, while in Shah Savar, their size visibly differs with order of placement in relation to the ruler/deity. This imagery gives the impression of a large-scale, billboard-style duplication of presentation scenes depicted in glyptic arts. No obvious natural or artificial features have been observed in the location where the reliefs were carved other than their exposure to imposing views of the open valley. A ruined sanctuary dated to at least the nineteenth century AD and a cemetery with carved guardian lion tombstones near the Shah Savar relief suggest some level of continuity in the cultic importance of the area into recent times.

The most significant expressions of the monumental sculptural arts of this time (ca. 1600 BC) are those at Kurangun (pl. 10) and Naqsh-e Rustam (pl. 16). At Kurangun, the seated bearded male is clearly designated as a divinity by his horned headdress, the coiled-serpent throne, and the serpents in his hand. His sidelocks and long back braid, which appear to be unattested on humans at this time, may also distinguish him as divine, though we cannot clearly see the detail of the worshipers on either side of him for comparison. The female deity is seated on an animal, perhaps with legs crossed, and also wears a horned headdress, long sidelocks and a long back braid (or possibly a pendant). At Naqsh-e Rustam, the pair of distinctive coiled-serpent thrones, on which apparently both male and female divinities could sit,

leaves us in no doubt that we are in the presence of a divine couple.

Compositionally, scholars have pointed out similarities between the imagery of the central panel at Kurangun and a schematic banquet scene on a seventeenth-century bitumen seal excavated at Susa (Amiet 1966, 322–23, no. 242; Aruz 1992a, 115–16, no. 74). The seal shows a male standing with hands clasped in a worshiping gesture facing a table and a seated couple holding small cups. The couple are arranged with the male seated on a stool in front of the female, who wears a long, flounced garment covering her feet and seems to be seated on a platform. A grape vine emerges from behind her, creating an overhanging canopy that bring to mind the streams of water flowing from the outstretched hand of the male divinity at Kurangun.[4]

As stated previously, an abridged version of the human/divine encounter in the Kurangun relief—a male divinity seated on a coiled-serpent throne presenting the ring and rod to a ruler—became an iconic visual formula for Elamite royalty, perhaps representing a ceremony of royal investiture. It prevailed for at least three centuries until the thirteenth century BC (pls. 73b and 74) (Miroschedji 1981b, 12). The best matches for this motif at Kurangun are found on the seals of the rulers Kuk-Nashur II (ca. 1620 BC), "*sukkal* of Susa, sister's son of Tempti-Agun," and Tan Uli (late sixteenth century BC), "*sukkal* of Elam and Shimashki, sister's son of Shilhaha"; in the second example, Tan Uli receives in his outstretched hands the two streams of water flowing from the male deity's hand, which also holds the rod and ring (pl. 14a). The gods represented on these seals are seated, like the male deity at Kurangun, on a coiled-serpent throne atop a platform with triangular extensions at either end (Miroschedji 1981b, pls. I.3 and 5).[5] Where the image of the ruler is preserved, there is no

cross-cultural ethnographic and anthropological examples reveals that royal succession via the sister's son was not an anomaly and that there are some distinct advantages in prioritizing a sister's male child over the king's own.

3. This singularity can be traced back to earlier layers of Elamite culture around 3000 BC, with the depiction of alabaster female statuettes adopting worshiping gestures (Amiet 1966, 128, nos. 91–92).

4. There is no indication of divine symbols, although Amiet suggested it could be a mountain god (Amiet 1966, 322–23, no. 242; 1972, no. 1899). Aruz (1992a, 115, no. 74) instead identifies the couple as a probable ruler and his queen. A similar lady holding a cup is depicted on a Kaftari-period (ca. 2000–1700 BC) sealing excavated at Anshan (Tell-e Malyan) (Sumner 1974, 172, fig. 12.l).

5. The oldest representation of the deity sitting on a coiled-serpent throne is on a seal of the scribe Sirahupitir, servant of the *sukkal* of Susa, Attahushu (nineteenth century BC).

indication of the side braids or long back braid characteristic of the divinities.

A comparable example in the medium of stone is provided by the celebrated fourteenth-century stele of Untash Napirisha (pl. 74).[6] In the fragmentary upper register, the king receives a rod and ring from a deity who holds a serpent and, most likely, sits on a coiled-serpent throne. The register below is occupied by a trio: two women and a man in between them. The women preserve inscriptions over their arms identifying them as Napir-Asu, the wife of king Untash-Napirisha (left), and perhaps the king's mother (right).[7]

Besides two-dimensional monumental sculpture and glyptic arts, visual expressions of this emblematic human-divine encounter were manufactured in metal and stone sculptural forms that were seemingly intended to stand inside the sanctuaries at Susa (pl. 73) (Miroschedji 1981b, pls. III and IX.5).

One such expression in metal representing an enthroned deity was found amid a deposit of small bronze sculptures in the temple of Inshushinak at Susa and dates to the *sukkalmah* period (pl. 73a) (Sb 2891; see Mecquenem 1905, 75, pl. 18.1–2; Amiet 1966, 310, no. 233A–B; Tallon, Hurtel and Drilhon 1989, 125, pl. I.3). The god raises the right arm in front and in the left hand holds a serpent. The body of the serpent extends downward to the left side and starts to coil, integrating its body into the side of the seat. Three more snakes slither up the back of a rectangular, wall-like panel behind the throne and extend their heads over the top to form a protective canopy above the deity. The horizontal floor below has clearly been broken off just in front of the deity, suggesting that it was once longer and perhaps originally supported the figure of a worshiper who faced the deity (see reconstruction in pl. 73a; Tallon, Hurtel, and Drilhon 1989, 127).

An example in stone is provided by a remarkable, albeit fragmentary, monumental sculpture from Susa representing a deity sitting on a throne composed of serpents (pl. 73b) (Amiet 1966, 378–79, no. 286A–C; Miroschedji 1981, pl. IX.5; Álvarez-Mon forthcoming b). The preserved lower section of the sculpture shows a long, flounced robe composed of narrow wavy strands of hair at the front, and its back and sides are formed by coiled serpents either spitting a flame or flicking out their forked tongue. The remnants on the lower body of a serpent indicates that a fourth serpent was once held over the divinity's chest. The throne was once fixed to a platform (evidenced by the presence of a tenon) and offers a three-dimensional counterpart to the imagery depicted in the upper register of the Untash-Napirisha stele.

Serpents and serpent hybrids held by the divinity singly or in pairs and functioning as divine companions are prominent in Elamite religious iconography. Discussed in the studies of Toscanne (1911, 154) and Miroschedji (1981b), they can be traced back to some of the earliest cultic expressions in the visual record of Elam. During the third millennium BC, the serpent was ubiquitous in cultic scenes of both eastern (Anshanite) and western (Susian) origin.[8] The divine throne formed by a coiled serpent with a bearded human head became a standard motif during the *sukkalmah* period. Later on, during the Middle Elamite period, the serpent wore a divine headdress, blurring the boundaries between animal, human, and divine realms. The Elamite serpent hybrid remains poorly defined; we do not know its origin, name, or symbolism nor whether we are dealing with a single or many entities. The serpent and serpent hybrid are generally represented with jaws open spitting flame or flicking the tongue, indicating apotropaic, protective roles. Their placement along the boundaries of stelae (pl. 74) and sacrificial tables, in combination with their chthonic properties, suggests they also had access to physical realms associated with darkness and the underworld.[9]

6. Found in fragments on the Acropole during excavations by Morgan (1900, pl. IIIb). It has been reconstructed to a height of ca. 2.62 m. It is 0.80 m wide. The reconstruction follows proposals by Pézard (1916, 119) and Miroschedji (1981a, 10, pl. IX.1–3).

7. The name of this lady remains problematic. It was read by Pezard (1916, 122) as Rarak Utik, *ra-rak Ú-tik*, who identified her as a priestess. König (1965, 69 n. 9) suggested *[xx]-ú-tik*. Vallat (1981, 31) disagrees and instead proposes *ù ra-an(?)-ish-tik*. For further information on these terms, see Hinz and Koch 1987, 244–45.

8. For example, in the Akkadian period, the serpent god, a male deity with a human upper half and a coiled serpentine lower half, appears at Susa. The snake god of Nirah, minister of the city god Ishtaran, was worshiped in the city of Der, located between Mesopotamia and Elam (Black and Green 1992, 166).

9. In spite of this iconographic relevance, a limited knowledge of Elamite theology prevents a comparative discussion of the role of

This corpus of representations from Kurangun and Susa showcases key aspects of Elamite religious iconography, belief systems, and political organization. With the *sukkalmah*, this system embraced highland and lowland pantheons and, correspondingly, sought to articulate an original "global Elamite" theological vision, bringing together the natural world, cultic practices, and sanctuaries. Precisely who the two trios of elite individuals—composed of a woman and two men—framing the divine couple at Kurangun may have been, and whether they embody some form of the Elamite family-centered political apparatus during the *sukkalmah* period, remains a matter of speculation. This exceptional group depiction finds no parallel in the artistic production of the ancient Near East. Here the special relation between the ruler and the divinity is extended to a body of individuals participating in a ceremony of royal investiture.[10] It is conceivable that this ceremony mirrored an actual Elamite royal investiture executed in the *kukunnum*, the shrine topping the Elamite ziggurat, where the ruler received a ring and rod from the hands of a deity seated on a coiled-serpent throne.

§18.2. The Twelfth–Eleventh Century BC: Qal-e Tul, Shekaft-e Salman, and the Shutrukid House

An appreciation of the artistic program of the Shutrukid dynasty, named after its founding king, Shutruk-Nahhunte (ca. 1190–1155), is often obscured by its notorious actions in Mesopotamia. Following a long succession of marriages between Elamite kings and Kassite princesses beginning around 1370 BC with the union of the Elamite prince Pahir-ishshan and the eldest daughter of the Kassite king Kurigalzu, Shutruk-Nahhunte and his two sons, Kutir-Nahhunte (1155–1150) and

Shilhak-Inshushinak (1150–1120), would follow a foreign policy of vindication, asserting the claim of Elamite kings over the Babylonian throne. Numerous raids on Mesopotamian cities and the eventual collapse of the Kassite dynasty in 1155 BC resulted in the arrival at Susa of large amounts of "booty" from Mesopotamia, some of which, such as the celebrated victory stele of the Akkadian king Naram-Sin (ca. 2225 BC), received dedication inscriptions to Inshushinak (Amiet 1992a). This period of Elamite imperial interventionism and accumulation of resources brought about unprecedented building activity throughout Elamite territory and could be regarded as an extension of the golden age initiated by the founder of Choga Zanbil, Untash-Napirisha.[11] In view of this heritage, the artistic program of the Shutrukids ought to be reevaluated to account for the likelihood that some of the Shekaft-e Salman reliefs were commissioned by these rulers as permanent memorials of their devotion. The contemplation of this possibility necessitates a review, first, of aspects of the monumental sculptural program enacted at Susa by the Shutrukids and, second, of these kings' intricate familial associations.

Two buildings with molded brick façades are known to have been erected at Susa at this time (pls. 19 and 72). One of these was an "exterior sanctuary" (a *kumpum kidua*) with a façade composed of an alternating sequence of two divinities, a protective lama and a bull-man holding a palm tree (Malbran Labat 1995, no. 41), which was probably built in the Apadana by Kutir-Nahhunte and later restored by his brother Shilhak-Inshushinak. Remains of at least twenty divine bull-men belonging to this façade have been discovered, and there must have been an equal number of lamas and palm trees, suggesting that this large sanctuary façade had symbolically depicted a sacred grove (pl. 72).[12] The second building was a *suhter*, a royal tabernacle, presumably associated with another *kumpum kidua* in the *alimelu* (the "high

the Elamite serpent within the framework of ancient Near Eastern religions and an exploration of possible analogies with, for example, the primordial form of the Egyptian god Atum, symbol of time and eternity (Vos 1999, 121), or the infamous snake of the Garden of Eden (see Hendel 1999, 744–47).

10. Textual evidence refers to Shutruk-Nahhunte II (ca. 717–699 BC) placing statues representing the Elamite monarchs Hutelutush-Inshushinak, Shilhina-hamru-Lagamar, and Humban-mena before the divinities in the *kukunnum* high temple (Montagne and Grillot-Susini 1996).

11. From Anshan to the shores of the Persian Gulf and the Susiana plain spread the construction of new temples, the reconstruction and ornamentation of old temples, and the installation of new sanctuaries (Stolper 1984, 41; Potts 2010b).

12. Whether or not they had originally belonged to a building in the Apadana mound has been debated (Steve and Gasche 1996, 329 n. 1; Malbran-Labat 1995, 150, plan of Susa; Caubet 2003; Álvarez-Mon 2010).

rising," upper town, or Acropole). It was dedicated to dynastic cultic activities and possibly comprised a shrine housing sculptures of protective deities (*nap bahappi*), ancestors, and living royal family members as well as a courtyard with a façade decorated lavishly with molded bricks depicting sequences of royal couples in worshiping demeanor (pl. 19) (Grillot 1983, 7–9; Malbran Labat 1995, 103). From inscriptions on the bricks, we know that two of the kings represented among the couples were the brothers Kutir-Nahhunte and Shilhak-Inshushinak, and additional textual evidence indicates that their consorts were one and the same lady: Nahhunte-Utu, who married Shilhak-Inshushinak after the death of his brother.

The enigmatic origins and family relations of Nahhunte-Utu have attracted considerable attention and deserve to be highlighted here given the probability that they were showcased in the highland sculptural program. One intriguing inscription mentions that Nahhunte-Utu's first husband, Kutir-Nahhunte, restored a temple of the goddess Kiririsha in the town of Liyan (present day Busher) "for my life, that of Nahhunte-Utu and that of her offspring" (EKI 31; Malbran-Labat 1995, 86, no. 37). A similar inscription by her second husband Shilhak-Inshushinak (likely referring to the restoration of the same temple in baked bricks) repeats the expression: "for my life, for that of Nahhunte-Utu, and for her offspring" (EKI 35; Malbran-Labat 1995, 97, no. 43). While in both cases the identity of her children is not specified, the names of nine of them can be ascertained from building restoration inscriptions by Shilhak-Inshushinak. Three of the texts list three boys (b) followed by three girls (g) in the same order after Nahhunte-Utu: "for my life, the life of Nahhunte-Utu and Hutelutush-Inshushinak (b), Shilhina-hamru-Lakamar (b), Kutir-Huban (b), Ishnikarab-huhun (g), Urutuk-El-halahu (g), and Utu-ehihi-Pinigir (g)."[13] A similar inscription names three additional girls, followed by a striking statement about the last named in the list, Bar-Uli: "for my life, the life of (names wife and six children in a slightly different order to the above), Temti-turkatash (g), Lil-airtash (g), and Bar-Uli (g), my well-beloved daughter, she who

represents my salvation" (EKI 41; Malbran-Labat 1995, 107–8, no. 47).[14]

The information gleaned from these dedicatory royal inscriptions is captivating. How can one interpret, for example, the special fondness of the king toward one particular daughter? Was it Shilhak-Inshushinak's explicit recognition of Bar-Uli's status as his only daughter and hence his "salvation" as prospective bearer of guaranteed legitimate grandchildren? As noted previously, a visual expression of this relationship can be seen on an inscribed bead depicting Shilhak-Inshushinak presenting a gift to Bar-Uli.[15] According to E. Sollberger (1965, 31), the inscription reads: "I, Shilhak-Inshushinak, enlarger of the kingdom, this jasper (of/in/to) Puralsiš I took. My completed work I placed there, and to Bar-Uli, my beloved daughter, I gave." This private, informal family depiction is a sharp contrast with the royal public personas displayed on the monumental façade of the royal tabernacle at Susa and in the Shekaft-e Salman I and II reliefs. At Shekaft-e Salman, the ruler is depicted with the standard long beard, sidelocks, and long braid that defined male divinities during the *sukkalmah* period. In the bead of Bar-Uli, however, he wears the typical Elamite "visor" hair-style and a short beard and lacks the sidelocks and braid. These contrasting features may indicate a difference in the formulation of a ruler's identity in private and public contexts in Elam.

No less captivating is the role assigned to Nahhunte-Utu in maintaining the stability of the Shutrukid House. Bearer of nine children (three boys and six girls), her first son and future king of Elam, Hutelutush-Inshushinak, is said to be "king of Elam and Susiana," the "well-beloved son" (*shak hanik*) of Kutir-Nahhunte and of Shilhak-Inshushinak (Malbran-Labat 1995, no. 51). On one occasion he is even the "well-beloved son" of Shutruk-Nahhunte, Kutir-Nahhunte, and Shilhak-Inshushinak (Vallat 1985; Malbran-Labat 1995, nos. 52 and 53).[16] Late

13. Malbran-Labat 1995, 101, no. 45 = EKI 34; Malbran-Labat 1995, 90, no. 39 = EKI. 59; Malbran-Labat 1995, 114–17, no. 50 = EKI 40.

14. For another text by Shilhak-Inshushinak mentioning the children, see EKI 47; Grillot 1983, 2–8.

15. It should be recalled that this bead was purchased in 1919 from the antiquities dealer I. Élias Géjou, who was known for his involvement in selling looted cuneiform tablets from Mesopotamia (Calmeyer 1988, 283).

16. Taking this information literally, Vallat suggested that the first six children (including Hutelutush-Inshushinak) were

in the twelfth century, when the Babylonian king Nebuchadnezzar I (1125–1104 BC) invaded Elam, Hutelutush was forced to retreat deep into the Bakhtiyari mountains to Qal-e Geli, about 100 km southeast of Izeh/Malamir. But Nahhunte-Utu's legacy had not yet ended; her second son, Shilhina-hamru-Lagamar, and perhaps another of her descendants, king Humban-mena, may have reigned well into the eleventh century BC (Steve, Vallat, and Gasche 2002, 470; Potts 2016, 244–46).

In brief, this remarkable illustration of family affiliations with queen Nahhunte-Utu as its center provides a window into the complex personal and political mosaic of the Shutrukid House (ca. 1190–1050 BC). It is with this in mind that we should attempt to query the elites represented in the Shekaft-e Salman reliefs. Another artistic and cultural expression of the Elamite highlands was brought into play in the relief from Qal-e Tul, ca. 20 km south of Izeh/Malamir, perhaps representing an elite marriage, a family, or the conclusion of a treaty. Here a larger-scale male and female are shown facing each other, each followed by two smaller figures. The large-scale female in this relief is further testimony to the singular role allocated to females in Elam.

Throughout this work, I have identified the couple and child in the Shekaft-e Salman I and II reliefs as a royal family and judged the couple to be highland counterparts to those represented on the fragmentary molded brick façade of the royal tabernacle at Susa. By the twelfth century BC, the males members of the royal families exhibited at Shekaft-e Salman and Susa embody a "national" royal image incorporating the pair of side braids or the long back braid that formerly defined the divinities.[17] Despite their different methods of crafting, the Susa mudbrick façade and the highland rock reliefs share patterns of proportions and styles of representation that suggest they were more closely associated in

conceptualization, planning, and manufacture than present categories and derived art-historical discourses lead us to believe. Indeed, they are suggestive of a coordinated artistic agenda with clearly defined aims. Seen in a Shutrukid family context, the two Shekaft-e Salman reliefs conceivably depict specific members of the dynasty, among whom we may perhaps identify Kutir-Nahhunte, Nahhunte-Utu, and Shilhak-Inshushinak. Such being the case, the male child could be the "well-beloved son" Hutelutush-Inshushinak. Archaeological work in the Izeh plain has provided evidence for Middle Elamite settlement with pottery comparable to forms excavated at Tall-e Ghazir. All together, artistic and archaeological evidence suggest the Izeh plain, Qal-e Tul, and Tall-e Ghazir may have constituted a natural north-to-south regional entity that witnessed a particularly flourishing period under the leadership of the Shutrukid dynasty.

§18.3. The ca. Ninth–Sixth Century BC: Kul-e Farah, Kurangun, and Naqsh-e Rustam in the Neo-Elamite Period

A gap between ca. 1050 and 813 BC in the textual records of Elam, Assyria, and Babylonia, and an apparent corresponding poverty of material in the archaeological record, long created the impression of an Elamite "dark age." Miroschedji (2003, 34) has suggested that this gap reflects a collapse of Elam's urban network that came hand in hand with territorial fragmentation and an adaptation to a mainly pastoral-nomadic existence. Inspired by a similar model, Amiet positioned the creative genius responsible for the Kul-e Farah reliefs and later additions at Kurangun within a parallel phenomenon of cultural transformation, linked to the commencement of an ethnogenesis (a term coined by Miroschedji 1985, 295) between Iranian-speaking migrant populations and local Elamites. In his view, the communal displays and rituals depicted in the reliefs illustrate a "new consciousness" that emerged from a process of settlement by nomadic populations after ca. 1000 BC (Amiet 1992b, 89 n. 37). Amiet did not elaborate on the specifics of this new way of thinking or which aspects of the society he perceived as outcomes of the presumed Iranization of the Elamite highlands.

Nahhunte-Utu's children with her own father Shutruk-Nahhunte I and that she was also sister of Shilhak and of Kutir-Nahhunte (Vallat 1985, 46 n. 7, 49). The meaning of these family affiliations increases in intricacy when one considers that he also employed the title "sister's son of Shilhaha," an epithet primarily used by the *sukkalmah* rulers (Vallat 1997, 233–34; Potts 2016, 151, table 6.1).

17. As noted, given the poor preservation of the elite individuals in Kurangun's central panel, it is not absolutely certain that these features had not already been incorporated into the graphic language of the Elamite ruling class.

The earlier Neo-Elamite reliefs clearly flag a new chapter in the history of Elamite sculptural art, and, as Amiet suggested, their depictions of large groups of individuals in a ritual setting surely arose from a new social consciousness. The numerous participants in KFIII (a total of 200 individuals and 21 animals), in KFIV (about 140 individuals), and at Kurangun (about 36 individuals) provide a remarkable display of social hierarchy and organization determined by scale, placement inside registers, physical relationship to the rulers, activities, and type of garment. To reiterate this point, there is a clear idealization of a community strengthened through social bonds intimately attached to the notion of place (Kul-e Farah and Kurangun), "ethnic" self-identity (a social group characterized by distinctive physical features, most particularly long, braided hair), and the enactment of custom and ritual (processions, animal sacrifice, a communal meal, and the worship of old Elamite deities). It is difficult to assert the degree to which these visual paradigms reflect societal changes and the presumed integration of recent Iranian-speaking migrants into Elamite culture. The depictions of animal sacrifice in KFI, KFII, and KFV and communal feasting in KFIV emphasize these two activities as vital aspects of the society, worthy of display. The "processional" reliefs of KFIII and KFVI do not show these activities, but perhaps it was taken for granted that they were about to occur (in KFIII following on from the meeting of the two groups). In terms of continuity of ritual practice, perhaps the most tangible and striking evidence is provided by the community of worshipers at Kurangun, very similar to those at Kul-e Farah, descending the staircases to join the thousand-year-old Elamite rulers in worshiping the divine couple.

Still, very little is known about the Elamite inhabitants of the Zagros highlands during this period, but the notion that they were nomadic pastoralists is no longer accepted by most specialists (Potts 2008a, 2008b).[18] Instead, it is likely that their socioeconomic and political fabric combined both sedentary agriculture and transhumant pastoralism.[19] The latter is a specialized branch of the economy involving the shepherding of large herds of sheep and goats; its ultimate goal is to maximize the products derived from these animals (milk, wool, meat, and hides).[20] These dual agropastoralist activities targeted three geographical zones: highland pastures, irrigated inner valleys, and lowland plains. Given how little we know about the highland-lowland corridor linking the Izeh/Malamir valley with the large urban settlements of the Ram Hormuz plain, however, it would be hazardous to speculate on the origins and economic activities of the populations depicted in the Izeh/Malamir and Kurangun reliefs.

The Elamite Zagros populations would have benefitted from a minimized exposure to the political upheavals of the west precipitated by the antagonism between Elamite rulers and the Assyrian kings whose increasingly expansionistic agendas brought about major changes in the international political arena of the ninth and eighth centuries. By encroaching on the neighboring territory of Babylon and the Zagros Mountains, traditionally areas of Elamite influence, they sent a powerful message to Elam's elite.[21] Our two main snapshots of late ninth-/early eighth-century political history show that Elamite-Assyrian relations were in a state of flux: in 813 BC, Elamite troops came to the aid of the Babylonian king Marduk-balassu-iqbi when he was at war with Assyria's Shamshi-Adad V (823–811 BC),[22] yet thirty years later,

18. Luke (1965, 76–79), relying on the Mari texts, and Briant (1982b, 47), relying on the classical-period accounts of the Zagros mountains inhabitants, challenged and successfully reversed the dominant dichotomy between settled and nonsettled populations, showing that the same peoples could perform a combination of pastoral and agricultural activities.

19. There has been a tremendous emphasis on the role of nomadic pastoralism in defining, among many other things, the socioeconomic characteristics of Iranian-speaking migrants in southwestern Iran. As a result, numerous scholars have adopted the view that nomadic pastoralism became a dominant way of life in the region of Fars around 1000 BC and in the rest of Elam by the latter part of the Neo-Elamite period (ca. 600 BC) (Miroschedji 1990, 62). As recently emphasized by Potts (2008b; 2014), however, there is no evidence to support this claim. True year-round nomadism (as practiced by the twentieth century Bakhtiyari) arose as a response to the Mongol invasion of the thirteenth century and the subsequent Turkish migrations into southwestern Persia (Planhol 1968, 211; Potts 2014, 427–28).

20. While goat hair is of high value, sheep are generally preferred for their wool, even though they require greater care than goats and tend to produce less milk (Barth 1961).

21. Well attested during the reigns of Ashurnasirpal II (883–859 BC) and Shalmaneser III (858–824 BC) (Potts 1999, 263).

22. They were in the company of the Kassite, Aramean, and Chaldean units that helped liberate Dur-Papasukkal, a royal city near Der besieged by the Assyrian king (Brinkman 1968, 208–9).

an Elamite ambassador in the Assyrian court and the manufacture and use of Elamite bows by the Assyrian troops are mentioned in a letter from Nimrud dated to the end of the reign of Adad-Ninari III (810–783 BC) (Dalley and Postgate 1984, CTN 3, 145; Zadok 1994, 47).

Evidence for the interlude from 720 to 674 BC, when Elamite influence and military power was at a peak, reveals a pattern of increasing confrontation with Assyria. Around 708 BC the Elamite king Shutruk-Nahhunte II sent a staggering eighty thousand bowmen in support of the Chaldean Merodach Baladan (Marduk-apal-iddina II) to regain independence from Assyria and take the Babylonian throne (Luckenbill 1927, 10).[23] According to the Babylonian Chronicle, he also carried the epithet *ruhushak* (son of the sister) of Huban-nikash I, the typical *sukkalmah* term of royal affiliation.[24] The same Elamite king left an inscription referring to the placement of statues of three of his predecessors inside the *kukunnum* high temple before the cult image of Inshushinak (Montagne and Grillot-Susini 1996). The use of antiquated titulature and the caretaking of royal ancestors reveals a keen awareness of tradition and continuity. The heavy burden of this historical memory was in a sense carried out, and passed on, by artistic accomplishments. It is also evident, for example, in restoration works on religious buildings bearing inscriptions left by previous sovereigns.[25] Much like the imagery exhibited in the open-air highland sanctuaries, the building inscriptions incorporating ancient titulatures were preserved in a "systemic context," providing a source of legitimacy and prestige by linking the monarch with previous rulers and his (perceived) royal ancestors.[26]

With the arrival in power of Sennacherib (705–681 BC), the strategy changed, and Elam openly opposed Assyrian authority. The drama peaked in 694 BC, when the Elamites captured (and probably executed) the Assyrian crown prince and king of Babylon, Ashur-nadin-shumi. The extent of Elamite military power and influence was revealed three years later when king Humban-Nimena (692–698 BC) assembled an extraordinary coalition of forces composed of Zagros highland entities (represented by Parsuas, Ellipi, Pasheru, and Anshan) and Mesopotamian lowlanders (represented by Chaldeans, Arameans, and Babylonians) against Sennacherib. In the subsequent period, we catch glimpses of peaceful interaction with Assyria, climaxing in 674 BC with an *adê* peace treaty between kings Esarhaddon (681–669 BC) and Urtak (675–664 BC). The treaty incorporated oaths sworn to Elamite and Assyrian gods and was sealed by an exchange of Elamite and Assyrian princes. In the end, neither the treaty nor the close ties between the royal houses prevented the invasion, looting, and devastation of western Elam and Susa by Ashurbanipal in 647 BC.

With their expressions of individual and group identity, unparalleled in the artistic record of the ancient Near East, the reliefs of KFIV, KFIII, and Kurangun II and III must be set against this complex background of migrations of Iranian-speaking populations, the Persian "ethno-genesis," and the events taking place in the international political arena of the ninth to seventh century BC. These large relief compositions give precedence to an idealized view of a community in clear hierarchical order, bound together through the sharing of rituals. The contrast with past representations of the Elamite ruling families and individual rulers in the act of worshiping is striking. Here the ruler's presence is integrated within a nexus of identity markers defining a population and a society. At the individual level, these markers constitute an idealized (highland) body type characterized by broad shoulders, narrow waist, muscular legs, and hair collected into a braid (which at Kurangun ends in a loop). At the communal level, the shared rituals are both expressions of traditional iconographic themes (a banquet) and original expressions of group performance (processions), which at Kurangun are a clear manifestation of continuity with past Elamite cults. Certain groups

23. In 703 BC, the same king had previously sent 4500 bowmen to help Nibe gain access to the throne of Ellipi (Potts 2016, 258).

24. For recent discussion, see Potts forthcoming.

25. For example, in the course of Shilhak-Inshushinak's restoration work on the temple of Inshushinak at Susa, he encountered restoration inscriptions of previous rulers; among these, he refers to an inscription by the *sukkalmah* Kuk-Kirwash bearing the epithet "son of the sister of Shilhaha," and he asks Kuk-Kirwash to intercede for him after Inshushinak (Malbran Labat 1995, 112, no. 49).

26. Systemic context "labels the condition of an element which is participating in a behavioral system," while archaeological context "describes materials which have passed through a cultural system, and which are now the objects of investigation of archaeologists" (Schiffer 1972, 157).

are distinguished by their activities (musicians) or their association with objects (weapon bearers in KFIV and KFI), while groups of bow bearers in KFIV underline the significant role of archery in the history of Elam (Álvarez-Mon forthcoming a).

Assyria's punitive raids in western Elam in 647 BC and the ensuing looting and destruction of Susa by Ashurbanipal did not bring the Elamite Kingdom to an end. The material, textual, and artistic assemblages represented at Susa, together with the elite material from the tombs of Arjan (ca. 600–570 BC) and Ram Hormuz/ Jubaji (ca. 585–539 BC), provide evidence of the survival of Elamite political power, culture, and traditions after the Assyrian invasion.[27] This material also manifests a period of close contact at the elite level between Elam and Assyria that began with the peace treaty of 674 BC and perhaps lasted as late as 626 BC, with the death of Ashurbanipal and the return of "the gods of Susa" by the Babylonian king Nabopolassar (implying the presence of a political authority and the restoration of the Susa shrines).[28]

How to best describe the power dynamics of the period based on the Assyrian version of events and the multiple succession of rulers is uncertain (Henkelman 2003, 254). Models proposed by D. T. Potts (1999, 259; 2010a, 122) and M. Liverani (2003, 10) convey two possible scenarios: (1) the existence of important regional dynastic tribes dominated by "petty kings" of the type exemplified by Hanni of Ayapir, with relatively high levels of autonomy and sometimes opposing interests, who nevertheless acknowledged the paramount position of the Elamite king at Susa, and (2) a unified but decentralized Neo-Elamite Kingdom whose cohesion and political integrity relied on well-established economic and administrative networks and gravitated around the Elamite king, multiple "royal towns," and regional alliances. Both models benefit from the work of P. Briant (1982a, 1982b, 1996) and W. F. M. Henkelman (2005, 2011a) regarding the inhabitants of the Zagros mountains east of Susa at the time of Alexander (ca. 330 BC). From the viewpoint of the classical-period sources, the Elymaeans and Uxians were tribal groups composed of lowlanders and highlanders, sedentary farmers and seminomadic pastoralists, that populated the territories from Susa to Persepolis, embracing the areas of Izeh and Tall-e Ghazir.[29] The assertive behavior of the highland Uxians and their ability to threaten the Greek troops advancing toward Persepolis merited episodes in the accounts of Alexander's military campaigns (Briant 1982a, 214–21; 1982b, 62–64). Their degree of political autonomy and links with the central power have been elucidated by Briant's (1982b, 89) insights into the customary gift remittance, or the "game of obligations," instituted by the Persian king. Every year, the agropastoralist tribes *Ouxoioi* and *Elymaioi* met the king or his representative: "In front of the narrow mountain pass there was a ceremony in which the two parties engaged one toward the other. The king presented gifts and in exchange received the submission of the highlanders" (Briant 1996, 752).

The seventh- to sixth-century BC reliefs of KFVI, KFII, and KFV offer condensed versions of cultic activities. In KFII and KFV, which center on animal sacrifice, the grand displays of the past become small vignettes, and the large-scale ruler towers over the other participants. KFVI instead partly replicates the representation in KFIII of a (probable) ruler atop a platform, refraining from including the object of the ritual. The past visual emphasis on sheer numbers of participants has again been rejected in favor of a selection of pivotal individuals. All three of these late Neo-Elamite reliefs nevertheless retain the same style of representation (unnatural forward-projecting shoulder, clasped hands, braided hair, and narrow waistline).

27. For discussion of these discoveries, see, for example, Henkelman 2008; Álvarez-Mon, Garrison, and Stronach 2011; Álvarez-Mon 2010a, 2012, 2018; Gorris 2014; and Wicks 2017.

28. Within this context, see also S. Dalley's (2007) study of the Hebrew book of Esther, which compellingly argues for a recontextualization of the story in a seventh-century BC Elamite-Assyrian context. Dalley (2007, 7, 183 n. 56) stresses an Assyrian viewpoint and the notion that "Persia adopted many Assyrian customs," and she also sets the stage for further study of the Elamite participation in this adoption. It is significant that an account of the story of Esther written in Elamite may have existed up until the third century AD.

29. "Nearchus says that there were four robber tribes; the Mardi, who were contiguous to the Persians; the Uxii and Elymæi, who were on the borders of the Persians and Susii; and the Cossæi, on those of the Medes; that all of them exacted tribute from the kings; that the Cossæi received presents, when the king, having passed his summer at Ecbatana went down to Babylonia" (Strabo, *Geographica* 11.13.6; translation from Hamilton and Falconer 1903).

Naqsh-e Rustam II stands apart both geographically and in content. This eighth- to seventh century BC addition to the original relief implies a continuity both in cultic practices and in the strategic importance of this territory of Fars. The representation of the crowned female and the standing male facing the Elamite deities advocates for a period of interaction between Assyria and the polities controlling this territory. The participation of an entity referred to as "Anshan" in the coalition against Sennacherib around 691 BC raises the possibility that at this time we could be looking at the representation of Anshan-based royalty embracing Elamite religious and artistic traditions. [30]

The KFI relief commissioned by Hanni of Ayapir, who placed himself under the aegis of the Elamite king Shutur-Nahhunte (ruling sometime between 650 and 550 BC), constitutes the last chapter in a long tradition of monumental sculpture dedicated to the representation of Elamite ruling families and rulers in ritual settings defined by significant natural features. It depicts a complex web of past artistic, sociopolitical, and religious references encompassing Shekaft-e Salman and Kul-e Farah. Hanni's inscription on this relief and those he added to SSI, SSII, SSIII, and SSIV all remain poorly understood, but they nonetheless force us to see the reliefs in the broader context of royal inscriptions, political ideology, Elamite theology, and cultic practices in open-air sanctuaries.

One important theme of the inscription that Hanni added to SSIII was the protection of the ruling family, recalling a persistent wish for family protection in the numerous building inscriptions of the Shutrukid king Shilhak-Inshushinak (Malbran-Labat 1995, nos. 39, 43, 45, 47–50). In KFI, he highlights a victory and the ensuing sacrifices, bringing forth a political dimension that is not self-evident in the reliefs. This recalls inscriptions left by Assyrian rulers on carved reliefs in open-air sanctuaries (Karlsson 2016, 111), the most conspicuous of which were immortalized at the "the source" of the

Tigris river, "the place where the water comes out." [31] The prestigious visitors attracted to this special place included the Akkadian king Naram-Sin (2254–2218 BC), and the Assyrian kings Tiglath-pileser I (1114–1076 BC) and Shalmaneser III (858–824 BC). The latter was keen to commemorate his activity at the site. In addition to carving four inscriptions and two reliefs in situ, he had a visual record of his visit replicated on the bronze bands of a monumental gate from Tell Balawat (Ingul-Enlil) and left a textual account of the expedition on the black obelisk erected at Nimrud. [32] According to this document: "In my seventh regnal year ... I went as far as to the source of the Tigris (*rēsh ídēni sha ídidiqlat*), the place where the water comes out. I washed the weapon of Ashur therein, made sacrifices to my gods, (and) put on a celebration banquet. I fashioned a splendid royal image of myself (*salam sharrūtīya*), inscribed thereon the praise of Ashur, my lord, (and) all the heroic deeds that I achieved in the lands, (and) set (it) up therein" (face D, 69–72). Although separated in time by about two centuries, this unique visual and textual record of Shalmaneser III offers a fascinating counterpart to Hanni's inscription at KFI. In both cases, one can discern a politico military discourse voicing the royal ideology of heroic conquest: the victory over the enemy is followed by the sacrifice of animals, a banquet, and the carving of an image of the ruler.

The animal sacrifice scenes in the reliefs find counterparts in the Elamite cultic heartland of Susa. A fragmentary inscription commissioned by the sixth century BC Elamite king Tepti-Huban-Inshushinak appears to include instructions for a large feast involving elite members of the Elamite court and temple and the sacrifice of livestock. [33] The sacrificial feast takes place inside a

30. For example, Garrison (2010, 399–400) has resituated the imagery of the seal of Kurash (PFS 93*) in a cultural Anshanite/Fars nexus that emerged at the time of Ashurbanipal and "whose origins are to be found not in Susa of the post-Assyrian destruction period, but in the (re-)emerging political state of Anshan/Fars under the Teispids in the second half of the 7th century B.C."

31. Located 25 km north of the town of Lyce, in the Diyarbakir province (Turkey); latitude: 38° 31' 46.04" N; longitude: 40° 32' 59.19" E. The Assyrians associated the source of the Tigris with the Birkleyn caves and tunnel, from which emerges a tributary of the Tigris River.

32. For detailed accounts, see Shafer 1998; Schachner 2004. For Hittite parallels, see Hawkins 1998. For interpretations, see Harmanşah 2007; 2015, 127.

33. The inscription was published in 1911 by Scheil (1911, 80–83, fig. 15) in the fourth volume, dedicated to the Elamite Anzanite texts found at Susa, and by König (1965, 171–72, EKI 85). Tepti-Huban-Inshushinak is dated by Vallat (1996) to 585–539 BC. For discussion

grove (Elamite *husa*) of sacred character associated with a sanctuary, implying a natural presence within an urban setting, realized through (presumably irrigated) gardens. Ideologically, the grove underscores the link between the residence of the deities (the temple) and the fertility of the gardens. Of further interest is the specification in this text of the total number of livestock to be slaughtered for the feast, precisely 31 cattle and 186 sheep/goats. This 1:6 ratio implies that one head of cattle may have had an economic and/or symbolic value equaling that of six head of sheep/goats. Intriguingly, this ratio is upheld in the Kul-e Farah animal sacrifice scenes: KFIII shows three zebus and eighteen sheep, KFII shows one zebu and six sheep, KFV shows one zebu and six sheep, and KFI shows perhaps one zebu and three carcasses of sheep (next to three sheep).

Further striking parallels exist between the Kul-e Farah reliefs and the ceremony involving a sacrificial feast known as *shup* in Elam and as *ship* during the early Achaemenid Persian period (Henkelman 2011b, 128, 131). As discussed by Henkelman and Khaksar (2014, 225), Achaemenid *ship* took place around November, when livestock was being brought back from the summer pastures and herds had to be downsized in preparation for winter, "but most importantly, the return of the herdsmen meant a re-unification of the society." It was also an opportunity for the social group to renew their reciprocal bonds with the divine through ritual and animal sacrifice.

One can hardly fail to notice that the hundreds of distinctive Elamites with braided hair, so conspicuous in the highland reliefs of Kul-e Farah and Kurangun, are without any discernible trace in Ashurbanipal's Assyrian palace reliefs (ca. 650 BC) dedicated to recounting the demise and humiliation of Elamite elites and the raided towns of the western Elamite lowlands. Nor are they represented in the imagery on the Arjan bowl (ca. 600 BC), on the Neo-Elamite glazed brick panels from Susa, or in the monumental stone reliefs of Persia. Although there are occasional depictions of individuals without braids in the highland reliefs (the platform bearers in KFIII and KFVI wear caps, and in KFI the long braid is clearly absent from the weapon bearer, the musicians, and possibly most of the priests and acolytes), this absence points to an enormous gap in our understanding of the peoples and broad geopolitical realities of Elam in the Neo-Elamite period.

of alternative dates, see Tavernier 2004 and Henkelman 2008, 445. To my knowledge, the time and place of the inscription's discovery are unknown.

§19. Concluding Remarks: The Sculptural Heritage of Highland Elam

When the first glazed, polychrome, molded brick panels came to light in the palace of Darius at Susa at the end of the nineteenth century (1884–1886), Marcel Dieulafoy, director of the French archaeological mission, suggested that the modeling of the human figures and the style of the garment folds represented a break with past sculptural conventions and a *nouvelle tendance* displaying Greek artistic influence (1891, 294–95, 297). Well versed in classical-period sources and relying on art-historical criteria that emphasized stylistic properties, Dieulafoy set the tone for future research, believing that he could find in the newly unearthed material record confirmation of Herodotus's "speedy transformation of barbarian Persia" (Dieulafoy 1891, 295). Like many of his contemporaries, Dieulafoy believed that Persian artistic and cultural greatness resulted from the assimilation of the monumental artistic traditions of the conquered peoples among whom the Greeks played a privileged role.[1]

Since the time of the classical-period authors, there has been a prevailing tendency to characterize the Persians as outsiders, as Iranian-speaking migrants of tribal nomadic backgrounds lacking cultural traditions of sculptural and monumental arts.[2] Moreover, classical-period sources were apparently unaware that the lands where the Iranian-speaking ancestors of the Persians settled had already been home to an ancient civilization.[3] Any conception of continuity between Elamite and Persian arts and culture has therefore, simply put, been left out of the intellectual equation.[4]

1. "Don't we know," queried Dieulafoy (1891, 297), that "Herodotus already accused the Persians of modelling themselves on the nations that war brought them in touch with? ... Should we then be astonished if they [i.e., the Persians] solicited the advice and assistance of such delicate and powerful artists as their neighbours [i.e., the peoples of Hellas]?"

2. "There are no indications that the Persians possessed a monumental art of their own, and there is no reason to suppose that the accident of discovery has withheld from us monuments of the pre-Achaemenian period. We should hardly expect nomadic tribes to extend their interest beyond the applied arts" (Frankfort 1946, 9).

3. "[The Greeks were] completely ignorant about Elamite power and Elamite history, so that Elam was excluded from their sequence of empires and from their reconstruction of the genesis of the Persian empire" (Liverani 2003, 10).

4. For a sample of the main intellectual paradigms behind the characterization and understanding of Persian art and culture, see the inaugural talk by P. Briant (Chaire d'histoire et civilization du monde Achéménide et de l'empire d'Alexandre) to the Collège de France, 10 March 2000, http://www.college-de-france.fr/.

Consequently, of all the traditions that participated in the formulation of the artistic agenda sponsored by the Persian rulers, the contributions of the native Elamites have been the least understood.

It has been noted by numerous commentators that the official visual metaphors of the Empire developed at the time of Darius I—"a master of propaganda" (Stronach 1985, 438)—offer a sharp counterpoint to previous illustrations of imperial power in the ancient Near East, particularly in the arts of Egypt and Assyria. This rejection of a visual rhetoric of power emphatically marked by warfare scenes, the humiliation of the defeated, and the harsh punishment of dissent has given rise to a scholarly notion of "Persian exceptionalism" and is sometimes described as a direct visual expression of the political *ideology of commonwealth* that defined the *Pax Persiaca*.[5] True, Darius's empire was not devoid of the capacity to exert retribution through ruthlessness (see, for instance, the Bisitun relief and associated inscriptions; Kuhrt 2007, 473).[6] Yet when the time came to articulate "trademark" images of the empire, as conveyed by the Persepolis Apadana reliefs and, to a lesser degree, in the tomb of Naqsh-e Rustam—"the most elaborate formulations of the legitimising process" (Sancisi-Weerdenburg 1986, 266)—Darius may not necessarily have had in mind, nor in sight, imperial models of self-representation going back to the Neo-Assyrian Empire.[7]

If Persian monumental art indeed "breathes a completely different spirit, and sounds an entirely different note"—to borrow a characterization of artistic exceptionalism in Dutch painting articulated by historian Johan Huizinga (Vries 1991, 253)—it was because it enunciated a view of royal-centered power cloaked in a layer of piety, self-control, and harmonious order that deviates from customary ideological visual imperial agendas of supremacy (Root 1979, 2). But this, on reflection, assumes the substitution of one idealized view of power for another, one that, in Briant's words (2002, 171) "ensured the idealized unity of one world but at the same time celebrated its ethnocultural and geographic diversity." What is of further interest, I think the reader would agree, is why it happened at this time and how it was lived. Margaret C. Root has endeavored to explain the reasons for this fundamental departure, suggesting that it "must relate somehow to the ways in which Indo-Iranian traditions maintained by the Persians interacted with various cultural traditions in western Asia during the course of a prolonged period of acculturation on the fringes of Mesopotamia" (Root 2000, 20). In this sense, Root strongly considers the possibility that behind Persian exceptionalism lay proto-Zoroastrian and Zoroastrian belief systems.[8] At the same time, she also acknowledges the possibility that the "end product we see in full bloom with the Achaemenid Persians" was the result of Elamite and Iranian "cultural interlacing" (Root 2000, 21).

From the Elamite-centered perspective espoused in these pages, it should become apparent that the existence of a well-developed local monumental sculptural tradition places Persian (and later Parthian and Sassanian) sculptural traditions within an altogether different background. In particular, looking at Persian sculptural arts through Elamite eyes forces the reexamination of established paradigms regarding the genesis and identity of Persian sculptural arts and compels one to query the extent to which the marginalization of Elam has stripped

5. Carl Nylander (1979, 357) used the notion of "ideology of commonwealth" to speak of a conscious and calculated "positive eclecticism" of a "new and higher order" that manipulated "the past arts for quotations but also for contrasts."

6. For the violent punitive actions taken by Darius against his enemies, see Vallat 2010, 54. For an informative introduction to the ideology of the Assyrian empire, see Liverani 1979.

7. This comment partially extends to the iconography of the Bisitun relief. It can convincingly be argued, I think, that its primary artistic references were of four kinds: (1) victory steles from the Susa Acropole (chiefly the stele of Naram-Sin, but possibly also the stele of the Vultures, a stele from Girsu/Tello attributed to king Rimush, a fragmentary sculpture of Puzur-Inshushinak, and the pedestal of statue Sb 5 discussed above (pl. 59b); (2) western Zagros highlands open-air victory reliefs (Root 1979, 196; Postgate and Roaf 1997; Feldman 2007, 268); (3) Elamite highland reliefs (in particular, the image of the bow/weapon bearer); and (4) Assyrian religious iconography (predominantly, the winged symbol).

8. The traditional "low" dates of Zoroaster's preaching and the emergence of the new religious identity are set around 630 or 588 BC (Gnoli 2000, 165). See Bruce Lincoln's (2008) commentary about the influence of religious ideology on imperialism and the notion of the Great King as the Wise Lord's chosen instrument to restore the primordial harmony of the universe. For a similar approach, see also Jacobs 2010.

Persian culture of its intrinsic meaning (Álvarez-Mon 2018).

I believe the present study offers a foundation upon which to build new paradigms of continuity and change within the autochthonous narratives and artistic programs of ancient Iran. Next to their placement in open-air natural environments, the Neo-Elamite and Persian highland monumental reliefs share obvious features of formal and ideological character. Both are structured along registers, and symmetrical groups are arranged around axial lines. Scale, location, and repetition, as well as the use of nonverbal communication through garments and body language (gestures), are used to mark status and ceremonial protocols. At the ideological level, the representation of the ruler sitting on a throne or carried atop a platform emerge as the central pivot of ritual practices embracing, in the Elamite case, the "community" (of the kingdom?) and, in the Persian case, the "peoples" (of the empire). These were ideological programs of codified behavior that recognize the critical importance of ritual practices in cementing reciprocal bonds within the society and on renewing human participation in the grand liturgy of the universe.[9]

While other cultural influences were unquestionably at play, the present study strongly suggests that basic artistic and ideological tenets pertaining to the depiction of royal power, community, and worship were the consequence of acculturation with Elam and of continuity with Elamite visual programs and manufacturing techniques.[10] There is nothing extraordinary in this expression of artistic continuity within the heartland of the Elamite and Persian empires; what is novel and in many ways remarkable is the degree to which the rhetoric of power and self-representation incorporated the past to articulate a new, idealized vision of civilization. In this sense, Persian artistic "exceptionalism" hinged on a pragmatic capacity to draw on the inherited wisdom of local traditions to generate a novel, idealized, universal message of unity, stability, and harmony centered on and defined by the authority of the Great King. It was, in short, a primarily autochthonous and purely Iranian phenomenon. "The fact that the Persians, whose ability to adapt is praised by Herodotus, reached a sedentary life in the midst of the Elamites was bound to have profound reverberation on their young civilization. We are only glimpsing the importance of this debt: she (Elam) must have contributed much to improve and discipline those virtues of humanity and strength that were to make their glory" (Amiet 1966, 572).

9. Neo-Elamite art provided two ideological templates for the development of the official court iconography of the Persian king established by Darius I: (1) the ruler carried aloft a platform and (2) the ruler in audience and giving gifts (tribute scene). A key iconographic theme of Elamite royalty, the ruler banqueting with the community and, sometimes, animal slaughter, was seemingly and incongruously—given the central role of large sacrificial feasts (*ship*) intimately connected with the king's table—absent from the Persian monumental sculptural program (Henkelman 2010, 671; Álvarez-Mon 2018).

10. For the latter, see Álvarez-Mon 2018.

REFERENCES

Adkins, L. 2004. *Empires of the Plain: Henry Rawlinson and the Lost Languages.* London: Macmillan.

Alcock, S. E., and R. Osborne, eds. 1994. *Placing the Gods: Sanctuaries and Sacred Space in Ancient Greece.* Oxford: Clarendon Press.

Alizadeh, A. 2013. "The Problem of Locating Ancient Huhnuri in the Ram Hormuz Region." *Nouvelles Assyriologiques Bréves et Utilitaires* 3:65.

Alizadeh, A., L. Ahmadzadeh, M. Omidfar, J. R. Alden, and L. Minc. 2014. *Ancient Settlement Systems and Cultures in the Ram Hormuz Plain, Southwestern Iran: Excavations at Tall-e Geser and Regional Surveys of the Ram Hormuz Area.* Chicago: Oriental Institute of the University of Chicago.

Álvarez-Mon, J. 2004. "Imago Mundi: Cosmological and Ideological Aspects of the Arjan Bowl." *IrAnt* 39:203–37.

———. 2009. "Ashurbanipal's Feast: A View from Elam." *IrAnt* 44:131–80.

———. 2010a. *The Arjan Tomb: At the Crossroads of the Elamite and the Persian Empires.* Leuven: Peeters.

———. 2010b. "Platform Bearers from Kul-e Farah III and VI." *Iran* 48:27–41.

———. 2011. "Elamite Garments and Headdresses of the Late Neo-Elamite Period (7th–6th Century BC)." *Archäologische Mitteilungen aus Iran* 42:207–35.

———. 2012. "Elam: The First Iranian Empire." Pages 740–57 in *A Companion to the Archaeology of the Ancient Near East.* Edited by D. T. Potts. London: Wiley-Blackwell.

———. 2013. "Braids of Glory: Elamite Sculptural Reliefs from the Highlands; Kul-e Farah IV." Pages 207–48 in *Susa and Elam: Archaeological, Philological, Historical and Geographical Perspectives; Proceedings of the International Congress Held at Ghent University, December 14–17, 2009.* Edited by K. De Graef and J. Tavernier. MDP 58. Ghent: University of Ghent.

———. 2014. "Aesthetics of the Natural Environment in the Ancient Near East: The Elamite Rock-Cut Sanctuary of Kurangun." Pages 741–71 in *Critical Approaches to Ancient Near Eastern Art.* Edited by M. Feldman and B. Brown. Berlin: De Gruyter.

———. 2015a. "Platforms of Exaltation: Elamite Sculptural Reliefs from the Highlands; Kūl-e Farah VI." *Elamica* 4:1–50.

———. 2015b. "A Highland Elamite Archer from Kūl-e Farah IV, CI:4." *IrAnt* 50:251–78.

———. 2015c. "Like a Thunderstorm: Storm-Gods 'Sibitti' Warriors from Highland Elam." *Annali dell'istituto universitario orientale* 74:1–30.

———. 2017a. "The Elamite Royal Orchestra from Madaktu (653 BC)." *Elamica* 7:1–34.

———. 2017b. "Storm-Gods of Western Elam." *Archäologische Mitteilungen aus Iran* 47 (2015): 75–94.

———. 2018. "The Elamite Artistic Heritage of Persia." Pages 829–50 in *The Elamite World.* Edited by J. Álvarez-Mon, G. P. Basello, and Y. Wicks. London: Routledge.

———. Forthcoming a. "The Bow of Elam, the Mainstay of Their Might." In *Susa and Elam II.* Proceedings of the International Congress held at Leuven la Neuve, Catholic University, Belgium, 2015. MDP 59. Ghent: University of Ghent.

———. Forthcoming b. "Puzur-Inšušinak, Last King of Akkad? Text, Image and Context Reconsidered." In *Elam and Its Neighbors: Recent Research and New Perspectives.* Edited by B. Mofidi-Nasrabadi, D. Prechel, and A. Pruß. Mainz: Johannes Gutenberg University of Mainz.

Álvarez-Mon, J., M. B. Garrison, and D. Stronach. 2011. "Introduction." Pages 1–34 in *Elam and Persia.* Edited by J. Álvarez-Mon and M. B. Garrison. Winona Lake, IN: Eisenbrauns.

Amiet, P. 1966. *Elam.* Auvers-sur-Oise: Archée.

———. 1967. "Élements émaillés du décor architectural néo-élamite." *Syria* 44:27–46.

———. 1972. *Glyptique susienne.* Mémoires de la délégation Archéologique en Iran 43. Paris: Geuthner.

———. 1973. "Glyptique élamite: A propos de documents nouveaux." *Arts Asiatiques* 26:3–45.

———. 1976. "Disjecta Membra Aelamica: Le decor architectural en briques emaillees a Suse." *Arts Asiatiques* 32:13–28.

———. 1992a. "Victory Stele of Naram-Sin." In *RCS*, 166–67.

———. 1992b. "Bronzes Elamites de la collection George Ortiz." *Archäologische Mitteilungen aus Iran* 25:81–89.

———. 1996. "Observations sur les sceaux de Haft Tépé (Kabnak)." *RA* 90:135–43.

———. 1998. "Les Sceaux de Kabnak (Haft Tappeh)." Pages 101–13 in *The Iranian World: Essays on Iranian Art and Archaeology Presented to Ezat O. Negahban.* Edited by A. Alizadeh, Y. Majidzadeh, and S. Malek-Shahmirzadi. Tehran: Iran University Press.

Aruz, J. 1992a. "Seals of the Old Elamite Period." In *RCS*, 106–20.

———. 1992b. Cylinder Seal with Banquet Scene. In *RCS*, 211.

Ashmore, W., and A. B. Knapp, eds. 1999. *Archaeologies of Landscape*. London: Wiley-Blackwell.

Askari, A. A., P. Callieri, and E. Matin. 2014. "Tol-e Ajori: A Monumental Gate of the Early Achaemenian Period in the Persepolis Area; The 2014 Excavation Season of the Iranian-Italian Project 'From Palace to Town.'" *Archäologische Mitteilungen aus Iran* 46:223–54.

Ataç, M.-A. 2006. "Visual Formula and Meaning in Neo-Assyrian Relief Sculpture." *Art Bulletin* 88:69–101.

Atarashi, K., and K. Horiuchi. 1963. *Fahlian I: The Excavation at Tepe Suruvan, 1959*. Iraq-Iran Archaeological Expedition Reports 4. Tokyo: Institute for Oriental Culture, University of Tokyo.

Barnett, R. D., E. Bleibtreu, and G. Turner. 1998. *Sculptures from the Southwest Palace of Sennacherib at Nineveh*. London: British Museum Press.

Barth, F. 1961. *Nomads of South Persia: The Basseri Tribe of the Khamseh Confederacy*. Oslo: Oslo University Press.

Beckman, G. M. 2004. "Sacred Times and Spaces: Anatolia." Pages 259–63 in *Religions of the Ancient World: A Guide*. Edited by S. I. Johnston. Cambridge: Harvard University Press.

Binder, A.-B. 2013. "Von Susa nach Anšan—zu Datierung und Ursprung des Felsreliefs von Kūrāngūn." *Elamica* 3:35–88.

Black, J., and A. Green. 1992. *Gods, Demons, and Symbols of Ancient Mesopotamia*. Austin: University of Texas Press.

Bode, C. A. de. 1843a. "Extracts from a Journal Kept While Travelling in January, 1841, Through the Country of the Mamaseni and Khogilu (Bakhtiyari) Situated Between Kazerun and Behbehan." *Journal of the Royal Geographic Society* 13:75–85.

———. 1843b. "Notes on a Journey, in January and February 1841, from Behbehan to Shushter; with a Description of the Bas-reliefs at Tengi-Saulek and Mal Amir; and a Digression on the Jad-dehi Atabeg, a Stone Pavement in the Bakhtiyari Mountains." *Journal of the Royal Geographic Society* 13:86–107.

Börker-Klähn, J. 1982. *Altvorderasiatische Bildstelen und vergleichbare Felsreliefs*. Baghdader Forschungen 4. Mainz am Rhein: Philipp von Zabern.

Bouquillon, A., A. Caubet, A. Kaczmarczyk, and V. Matoïan. 2007. *Faïences et matières vitreuses de l'Orient ancien, étude physico-chimique et catalogue des ouvres du département des Antiquités orientales*. Paris: Musée du Louvre.

Boyce, M. 1982. *A History of Zoroastrianism*. Vol. 2, *Under the Achaemenians*. Leiden: Brill.

Briant, P. 1982a. "La campagne d'Alexandre contre les Ouxiens (début 330)." Pages 214–58 in *Rois, tributs et paysans: Études sur les formations tributaires du Moyen-Orient ancien*. Paris: Les Belles Lettres.

———. 1982b. *Etats et Pasteurs au Moyen-Orient Ancien*. Cambridge: Cambridge University Press.

———. 1996. *Histoire de l'empire Perse de Cyrus à Alexandre*. Paris: Fayard.

———. 2002. *From Cyrus to Alexander: A History of the Persian Empire*. Winona Lake, IN: Eisenbrauns.

Brinkman, J. A. 1968. *A Political History of Post-Kassite Babylonia, 1158–722 B.C.* Rome: Pontificio Istituto Biblico.

Calmeyer, P. 1973. "Zur Genese altiranischer Motive." *Archäologische Mitteilungen aus Iran* 6:135–52.

———. 1980. "Zur Genese altiranischer Motive. VII. Achsnägel in form von Betenden." *Archäologische Mitteilungen aus Iran* 13:9–111.

———. 1988. "Mālamīr. C. Archäologisch." *Reallexikon der Assyriologie* 7:281–87.

———. 1992. "Zur genese Altiranischer motive XI. 'Eingewebte Bilchen' von Städten. *Archäologische Mitteilungen aus Iran* 25:95–124.

———. 1995. "Middle Babylonian Art and Contemporary Iran." Pages 33–45 in *Later Mesopotamia and Iran: Tribes and Empires, 1600–539 BC*. Edited by J. Curtis. London: British Museum Press.

Carter, E. 1984. "Archaeology." Pages 103–230 in *Elam: Surveys of Political History and Archaeology*. Edited by E. Carter and M. W. Stolper. Berkeley: University of California Press.

———. 1988. "Buchbesprechungen: U. Seidl's Die elamischen Felsreliefs von Kūrāngun und Naqš-e Rustam, Berlin 1986." *Zeitschrift für Assyriologie* 78:145–48.

———. 1992. "The Middle Elamite Period, ca. 1500–1000 BC." In *RCS*, 121–22.

———. 1994. "Bridging the Gap Between the Elamites and the Persians in Southeastern Khuzestan." *Achaemenid History* 8:65–77.

———. 1996. *Excavations at Anshan (Tal-e Malyan): The Middle Elamite Period*. Philadelphia: University Museum of Archaeology and Anthropology, University of Pennsylvania.

———. 2014. "Royal Women in Elamite Art." Pages 41–61 in *Extraction and Control: Studies in Honor of Matthew W. Stolper*. Edited by M. Kozuh, W. Henkelman, C. Jones, and C. Woods. Chicago: Oriental Institute of the University of Chicago.

Caubet, A. 2003. "Le temple d'Inshushinak de Suse et l'architecture monumentale en 'faience.'" Pages 325–32 in *Culture Through Objects: Ancient Near Eastern Studies in Honour of P. R. S. Moorey*. Edited by T. Potts, M. Roaf, and D. Stein. Oxford: Griffith Institute.

Chardin, J. 1711. *Voyages de monsieur le chevalier Chardin en Perse et autres lieux de l'orient IX*. Amsterdam.

Cheng, J. 2001. "Assyrian Music as Represented and Representations of Assyrian Music." Ph.D. diss., Harvard University.

Choksy, J. K. 2002. "In Reverence for Deities and Submission to Kings: A Few Gestures in Ancient Near Eastern Societies." *IrAnt* 38:7–29.

Collon, D. 1981. *Catalogue of Western Asiatic Seals in the British Museum: Cylinder Seals II, Akkadian–Post Akkadian and Ur III periods*. London: British Museum Press.

———. 2001. *Catalogue of Western Asiatic Seals in the British Museum: Cylinder Seals V, Neo-Assyrian and Neo-Babylonian Periods*. London: British Museum Press.

Conteneau, G. 1947. *Manuel d'archéologie orientale*. Vol. 4. Paris: Picard.

Curzon, G. N. 1892. *Persia and the Persian Question*. 2 vols. London: Longmans, Green. Repr., London: Cass, 1966.

Dabirsiaqi, M. 2011. "ĀṮĀR-e ʿAJAM." In *Encyclopaedia Iranica* Updated 17 August 2011. http://www.iranicaonline.org/articles/atar-e-ajam-on-fars.

Dalley, S. 2007. *Esther's Revenge at Susa: From Sennacherib to Ahasuerus.* Oxford: Oxford University Press.

Dalley, S., and J. N. Postgate. 1984. *Tablets from Fort Shalmaneser.* Vol. 3, *Cuneiform Tablets from Nimrud.* London: British School of Archaeology in Iraq.

Debevoise, N. C. 1942. "The Rock Reliefs of Ancient Iran." *Journal of Near Eastern Studies* 1:78–80.

Delougaz, P., and H. J. Kantor. 1996. *Chogha Mish.* Vol. 2, *The First Five Seasons of Excavations, 1961–1971.* Edited by A. Alizadeh. Oriental Institute Publications 101. Chicago: Oriental Institute of the University of Chicago.

Derks, T. 1997. "The Transformation of Landscape and Religious Representation in Roman Gaul." *Archaeological Dialogues* 4:126–47.

De Waele, E. 1972a. "Shutruk-Nahunte II et les reliefs rupestres dits Néo-Elamites d'Iseh/Malamīr. *Revue des Archéologues et Historiens d'Art de Louvain* 5:17–32.

———. 1972b. *Quelques aspects de la religion d'Élam à travers l'art rupestre d'époque Neo-Élamite D'Izeh/Malamir.* Tehran: Iran Bastan Museum.

———. 1973. "Une page d'art Iranien: Les reliefs rupestres d'Īzeh Mālamīr." *Archeologia* 60:31–46.

———. 1976a. "Les reliefs rupestres Élamites de Shekāf-e Salmān et Kul-e Farah près d'Izeh (Mālamir)." Ph.D. diss., Université Catholique de Louvain.

———. 1976b. "Remarques sur les inscriptions Élamites de Šekākt-e Salmān et Kūl-e Farah près Izeh, I. Leur corrélation avec les bas-reliefs." *Le Muséon* 89, fasc. 3–4: 441–50.

———. 1979. "Les Processions avec statues divines sur les reliefs ruprestres Elamites, Kul-e Farah III et Kul-e Farah VI (Īzeh)." Pages 93–101 in *Akten de VII. Internationalen Kongresses für Iranische Kunst und Archäologie.* Berlin: Dietrich Reimer Verlag.

———. 1981. "Travaux archéologiques à Shekaft-e Salmān et Kul-e Farah prés d'Īzeh (Mālamīr)." *IrAnt* 16:45–61.

———. 1989. "Musicians and Musical Instruments on the Rock Reliefs in the Elamite Sanctuary of Kul-e Farah (Īzeh)." *Iran* 27:29–38.

Dieulafoy, M. 1885. "Note relative à la découverte sus le Tombeaux de Darius de sept inscriptions nouvelles." *RA* 6:224–27.

———. 1890. *L'Acropole de Suse d'aprés les fouilles exécutées en 1884, 1885, 1886 sous les auspices du Musée du Louvre.* Première partie: Histoire et Géographie. Paris.

———. 1891. *L'Acropole de Suse d'aprés les fouilles exécutées en 1884, 1885, 1886 sous les auspices du Musée du Louvre.* Troisième partie: Faiences et terres cuites. Paris.

Dumbrill, R. J. 2005. *The Archaeomusicology of the Near East.* 2nd ed. Victoria, BC: Trafford.

Eco, U. 1988. *The Aesthetics of Thomas Aquinas.* Cambridge: Harvard University Press.

Edlund, I. E. M. 1987. *Gods and the Place: Location and Function of Sanctuaries in the Countryside of Etruria and Magna Graecia (700–400 BC).* Stockholm: Svenska Institutet i Rom.

Eilers, W. 1971. *Mongolische Ortsnamen in Iran.* Rome: Academica Nazionale dei Lincei.

Feldman, M. H. 2007. "Darius I and the Heroes of Akkad: Affect and Agency in the Bisitun Relief." Pages 265–94 in *Ancient Near Eastern Art in Context: Studies in Honor of Irene J. Winter by Her Students.* Edited by M. H. Feldman and J. Cheng. Leiden: Brill.

Frandsen, P. J. 2009. *Incestuous and Close-Kin Marriage in Ancient Egypt and Persia: An Examination of the Evidence.* Copenhagen: Museum Tusculanum Press, University of Copenhagen.

Frankfort, H. 1946. "Achaemenian Sculpture." *American Journal of Archaeology* 50:6–14.

Frechette, C. 2008. "Reconsidering ŠU.IL$_2$.LA$_{(2)}$ as a Classifier of the Āšipu in Light of the Iconography of Reciprocal Hand-Lifting Gestures." Pages 41–47 in *Proceedings of the 51st RAI, July 18–22, 2005.* Chicago: Oriental Institute of the University of Chicago.

Garrison, M. B. 2009. "Visual Representation of the Divine and the Numinous in Early Achaemenid Iran: Old Problems, New Directions." *Iconography of Deities and Demons in the Ancient Near East.* Accessed 6 January 2016. http://www.religionswissenschaft.uzh.ch/idd/prepublications/e_idd_iran.pdf.

———. 2010. "The Seal of "Kuraš the Anzanite, Son of Šešpeš" (Teispes), PFS 93*: Susa—Anšan—Persepolis." Pages 375–405 in *Elam and Persia.* Edited by J. Álvarez-Mon and M. B. Garrison. Winona Lake, IN: Eisenbrauns.

———. 2012. "Fire Altars." *Encyclopaedia Iranica* 9, fasc. 6:613–19.

Ghirshman, R. 1966. *Tchoga Zanbil (Dur-Untash).* Vol. 1, *La Ziggurat.* Mémoires de la délégation Archéologique en Iran 39. Paris: Geuthner.

———. 1968. *Tchoga Zanbil (Dur-Untash).* Vol. 2, *Temenos, Temples, Palais, Tombes.* Mémoires de la délégation Archéologique en Iran 40. Paris: Geuthner.

Goldman, B. 1999. "Some Assyrian Gestures." *Bulletin of the Asia Institute* 4:41–49.

Gorris, E. 2014. "Power and Politics in the Neo-Elamite Kingdom." Ph.D. diss., Catholic University of Leuven.

Grillot, F. 1983. "Le 'suhter' royal de Suse." *IrAnt* 18:1–23.

———. 1986. "Kirisiša." Page 167 in *Fragmenta historiae Elamicae.* Edited by L. de Meyer, H. Gasche, and F. Vallat. Paris: Editions Recherche sur les Civilisations.

Grillot, F., and F. Vallat. 1984. "Dédicace de Silhak-Insusinak à Kiririsa." *IrAnt* 19:21–29.

Gropp, G. 1992. "A 'Great Bath' in Elam." Pages 113–18 in *South Asian Archeology, 1989.* Edited by C. Jarrige. Madison: University of Wisconsin Press.

Hamilton, H. C., and W. Falconer, trans. *The Geography of Strabo: Literally Translated, with Notes, in Three Volumes.* London: George Bell & Sons, 1903. Available online at http://www.perseus.tufts.edu/hopper/text?doc=Perseus:text:1999.01.0239/.

Hansman, J. 1972. "Elamites, Achaemenians and Anshan." *Iran* 10:101–25.

Harmanşah, Ö. 2007. "'Source of the Tigris'": Event, Place and Performance in the Assyrian Landscapes of the Early Iron Age." *Archaeological Dialogues* 14.2: 179–204.

———. 2015. *Place, Memory, and Healing: An Archaeology of Anatolian Rock Monuments.* New York: Routledge.

Harper, P. O. 1992. "Stele with an Elamite Ruler Approaching a Seated God." In *RCS,* 181–82.

Hassanzadeh, Y., and H. Mollasalehi. 2011. "New Evidence for Manean Art." Pages 407–18 in *Elam and Persia.* Edited

by J. Álvarez-Mon and M. B. Garrison. Winona Lake, IN: Eisenbrauns.

Hawkins, J. D. 1998. "Hattusa, Home to the Thousand Gods of Hatti." Pages 65–81 in *Capital Cities: Urban Planning and Spiritual Dimensions.* Edited by J. G. Westenholz. Jerusalem: Bible Lands Jerusalem.

Heim, S. 1989. "Glazed Architectural Elements in Elam and Related Material from Lorestān." Ph.D. diss., New York University.

———. 1992, "Glazed Objects and Elamite Glaze Industry." In *RCS*, 202–8.

Hendel, R. S. 1999. "Serpent." Pages 744–47 in *Dictionary of Deities and Demons in the Bible.* Edited by K. van der Toorn, B. Becking, and P. W. van der Horst. Leiden: Brill.

Henkelman, W. F. M. 2003. "Persians, Medes and Elamites: Acculturation in the Neo-Elamite Period." Pages 181–231 in *Continuity of Empire (?) Assyria, Media, Persia.* Edited by G. B. Lanfranchi, M. Roaf, and R. Rollinger. History of the Ancient Near East. Monographs 5. Padova: Sargon.

———. 2005. "Animal Sacrifice and 'External' Exchange in the Persepolis Fortification Tablets." Pages 137–65 in *Approaching the Babylonian Economy: Proceedings of the START Project Symposium Held in Vienna, 1–3 July 2004.* Edited by H. D. Baker and M. Jursa. Münster: Ugarit-Verlag.

———. 2008. *The Other Gods Who Are: Studies in Elamite Iranian Acculturation Based on the Persepolis Fortification Texts.* Achaemenid History 14. Leiden: Brill.

———. 2010. "'Consumed Before the King': The Table of Darius, That of Irdabama and Irtaštuna, and That of His Satrap, Karkiš*." Pages 667–775 in *Der Achämenidenhof / The Achaemenid Court: Akten des 2. Internationalen Kolloquiums zum Thema "Vorderasien im Spannungsfeld klassischer und altorientalischer Überlieferungen," Landgut Castelen bei Basel, 23.–25. Mai 2007.* Edited by B. Jacobs and R. Rollinger. Wiesbaden: Harrassowitz.

———. 2011a. "Of Tapyroi and Tablets, States and Tribes: The Historical Geography of Pastoralism in the Achaemenid Heartland in Greek and Elamite Sources." *Bulletin of the Institute of Classical Studies* 542.2: 1–16.

———. 2011b. "Parnakka's Feast: Šip in Pārsa and Elam." Pages 89–166 in *Elam and Persia.* Edited by J. Álvarez-Mon and M. B. Garrison. Winona Lake, IN: Eisenbrauns.

———. 2018. "Elamite Administrative and Religious Heritage in the Persian Heartland." Pages 803–28 in *The Elamite World.* Edited by J. Álvarez-Mon, G. P. Basello, and Y. Wicks. London: Routledge.

Henkelman, W. F. M., and S. Khaksar. 2014. "Elam's Dormant Sound: Landscape, Music and the Divine in Ancient Iran." Pages 211–31 in *Archaeoacoustics: The Archaeology of Sound; Publication of Proceedings from the 2014 Conference in Malta.* Edited by L. C. Eneix. Myakka City, FL: OTSF.

Herrmann, G. 1981. *The Sasanian Rock Reliefs at Bishapur: Part 2.* Iranische Denkmäler. Berlin: Reimer.

Hermann, G., H. Coffey, and S. Laidlaw. 2004. *The Published Ivories from Fort Shalmaneser, Nimrud: A Scanned Archive of Photographs.* London: Institute of Archaeology, University College, and British School of Archaeology in Iraq.

Herzfeld, E. 1926. "Reisebericht." *Zeitschrift der Deutschen Morgenländischen Gesellschaft* 80:225–84.

———. 1941. *Iran in the Ancient East.* New York: Oxford University Press.

Hinz, W. 1962. "Die Elamischen Inschriften des Hanne." Pages 105–16 in *A Locust's Leg: Studies in Honour of S. H. Taqizadeh.* Edited by W. B. Hennig and E. Yarshater. London: Percy Lund, Humphries.

———. 1964. *Das Reich Elam.* Stuttgart: Kohlhammer.

———. 1966. "Nachlese Elamischer Denkmäler." *IrAnt* 6:43–47.

———. 1967. "Elams Vertrag mit Narām-Sîn von Agade." *Zeitschrift für Assyriologie* 58:66–96.

———. 1971. "Religion in Ancient Elam." *Cambridge History of Iran* 1.2: 662–73.

———. 1972. *The Lost World of Elam: Re-creation of a Vanished Civilation.* Translated by Jennifer Barnes. New York: New York University Press.

Hinz, W., and H. Koch. 1987. *Elamisches Wörterbuch.* 2 vols. Archäologische Mitteilungen aus Iran: Ergänzungsband 17. Berlin: Dietrich Reimer.

Huart, C., and L.-J. Delaporte. 1943. *L'Iran antique, Elam et Perse, et la civilisation iranienne.* Paris: Albin Michel.

Hüsing, G. 1908. *Der Zagros und seine Völker: Eine archäologisch-ethnographische Skizze.* Leipzig: J. C. Hinrichs.

Jacobs, B. 2010. "Herrschaftsideologie und Herrschaftsdarstellung bei den Achämeniden." Pages 109–13 in *Concepts of Kingship in Antiquity: Proceedings of the European Science Foundation Exploratory Workshop held in Padova, November 28th–December 1st, 2007.* Edited by G. Lanfranchi and R. Rollinger. Padua: Sargon.

Jéquier, G. 1901. "Description du site de Mālamīr (Appendice)." In *MDP*, 3:133–44.

———. 1905. "Fouilles de Suse 1899–1900, 1900–1901, 1901–1902: Description des monuments." In *MDP*, 7:9–42.

———. 1968. *En Perse 1897–1902: Journal et lettres de Gustave Jéquier.* Edited by Michel Jéquier. Neuchâtel: La Baconnière.

Kaempfer, E. 1712. *Amoenitatum Exoticarum Political-Physico-Medicarum Fasc. V, Variae Relationes, Observationes & Descriptiones Rerum Persicarum and Ulteriores Asiae.* Lemgo.

Keel-Leu, H., and B. Teissier. 2004. *Die vorderasiatischen Rollsiegel der Sammlungen "Bibel+Orient" der Universität Freiburg Schweiz.* Fribourg: Academic Press.

Kleiss, W. 1981. "Ein Abschnitt der achaemenidischen Konigsstrasse von Pasargadae und Persepolis nach Susa, bei Naqsh-i Rustam." *Archäologische Mitteilungen aus Iran* 14:45–53.

———. 1993. "Kurangūn, die Burganlage am Elamischen Felsrelief in Sudwest-Iran." Pages 357–60 in *Aspects of Art and Iconography: Anatolia and Its Neighbors; Studies in Honor of Nimet Özgüç.* Edited by M. J. Mellink, E. Porada, and T. Özgüç. Ankara: Türk Tarih Kurumu Basımevi.

Knapp, A. B., and W. Ashmore. 1999. "Archaeological Landscapes: Constructed, Conceptualized, Ideational." Pages 1–30 in *Archaeologies of Landscape.* Edited by W. Ashmore and A. B. Knapp. London: Wiley-Blackwell.

König, F. W. 1965. *Die elamischen Königsinschriften.* Archiv für Orientforschung Beiheft 16. Graz: E. Weidner. Repr., Berlin: Biblio Verlag, 1977.

Kozuh, M. G. 2006. "The Sacrificial Economy: On the Management of Sacrificial Sheep and Goats at the Neo-Babylonian/

Achaemenid Eanna Teple of Uruk (c. 625–520 BC)." Ph.D. diss., University of Chicago.

Kuhrt, A. 2007. *The Persian Empire: A Corpus of Sources from the Achaemenid Period*. London: Routledge.

Lambert, M. 1978. "Disjecta Membra Aelamica (II): Inscriptions du décor architectural construit par Shilhak-Inshushinak." *Arts Asiatiques* 34:3–27.

Lampre, G. 1900. "Tranchées no 7 et 7&." In *MDP*, 1:100–110.

Lawergren, B. 2003. "Harp." *Encyclopaedia Iranica* 12, fasc. 1:7–13.

———. 2009. "Music History I: Pre-Islamic Iran." In *Encyclopaedia Iranica*. http://www.iranicaonline.org/articles/music-history-i-pre-islamic-iran.

———. 2018. "Music." Pages 781–800 in *The Elamite World*. Edited by J. Álvarez-Mon, G. P. Basello, and Y. Wicks. London: Routledge.

Lawergren, B., and O. R. Gurney. 1987. "Sound Holes and Geometrical Figures: Clues to the Terminology of Ancient Mesopotamian Harps." *Iraq* 49:37–52.

Layard, A. H. 1842. "Ancient Sites Among the Baktiyari Mountains: With Remarks on the Rivers of Susiana, and the Site of Susa." *Journal of the Royal Geographic Society* 12:102–9.

———. 1846. "A Description of the Province of Khuzistan." *Journal of the Royal Geographic Society* 16:75–80.

———. 1851. *Inscriptions in the Cuneiform Character from Assyrian Monuments*. London.

———. 1853. *A Second Series of the Monuments of Nineveh from Drawings Made on the Spot*. London.

———. 1894. *Early Adventures in Persia, Susiana, and Babylonia Including a Residence Among the Bakhtiyaei and Other Wild Tribes Before the Discovery of Nineveh*. London. Originally published London, 1887.

Lincoln, B. 2008. "The Role of Religion in Achaemenian Imperialism." Pages 221–42 in *Religion and Power: Divine Kingship in the Ancient World and Beyond*. Edited by N. Brisch. Chicago: Oriental Institute of the University of Chicago.

Liverani, M. 1979. "The Ideology of the Assyrian Empire." Pages 297–318 in *Power and Propaganda: A Symposium on Ancient Empires*. Edited by M. Trolle-Larse. Copenhagen: Akademisk Vorlag.

———. 2003. "The Rise and Fall of Media." Pages 1–12 in *Continuity of Empire (?) Assyria, Media, Persia*. Edited by G. B. Lanfranchi, M. Roaf, and R. Rollinger. History of the Ancient Near East. Monographs 5. Padova: Sargon.

Luckenbill, D. D. 1927. *Ancient Records of Assyria and Babylonia*. 2 vols. Chicago: University of Chicago Press. Repr., London: Histories and Mysteries of Man, 1989.

Luke, J. T. 1965. "Pastoralism and Politics in the Mari Period: A Reexamination of the Character and Political Significance of the Major West Semitic Tribal Groups on the Middle Euphrates, ca. 1828–1758 B.C." Ph.D. diss., University of Michigan.

Lukonin, V. G. 1967. *Persia II*. Translated by James Hogarth. Archaeologia Mundi. Geneva: Nagel.

Magen, U. 1986. *Assyrische Köningsdarstellungen: Aspekte der Herrschaft; Eine Typologie*. Mainz am Rhein: Philipp von Zabern.

Malbran-Labat, F. 1995. *Les Inscriptions royales de Suse, Briques de l'époque paléo-élamite à l'Empire néo-élamite*. Paris: Réunion des musées nationaux.

Mann, O. 1910. "Die Bachtiaren und ihr Land." *Westermanns Monatshefte* 109:435–46.

Martinez-Sève, L. 2002. *Les Figurines de Suse, de l'époque néo-élamite à l'époque sassanide*. Paris: Réunion des musées nationaux.

McInerny, R., and J. O'Callaghan. 2010. "Saint Thomas Aquinas." In *The Stanford Encyclopedia of Philosophy*, Winter 2010 edition. http://plato.stanford.edu/archives/win2010/entries/aquinas/.

Mecquenem, R. de. 1905. "Offrandes de fondation du temple de Chouchinak." In *MDP*, 7:61–130.

———. 1925. "Inventaires des cachets et de cylindres (Suse, 1923–1924)." *RA* 22:1–15.

———. 1934. "Fouilles de Suse 1929–1933." In *MDP*, 25:177–237.

———. 1943. "Fouilles de Suse 1933–1939." *Mémoires de la mission archéologique en Iran* 29:3–161.

———. 1947. "Contribution à l'étude du palais Achaemenid de Suse." *Mémoires de la mission archéologique en Iran* 30:1–119.

Melville, S. C. 1999. *The Role of Naqia/Zakutu in Sargonid Politics*. State Archives of Assyria Studies 9. Helsinki: Neo-Assyrian Text Corpus Project.

Messina, V., and J. Mehrkian. 2010. "The Iranian-Italian Joint Expedition in Khuzistan Hung-e Azdhar: 1st Campaign (March 4–12, 2008)." *Parthica* 12:31–34.

———. 2015. "Hung-e Azhdar: History of Research and Problems of Interpretation." *Parthica* 17:15–36.

Michalowski, P. 1993. "The Torch and the Censer." Pages 152–62 in *The Tablet and the Scroll: Near Eastern Studies in Honor of William W. Hallo*. Edited by M. E. Cohen, D. C. Snell, and D. B. Weisberg. Bethesda, MD: CDL.

Milano, L., S. De Martino, F. M. Fales, and G. B. Lanfranchi, eds. 2000. *Landscapes: Territories, Frontiers and Horizons in the Ancient Near East; Papers Presented to the XLIV Rencontre assyriologique internationale, Venezia, 7–11 July 1997*. Padua: Sargon.

Miroschedji, P. de. 1978. "Stratigraphie de la période néo-élamite à Suse (c. 1100–c. 540)." *Paléorient* 4:213–28.

———. 1981a. "Fouilles du chantier Ville Royale II à Suse (1975–1977). I. Les niveaux Elamites." *Cahiers de la délégation archéologique francaise en Iran* 12:9–136.

———. 1981b. "Le Dieu Elamite au serpent et aux eaux jaillissantes." *IrAnt* 16:1–25.

———. 1985. "La Fin du royaume d'Ansan et de Suse et la naissance de l'Empire perse." *Zeitschrift für Assyriologie* 75:266–306.

———. 1989. Review of *Die elamischen Felsenretiefs von Kurangun und Naqs-e Rustam: Iranische Denkmäler, Lieferung 12: Reihe 2*, by Ursula Seidl. *Syria* 66:358–62.

———. 1990. "La Fin de l'Elam: Essai d'analyse et d'interpretation." *IrAnt* 25:47–95.

———. 2003. "Susa and the Highlands: Major Trends in the History of Elamite Civilization." In *YBYN*, 17–38.

Mofidi-Nasrabadi, B. 2005. "Eine Steininschrift der Amar-Suena aus Tappe Bormi (Iran)." *Zeitschrift für Assyriologie* 95:161–71.

———. 2011. "Die Glyptik aus Haft Tappeh: Interkulturelle Aspekte zur Herstellung und Benutzung von Siegeln in der Anfangsphase der Mittelelamischen Zeit." *Elamica* 1.

———. 2014a. "Qualitative Veränderungen in der serienmäßigen Herstellung des Knopfbechers in der Spätbronzezeit Elams." Pages 385–97 in *Recent Trends in the Study of Late Bronze Age Ceramics in Syro-Mesopotamia and Neighbouring*

Regions: Proceedings of the International Workshop in Berlin, 2–5 November 2006. Edited by M. Luciani and A. Hausleiter. Orient-Archäologie 32. Rahden: Verlag Marie Leidorf.

———. 2014b. "Vorbericht der archäologischen Ausgrabungen der Kampagnen 2012–2013 in Haft Tappeh (Iran)." *Elamica* 4:67–168.

Montagne, Ch., and F. Grillot-Susini. 1996. "Les inscriptions royales de Suse, Musée du Louvre (R.M.N., Paris, 1995), par Florence Malbran-Labat." *Nouvelles Assyriologiques Brèves et Utilitaires* 1.33.

Moortgat, A. 1969. *The Art of Ancient Mesopotamia*. London: Phaidon.

Morgan, J. de. 1900. *Recherches archéologiques*. MDP 1. Paris: Ernest Leroux.

Mousavi, A. 1990. "Tépé Horreeye, le bit akitu de Tchogha Zanbil?" Pages 143–45 in *Contribution à l'histoire de l'Iran: Mélanges offerts à Jean Perrot*. Edited by F. Vallat. Paris: Editions Recherche sur les civilisations.

Muscarella, O. W. 1974. "Decorated Bronze Beakers from Iran." *American Journal of Archaeology* 78.3: 239–54.

———. 1992. "Stele of ādda-Hamiti-Inshushinak." In *RCS*, 198–99.

Negahban, E. O. 1991. *Excavations at Haft Tepe, Iran*. Philadelphia: University Museum of Archaeology and Anthropology, University of Pennsylvania.

Nylander, C. 1979. "Achaemenid Imperial Art." Pages 345–59 in *Power and Propaganda: A Symposium on Ancient Empires*. Edited by M. T. Larsen. Copenhagen Studies in Assyriology 7. Copenhagen: Akademisk Forlag.

Oppert, J. 1879. *Le Peuple et la langue des Mèdes*. Paris.

Ornan, T. 2005. *The Triumph of the Symbol*. Fribourg: Academic Press.

Overlaet, B. 2003. *The Early Iron Age in the Posht-e Kuh*. Luristan Excavation Documents 4, Acta Iranica 40. Leuven: Peeters.

———. 2005. "The Chronology of the Iron Age in the Pusht-i Kuh, Luristan." *IrAnt* 40:1–33.

Parrot, A., and J. Nougayrol. 1956. "Asarhaddon et Naqi'a sur un bronze du Louvre (AO 20.185)." *Syria* 33:147–60.

Perrot, G., and C. Chipiez. 1890. *Histoire de l'art dans l'antiquité*. Vol. 5, *Perse, Phrygie, Lidie et Carie, Lycie*. Paris.

Pezard, M. 1916. "Reconstitution d'une stèle d'Untaš NAP GAL." *RA* 13:119–24.

Pittman, H. 2003. "Reconsidering the Trouvaille de la Statuette d'Or." In *YBYN*, 177–91.

Planhol, X. de. 1968. *Les Fondements géographiques de l'histoire de l'Islam*. Paris: Flammarion.

Pongratz-Leisten, B. 1997. "Festzeit und Raumverständnis in Mesopotamien am Beispiel der akītu-Procession." *Ars semeiotica* 20:53–67.

———. 2006. "Prozession(sstraße). A." *Reallexikon der Assyriologie* 11.1–2: 98–103.

Porada, E. 1965. *The Art of Ancient Iran: Pre-Islamic Cultures*. New York: Crown.

———. 1970. *Tchoga Zanbil*. Vol. 4, *La Glyptique*. MDP 42. Paris: Geuthner.

Porter, K. 1821. *Travels in Georgia, Persia, Armenia, Ancient Babylonia, &c, &c*. 2 vols. London.

Postgate, N., and M. Roaf. 1997. "The Shaikhan Relief." *Al-Rāfidān* 18:143–60.

Potts, D. T. 1999. *The Archaeology of Elam: Formation and Transformation of an Ancient Iranian State*. Cambridge: Cambridge University Press.

———. 2004. "The Numinous and the Immanent: Some Thoughts on Kūrangūn and the Rudkhaneh-e Fahliyān." Pages 143–56 in *From Handaxe to Khan: Essays Presented to Peder Mortensen on the Occasion of His 70th Birthday*. Edited by K. von Folsach, H. Thrane, and I. Thuesen. Aarhus: Aarhus University Press.

———. 2008a. "The Persepolis Fortification Texts and the Royal Road: Another Look at the Fahliyan Area." Pages 275–301 in *L'Archive des fortifications de Persépolis: État des questions et perspectives de recherches*. Edited by P. Briant, W. Henkelman, and M. Stolper. Persika 12. Paris: De Boccard.

———. 2008b. Review of *The Origins of State Organizations in Prehistoric Highland Fārs, Southern Iran: Excavations at Tall-e Bakun*, by A. Alizadeh et al. Oriental Institute Publications 128 (Chicago: Oriental Institute of the University of Chicago, 2006). *Bibliotheca Orientalis* 65.1–2: 196–206.

———. 2010a. "Monarchy, Factionalism and Warlordism: Reflections on Neo-Elamite Courts." Pages 107–37 in *Der Achaemenidenhof / The Achaemenid Court: Akten des 2. Internationalen Kolloquiums zum Thema "Vorderasien im Spannungsfeld klassischer und altorientalischer Überlieferungen," Landgut Castelen bei Basel, 23.–25. Mai 2007*. Edited by B. Jacobs and R. Rollinger. Wiesbaden: Harrassowitz.

———. 2010b. "Temple Building and Appendix 2: Catalogue of Elamite Sources." Pages 49–60 and 479–509 in *From the Foundations to the Crenellations: Essays on Temple Building in the Ancient Near East and Hebrew Bible*. Edited by M. J. Boda and J. Novotny. Münster: Ugarit Verlag.

———. 2014. *Nomadism in Iran: From Antiquity to the Modern Era*. Oxford: Oxford University Press.

———. 2016. *The Archaeology of Elam: Formation and Transformation of an Ancient Iranian State*. 2nd ed. Cambridge: Cambridge University Press.

———. Forthcoming. "The Epithet 'Sister's Son' in Ancient Elam: Aspects of the Avunculate in Cross-Cultural Perspective."

Potts, D. T., Alireza Asgari Chaverdi, Cameron Petrie, Amanda Dusting, F. Farhadi, Kate McRae, S. Shikhi, E. H. Wong, Arash Lashkari, and A. Javanmard Zadeh. 2007. "The Mamasani Archaeological Project, Stage Two: Excavations at Qaleh Kali (Tappeh Servan/Jinjun [MS 46])." *Iran* 45:287–300.

Potts, D. T., and K. Roustaei, eds. 2006. *The Mamasani Archaeological Project Stage One: A Report on the First Two Seasons of the ICAR–University of Sydney Expedition to the Mamasani District, Fārs Province, Iran*. Tehran: Iranian Center for Archaeological Research.

Potts, D. T., K. Roustaei, C. A. Petrie, and L. R. Weeks, eds. 2009. *The Mamasani Archaeological Project Stage One*. Oxford: Archaeopress.

Rappaport, R. A. 1999. *Ritual and Religion in the Making of Humanity*. Cambridge: Cambridge University Press.

Rashid, S. A. 1984. *Musikgeschichte in Bildern: Mesopotamien*. Leipzig: Deutscher Verlag für Musik.

Rawlinson, H. C. 1839. "Notes on a March from Zohab, at the Foot of Zagros Along the Mountains to Khuzistan (Susiana), and Thence Through the Province of Lorestān to Kirmanshah



in the Year 1836." *Journal of the Royal Geographic Society* 9:26–116.

———. 1873. *The Sixth Great Oriental Monarchy: or, The Geography, History, and Antiquities of Parthia; Collected and Illustrated from Ancient and Modern Sources.* London: Longmans, Green.

Reade, J. 1977. "Shikaft-i Gugul: Its Date and Symbolism." *IrAnt* 12:33–44.

———. 1987. "Was Sennacherib a Feminist?" Pages 139–45 in *La Femme dans le Proche-Orient antique: Compte rendu de la XXXIIIe rencontre assyriologique internationale (Paris, 7–10 juillet 1986)*. Edited by J.-M. Durand. Paris: Editions Recherche sur les civilisations.

Roach, K. 2008. "The Elamite Cylinder Seal Corpus, c. 3500–1000 BC." Ph.D. diss., University of Sydney.

Roberts, H. E., ed. 1998. *Encyclopedia of Comparative Iconography: Themes Depicted in Works of Art.* Chicago: Fitzroy Dearborn.

Root, M. C. 1979. *The King and Kingship in Achaemenid Art: Essays in the Creation of an Iconography of Empire.* Acta Iranica 19. Leiden: Diffusion, Brill.

———. 2000. "Imperial Ideology in Achaemenid Persian Art: Transforming the Mesopotamian Legacy." *Canadian Society for Mesopotamian Studies Bulletin* 35:19–27.

Sajjidi, M., and H. T. Wright. 1979. "Test Excavations in the Elamite Layers at the Izeh East Face." Pages 106–13 in *Archaeological Investigations in Northeastern Xuzestan*. Edited by H. T. Wright. Technical Reports 10, Research Reports in Archaeology 5. Ann Arbor: Museum of Anthropology, University of Michigan.

Sami, A. 1971. *Persepolis: Takht-I-Jamshid.* Shiraz: Musavi Print Office.

Sancisi-Weerdenburg, H. 1986. "The Quest for an Elusive Empire." Pages 261–74 in *Centre and Periphery: Proceedings of the Groningen 1986 Achaemenid History Workshop*. Edited by H. Sancisi-Weerdenburg and A. Kuhrt. Achaemenid History 4. Leiden: Nederlands Institut voor het Nabije Oosten.

Sarre, F., and E. Herzfeld. 1910. *Iranische Felsreliefs.* Berlin: Ernst Wasmuth.

Sayce, A. H. 1874. "The Language of the Cuneiform Inscriptions of Elam and Media." *Transactions of the Society of Biblical Archaeology* 3:465–85.

Schachner, A. 2004. "Birkleyn/Tigris Tunnel." http://www.vaa.fak12.uni-muenchen.de/ Birkleyn/index.htm. http://www.vorderas-archaeologie.unimuenchen.de/forschung/abgeschl_projekte/tigristunnel/index.html.

Scheil, V. 1901. *Textes élamites-anzanites, première série.* MDP 3. Paris: Ernest Leroux.

———. 1908. "Kudurru de Melišihu." In *MDP*, 10:87–94, pls. 11–13.

———. 1911. *Textes élamites-anzanites, quatrième série.* MDP 11. Paris: Ernest Leroux.

———. 1939. *Mélanges épigraphiques.* Mémoires de la mission archéologique en Perse 28. Paris: Ernest Leroux.

Schiffer, M. B. 1972. "Archaeological Context and Systemic Context." *American Antiquity* 37.2: 156–65.

Schippmann, K. 1971. *Die iranischen Feuerheiligtümer.* Religionsgeschichtliche Versuche und Vorarbeiten 31. Berlin: De Gruyter.

Schmidt, E. F. 1939. *The Treasury of Persepolis and Other Discoveries in the Homelands of the Achaemenians.* Chicago: University of Chicago Press.

———. 1953. *Persepolis I.* Chicago: University of Chicago Press.

———. 1957. *Persepolis II.* Chicago: University of Chicago Press.

———. 1970. *Persepolis III.* Chicago: University of Chicago Press.

Schmidt, J. 1978. *Uruk-Warka: Vorläufiger Bericht 28.* Berlin: Verlag der Akadamie der Wissenschaften.

Scully, V. 1962. *The Earth, The Temple, and the Gods: Greek Sacred Architecture.* New Haven: Yale University Press.

Seidl, U. 1965. "Zur Umarbeitung zweier Stelenbekronungen aus Susa und anderer altorientalischen Reliefs." *Berliner Jahrbuch für Vor- und Frühgeschichte* 5:175–86.

———. 1986. *Die Elamischen Felsreliefs von Kurangûn und Naqsh-e Rustam.* Berlin: Deutsches Archaeologisches Institut.

———. 1999. "Naqš-i Rustam." *Reallexikon der Assyriologie* 9:165–68.

Shafer, A. T. 1998. "The Carving of an Empire: Neo-Assyrian Monuments on the Periphery." Ph.D. diss., Harvard University.

Shahbazi, A. S. 1992. "Clothing." In *Encyclopaedia Iranica*, fascicle 7:719–37.

Shibata, D. 2010. "Ritual Contexts and Mythological Explanations of the Emesal Šuilla-Prayers in Ancient Mesopotamia." *Orient* 45:67–86.

Shirazi, F. 1896. *Atar-e Ajam.* Bombay.

Shishegar, A. 2015. *Tomb of the Two Elamite Princesses of the House of King Shutur-Nahunte Son of Indada* [in Persian with an English summary]. Tehran: Cultural Heritage, Handcrafts and Tourism Organization.

Slanski, K. E. 2003. *The Babylonian Entitlement narûs (kudurrus): A Study in Their Form and Function.* Boston: American Schools of Oriental Research.

Smith, D., C. Simpson, and I. Davies. 1981. *Mugabe.* London: Sphere.

Smith, D. E. 2012. "The Greco-Roman Banquet as a Social Institution." Pages 23–33 in *Meals in the Early Christian World: Social Formation, Experimentation, and Conflict at the Table*. Edited by D. E. Smith and H. E. Taussig. New York: Palgrave Macmillan.

Sollberger, E. 1965. "A New Inscription of Šilhak-Inšušinak." *Journal of Cuneiform Studies* 19:31–32.

Spycket, A. 1981. *La statuaire du Proche-Orient ancien.* Leiden: Brill.

———. 1995. "Reliefs, Statuary, and Monumental Paintings in Ancient Mesopotamia." Pages 2583–600 in *Civilizations of the Ancient Near East*. Edited by J. M. Sasson. New York: Scribner's.

Steadman, S. 2005. "Reliquaries in the Landscape: Mounds as Matrices of Human Cognition." Pages 286–307 in *Archaeologies of the Middle East: Critical Perspectives*. Edited by S. Pollock and R. Bernbeck. Malden: Blackwell.

Stein, A. 1940. *Old Routes of Western Iran.* London: Macmillan.

Steve, M.-J., and H. Gasche. 1996. "L'acces a l'au-dela, a Suse." Pages 329–48 in *Collectanea Orientalia: Histoire, arts de l'espace et industrie de la terre; Etudes offertes en hommage à Agnès Spycket*. Edited by H. Gasche and B. Hrouda. Civilisations du Proche-Orient 3. Paris: Recherches et publications.

Steve, M.-J., F. Vallat, and H. Gasche. 2002. "Suse." In *Supplément au Dictionnaire de la Bible*, 74:359–651.

Stolper, M. W. 1984. "Political History." Pages 89–96 in *Elam: Surveys of Political History and Archaeology*. Edited by E. Carter and M. W. Stolper. Berkeley: University of California Press.

———. 1978. "Inscribed Fragments from Khuzistān." *Cahiers de la délégation archéologique francaise en Iran* 8:89–96.

———. 1988. "Mālamīr. B. Philologisch." *Reallexikon der Assyriologie* 7:276–81.

Stronach, D. 1985. "The Apadana: A Signature of the Line of Darius I." Pages 433–45 in *De l'Indus aux Balkans: Recueil à la mémoire de Jean Deshayes*. Edited by J.-L. Huot, M. Yon, and Y. Calvet. Paris. Editions Recherche sur les civilisations.

———. 2004. "Notes on a Fortified Building and a 'Yurt' in Adjacent Registers of the Arjān Bowl." Pages 711–28 in *A View from the Highlands: Archaeological Studies in Honour of Charles Burney*. Edited by A. Sagona. Leuven: Peeters.

Sumner, W. 1974. "Excavations at Tall-i Malyan, 1971–72." *Iran* 12:55–80.

———. 1986. "Achaemenid Settlement in the Persepolis Plain." *American Journal of Archaeology* 90:3–31.

Tallon, F. 1992a. "The 'Trouvaille de la statuette d'or' from the Inšušinak Temple Precinct." In *RCS*, 145–48.

———. 1992b. "Statue of Queen Napir-Asu." In *RCS*, 132–35.

Tallon, F., L. Hurtel, and F. Drilhon. 1989. "Un aspect de la métallurgie du cuivre à Suse: La petite statuaire du IIe millénaire avant J.-C." *IrAnt* 24:121–51.

Tavernier, J. 2004. "Some Thoughts on Neo-Elamite Chronology." *Achaemenid Research on Texts and Archaeology* 2004.003:1–44.

Thompson, C. R., and R. W. Hutchinson. 1931. "The Site of the Palace of Ashurnasirpal at Nineveh, Excavated in 1929–30 on Behalf of the British Museum." *Annals of Archaeology and Anthropology* 18:79–112.

Toscanne, R. 1911. "Etudes sur le serpent: Figure et symbole dans l'antiquité élamite." In *MDP*, 12:154–228.

Trokay, M. 1991. "Les origines du dieu élamite au serpent." Pages 153–61 in *Mésopotamie et Elam: Actes de la XXXVIIième Rencontre Assyriologique Internationale, Gand, 10–14 juillet 1989*. Ghent: University of Ghent.

Ullmann, L. Z. 2010. "Movement and the Making of Place in the Hittite Landscape." Ph.D. diss., Columbia University.

Unger, E. 1938. "Diadem und Krone." *Reallexikon der Assyriologie* 2:201–11.

Vallat, F. 1981. "L'inscription de la stele d'Untash-Napirisha." *IrAnt* 16:27–33.

———. 1983. "Le Dieu enzak: Une divinité dilmunite vénérée à Suse." Pages 93–100 in *Dilmun: New Studies in the Archaeology and Early History of Bahrain*. Edited by D. T. Potts. Berliner Beiträge zum Vorderen Orient 2. Berlin: Dietrich Reimer Verlag.

———. 1984. "Kidin-Hutran a l'époque néo-Elamite." *Akkadica* 37:1–17.

———. 1985. "Hutelutuš-Inšušinak et la famille royale élamite." *RA* 79:43–50.

———. 1995. "Shutruk-Nahunte, Shutur-Nahhunte et l'imbroglio néo-élamite." *Nouvelles Assyriologiques Bréves et Utilitaires* 44.

———. 1996. "Nouvelle analyse des inscriptions neo-elamites." Pages 385–96 in *Collectanea Orientalia: Histoire, arts de l'espace et industrie de la terre; Etudes offertes en hommage à Agnès Spycket*. Edited by H. Gasche and B. Hrouda. Civilisations du Proche-Orient 3. Paris: Recherches et publications.

———. 1997. "Nouveaux problèmes de succession en Elam." *IrAnt* 32:53–70.

———. 1999. "Le Palais élamite de Suse." *Akkadica* 112:34–43.

———. 2004. "Chroniques bibliographiques 4: Curiosités Élamites." *RA* 98:179–84.

———. 2006. "Atta-hamiti-Insusinak, Shutur-Nahhunte et la chronology neo-elamite." *Akkadica* 127:59–62.

———. 2010. "Les principales inscriptions achéménides de Suse." Pages 300–21 in *Le Palais de Darius à Suse: Une résidence royale sur la route de Persépolis à Babylone*. Edited by Jean Perrot. Paris: PUPS, 2010.

Vanden Berghe, L. 1959. *Archéologie de l'Irān ancien*. Leiden: Brill.

———. 1963. "Les Reliefs élamites de Mālamir." *IrAnt* 3:22–39.

———. 1966. *Archéologie de l'Iran ancien*. 2nd ed. Leiden: Brill.

———. 1968. *Het Archeologisch Onderzoek naar de Bronscultuur van Luristan: Opgravingen in Pusht-i Kuh I Kalwali en War Kabud (1965 en 1966)*. Brussels: Paleis der Academiën.

———. 1984. *Reliefs rupestres de L'Iran ancien*. Brussels: Musées royaux d'art et d'histoire.

———. 1986. "Données nouvelles concernant le relief rupestre élamite de Kūrangūn." Pages 157–67 in *Fragmenta historiae Elamicae*. Edited by L. de Meyer, H. Gasche, and F. Vallat. Paris: Editions Recherche sur les Civilisations.

Van Ess, M. V., and F. Pedde. 1992. *Uruk: Kleinfunde II. Ausgrabungen in Uruk-Warka Endberichte*. Vol. 7. Mainz am Rhein: Philipp von Zabern.

Vaux, W. S. W. 1884. *Ancient History from the Monuments: Persia from the Earliest Period to the Arab Conquest*. London.

Vos, R. L. 1999. "Atum." Pages 119–24 in *Dictionary of Deities and Demons in the Bible*. Edited by K. van der Toorn, B. Becking, and P.W.van der Horst. Leiden: Brill.

Vries, J. de. 1991. "Art History." Pages 249–71 in *Art in History and History in Art: Studies in Seventeenth-Century Dutch Culture*. Edited by D. Freedberg and J. de Vries. Chicago: University of Chicago Press.

Walser, G. 1966. *Die Völkerschaften auf den Reliefs von Persepolis: Historische Studien über den sogenannten Tributzug an der Apadanatreppe*. Berlin: Mann.

Weissbach, F. H. 1894. "Neue Beiträge zur Kunde der susischen Inschriften." *Abhandlungen der Sächsischen Akademie der Wissenschaften zur Leipzig* 34:731–77.

Wicks, Y. 2015. *Bronze "Bathtub" Coffins in the Context of 8th–6th Century BC Babylonian, Assyrian and Elamite Funerary Practices*. Oxford: Archaeopress.

———. 2017. "'Alas, Short Is the Joy of Life!' Elamite Funerary Practice in the First Half of the First Millennium BCE." Ph.D. diss., University of Sydney.

Wigand, K. 1912. "Thymiateria." PhD. diss., Rheinischen Friedrich-Wilhelms-Universität.

Wiggerman, F A. M. 1997. "Transtigridian Snake Gods." Pages 33–55 in *Sumerian Gods and Their Representation*. Edited by I. L. Finkel and M. J. Geller. Cuneiform Monographs 7. Groningen: STYX.

Wright, H. T., ed. 1979. *Archaeological Investigations in Northeastern Xuzestan*. Technical Reports 10, Research Reports in Archaeology 5. Ann Arbor: Museum of Anthropology, University of Michigan.

Wright, H. T., and E. Carter. 2003. "Archaeological Survey on the Western Ram Hormuz Plain." In *YBYN*, 61–82.

Yamada, S. 2000. *The Construction of the Assyrian Empire: A Historical Study of the Inscriptions of Shalmanesar III Relating to His Campaigns in the West*. Leiden: Brill.

Zadok, R. 1994. "Elamites and Other Peoples from Iran and the Persian Gulf Region in Early Mesopotamian Sources." *Iran* 32:31–51.

Zeidi, M., B. McCall, and A. Khosrowzadeh. 2009. "Survey of Dasht-e Rostam-e Yek and Dasht-e Rostam-e Do." Pages 147–59 in *The Mamasani Archaeological Project Stage One*. Edited by D. T. Potts, K. Roustaei, C. A. Petrie, and L. R. Weeks. Oxford: Archaeopress.

Plates

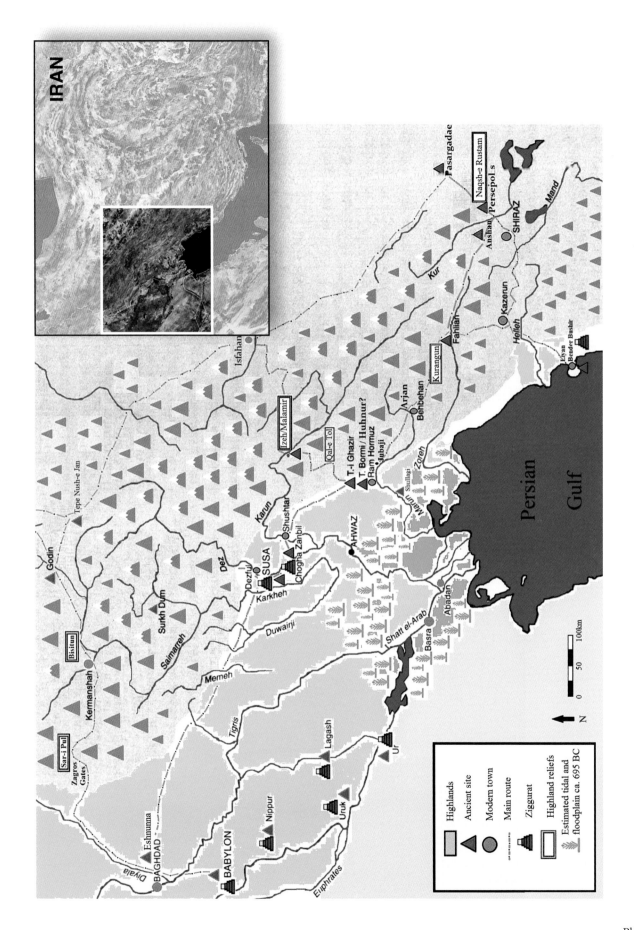

Plate 1

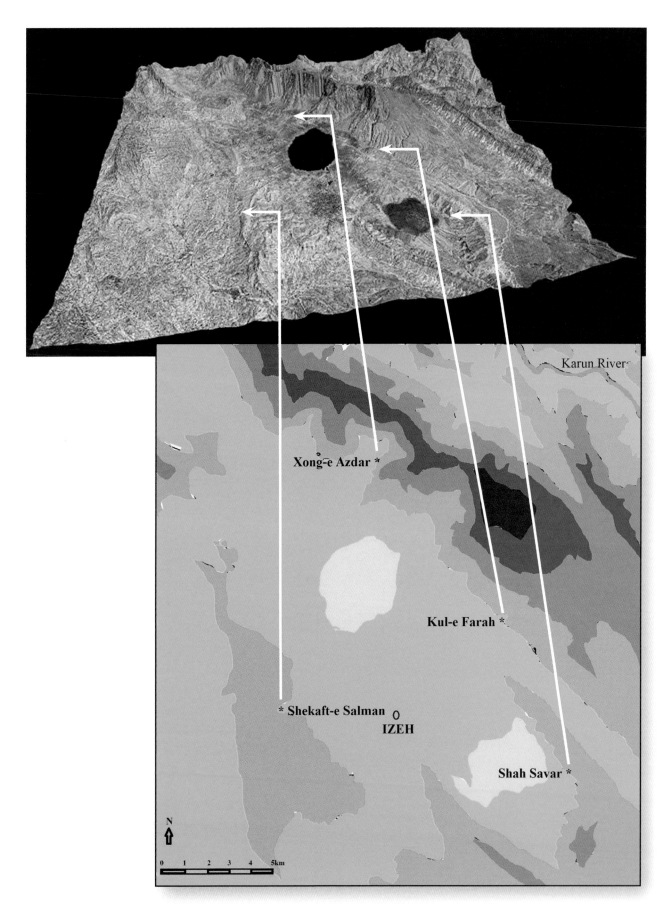

Plate 2

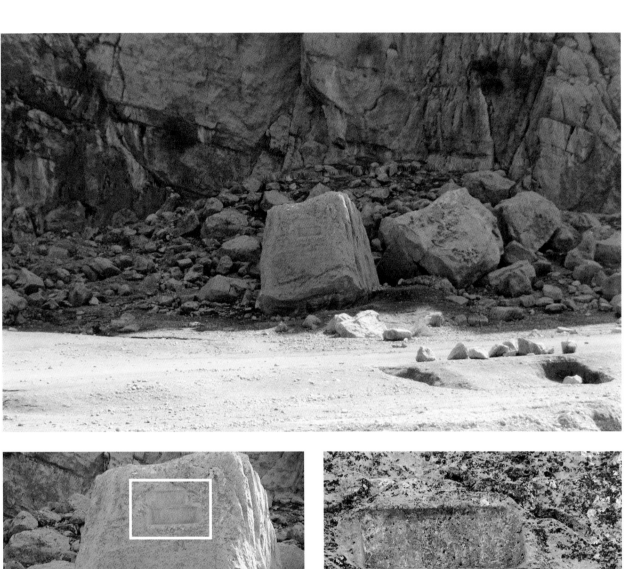

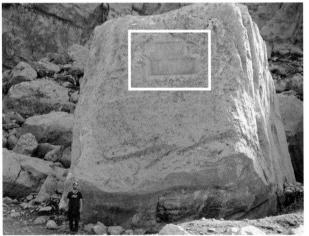

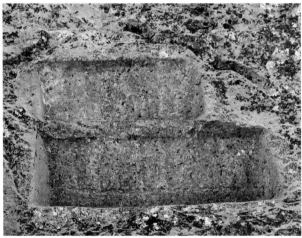

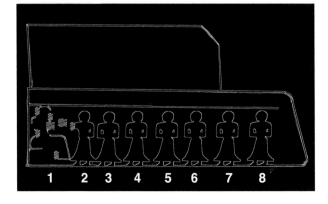

1 2 3 4 5 6 7 8

Plate 3

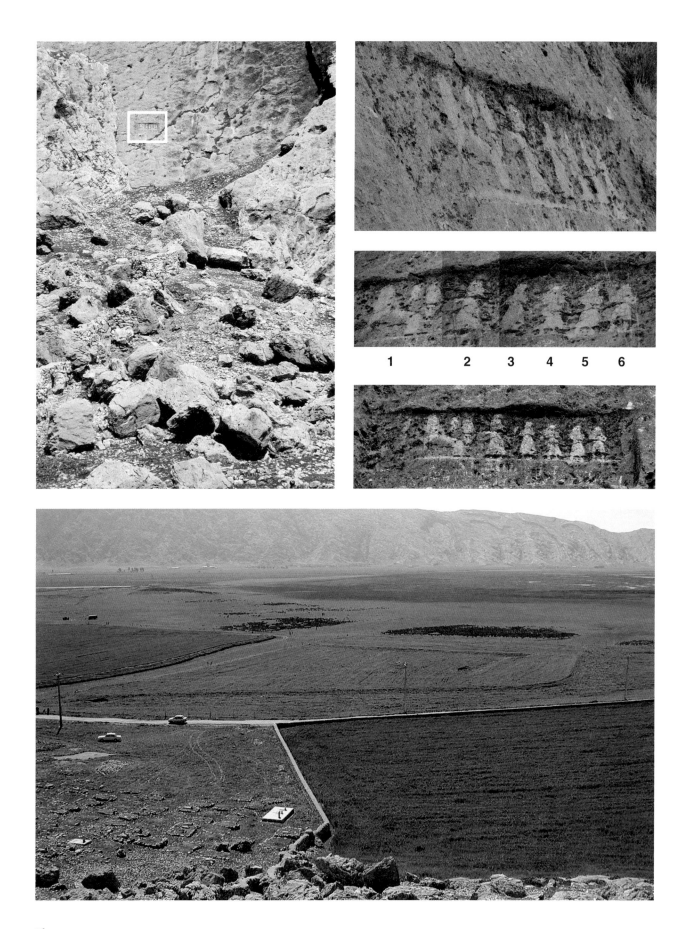

Plate 4

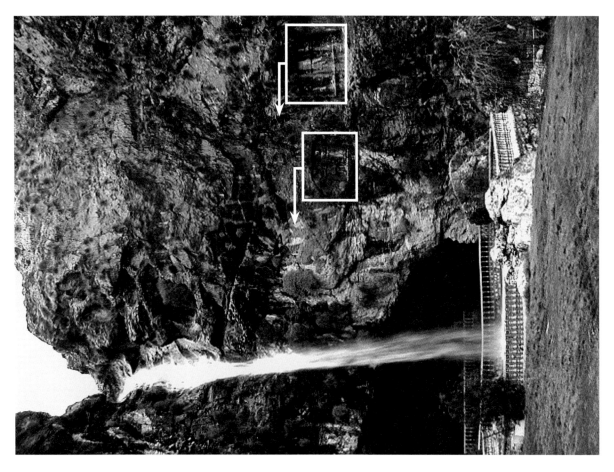

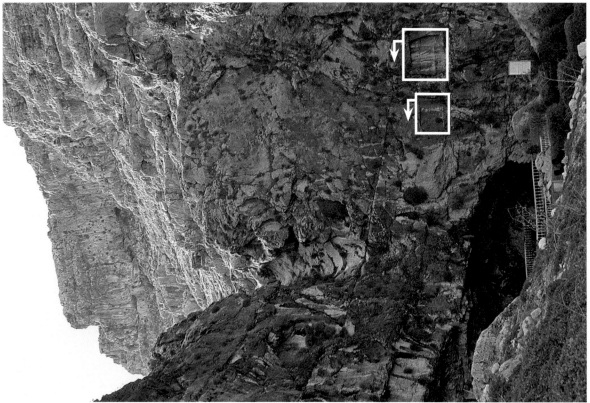

Plate 5

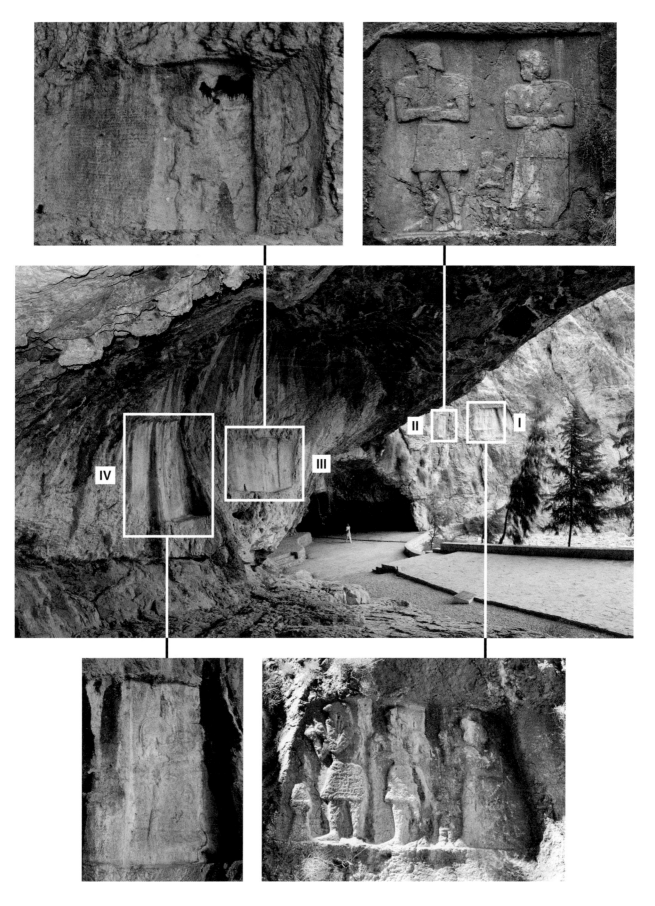

Plate 6

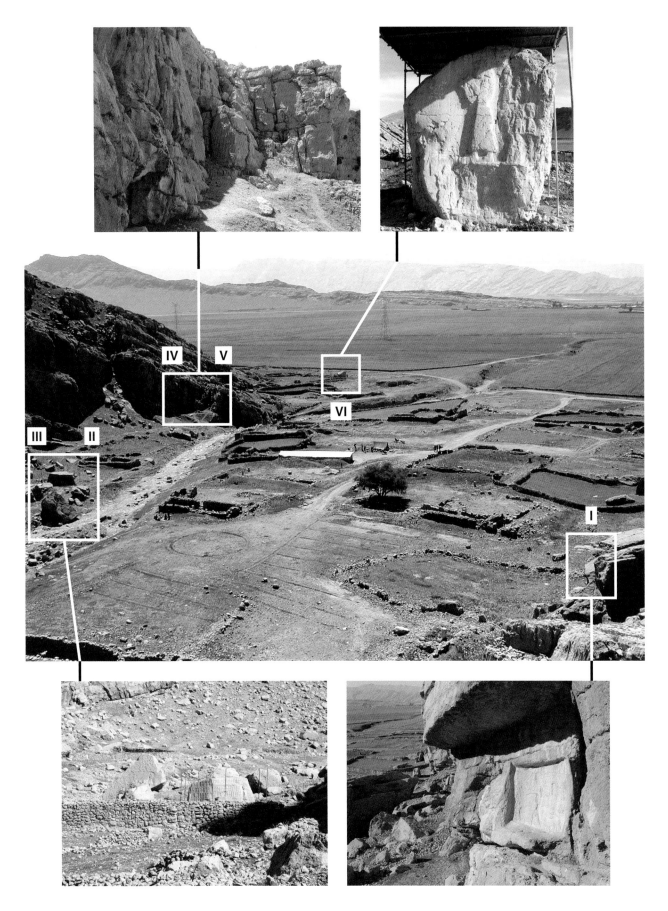

IV V

III II

VI

I

Plate 7

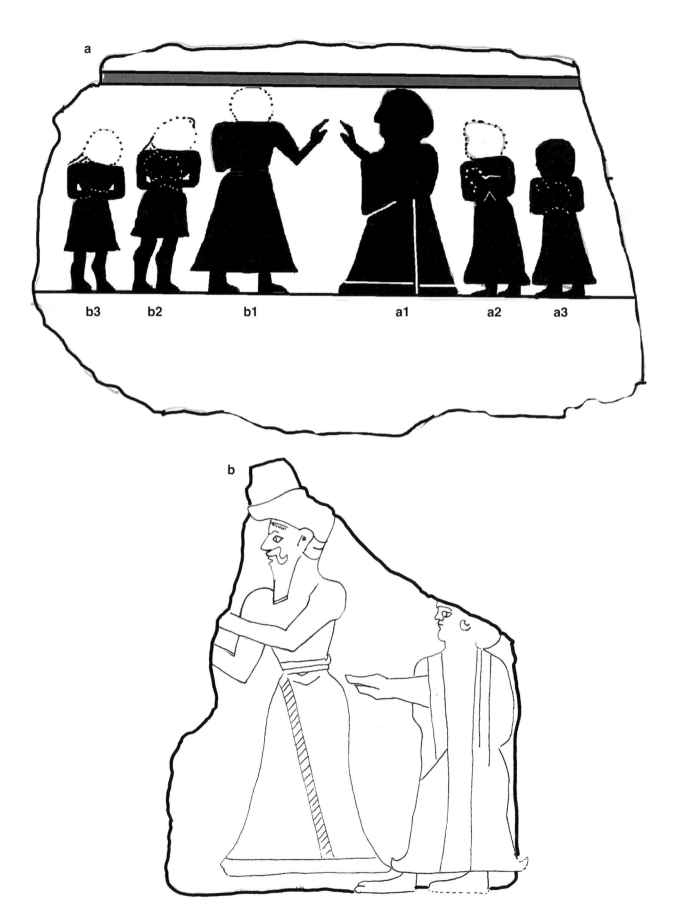

a

b3 b2 b1 a1 a2 a3

b

Plate 8

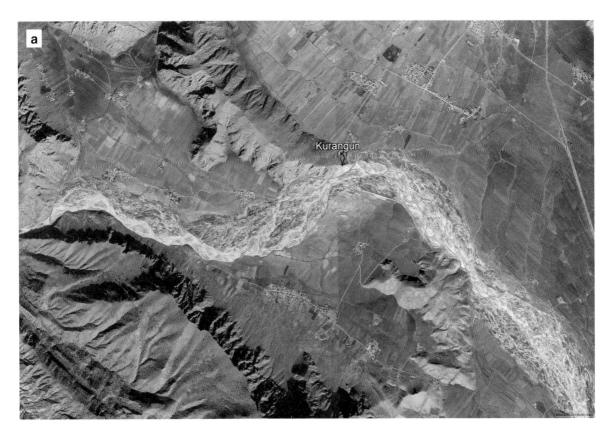

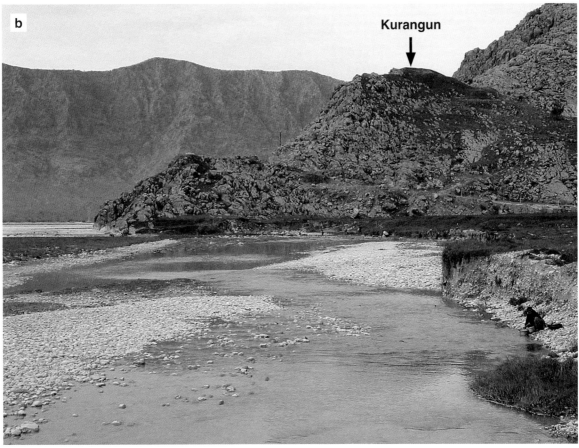

Plate 9

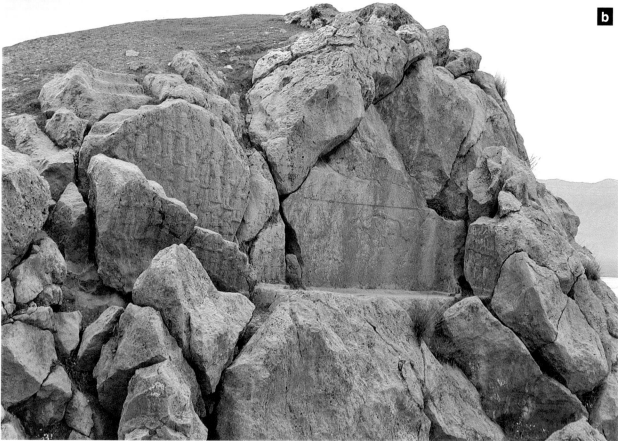

Plate 10

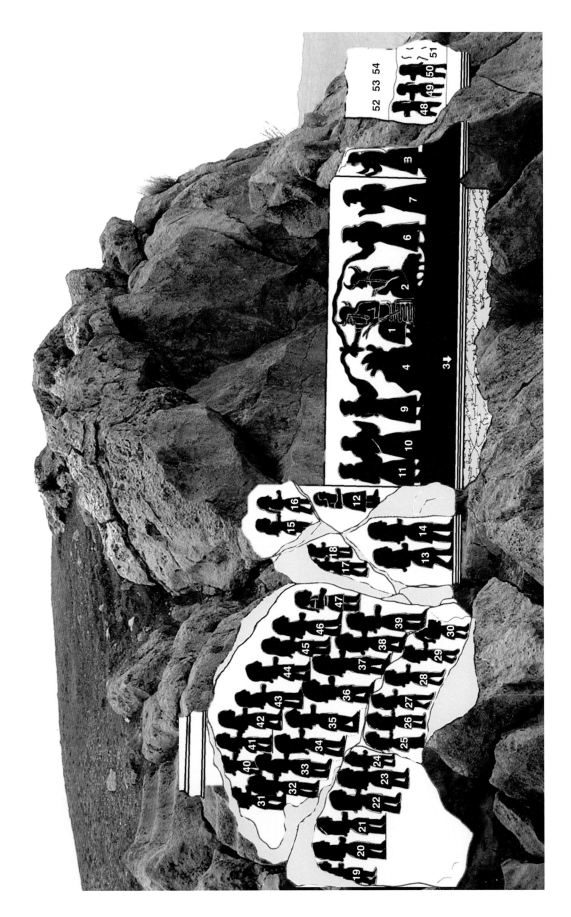

Plate 11

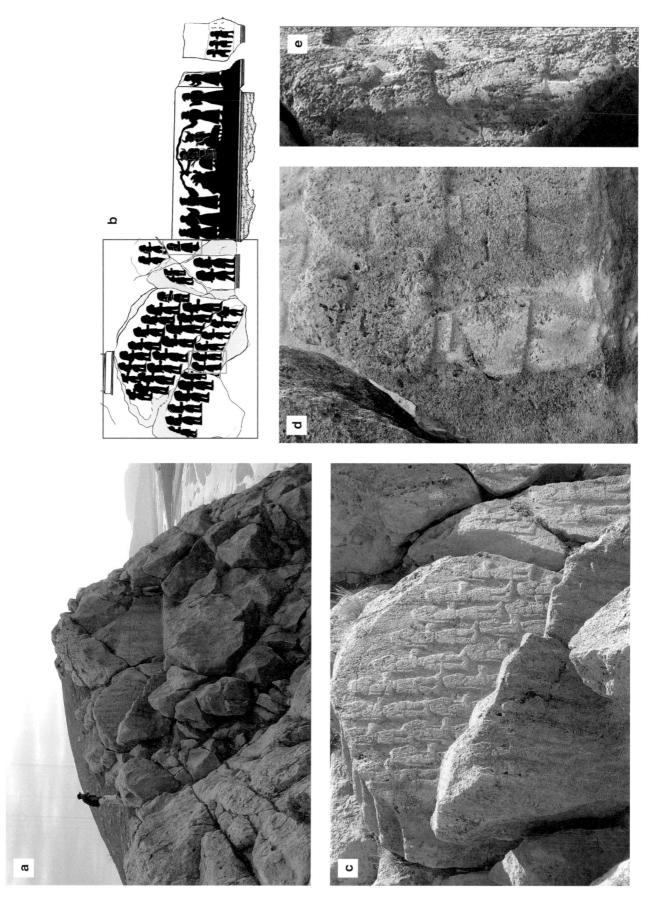

Plate 12

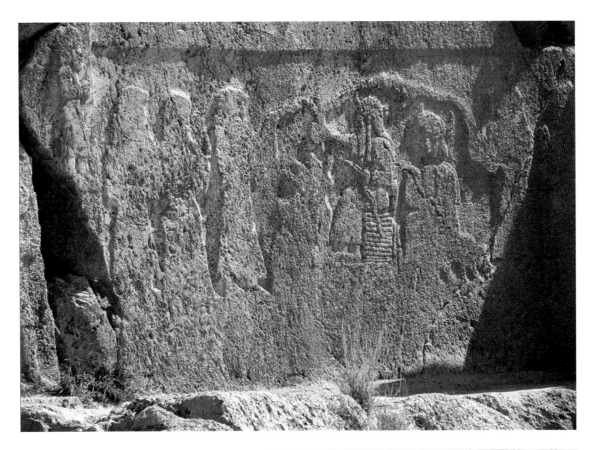

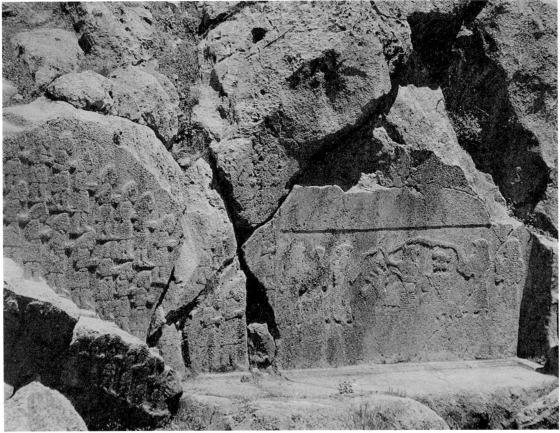

Plate 13

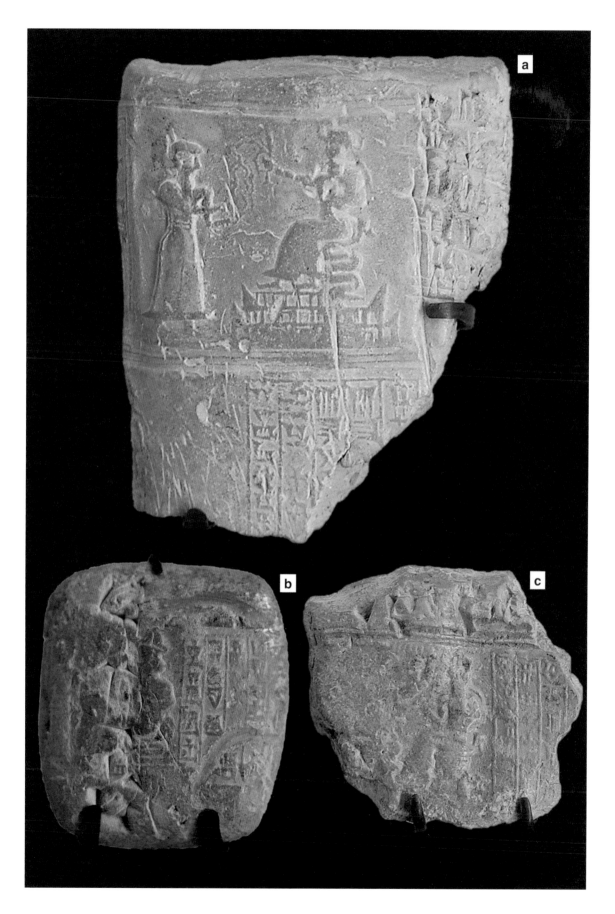

Plate 14

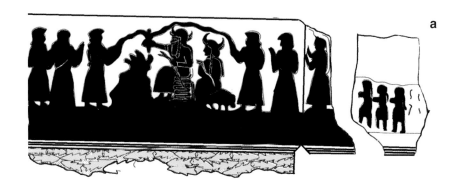

a

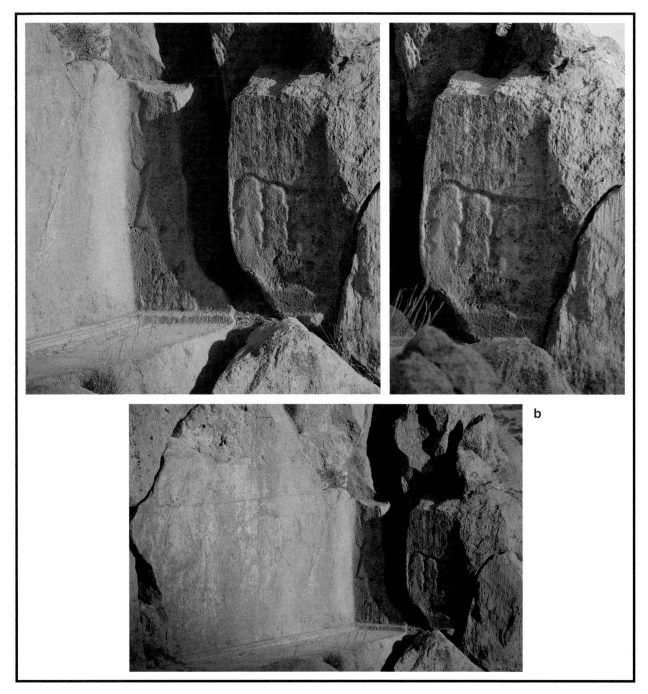

b

Plate 15

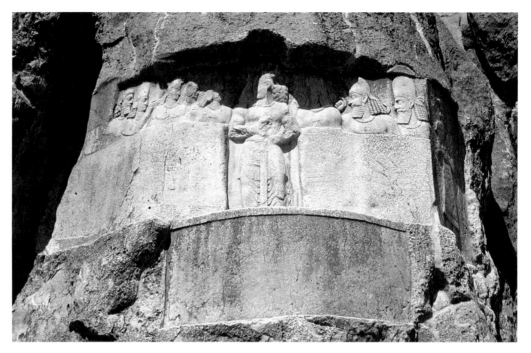

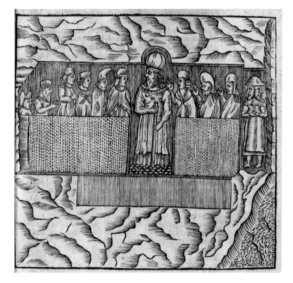

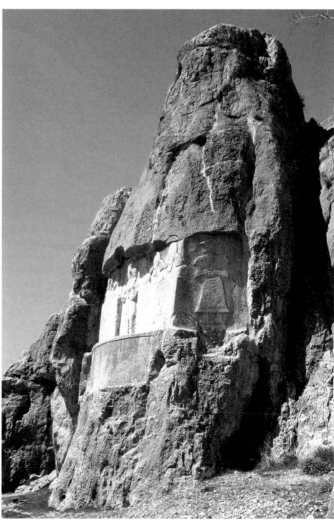

Plate 16

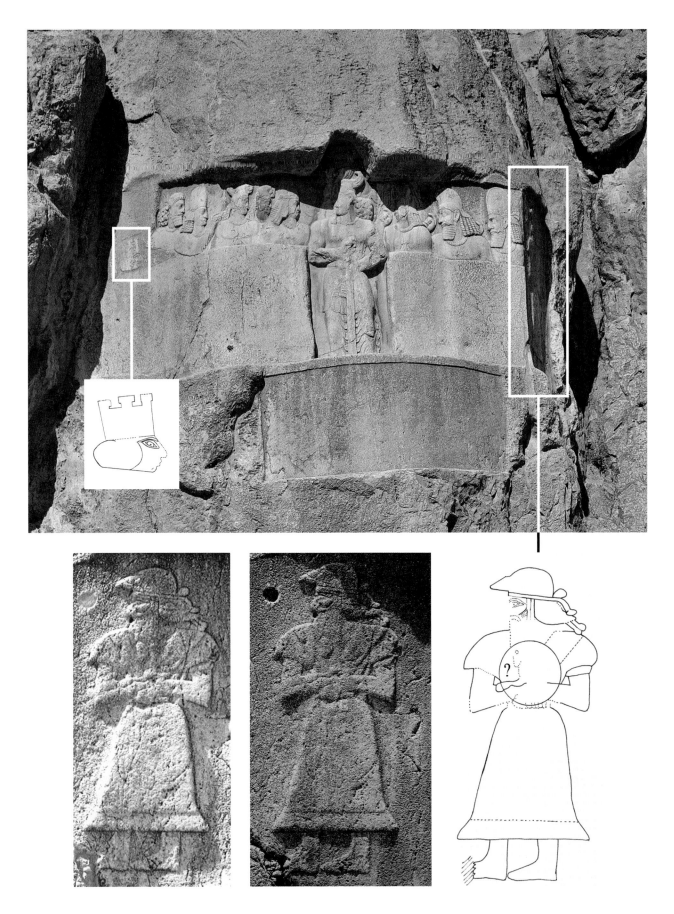

Plate 17

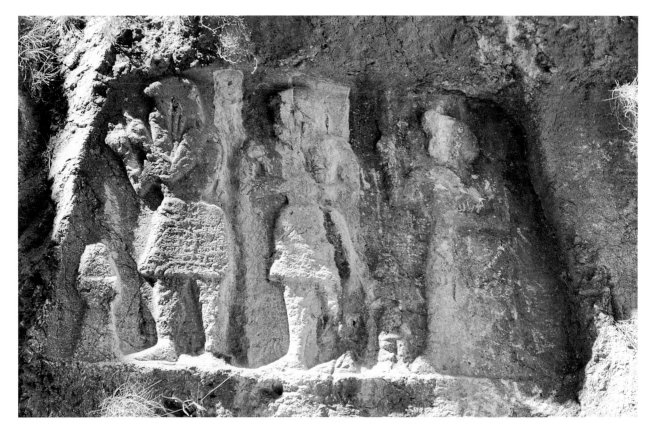

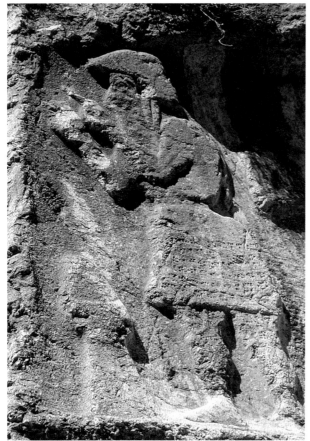

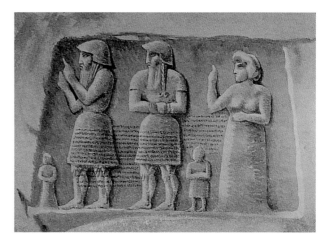

Plate 18

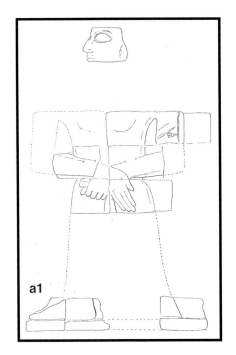

a1

a

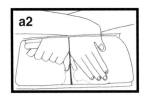

a2

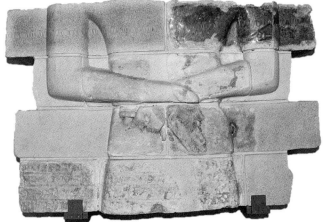

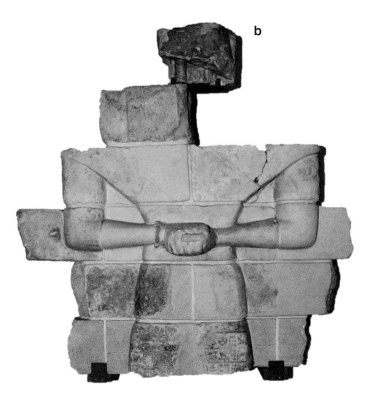

b

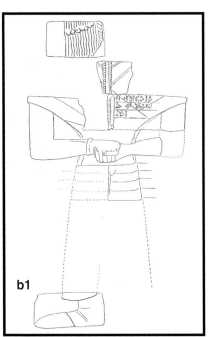

b1

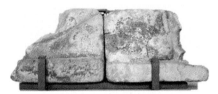

a1

b1

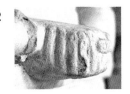

b2

Plate 19

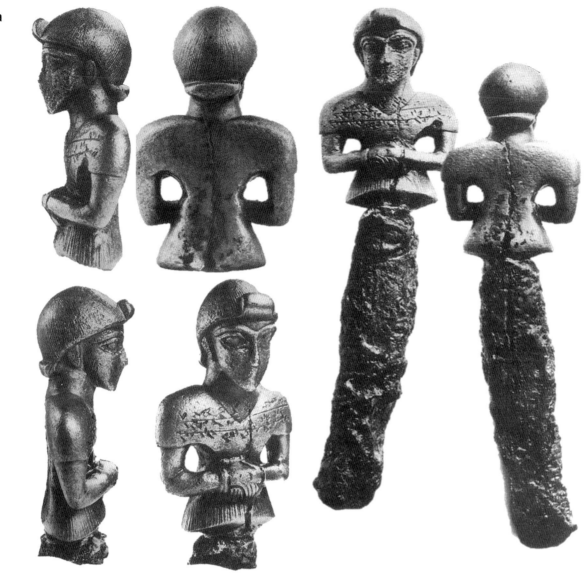

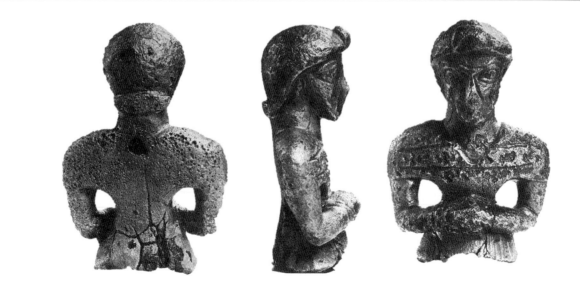

Plate 20

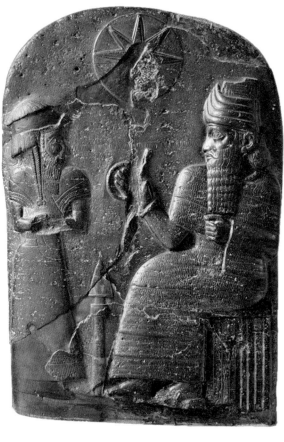

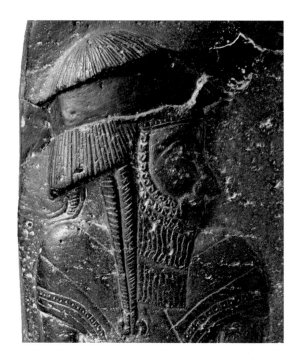

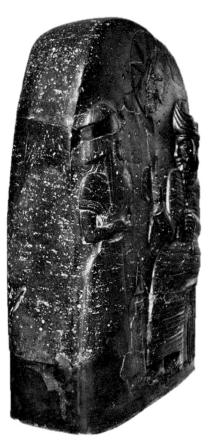

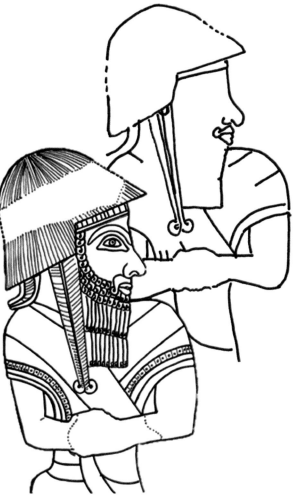

Plate 21

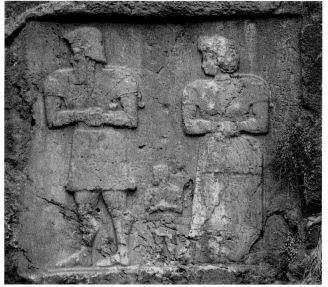
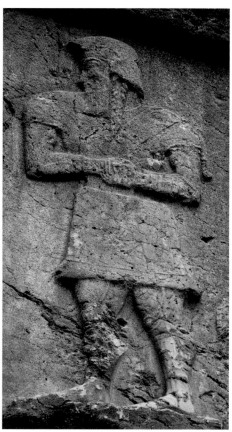
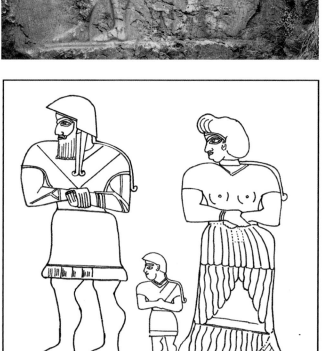
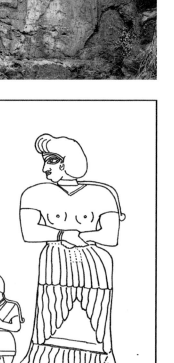

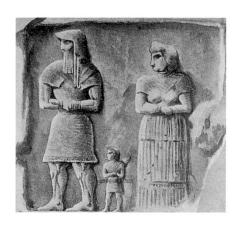

Plate 22

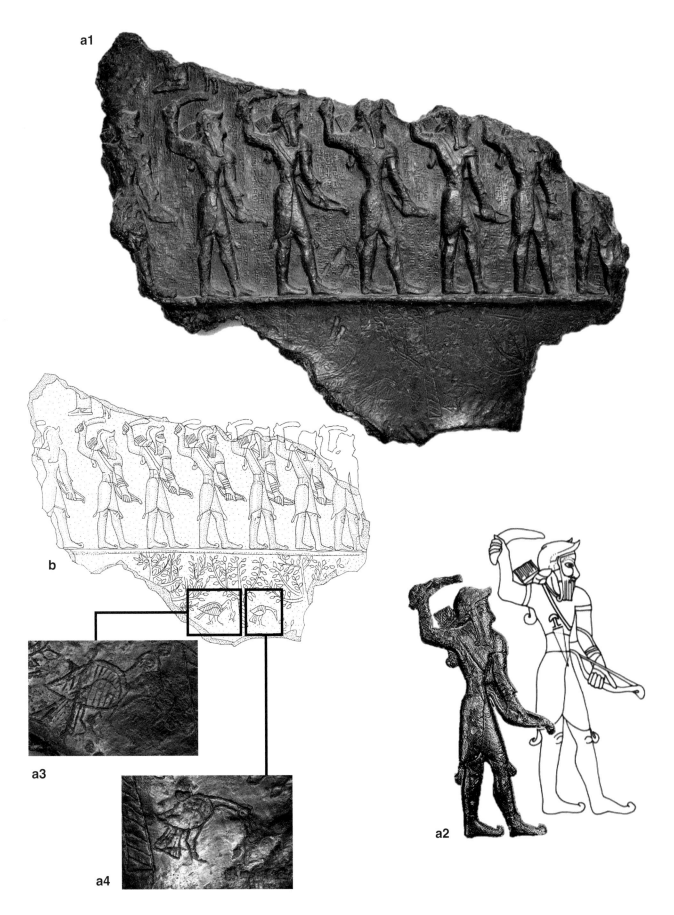

a1

b

a3

a4

a2

Plate 23

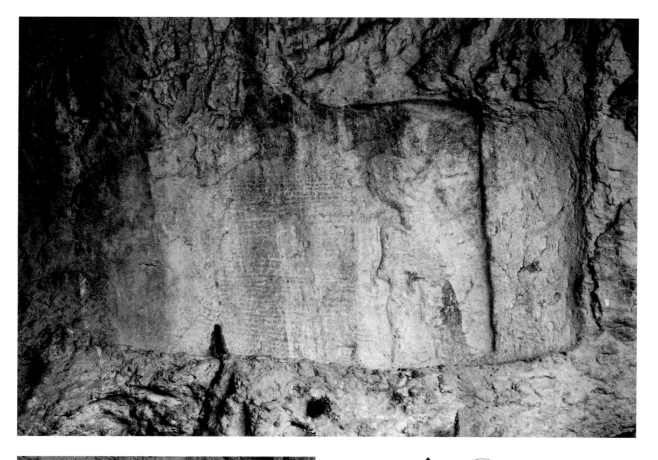

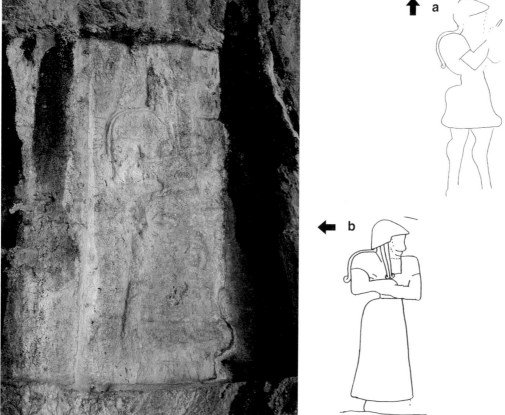

Plate 24

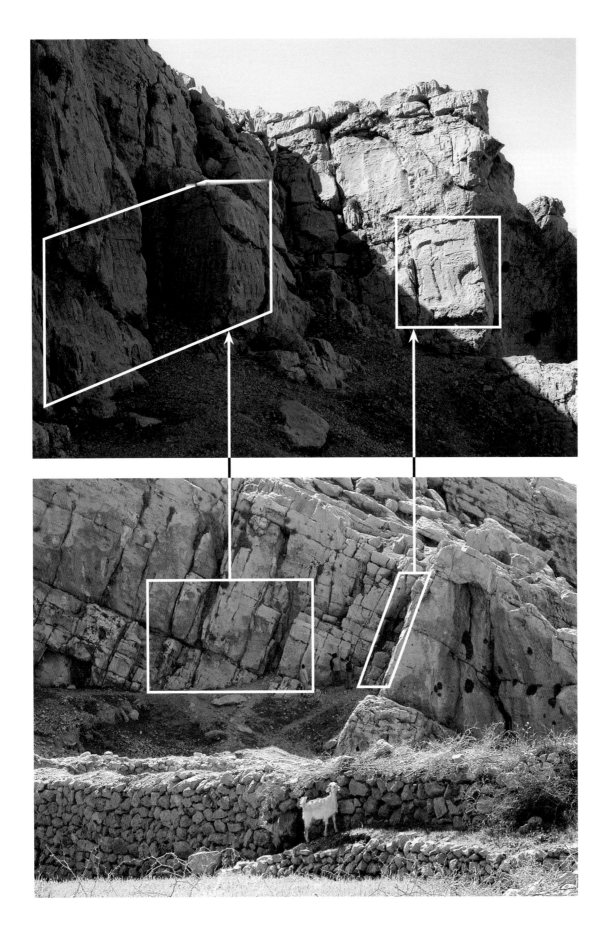

Plate 25

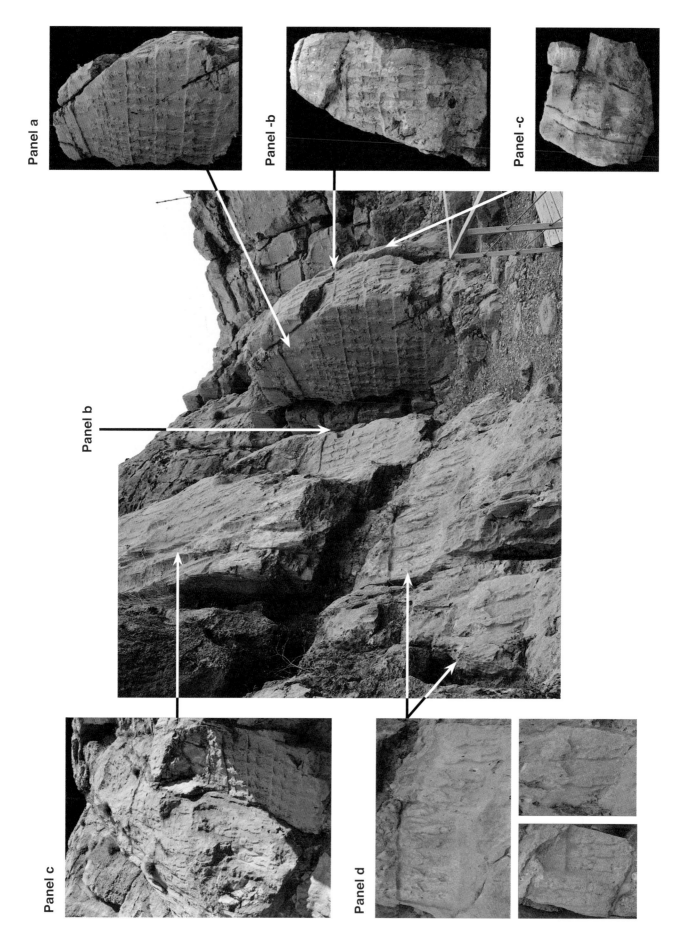

Panel a

Panel -b

Panel -c

Panel b

Panel c

Panel d

Plate 26

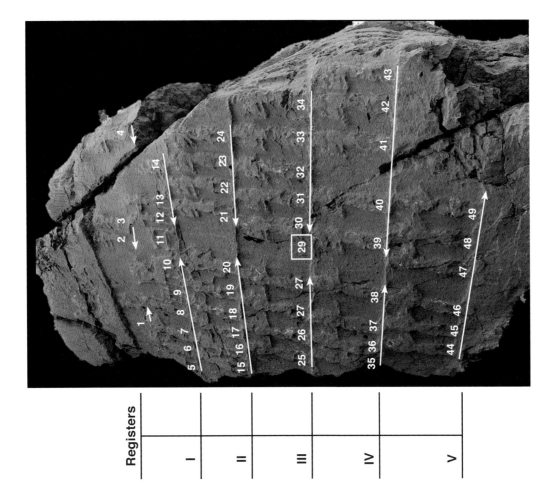

Registers

I

II

III

IV

V

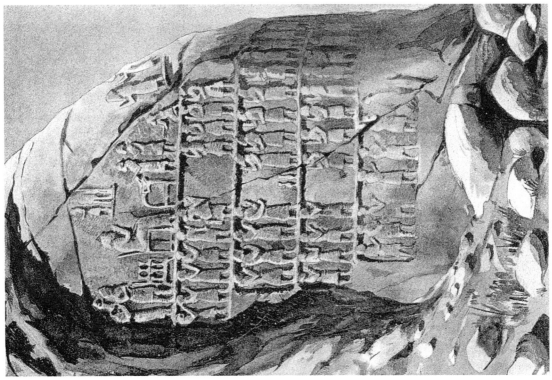

Plate 27

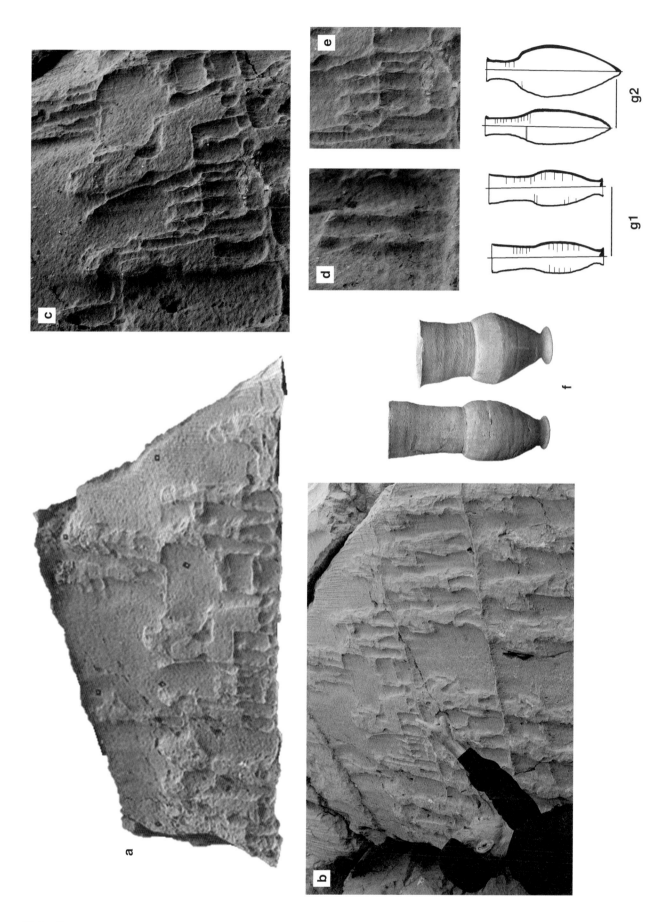

Plate 28

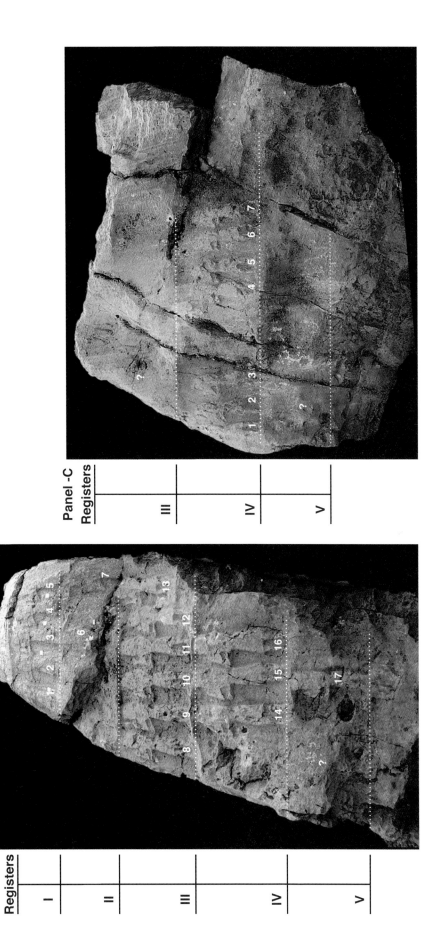

Plate 29

Panel BI
Registers

I

II

III
Missing?

16 17 18

19 20 21

Panel BII
Registers

I

II

III

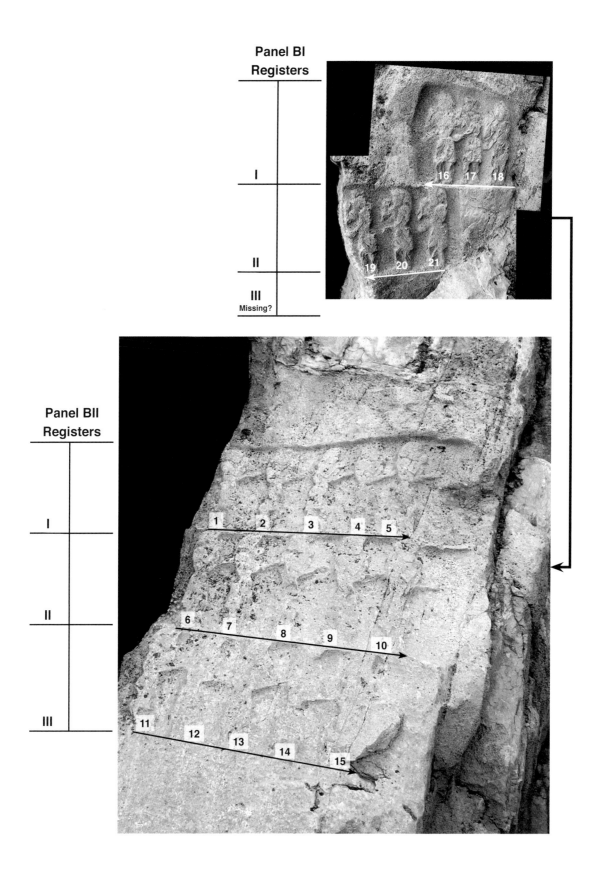

1 2 3 4 5

6 7 8 9 10

11 12 13 14 15

Plate 30

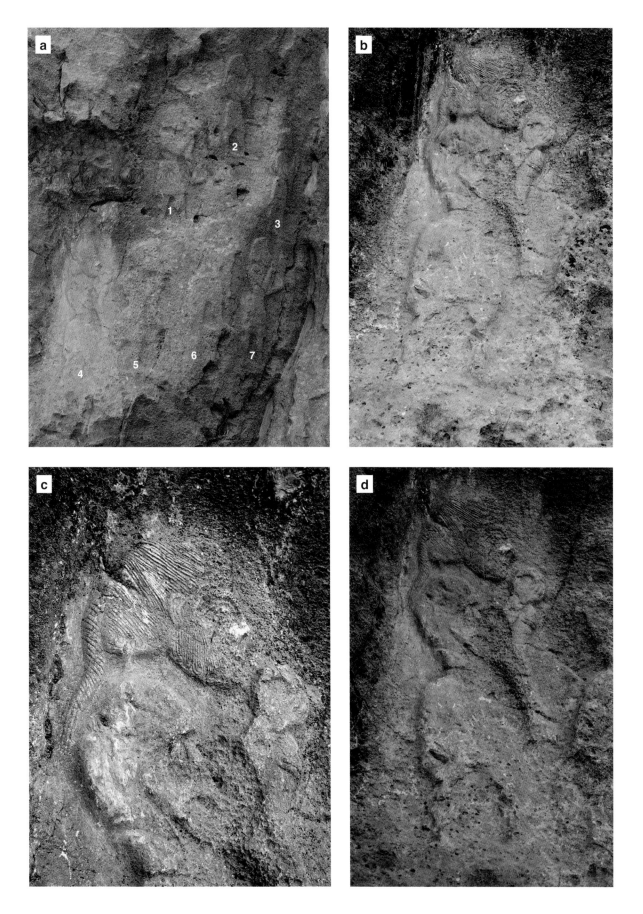

Plate 31

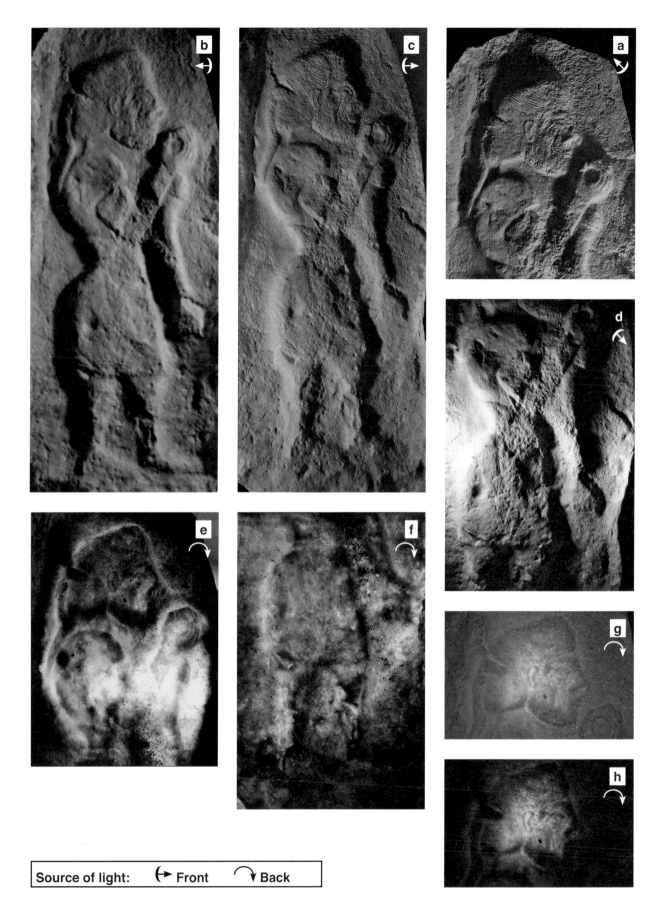

Source of light: ↔ Front ⌒ Back

Plate 32

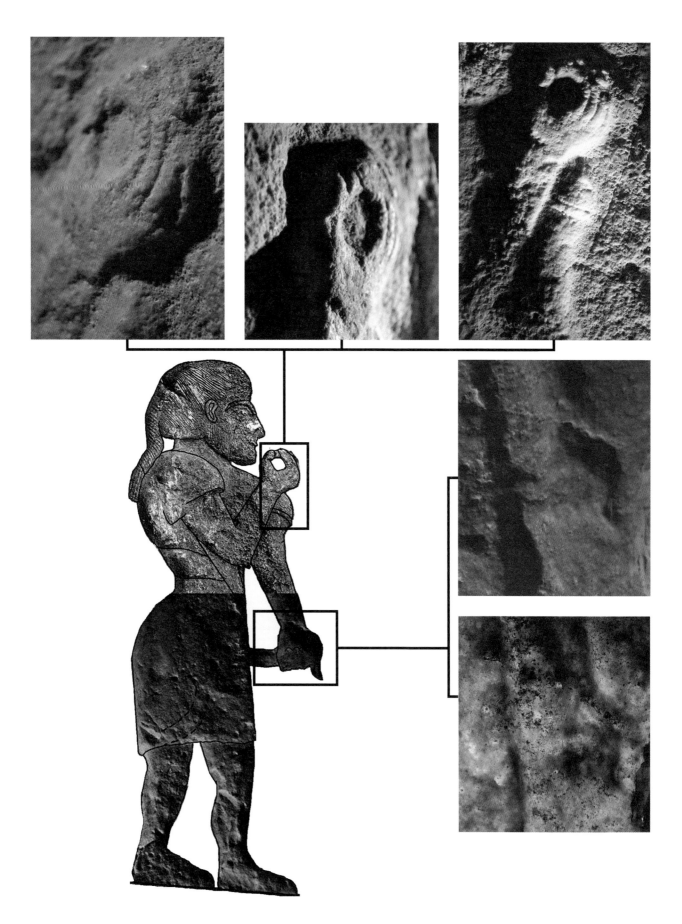

Plate 33

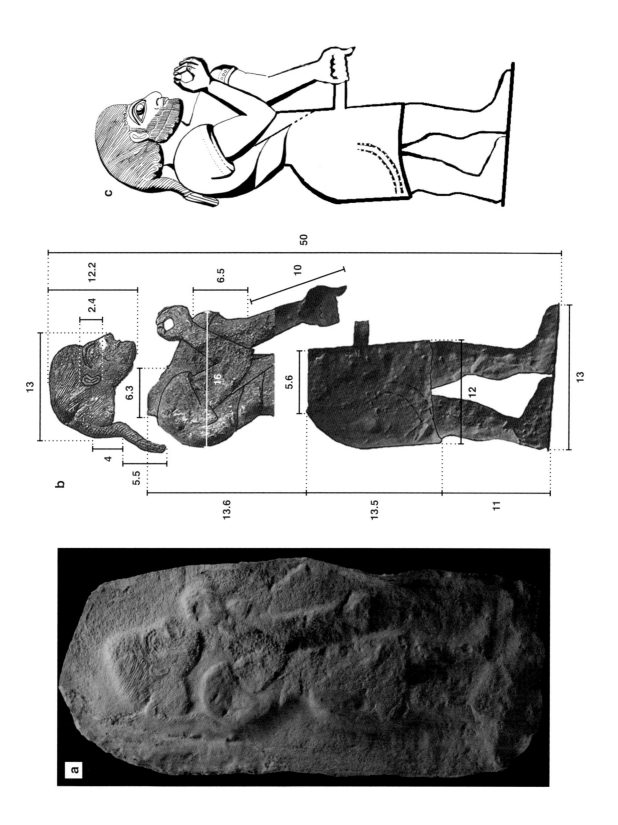

50

12.2

2.4

13

6.3

4

5.5

b

c

16

6.5

10

5.6

12

13

13.6

13.5

11

a

Plate 34

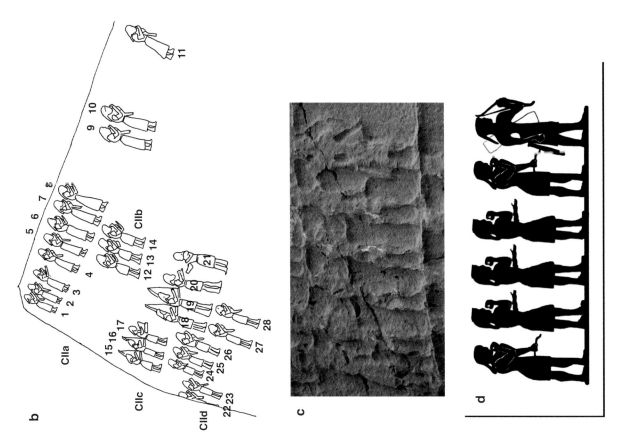

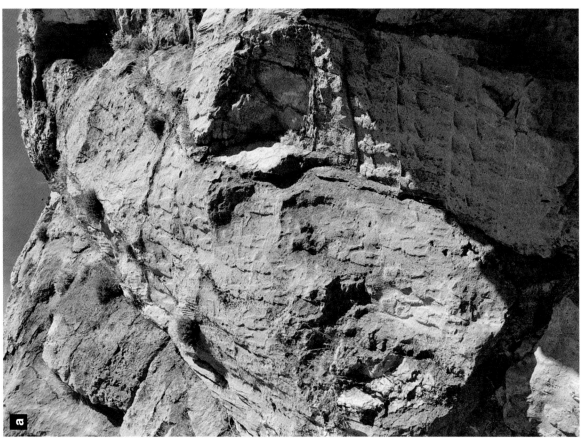

Plate 35

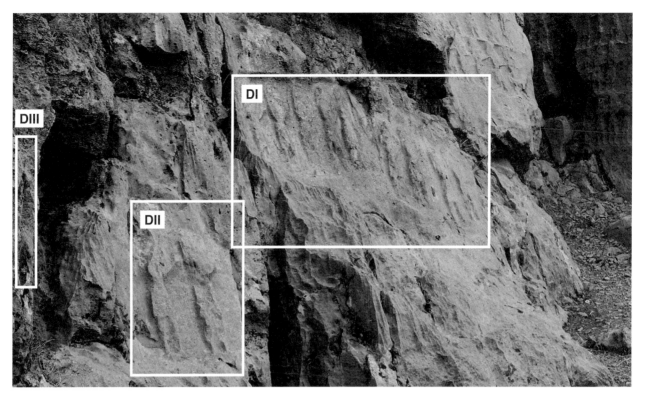

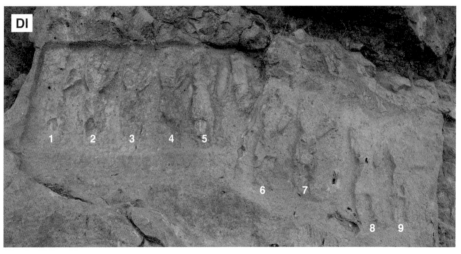

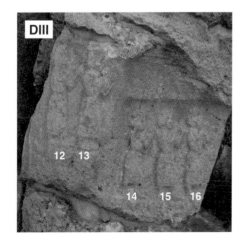

Plate 36

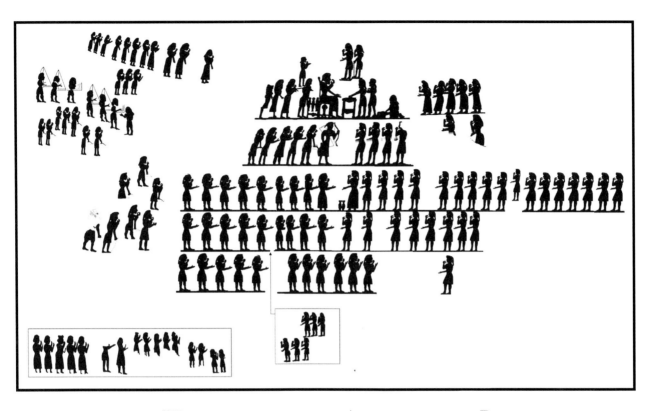

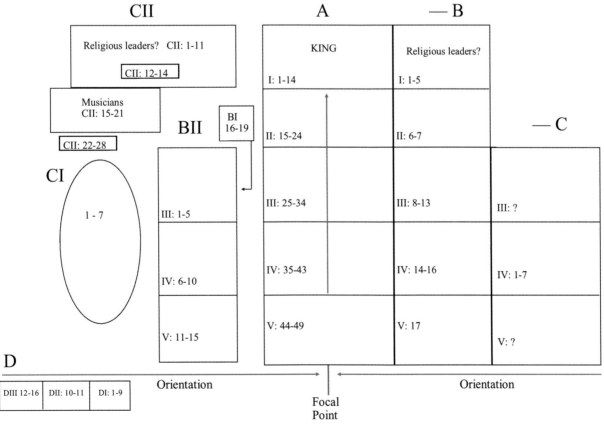

Plate 37

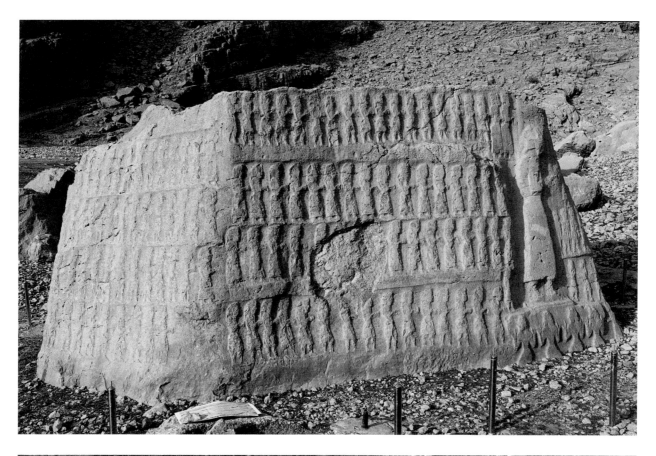

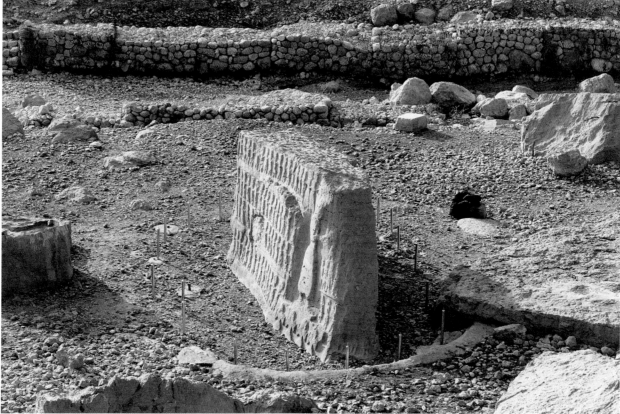

Plate 38

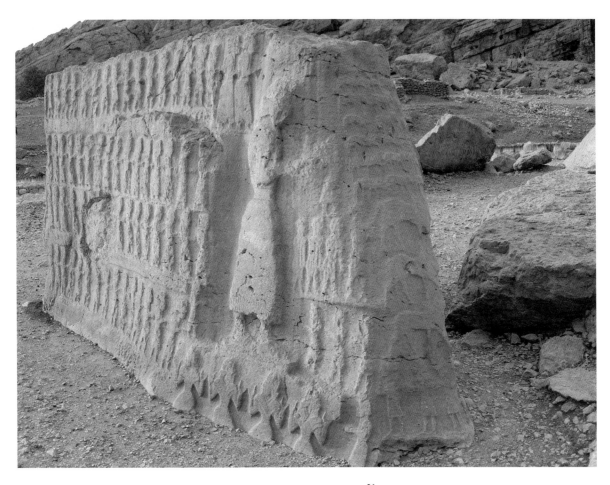

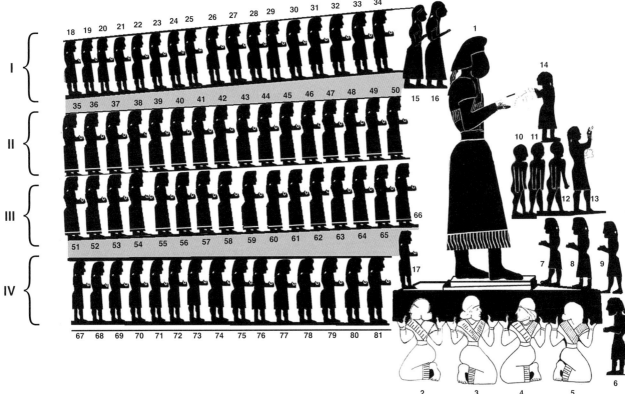

Plate 39

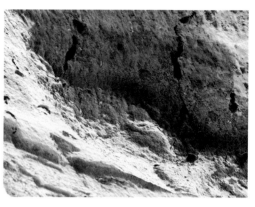

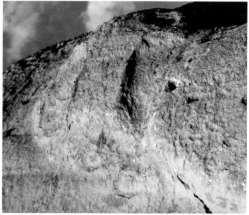

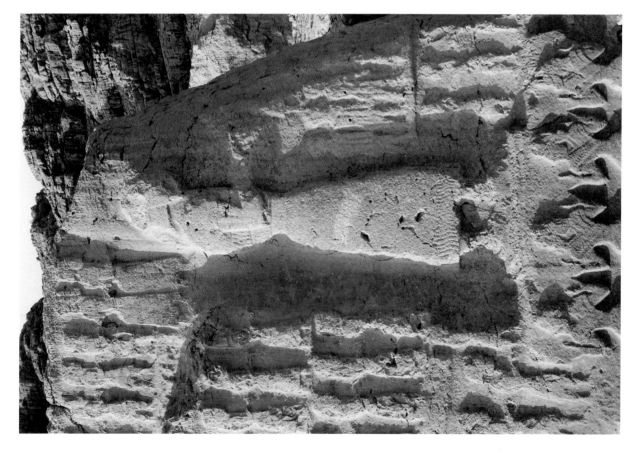

Plate 40

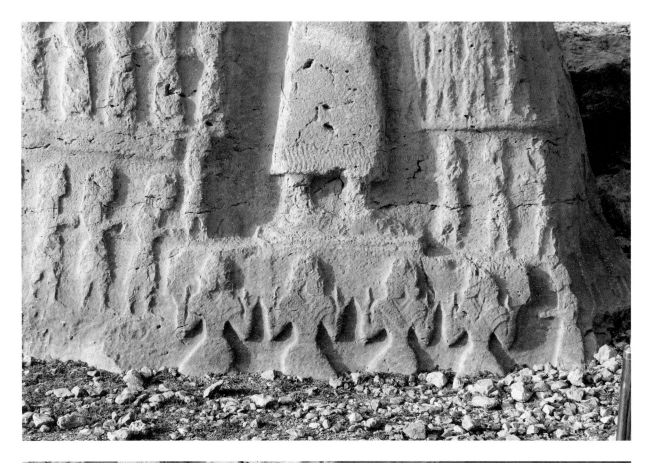

Plate 41

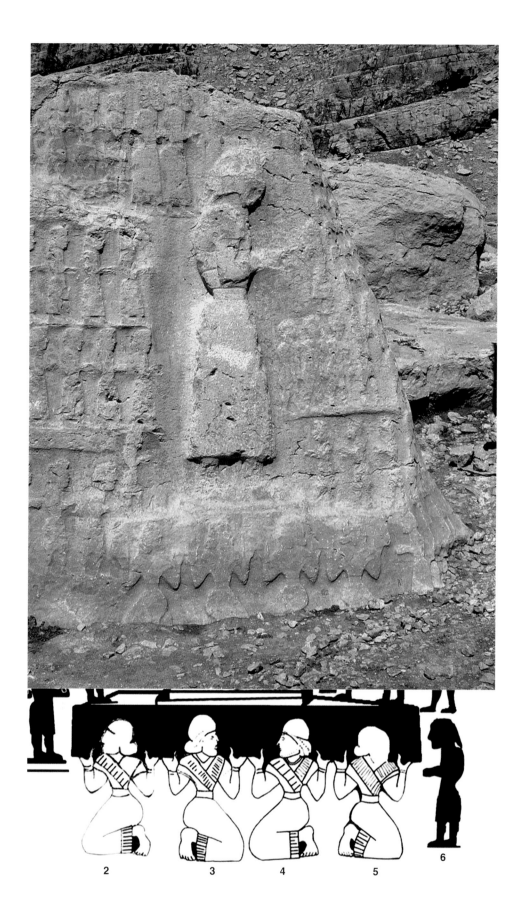

2 3 4 5 6

Plate 42

Plate 43

Plate 44

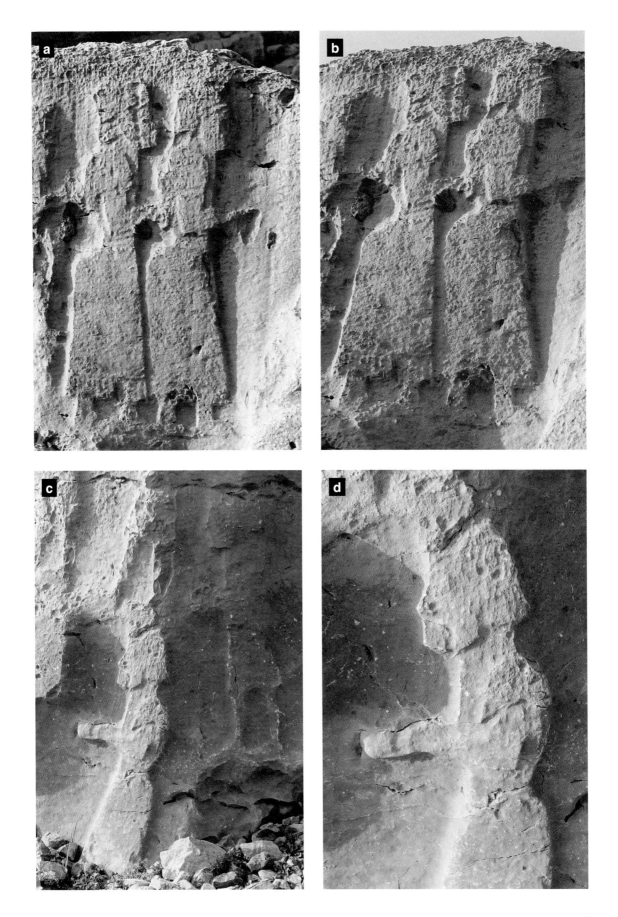

Plate 45

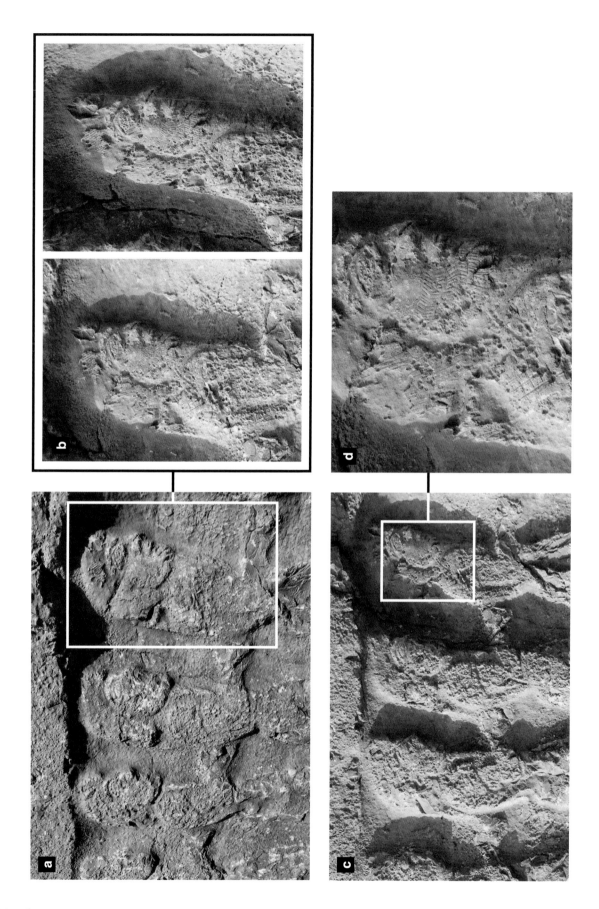

Plate 46

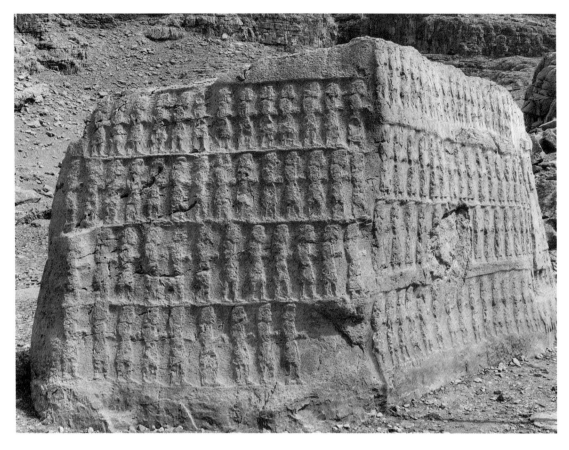

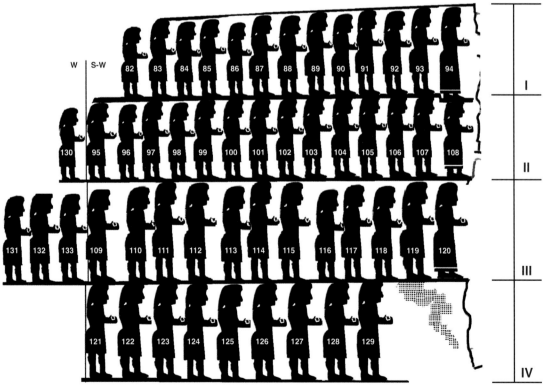

Note: The diagram contains labels. W | S-W, and numbers 82-94 (row I), 130, 95-108 (row II), 131, 132, 133, 109-120 (row III), 121-129 (row IV). Right side labels: I, II, III, IV.

Plate 47

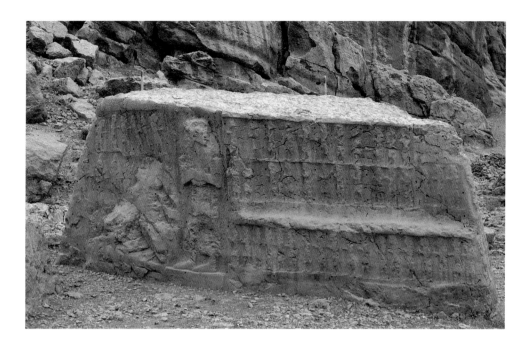

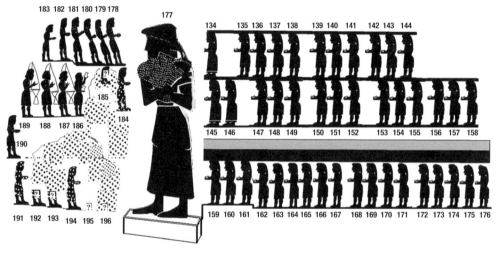

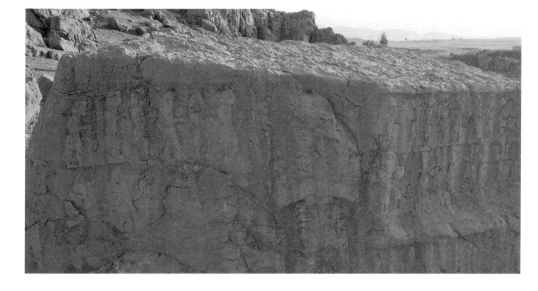

Plate 48

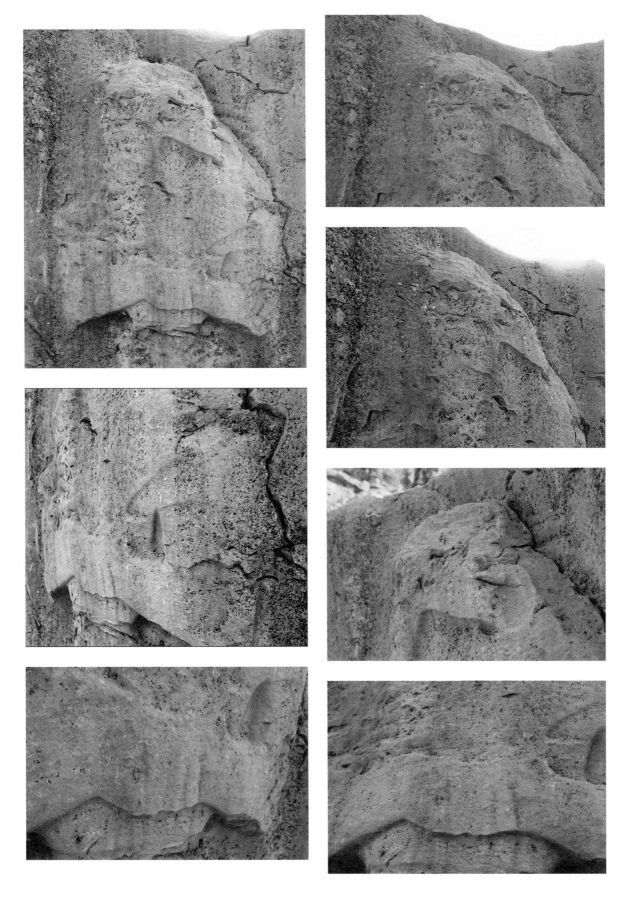

Plate 49

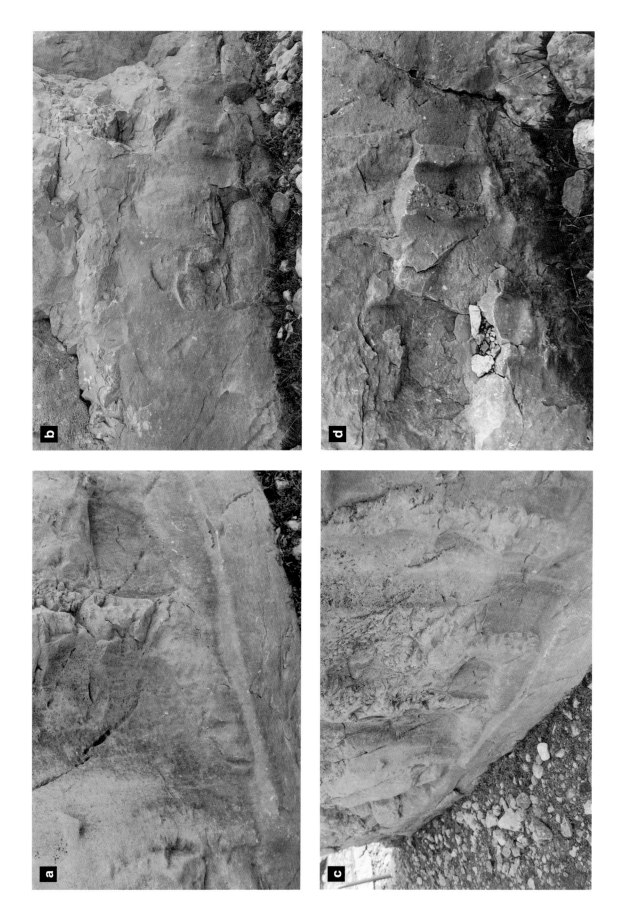

Plate 50

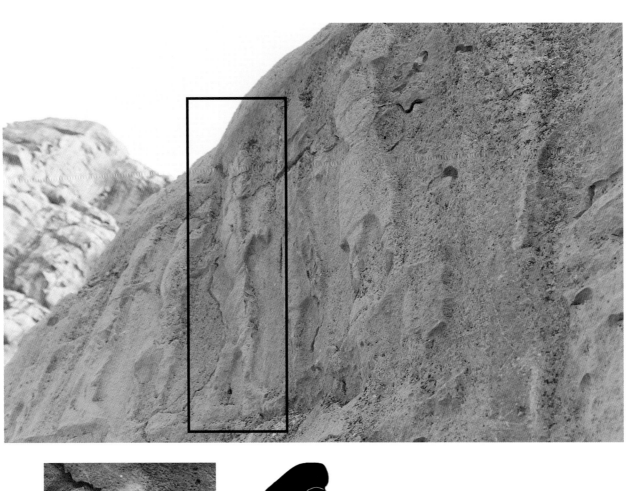

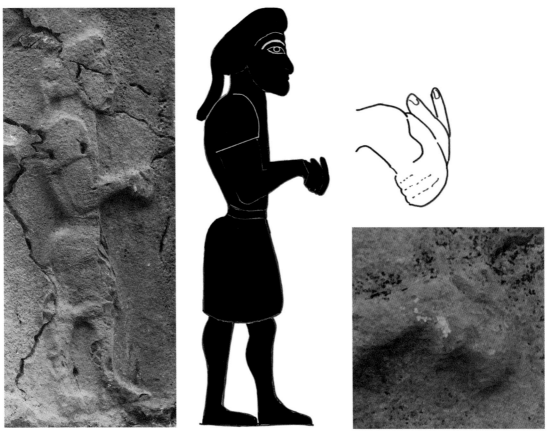

Plate 51

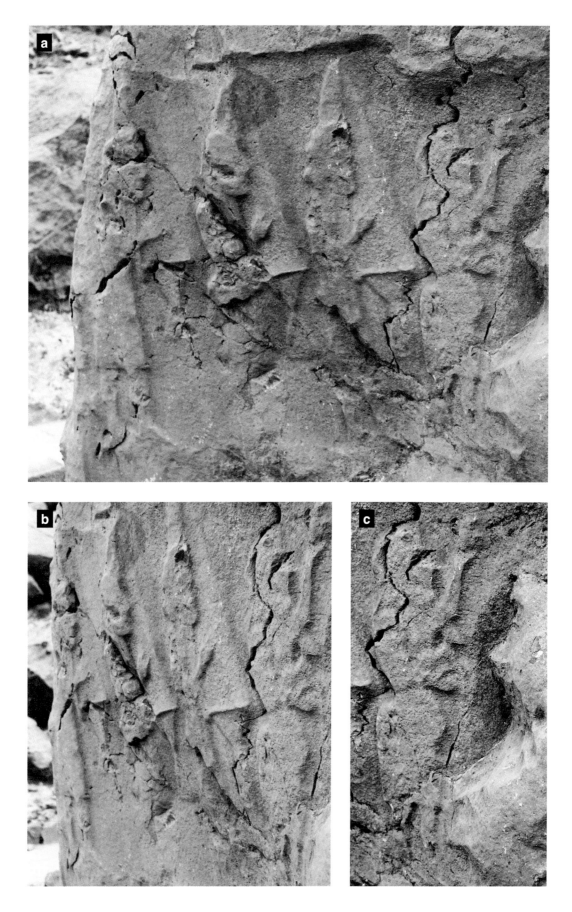

Plate 52

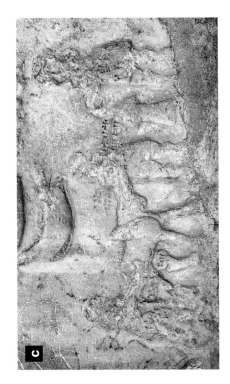

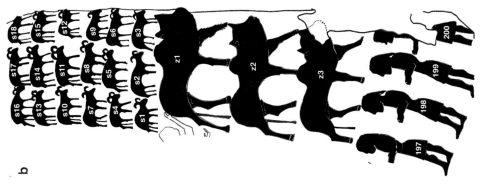

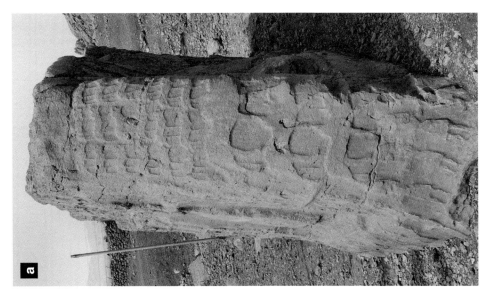

Plate 53

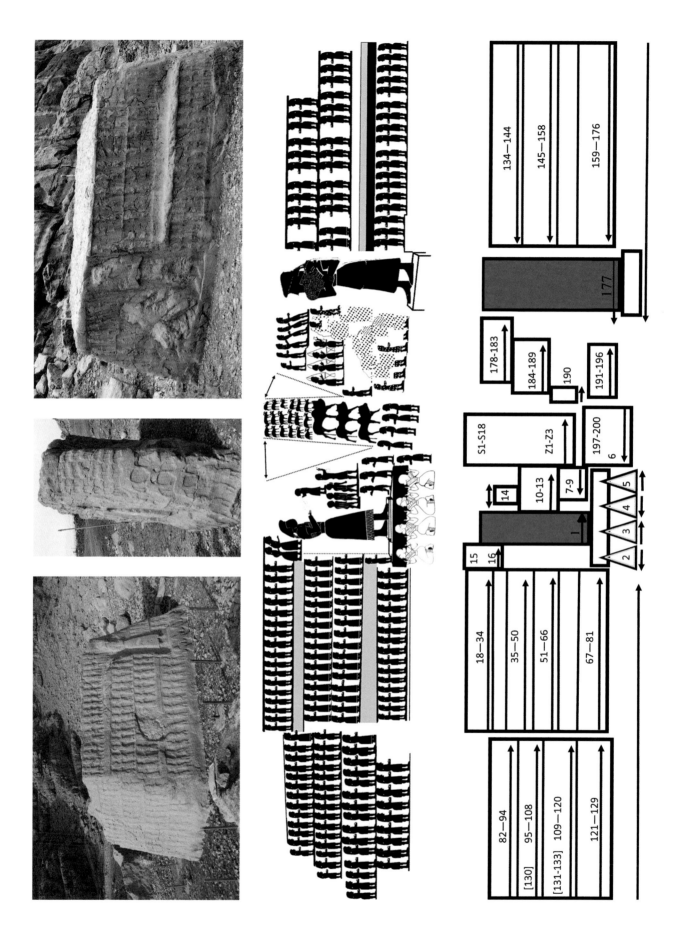

Plate 54

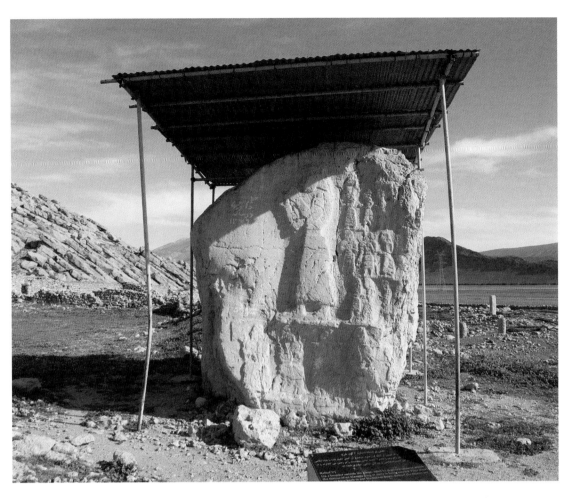

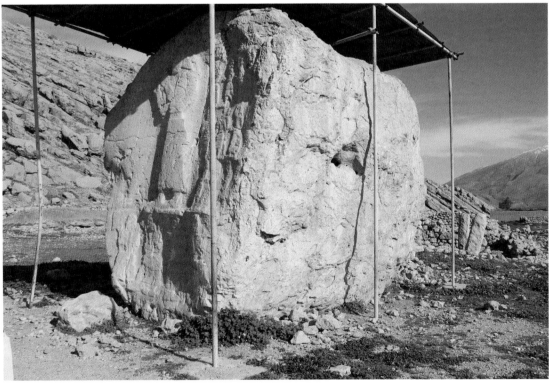

Plate 55

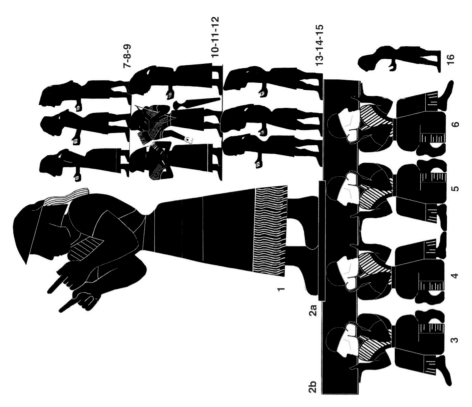

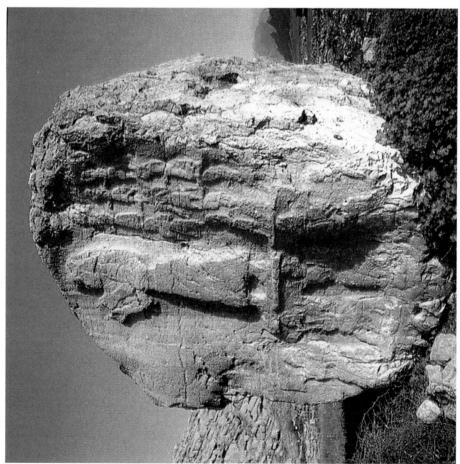

Plate 56

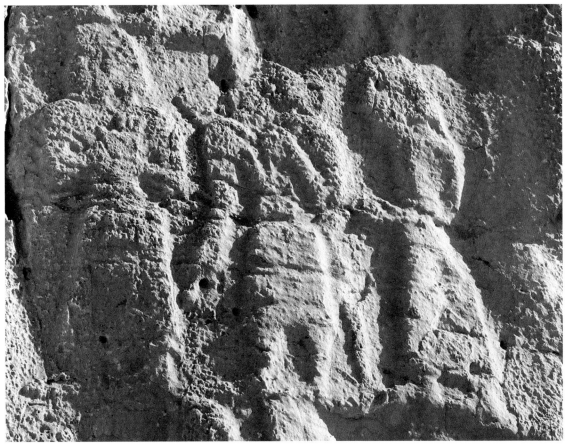

Plate 57

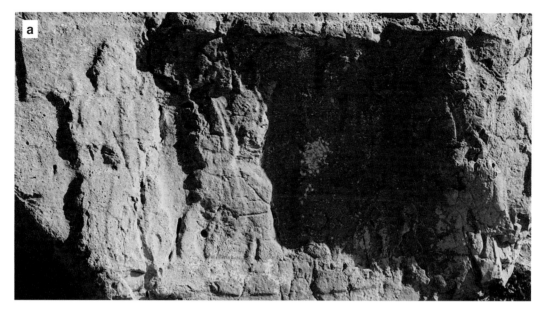

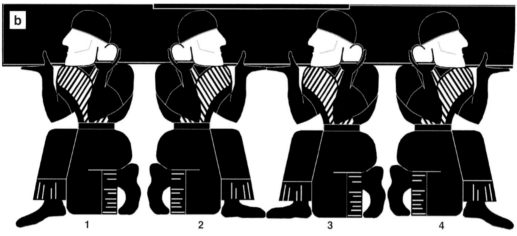

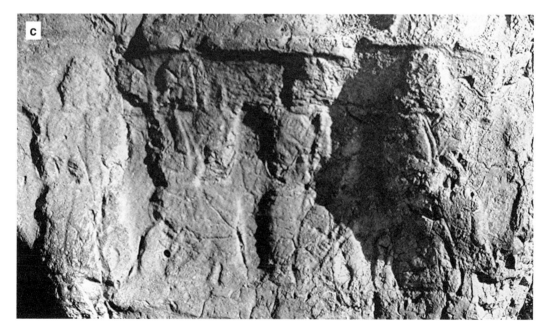

Plate 58

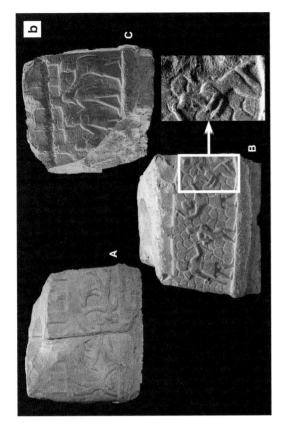

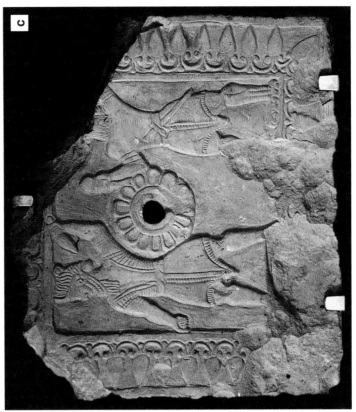

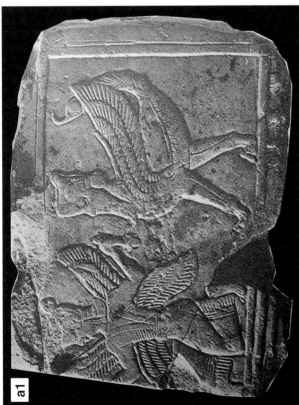

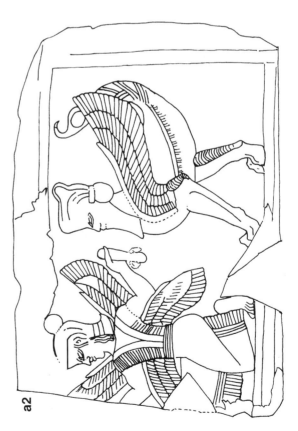

Plate 59

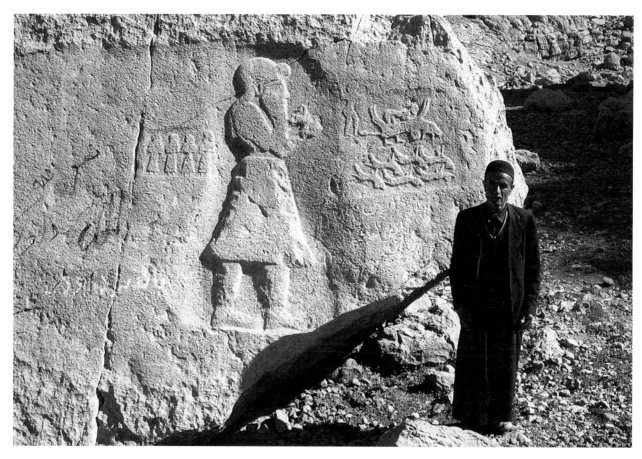

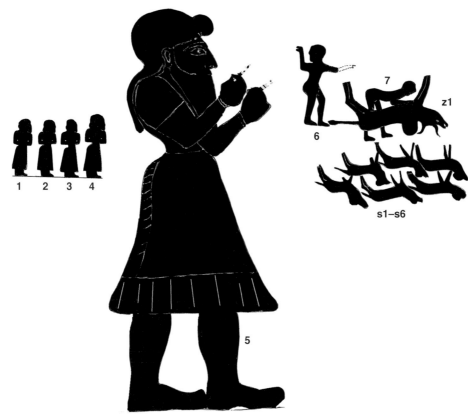

Plate 60

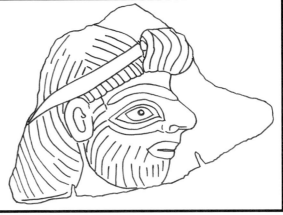

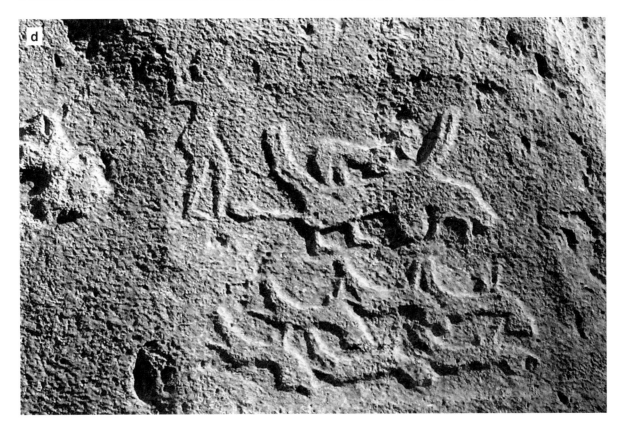

Plate 61

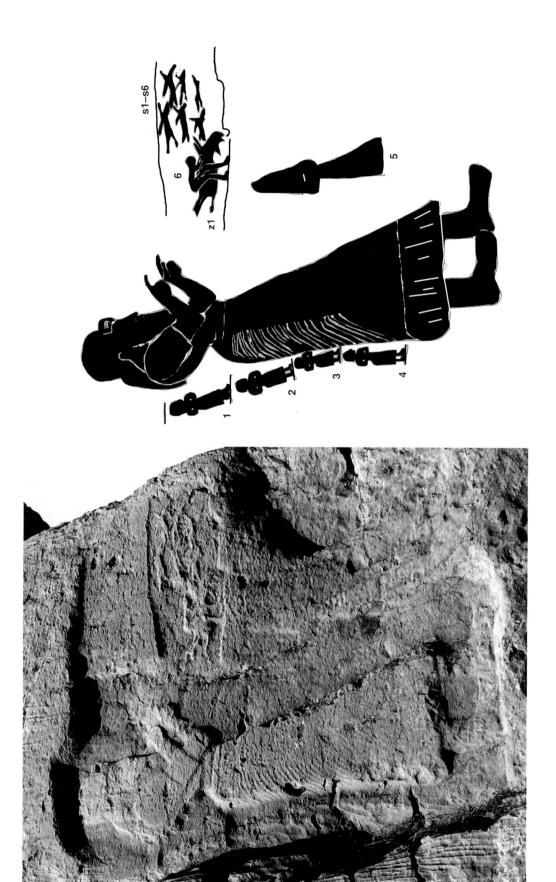

Plate 62

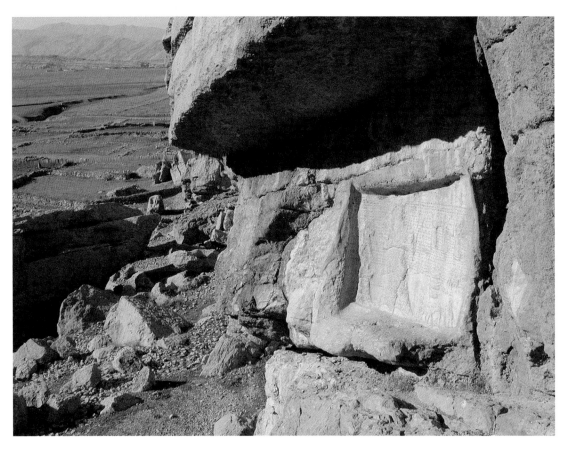

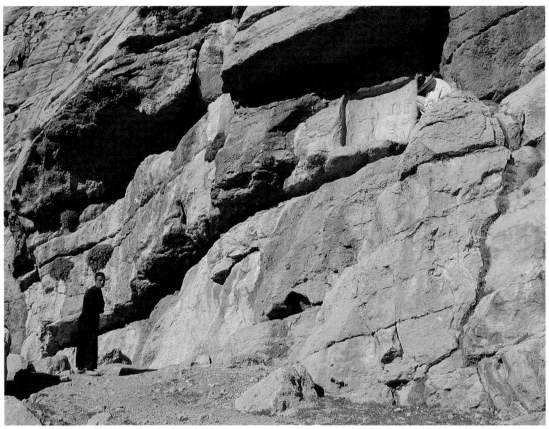

Plate 63

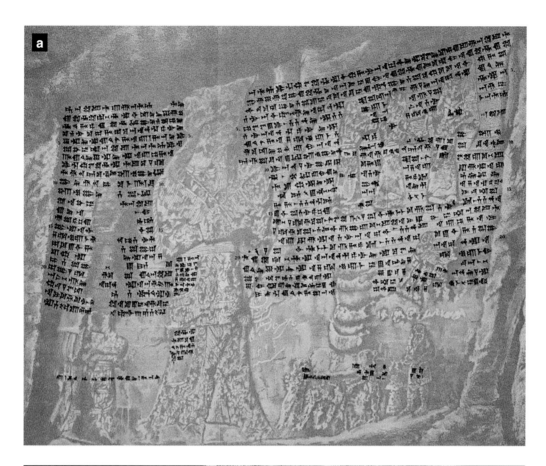

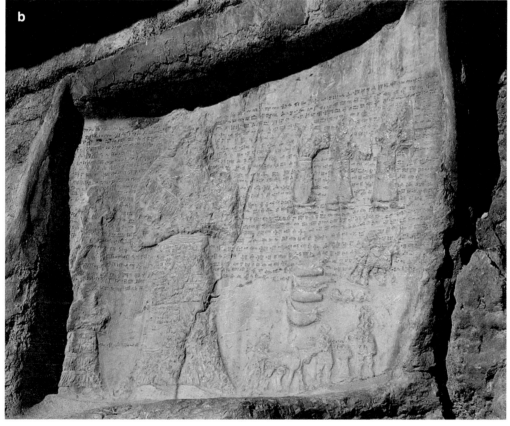

Plate 64

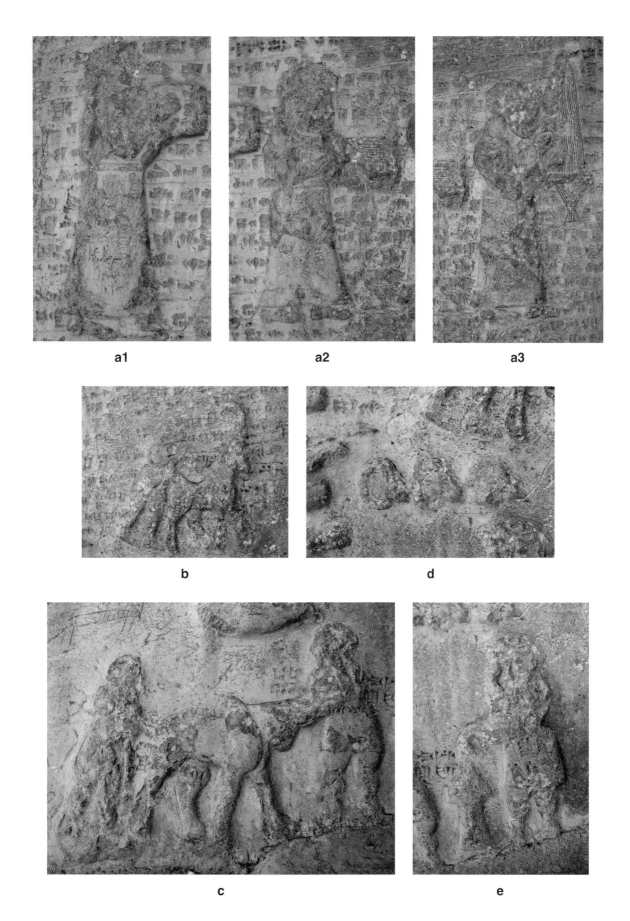

a1 a2 a3

b d

c e

Plate 65

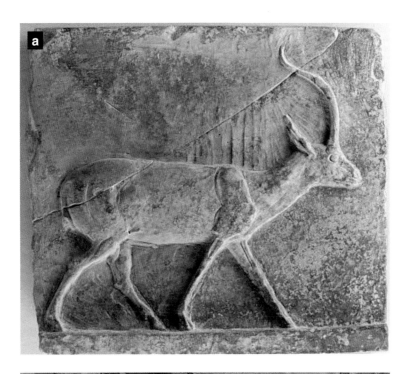

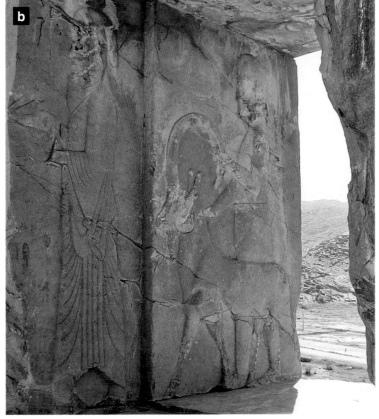

Plate 66

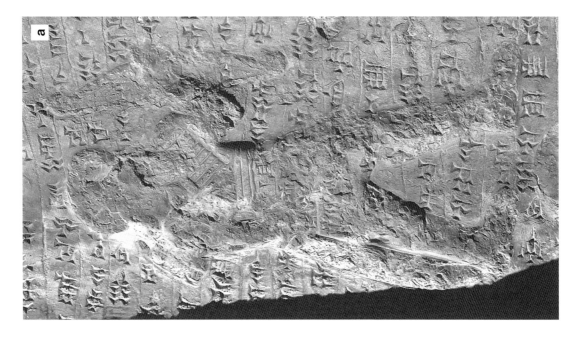

Plate 67

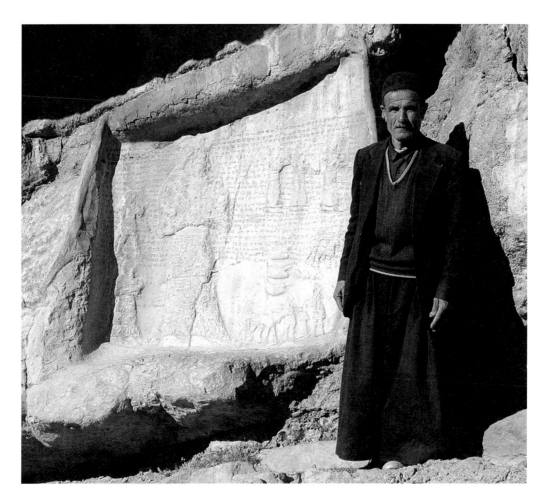

Plate 68

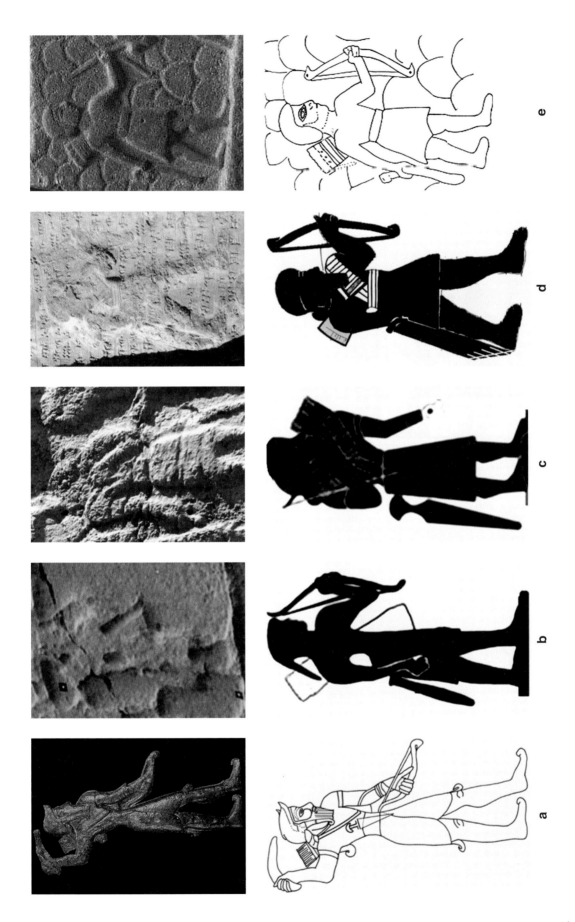

Plate 69

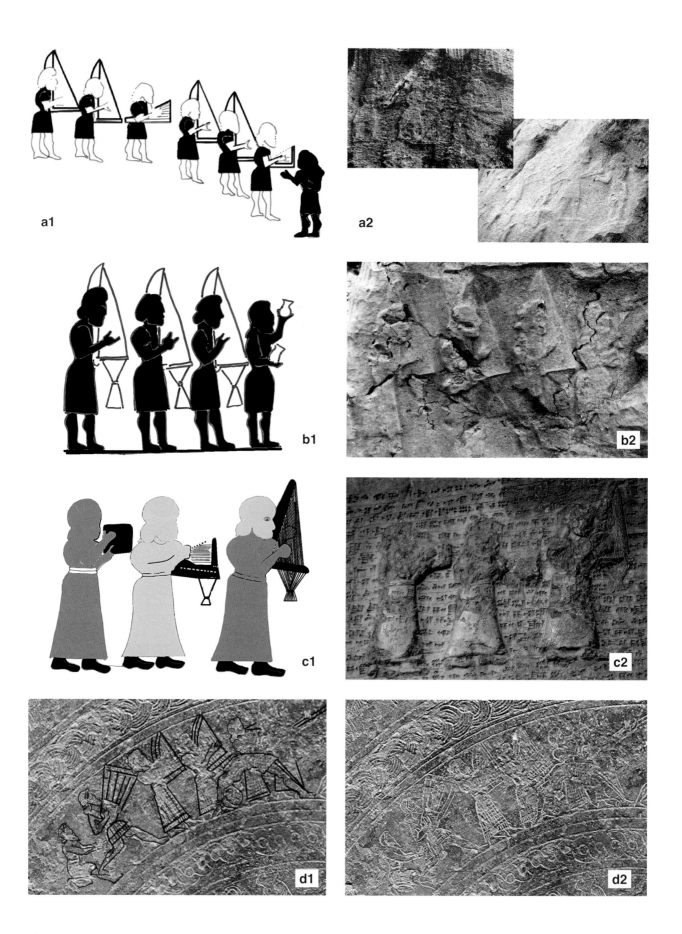

a1

a2

b1

b2

c1

c2

d1

d2

Plate 70

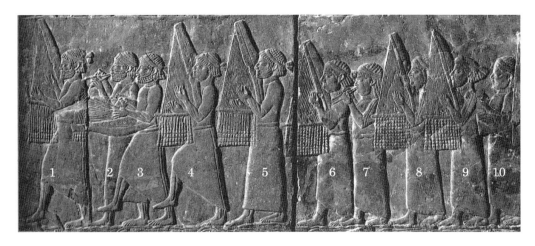

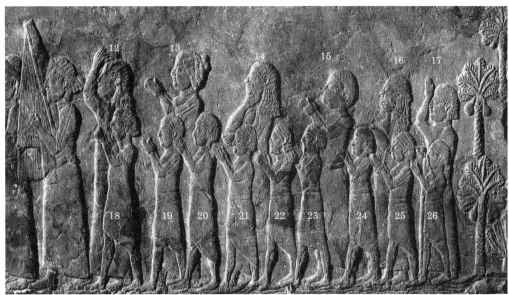

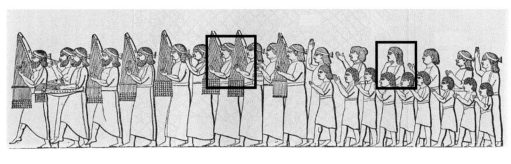

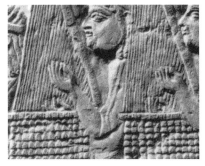
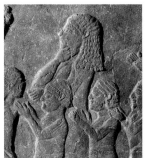

Plate 71

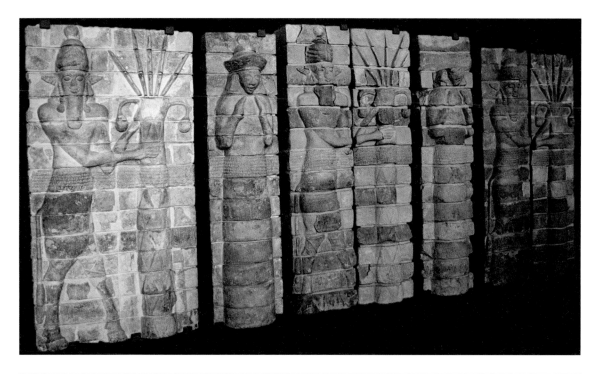

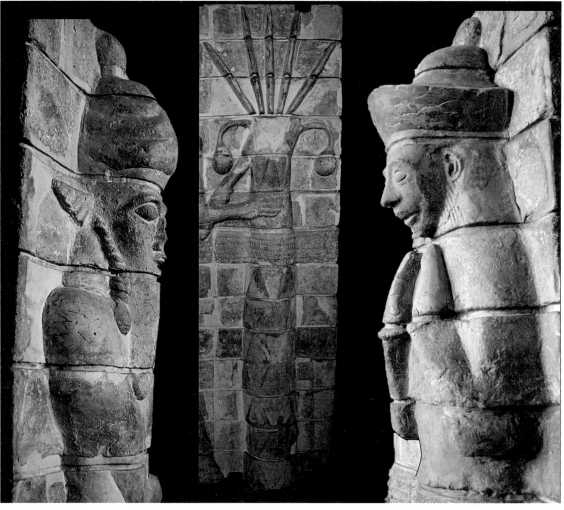

Plate 72

a

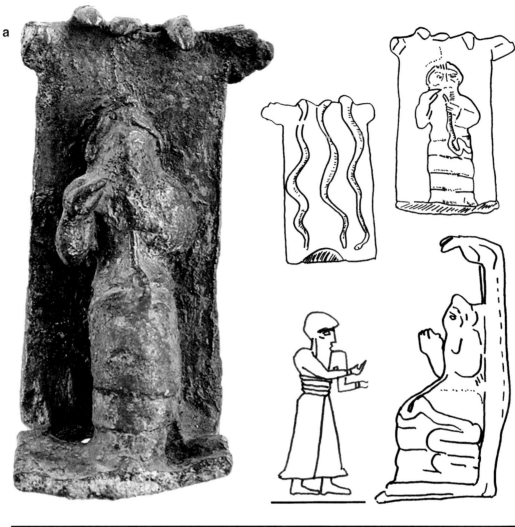

b

Plate 73

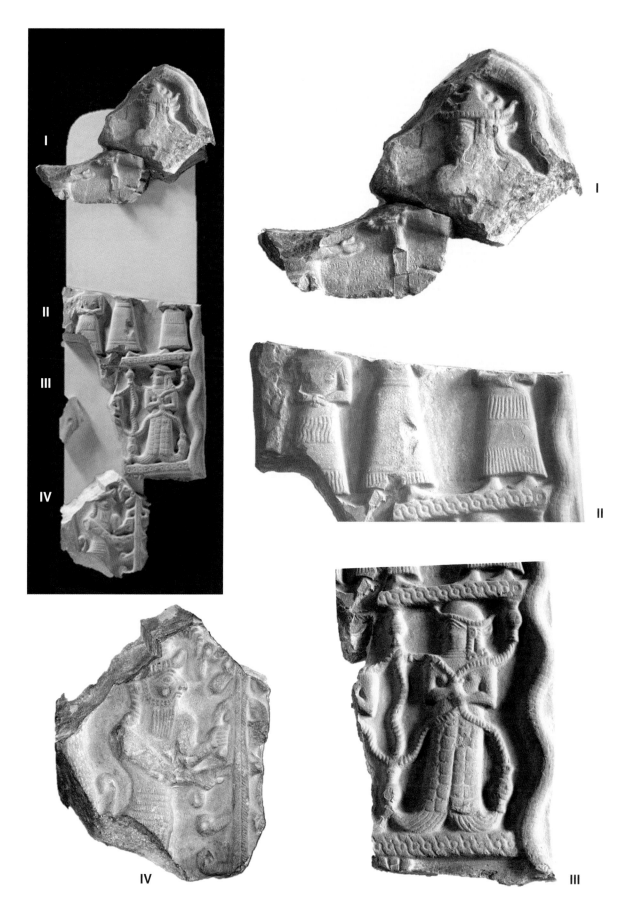

Plate 74